Bravo for not saying bravo. The editors have avoided the trap of being cheerleaders and instead embraced the complexity – in terms of theory, practice and certainly epistemology – of artistic interventions in organizations. In doing so, they provide a much-needed and timely summary, and an excellent place for moving forward in this exciting domain.
 Steven S. Taylor, Associate Professor, Worcester Polytechnic University, USA

Today's leaders increasingly open their organizations to artistic interventions. They're collaborating with artists and using art processes to produce better outcomes. In this book, the world's foremost authors on this subject bring us up to date on this trending activity.
 Robert D. Austin, Professor, Copenhagen Business School, Denmark

Aesthetic experience is always an experience of choice that challenges us yet this book opens up the discussion and allows us to understand artistic intervention in organizations and how they can be used to make a positive change and improvement. I strongly recommend it.
 Silvia Gherardi, Professor, University of Trento, Italy

This is a delightful and important book, dedicated to how artistic and creative interventions can – evolutionarily or revolutionarily – influence organizing. A book for all times, but perhaps particularly important currently, in an era when imagination and genuine creativity are all but banned from mainstream workplaces.
 Monika Kostera, Professor Ordinaria in Management, The Jagiellonian University in Kraków, Poland and Guest Professor at Bradford University, UK

Artistic Interventions in Organizations

Artistic intervention, where the world of the arts is brought into organizations, has increasingly become a research field in itself with strong links to both creativity and innovation. Opportunities for the arts to interact with public and private organizations occur worldwide, but during the last decade artistic interventions have received growing attention in both practice and research.

This book is the first comprehensive attempt to map the development of the field and provides an international overview of the area of artistic interventions and their impact on organizations from different perspectives, ranging from strategic management to organizational development, innovation and organizational learning. Featuring chapters from prominent and emerging scholars, including Nancy J. Adler, Barbara Czarniawska, Lotte Darsø and Alexander Styhre, it places artistic interventions within an international context. The book also offers readers the opportunity to learn from experiences in a varied range of organizations, including newspapers, manufacturing, government, schools, and covers many art-forms, such as music, contemporary dance, painting, photography and theatre.

Using extensive empirical examples, this book is vital reading for researchers and scholars of creativity and cultural industries, as well as innovation, creative entrepreneurship, organizational studies and management.

Ulla Johansson Sköldberg is Professor Emeritus from Gothenburg University, Sweden.

Jill Woodilla is Honorary Visiting Professor, School of Business, Economics and Law, and Affiliated Researcher, Business & Design Lab, University of Gothenburg, Sweden.

Ariane Berthoin Antal is Senior Fellow at the WZB Berlin Social Science Center, Germany and Distinguished Research Professor at Audencia Nantes School of Management, France.

Routledge Research in Creative and Cultural Industries Management
Edited by Ruth Rentschler

Routledge Research in Creative and Cultural Industries Management provides a forum for the publication of original research in cultural and creative industries, from a management perspective. It reflects the multiple and inter-disciplinary forms of cultural and creative industries and the expanding roles which they perform in an increasing number of countries.

As the discipline expands, there is a pressing a need to disseminate academic research, and this series provides a platform to publish this research, setting the agenda of cultural and creative industries from a managerial perspective, as an academic discipline.

The aim is to chart developments in contemporary cultural and creative industries thinking around the world, with a view to shaping future agendas reflecting the expanding significance of the cultural and creative industries in a globalized world.

Published titles in this series include:

1. **Arts Governance**
 People, Passion, Performance
 Ruth Rentschler

2. **Building Better Arts Facilities**
 Lessons from a U.S. National Study
 Joanna Woronkowicz, D. Carroll Joynes, and Norman M. Bradburn

3. **Arts and Commerce**
 The Colonization of No Man's Land
 Edited by Peter Zackariasson & Elena Raviola

4. **Artistic Interventions in Organizations**
 Research, Theory and Practice
 Edited by Ulla Johannson Sköldberg, Jill Woodilla and Ariane Berthoin Antal

5. **Rethinking strategy for Creative Industries**
 Innovation and Interaction
 Milan Todorovic with Ali Bakir

6. **Arts and Business**
 Building a Common Ground for Understanding Society
 Edited by Elena Raviola and Peter Zackariasson

Artistic Interventions in Organizations

Research, theory and practice

Edited by Ulla Johansson Sköldberg, Jill Woodilla and Ariane Berthoin Antal

LONDON AND NEW YORK

First published 2016
by Routledge
2 Park Square, Milton Park, Abingdon, Oxon OX14 4RN

and by Routledge
711 Third Avenue, New York, NY 10017

First issued in paperback 2017

Routledge is an imprint of the Taylor & Francis Group, an informa business

© 2016 Ulla Johansson Sköldberg, Jill Woodilla and Ariane Berthoin Antal

The right of the editors to be identified as the authors of the editorial material, and of the authors for their individual chapters, has been asserted in accordance with sections 77 and 78 of the Copyright, Designs and Patents Act 1988.

All rights reserved. No part of this book may be reprinted or reproduced or utilised in any form or by any electronic, mechanical, or other means, now known or hereafter invented, including photocopying and recording, or in any information storage or retrieval system, without permission in writing from the publishers.

Trademark notice: Product or corporate names may be trademarks or registered trademarks, and are used only for identification and explanation without intent to infringe.

British Library Cataloguing-in-Publication Data
A catalogue record for this book is available from the British Library

Library of Congress Cataloging-in-Publication Data
 Artistic interventions in organizations : research, theory and practice / edited by Ulla Johansson Skoldberg, Jill woodilla and Ariane Berthoin Antal. —
1 Edition.
 pages cm. — (Routledge research in creative and cultural industries management)
 Includes bibliographical references and index.
 1. Organizational change. 2. Leadership. 3. Art, Modern—Social aspects. I. Skoldberg, Ulla Johansson, editor. II. Woodilla, Jill, 1942– editor. III. Antal, Ariane Berthoin, editor.
 HD58.8.A78 2016
 658.4'06—dc23
 2015013230

ISBN 13: 978–1–138–49743–6 (pbk)
ISBN 13: 978–1–138–82113–2 (hbk)

Typeset in Bembo
by Apex CoVantage, LLC

Contents

List of figures — xi
List of tables — xii
Notes on contributors — xiii
Preface — xx

PART I
Framing the field — 1

1 Artistic interventions in organizations: introduction — 3
ARIANE BERTHOIN ANTAL, JILL WOODILLA AND
ULLA JOHANSSON SKÖLDBERG

2 Arts-in-business from 2004 to 2014: from experiments in practice to research and leadership development — 18
LOTTE DARSØ

PART II
Assessment and evidence — 35

3 Multistakeholder perspectives on searching for evidence of values-added in artistic interventions in organizations — 37
ARIANE BERTHOIN ANTAL AND ANKE STRAUß

4 Assessing the business impact of Arts-Based Initiatives — 60
GIOVANNI SCHIUMA AND DANIELA CARLUCCI

PART III
Learning from success and failure 75

5 A newspaper changes its identity through an artistic intervention 77
MARCUS JAHNKE

6 Fostering creativity through artistic interventions: two stories of failed attempts to commodify creativity 90
ELENA RAVIOLA AND CLAUDIA SCHNUGG

7 Artistic interventions as *détournement* and constructed situations 107
ALEXANDER STYHRE AND JONAS FRÖBERG

PART IV
Experiences with different art forms 121

8 From aspiration to evidence: music, leadership and organizational transformation 123
LINDA M. IPPOLITO AND NANCY J. ADLER

9 Choreographing creative processes for innovation 149
NINA BOZIC YAMS

10 Playing the 'Magic If': a theatre director's perspective on intervening 164
VICTORIA BRATTSTRÖM

PART V
Responsibility for making it happen 183

11 Managers in artistic interventions and their leadership approach 185
KATARINA ZAMBRELL

12 Mind the gap! Bridging strategies for artistic interventions in organizations 204
ULLA JOHANSSON SKÖLDBERG AND JILL WOODILLA

13 **Organizational studios: enabling innovation** 225
STEFAN MEISIEK AND DAVED BARRY

PART VI
Reflections 239

14 **From revolution to evolution ... and back again?** 241
ARIANE BERTHOIN ANTAL, JILL WOODILLA
AND ULLA JOHANSSON SKÖLDBERG

15 **Postlude** 250
BARBARA CZARNIAWSKA

Index 253

Figures

4.1	The Arts Value Map	66
4.2	A simplified version of Arts Value Map illustrating the expected benefits to be achieved through Arts-Based Initiatives	69
4.3	An example of the application of Analytical Hierarchy Process	70
9.1	Dancers' creative process and tools	151
11.1	Five areas of managers' aesthetic-inspired leadership	191

Tables

4.1	From designing Arts Value Map to planning Arts-Based Initiatives: the main phases of the process in the company	68
11.1	Leadership areas expressed by Airis managers	195
12.1	Intermediary organization differences	218
12.2	Intermediary process differences	219

Contributors

Nancy J. Adler is the S. Bronfman Chair in Management at McGill University. She conducts research and consults worldwide on global leadership, cross-cultural management and arts-inspired leadership practices. She has authored more than 125 articles, produced 3 films and published 10 books and edited volumes. She is a Fellow of the Academy of Management, the Academy of International Business and the Royal Society of Canada and has been recognized as one of the top university teachers in Canada. Nancy is also a visual artist and has been an artist-in-residence at The Banff Centre. Her paintings and monotype prints are held in private collections worldwide.

Daved Barry is Professor of Creative Organization Studies at Copenhagen Business School, Denmark and adjunct Professor of Management at NovaSBE in Lisbon, Portugal. He received his PhD in Strategic Management and Organizational Psychology from the University of Maryland, USA. His research focuses on the intersection of enterprise design, the humanities and studio practices. Currently, he is developing enterprise design frameworks that bring together perspectives from the applied arts and classical analytic organization design.

Ariane Berthoin Antal is Senior Fellow at the Wissenschaftszentrum Berlin für Sozialforschung (WZB) where she has led the research stream on "Artistic Interventions in Organizations" since 2008, building on her earlier work on organizational learning and corporate social responsibility. She is Distinguished Research Professor at Audencia Nantes School of Management in France and Honorary Professor at the Technical University of Berlin. In addition to publishing extensively in academic journals, she has been invited to present her findings to policymakers and managers at events throughout Europe and Asia. Recent books include the *Handbook of Organizational Learning and Knowledge* (co-edited with M. Dierkes, J. Child and I. Nonaka, Oxford University Press, 2001); *Learning Organizations: Extending the Field* (co-edited with P. Meusburger and L. Suarsana, Springer, 2014) and *Moments of Valuation: Exploring Sites of Dissonance* (co-edited with Michael Hutter and David Stark, Oxford University Press, 2015).

Nina Bozic Yams is a PhD student in Innovation and Design at the School for Innovation, Design and Engineering, Mälardalen University, Eskilstuna, Sweden. Her research focuses on exploring how knowledge and methods from contemporary dance practice can be applied in organizations to enable innovation. Her research and teaching are influenced by her experience in both dance and business and her belief in emergent, people-driven processes. Prior to her PhD studies she worked as a manager, consultant and trainer in the areas of management, creativity, innovation and entrepreneurship in both public and private sectors. She currently leads a two-year consulting and research project, helping to build innovation capability in a municipality with 8,500 employees.

Victoria Brattström is a Director and Actor trained at the Academy of Music and Drama, University of Gothenburg, Sweden, where she now teaches students in acting and musical theatre. Her broad experience as an actor and director ranges from community theatre productions to modern musicals. She has directed outdoor performances with circus acrobats, choirs and dancers as well as chamber plays for Swedish Radio and Television. Since 2007 she has applied her work as an actor and director in several artistic intervention projects produced by the intermediary organization TILLT. Victoria is currently undertaking PhD studies in Performance in Theatre at the Academy of Music and Drama, University of Gothenburg in a collaborative project with the University of Gothenburg Centre for Person-Centred Care (www.gpcc.gu.se).

Daniela Carlucci, BEng Meng, PhD in Business Management, is Assistant Professor at the University of Basilicata, Italy, where she teaches business management and project evaluation and management. Her main research interests include knowledge assets management, business performance measurement and management, innovation, decision support methods, arts for innovation and organizational development. She has been a Visiting Scholar at the Centre for Business Performance, Cranfield School of Management, UK and Visiting Professor at the Department of Business Information Management and Logistics, Tampere University of Technology, Finland. Since November 2014 she has been a Visiting Researcher at the University of the Arts London, UK. She has authored and co-authored chapters in books and articles in journals such as *Expert Systems with Applications, Production Planning and Control, Healthcare Management Science, Measuring Business Excellence, Knowledge Management Research and Practice*.

Barbara Czarniawska holds a Research Chair in Management Studies at Gothenburg Research Institute, School of Business, Economics and Law at Göteborg University, Sweden. Her research takes a constructionist perspective on organizing, most recently exploring the management of overflows. She is interested in methodology, especially in fieldwork techniques and in

the application of narratology to organization studies. She is a Member of the Swedish Royal Academy of Sciences, the Swedish Royal Engineering Academy, the Royal Society of Art and Sciences in Göteborg and the Finnish Society of Sciences and Letters. She received the Lily and Sven Thuréus Technical-Economic Award for internationally renowned research in organization theory, 2000 and a Wihuri International Prize in 2003, recognizing "creative work that has specially furthered and developed the cultural and economic progress of mankind". Her recent books in English are *A Theory of Organizing* (second edition, 2014) and *Social Science Research from Field to Desk* (2014).

Lotte Darsø, Ph.D., Associate Professor in Innovation, Department of Education, University of Aarhus, Denmark, is a researcher, author and a respected conference speaker, nationally and internationally. Her primary interests are innovation, creativity and artful approaches in educational and organizational settings. As one of Denmark's leading experts in creativity and innovation her distinct focus is on the "human factor" and its significance for leading and succeeding with innovation. She co-founded the executive master program: Leadership and Innovation in Complex Systems (www.laics.net). She received The Industrial PhD Fellowship Prize 2000 for her research on innovation (*Innovation in the Making*, 2001). Her book *Artful Creation: Learning-Tales of Arts-in-Business* (2004) led to an invitation to lead a workshop at the World Economic Forum in Davos. In 2011 she published a book on innovation pedagogy in Danish, which has become widely used in educational curricula in Scandinavia and will be translated into English.

Jonas Fröberg is Artistic Director, Teater Spira, Gothenburg, Sweden. As an actor and writer he has continued to examine management since his AIRIS experience in 2006. In dialogue with scientists in the fields of history of economics, political science, education, management and global studies he has led artistic and theatre processes at the Gothenburg Mayor's Office, schools and the Gothenburg department of education. He uses storytelling exercises that involve workers, teachers, management and youth in making public readings, plays, books and seminars. One perspective has been to illuminate the workings of New Public Management policies implemented in Sweden since the 1980s. Another example is Jonas' work with youth ages 15–19, some with poor or no grades in core subjects, where his aim is to increase their engagement in schoolwork and raise their academic level.

Linda M. Ippolito, Senior Partner, Sheridan, Ippolito & Associates, Barristers & Solicitors, Toronto, Canada and Lecturer at York University, Canada, is a classical pianist, litigation lawyer, alternative dispute resolution practitioner, teacher and scholar. She has participated in international piano competitions in Moscow, Australia and Canada and has performed throughout North America and Europe. Linda holds an LL.B., an LL.M. in Alternative Dispute

Resolution and a PhD from Osgoode Hall Law School, York University (Canada). Linda teaches advocacy, negotiation and dispute resolution at Queens Law School, Osgoode Hall Law School and Osgoode Professional Development. Linda's passion lies in the intersection between music and conflict. Her master's thesis explored collaborative vocal music-making as an innovative approach to conflict resolution and peacebuilding. Her doctoral dissertation examined shifting dominant culture disputing metaphors and mindsets from war and games to the musical ensemble and building creative capacities by using music-based teaching and learning modalities.

Marcus Jahnke is a Researcher at SP Technical Research Institute of Sweden. Until recently he was a Senior Lecturer in Design at the School of Design and Crafts (HDK), University of Gothenburg, Sweden, where he conducted research and lectured in the master programme in Business & Design. Marcus holds a BSc in Innovation Engineering (1994) from the University of Halmstad, Sweden and an MFA in design (2005) from the School of Design and Crafts at the University of Gothenburg. His current research interest concerns the intersection between design practice and innovation, which was also the topic of his PhD study (2013). Marcus also studies gender and design issues with experimental research approaches in collaboration with several companies and authorities. Other interests concern sustainability and social innovation. Marcus has a practice background from the automotive and building sectors, where he worked with environmental management systems.

Ulla Johansson Sköldberg, PhD, held the Torsten and Wanja Söderberg Chair in Design Management at the School of Design and Crafts until 2015 when she became Professor Emerita there and at the Business and Design Lab and Gothenburg Research Institute of the University of Gothenburg, Sweden. Her research interests are the concepts of responsibility, irony and design management. She combines a general interest in art, earlier studies in architecture and on-going critical management perspectives. During the last decade Ulla has engaged in entrepreneurial academic work, including founding programs that cross faculty borders, such as the program for interior decoration and visual communication at Linneaus University, Sweden and the Business & Design Lab, a co-operation between the School of Business Economics and Law and the School of Design and Crafts at Gothenburg University. She has written and edited seven books, numerous book chapters and published in many academic journals.

Stefan Meisiek is Director of Educational Practice and Associate Professor at University of Sydney Business School and Visiting Associate Professor at Copenhagen Business School and Hong Kong University. He received his PhD in Management from the Stockholm School of Economics and his MA from the Free University, Berlin. His research interests concern leadership

and business innovation. Currently, Stefan is working to develop business studios; environments and processes for practice-based learning.

Elena Raviola, PhD, is Assistant Professor at the Department of Business Administration, School of Business, Economics and Law, University of Gothenburg, Sweden and at the Department of Organization, Copenhagen Business School, Denmark. Elena is interested in professional work and its current changes related to new technologies as well as its relation with management. Her field studies have concentrated on the media industries, in particular news organizations and on artistic interventions of different kinds. Her research is published in *Organization Studies, Journal of Change Management, Information, Theory and Society, Journal of Media Business Studies, International Journal of Media Management* and a number of edited volumes.

Giovanni Schiuma is Professor of Arts Based Management and Director of the Innovation Insights Hub at University of the Arts, London, UK and Professor at Università della Basilicata, Italy. His book *The Value of Arts for Business* (Cambridge University Press, 2011) is regarded as a seminal text on how Arts-Based Initiatives (ABIs) can transform business models. He is a regular speaker at conferences and has teaching and consultancy experience across Europe on arts for business, knowledge and innovation management as well as strategic performance measurement and management. Giovanni has authored or co-authored more than 180 publications on topics including strategic knowledge asset and intellectual capital management, strategic performance measurement and management, innovation systems and organizational development. He is chief editor of the journal *Knowledge Management Research and Practice* and co-editor in chief of the international journal *Measuring Business Excellence* and chairs the International Forum on Knowledge Assets Dynamics.

Claudia Schnugg earned her PhD in social and economic sciences from the University of Linz, Austria. She is Senior Researcher and Senior Curator, Ars Electronica Futurelab, Linz, Austria. She curates, produces and studies artistic residencies and art and science collaborations in the transdisciplinary field of art, technology and society and she mentors artists and students in Ars Electronica programmes. Her interests are in aesthetic and embodied knowing and understanding and its influence on creating, work and organization. She conducts research in transdisciplinary teams integrating artistic methods to study questions in the disciplines of social science, technology and psychology. As curator she works with artists from diverse backgrounds on artistic projects and artistic research projects that include scientific, technological and social research questions. Previously she was Assistant Professor at the Johannes Kepler University, Linz, Austria and a Visiting Researcher at the Copenhagen Business School, Denmark.

Anke Strauß works as a researcher for critical perspectives on entrepreneurship and work–life balance at the European University Viadrina, Germany She is interested in relationships between the art and business sphere. After earning her PhD at the University of Essex, UK, for which she used a Deleuzian concept of dialogue to examine different attempts of collaboration between artists and a business organization, she worked at the WZB Berlin Social Science Center, Germany. There her research focused on different aspects of artistic interventions in organizations, including the processes and dynamics of an artistic intervention in an organization, issues of evaluating such initiatives, as well as the work and roles of intermediaries. She is currently working with a performance artist on the performativity of utopian thought for (re-)organizing cultural labour.

Alexander Styhre, PhD (Lund University) is Chair of Organization Theory and management, Department of Business Administration, School of Business, Economics and Law, University of Gothenburg, Sweden. He has published widely in the field of management studies, including his two most recent books *Management and Neoliberalism* (Routledge, 2014) and *Biomaterials Innovation: Bundling Technologies and Life* (Edward Elgar, 2014). Styhre is also a former member of the board of directors of TILLT (2010–2014), a Swedish organization orchestrating collaborations and exchanges between industry and the culture sector (in the widest sense of the term) and he has thus been involved in artist interventions from a certain distance.

Jill Woodilla, PhD (University of Massachusetts-Amherst, USA), is Honorary Visiting Professor, School of Economics and Law and Affiliated Researcher, Business & Design Lab, University of Gothenburg, Sweden. Jill applies an ironic perspective to take a critical view of the multiple realities of diverse situations and her research interests include the intersection of art, design and management, organizational discourse and management learning. Her study with Ulla Johansson Sköldberg of the roles that intermediaries play in the artistic intervention process is an example of her overarching interest in people and the systems in which they work. She has published in academic journals on design thinking, irony, organizational discourse, academic retirement and teaching cases and co-edited *Irony and Organizations: Epistemological Claims and Supporting Field Stories* (Liber-Copenhagen Business School Press, 2005) and *New Perspectives in Design Management: Selected Writings from Business & Design Lab, 2007–2010* (University of Gothenburg, 2010) with Ulla Johansson Sköldberg.

Katarina Zambrell is Senior Lecturer at the School of Business & Economics, Linnaeus University, Kalmar, Sweden and she has held leadership positions as Head of School and Head of Department at Linnaeus University for over ten years. She is completing her PhD studies at University of Gothenburg, Sweden, where her doctoral thesis explores the leadership of artistic

interventions in Swedish organizations and its implications for identity work in such contexts. She earned a licentiate degree from University of Gothenburg with a thesis about the construction of personal identity in work, empirically based on the experiences of middle managers (2004). Katarina's research interests focus on how aspects in working life influence and confirm personal identity. She has presented her work in international conferences and published a book chapter about the identity of cultural workers, which led to her interest in the management of Arts-Based Initiatives in organizations.

Preface

"You should write a book about artistic interventions in organizations" colleagues told Ulla and Ariane in different contexts. "There is so much happening in the field, it is time to provide an overview". In 2011, Ulla took up the challenge and started collecting material for a book in Swedish based on her close-up observations of TILLT, a leading producer of artistic interventions, while Ariane continued studying cases all around Europe. Ulla also saw the need to write for an international readership, and invited Jill to join her in putting together a volume in English.

A conversation with Routledge at the 2013 European Group for Organization Studies (EGOS) Colloquium in Montreal persuaded Ulla that they should expand the focus of the book beyond Sweden. They invited potential authors from different countries to meet in Gothenburg at the TILLT office, and it quickly became clear to everyone in the room: we have something new to say together!

Half a year later we met again to discuss drafts of our chapters on "Ulla's island" in Sweden, and Ariane accepted the invitation to join the editorial team, after having turned down a publisher's invitation to write a book on her own. Artistic interventions in organizations are collaborative adventures, so she wanted to engage in creating a book collaboratively as well.

We therefore want to thank the visible and invisible people and organizations that contributed to this venture in various ways. First and foremost to our authors, whose curiosity about each other's work fuelled our meetings and whose dedication to writing and revising their chapters led to the strong and original contributions you now have in your hands. We are grateful for the generous support of TILLT, who hosted Ulla during her research, as well as the first authors' meeting. Equally, we thank the Business & Design Lab of the University of Gothenburg for helping make the second authors' meeting so enjoyable. Without Routledge's interest in an international volume and their responsiveness throughout the preparation of the manuscript, this book would not have seen the light of day.

And now, we hand over the volume to our readers, thanking you in advance for keeping the field alive and taking the ideas forward in your writing or in your organizations.

<div style="text-align: right">
Ulla Johansson Sköldberg, Luz, Portugal

Jill Woodilla, Stonington, Connecticut, USA

Ariane Berthoin Antal, Berlin, Germany

March 2015
</div>

Part I
Framing the field

1 Artistic interventions in organizations

Introduction

Ariane Berthoin Antal, Jill Woodilla and Ulla Johansson Sköldberg

Imagine you are on the management board of a media group in which the circulation of a local newspaper has been falling. Someone from an intermediary that specializes in bringing artists into organizations to stimulate learning and change suggests: Why not invite an artist to work with the staff of the local newspaper for several months and see if they come up with fresh ideas about how to find new readers?

Or imagine you are a theatre director and have embarked on a project in a municipality that wants to prepare its staff to respond better to the needs of its multicultural community. After some weeks the members of the group you are working with express their scepticism about the process, and particularly about management's intentions. You are excited: this is the kind of tension that makes things come alive in the theatre and could signal a turning point! Which of your approaches from working on stage will help the participants take their story forward?

Or put yourself in the shoes of a PhD student who wants to make a difference in the real world. Can you test whether engaging with music will affect the way people negotiate in conflictual situations?

What all three of these situations have in common is that they are what we call "artistic interventions" – when people, practices or products from the world of the arts enter organizations to make a difference (Berthoin Antal 2009, p. 4; see also Schiuma 2011, who calls them Arts-Based Initiatives, ABIs). While every situation is unique and there is no such thing as a typical artistic intervention, the number of such experiments is growing, particularly in Europe but also in other parts of the world. Why?

At first glance, the idea of artists accepting managers' invitations to work in an organization outside the art-world for hours, days or even months appears antithetical because they have such different values, driving forces and ways of thinking and behaving, particularly when the organizations in question are in the private sector. The two worlds are often positioned as extreme opposites: art for art's own sake (Guerard 1936) and business for economic development and profit (Friedman 2007). It is important to recognize the distinctions, but misleading to represent the artistic endeavour and the purpose of management so narrowly. The pursuit of welfare and value creation in the contexts in which organizations are embedded is also considered to be part of management's remit in modern societies (Normann and Ramirez 1993), while social engagement and critique are also part of artists' raison d'être (Thompson 2012).

Conceiving of the worlds of the arts and the world of organizations as different cultures with distinct basic assumptions, norms and languages, rather than polar opposites makes it possible to envisage learning with and from each other while still maintaining their own identity (Strauß 2009). Like other cross-cultural learning processes, it entails moving out of the comfort zone and dealing with irritations, misunderstandings and clashes along the way (Eriksson 2009). Dissonances are especially likely in this particular kind of cross-cultural interaction because one of the roles of the art-world is to critique society and to give voice to whatever lacks a voice. What do the two worlds hope to learn from engaging with one another? Managers who embark on artistic interventions have diverse objectives, including developing employees' competences (such as creativity and leadership), improving communication and stimulating innovation processes. Artists, too, have different kinds of objectives: some are looking for new contexts in which to make art outside the art-world, others seek fresh inspiration for projects they want to present in the art-world, and some want opportunities to stimulate change in society (Berthoin Antal 2009). To what extent are members of the two worlds actually achieving their diverse objectives? Are they discovering other unexpected benefits or negative consequences from crossing the cultural divide?

The objective of this book is to illustrate what is happening and to discuss its implications for organizations and for artists. The chapters in this volume offer examples in diverse kinds of organizations across Europe and in North America, with many different art forms. The authors reflect on the desired outcomes and the different effects of these interventions. In doing so, they take various perspectives – management, employees, artists and the intermediaries that are bridging between the world of the arts and the world of organizations to produce such artistic interventions.

Before sending you, the reader, off into these interesting studies, we provide some background about the development of the field in practice and the different discourses in the growing body of literature about artistic interventions.

Historical development and geographic spread of artistic interventions in organizations

Early examples

Looking back into the past, there is evidence that managers have tried to learn from the arts. Corporate art collections can be considered the oldest and longest lasting type of artistic intervention in organizations. For example, the American magnate Albert C. Barnes wanted to edify his employees with his art collection in the first quarter of the twentieth century. Many organizations' art collections may still just be about "personal aggrandizement, organizational prestige, and long-term investment and the decoration of the work environment", but a number of collectors are coming to view their art collections as a possible resource for learning to see and think differently in the organization (Barry and Meisiek

2010, p. 1511). Far from simply decorating the workplace in a pleasing manner, some collections (for example, EA Generali Austria and Novo Nordisk in Denmark) are intended to provoke and irritate, thereby generating "creative unrest" and signalling to employees that unusual ideas and projects are welcome in the organization (Barry and Meisiek 2010, p. 1512; see also Jacobson 1996, 1994).

Another way that artists have entered organizations is by becoming artists-in-residence and creating work on site. Whereas most artists who chose to work *in situ* in the 1970s were taking flight from the "private place, an ivory tower perhaps" of the studio (Buren 1979/2010, p. 156), some were motivated by a desire to engage with people in non-arts-based organizations. First experiments with such interactive residencies are usually traced back to projects like the Artists' Placement Group in the United Kingdom in the 1970s (Steveni 2001) and PAIR at Xerox PARC in the United States (Harris 1999).

Expansion of the field

There are various precedents to the artistic interventions in organizations that are the subject of this volume. What is new since the late 1990s is their rapid expansion, as artists of all genres and managers in diverse kinds and sizes of organizations – not just wealthy private firms – have undertaken experiments together. Various factors have fuelled the growth. The most frequently mentioned reasons for people in organizations – including the public sector – needing to learn from the arts are the pressures to be ever more innovative, competitive and responsive in their markets ("Schumpeter" 2011), and to attract employees from the "creative class" (Florida 2002). Such terms, stemming from the "dehydrated language of management" (Adler 2010), may be more effective as rhetorical devices for legitimising risky decisions to experiment with the arts than to reflect the true reasons that motivated the managers to try out a new approach. Within the academy, interest in organizational aesthetics provided an impetus for looking at organizational activity through a different lens (for example, Strati 1999; Taylor and Hansen 2005) and a platform from which to critically assess connections between art and management (Carr and Hancock 2003, 2007).

Enabling agents

Several other potent factors have played significant roles in the multiplication of artistic interventions: intermediary organizations, funding bodies, and pioneers in business schools and universities, and publications.

Intermediaries

Intermediary organizations that specialize in matching artists with organizations and supporting them during their interaction are largely responsible for creating the market for artistic interventions (Berthoin Antal 2012; Grzelec and

Prata 2013; in this volume see Johansson Sköldberg and Woodilla). They are able to bridge between the worlds of arts and organizations often because their staff comes from those contexts; and they tend to be savvy about finding and combining sources of funding for such ventures. Among the earliest and most active intermediaries are TILLT in Sweden (www.tillt.se), Conexiones Improbables in Spain (www.conexionesimprobables.es), Artists in Labs in Switzerland (https://www.zhdk.ch/index.php?id=ics_artistsinlabs) and Arts & Business in the UK (http://artsandbusiness.bitc.org.uk/). These intermediaries have stimulated learning processes between organizations by facilitating meetings for sharing experiences among their participants, and, since 2008, by initiating cross-border learning processes through conducting multi-country projects with European funding (such as Creative Clash http://www.creativeclash.eu). The events and publications of those European projects encouraged others to develop intermediary activities in their contexts, such as ARCOM in South Korea and Unternehmen! KulturWirtschaft in northern Germany (http://www.nordkolleg.de/fachbereiche/kulturwirtschaft/unternehmen-kulturwirtschaft-2012–2015.html).

Public sources of funding for artistic interventions

Public sources of funding to bring artists into organizational contexts outside the art-world have also contributed to the development of artistic interventions. In addition to funding bodies with a cultural remit, which have sought to expand the range of activities and outlets for artists as well as to bring art to people in different contexts, regional and economic development agencies have created programmes to support projects destined to stimulate employment and innovation (for an early study in the UK see Stephens 2001; for a recent European overview see Vondracek 2013). Funding from the European Union has started to support artistic intervention projects in central and eastern European countries as well.

Pioneers in business schools and universities

A third source of impetus for artistic interventions is pioneers in business schools and universities. They have played a role in the growth over the past 5 to 10 years by adding arts-based modules to their programmes for students of business (sometimes also in engineering and medicine, see for example Osburn and Stock 2005). These initiatives were founded on the belief that engaging with the arts can stimulate the students' innovative thinking, and expand and deepen their understanding of human beings and their interactions, thereby also enhancing their capacity for leadership (Adler 2011; Nissley 2002; Springborg 2012). The pioneers who spearheaded these activities were in Canada (Nancy Adler at McGill University), Denmark (Lotte Darsø at the Learning Lab), France (Anne Valérie Delval at HEC Paris), Portugal (Daved Barry and Stefan Meisiek at the Nova School of Business and Economics in Lisbon),

Slovenia (Danica Purg at IEDC Bled School of Management), the United Kingdom (Gay Haskins at the London Business School, and Howell Schroeder at Ashridge Management College), and the United States (Steven Taylor at Worcester Polytechnic Institute in Massachusetts). The Banff Centre in Canada has catalysed thinking in the field over the years through its residency programs and special events.

New academic hubs for research on artistic interventions and innovative educational programmes relating the arts and design with management emerged towards the end of the first decade of this century: Copenhagen Business School (where scholars such as Pierre Guillet de Monthoux, Daved Barry, Stefan Meisiek experimented with the Studio), University of Gothenburg (where Ulla Johansson Sköldberg and colleagues at the Business & Design Lab, and Gothenburg Research Institute conducted research and developed doctoral students), the research unit on Cultural Sources of Newness at the WZB Berlin Social Science Center (where Ariane Berthoin Antal launched a large international research program), and most recently, the Innovation Insights Hub at University of the Arts in London (that Giovanni Schiuma is building up). Now in 2015 business schools in many countries boast having some form of art in their program. Although such programs are focused on individual development, they encourage experimentation in organizations when former participants draw on the experience to bring such an approach into their workplace (Sutherland 2013).

Another way that scholars have stimulated the expansion of artistic interventions in organizations is by writing about the field. Publications have drawn attention to the phenomenon and have contributed to raising expectations about its benefits. Scholars are not the only producers of articles and books about artistic interventions in organizations, and even among scholars there are quite different discourses. It is to these different materials that we now turn.

Development of publications and discourses

The growth in number and types of publications about artistic interventions in organizations is both a reflection of the expansion of the field and a contributor to stimulating further experimentation. Lotte Darsø's bestselling *Artful creation: Learning-tales of arts-in-business* (2004) documented a wide variety of activities in companies and business schools around the world, thereby inspiring and legitimizing initiatives in new settings.

Different kinds of publications and authors

In the meantime, there is great diversity of types of publications, ranging from reports on experience, books and articles for practicing managers, through to conceptual pieces. Authors include artists (such as Brellochs and Schrat 2005; Ibbotson 2008; Zander and Zander 1998), intermediaries (such as Artlab n.d.; Stockil 2006), academics who have theorized about the field (such as

Biehl-Missal 2011;Taylor and Ladkin 2009), and academics who have collected data in organizations (such as Berthoin Antal 2013, 2014; Clark and Mangham 2004; Styhre and Eriksson 2008), sometimes by generating experiments themselves (for most recent examples, see in this volume Bozic Yams; Ippolito and Adler). Doctoral and masters theses have been adding both empirically and conceptually to the body of literature (for example, Ferro-Thomsen 2005; Jahnke 2013; Rae 2011; Strauß 2013; Teichmann 2001). One of the drivers of publications has been the demand by policymakers and funding bodies, such as the European Commission and Arts & Business, for evidence of the values-added by artistic interventions (for example, Berthoin Antal and Strauß 2013; Carlson 2007).

Different discourses

Another important distinction to consider when mapping the growing body of literature on artistic interventions is that publications are oriented to different discourses. We use "discourse" in its general meaning to indicate a conversation or formal discussion, either oral or written, as a way of creating knowledge about a topic. From our review, we currently observe four dominant discourses in which the authors relate to different bodies of literature and communities of readers.

Managerial discourse: interventions for improvement/growth

There is a strong managerial focus in many publications, offering decision makers examples and arguments for trying out artistic interventions in their organizations. These authors write from within the discourses of business and management, often with the aim of demonstrating the use of the arts to practicing managers for purposes such as improving innovation, creativity or branding. Within this discourse Schiuma's (2011) description of Arts-Based Initiatives (ABI) and the Arts-Value Matrix provides a resource for business managers, while Austin and Devin (2003) demystify the artistic process, demonstrating similarities with managerial work. Biehl-Missal (2011) extended this discourse into the German context. Two "arts-based training" themed issues of the *Journal of Business Strategy* (Seifer and Buswick 2005, 2010) provide descriptive case studies aimed at managerial interests.

Aesthetic-inspired discourse: the arts as inspiration for action

A second stream relates to the arts inspirationally rather than instrumentally. Their contributions connect to two quite different bodies of literature: leadership and aesthetics. Guillet de Monthoux (2004), Linstead and Höpfl (2000) and Strati (1999) provided much of the theoretical underpinning for this discourse. Authors like Adler (2006, 2011), Darsø (2014) and Ladkin (2008) draw

on examples from the arts and emphasise the aesthetic category of beauty to encourage leaders to aspire to values beyond corporate profit. In *The Fine Art of Success*, the German artist Jörg Reckhenrich teamed up with two management scholars to provide numerous examples of artists whose life and work can inspire managers, based on their experience co-teaching executive education courses (Anderson, Reckhenrich and Kupp 2011). An empirical, and critical, example is the study that Koivunen and Wennes (2011) undertook, demonstrating how activities of symphony orchestra conductors emphasize the importance of aesthetic elements of leadership theory.

Arts metaphors: translation to organization theory

A third stream engages in a metaphorical discourse to translate artistic concepts into management or organization theory. It encompasses the metaphorical conceptualization of the "art of management", or how managers or organizational members are engaging with the arts through art-perceiving or art making. Vail's *Managing as a Performing Art* (1989) is generally acknowledged as the beginning of this stream. Jazz has been a particularly rich metaphor that scholars have used to relate to leadership and organizational theories (Barrett 1998; Hatch 1998, 1999; Hatch and Yanow 2008).

Multistakeholder discourses: participants' experiences

Interpretive researchers tend to focus on the experiences of participants in artistic interventions and strive to present multiple perspectives. These multistakeholder discourses represent the views of artists engaged in organizational interventions, managers who commission the intervention, employees who participate and intermediary organization members who accompany them. Many of the publications in this stream emerged from evaluation studies for funding bodies, so they are richly descriptive rather than explicitly theoretical. Their findings contribute to the literature on evaluation methods in policy making (Johansson 2012), and on decision-making in organizations, particularly by expanding the criteria to include aesthetic categories (Styhre and Eriksson 2008). Some authors in this stream frame the analysis in terms of organizational development and learning theories, addressing the individual, collective, and organizational levels (for example, Berthoin Antal 2014; Berthoin Antal, Taylor and Ladkin 2014).

The differences among the discourses have implications for the expectations about the relationship between arts and business in general and artistic interventions in particular. The managerial discourse positions arts as a new instrument for achieving corporate ends. The multistakeholder discourses assume the presence of diverse objectives and interests in an artistic intervention, which may (or may not) lead to mutual learning processes. The aesthetically inspired discourse has tended to focus primarily on top leadership, with the expectation

that a change in leadership style will expand the humanity of the organization, while the metaphorical discourse addresses latent informal leadership potential throughout the organization as a potential source of organizational change. Overall the tenor of the literature on artistic interventions has been enthusiastic, highlighting the possibility of the arts to improve conditions in organizations and society, but each of the four discourses has a different kind of critical potential. The aesthetically inspired discourse may be the most critical of the four, challenging the core values of leadership in organizations today, but its impact may be limited somewhat by its focus on just one aspect of aesthetics, namely beauty (see Strati 1992 and 1996 for a wider range of dimensions). The metaphorical discourse at first glance appears to be the least critical form because thinking metaphorically about the connection between the arts and organizations does not require direct engagement with an art form, allowing people to stay within their comfort zones. However, the potential for connecting metaphorical discourse to critical management theory and philosophy may be a rich vein to tap. In this volume we have consciously chosen authors who relate to these diverse discourses, in order to represent the key streams of thought currently in the field.

What awaits the readers of this volume?

The history of this field is in the making. Our introductory description in this chapter of the development of artistic interventions in organizations and research about them is enlivened in the second chapter of this volume. We invited Lotte Darsø to think back to 2004, when she published her ground-breaking book, and to reflect on what has happened in the ensuing decade. She starts by leading the reader into the excitement of the early phase, illustrating the mood by describing the enthusiasm she encountered in the session she led at the World Economic Forum in Davos. What came of the high expectations for the revolutionary potential of artistic interventions? After discussing how the context became more sober as a result of economic pressures, she offers two new cases in educational settings. She observes that, although she had hoped for revolution, the ongoing evolution of the field is promising, particularly if it succeeds in infusing the education system.

Part II. Assessment and evidence

Possibly the most frequently posed question about artistic interventions is: what difference do they make? The two chapters in this section, "Multistakeholder perspectives on searching for evidence of values-added in artistic interventions in organizations" by Ariane Berthoin Antal and Anke Strauß, and "Assessing the business impact of Arts-Based Initiatives" by Giovanni Schiuma and Daniela Carlucci, provide answers from different perspectives on outcomes of activities and ways to assess them. The former take an evidence-based approach by analysing empirical data in publications and from their own seven-year research

program on artistic interventions in Europe. They identify eight groups of documented impacts at the personal, interpersonal and organizational level that can emerge from the 'interspace' of possibility experienced in artistic interventions. In Chapter 4, Schiuma and Carlucci take a managerial perspective to understanding how artistic initiatives affect organizational value dynamics and present their Arts Value Map framework, operationalized through their Analytic Hierarchy Process, as a method to plan an initiative coherent with the organization's strategy and desired organizational performance improvements. They illustrate the process in the case of a construction company in Italy.

While the authors in Part II represent two different discourses (multistakeholder vs. managerial), both chapters are concerned about the lack of reliable evaluation methods for artistic interventions or Arts-Based Initiatives. They highlight issues to be considered in planning, conducting and assessing similar activities, but their focus differs. Berthoin Antal and Strauß analyse the outcomes of completed projects from a multistakeholder perspective, while Schiuma and Carlucci contend that the design of the intervention is of paramount importance as a basis for establishing the objectives managers can then use in evaluating the project.

Part III. Learning from success and failure

A key challenge to the field lies in accessing the processes that lie behind the realisation (or not) of the expectations placed on artistic interventions. In the early years the literature was almost exclusively about success stories (Clark and Mangham's 2004 study was a notable exception). In this volume, three chapters present empirical studies that provide insights into factors that contribute to successful or disappointing outcomes. In "A newspaper changes its identity through an artistic intervention", Marcus Jahnke describes and analyses an intervention in a small-town newspaper in which an effective process of meaning-making leads to significant changes in the organization. Elena Raviola and Claudia Schnugg discuss the problematic expectation of heightened creativity as an outcome of artistic interventions in their chapter, "Fostering creativity through artistic interventions: Two stories of failed attempts to commodify creativity". In "Artistic interventions in organizations as *détournement* and constructed situations", Alexander Styhre and Jonas Fröberg introduce concepts developed by the activist group Situationists International during 1957–1972 to examine an intervention by an artist (one of the authors) in a Swedish automotive company.

The chapters in Part III relate to the multistakeholder discourse and reach over to the arts metaphors discourse by connecting critically to organization theory. Taken together, they illustrate the tenuous nature of outcomes, such that success and failure may be equally likely to occur, often depending on the point of view of the evaluator, and theoretical concepts that may be used to explore results. In addition to enriching the field by addressing causes of failure as well as success, the authors in this section make valuable contributions by reaching beyond mainstream organizational behaviour theories in

their analysis. Jahnke follows a philosophical theory of knowledge developed by Heidegger and Gadamer in the first half of the twentieth century but based on much earlier interpretation or exegesis of biblical texts (Jahnke 2013), while Raviola and Schnugg and Styhre and Fröberg have critical approaches based in Marxist theory. Of these, the work of the Situationists International most closely links the discourses of arts and business through connections between Marxism and the avant-garde art movement of the early twentieth century.

Part IV. Experiences with different art forms

Artistic interventions can involve all art forms! Throughout this volume the authors refer to various examples. In Part IV, three chapters provide rich details about interventions with music, dance and theatre in very different contexts: in the first conflictual situations around the world, in the second an action research project on innovation in Sweden, and in the third a Swedish municipality seeking to develop its capacity to respond to a diverse community.

In "From aspiration to evidence: Music, leadership and organizational transformation" Linda M. Ippolito and Nancy J. Adler discuss the potential of music in both large- and small-scale interventions. They first describe a variety of music-based societal interventions that have been tried in conflict situations around the world, with varying degrees of success, then they delve deep into the data from an experimental study designed to clarify whether music can enhance problem solving and dispute resolution capacity. Dance is possibly the least frequently studied (and used) art form in artistic interventions, so the inclusion of the chapter "Choreographing creative processes for innovation", by Nina Bozic Yams, is very useful. She explains how concepts and tools from contemporary dance and choreography can provide new insights about enabling innovation in organizations. She develops a model of dancers' creative processes, describes the experience of applying the concept in a management development course, and illustrates how participants used some of the exercises later in their workplaces. Victoria Brattström, an actor and theatre-director who has worked in several artistic interventions, describes in her chapter "Playing the 'Magic If': A theatre-director's perspective on intervening", how she used artistic inquiry to reveal the process she used to deal with a critical incident. She breaks with academic conventions in her writing in order to share her process through a theatrical script and voice-over that vividly recreates the situation for the reader. She also shows how theatrical concepts and her related professional competencies applied in the intervention leading to implications on the role of the artist in an intervention for readers, researchers and other artists.

The authors in all three of these chapters are personally involved in working with the art forms they write about and, to differing degrees, they include their experience in the inquiry and writing process. Ippolito and Adler offer the only example of a controlled experiment in this volume, and Bozic Yams undertook an action research kind of experiment in which she observed others

as well as herself. Brattström's artistic inquiry method generated insights that helped her in the actual situation she faced, then writing allowed her to reflect on and refine her own artistic practice. The chapters by Bozic Yams and Brattström expand the body of literature on artistic interventions by drawing on theories and concepts from the fields of choreography and theatre, respectively. All three chapters have something to add to the multistakeholder discourse but they cross-over to other discourses as well: the chapter by Ippolito and Adler illustrates how a contribution can connect this discourse to the aesthetically inspired discourse, and Bozic Yams shows the value of metaphorical transfer of concepts from the world of dance and choreography for organizational theory.

Part V. Responsibility for making it happen

We now turn to research on three quite different and important but often-forgotten factors in an intervention: the managers who are "bold" enough to risk introducing an artist into their organization, the intermediaries that connect the artists and organizations that embark on these ventures, and the organizational space in which interventions occur. Katarina Zambrell offers insights from her interviews in her chapter, "Managers in artistic interventions and their leadership approach"; and in "Mind the gap! Bridging strategies for artistic interventions in organizations", Ulla Johansson Sköldberg and Jill Woodilla compare the work of members of three Swedish intermediary organizations. Rather than focusing on people, Stefan Meisiek and Daved Barry draw attention to space in the third chapter in this section, "Organizational studios: enabling innovation". They investigate how an artistic studio, developed in a special space in building, can become a catalyst for an intervention without an artist present, and what it takes to create and maintain the space.

All three chapters draw on data from interviews, but they relate to different discourses. In Zambrell's study, telephone interviews with 33 Swedish managers who had been responsible for artistic interventions between 2006 and 2010 yielded transcripts that she subsequently analysed for themes in the managers' leadership approaches. She suggests that an aesthetic leadership approach is a common factor in managers who support artistic interventions, thereby relating her findings to the aesthetic inspired discourse. Johansson Sköldberg and Woodilla conducted in-depth face-to-face interviews with individuals from three Swedish intermediary organizations who facilitated interactions between an artist and members of an organization on a regular basis. Their multistakeholder analysis reveals similarities and differences in their process that reflect underlying institutional logics. Meisiek and Barry's interviews with members of a Danish government organization who embarked on an artistic intervention without an artist by creating a special studio with arts-based methods show that the participants felt the experiment was a great success, until a major reorganization resulted in its dismantlement. Their concept of the organizational studio can be positioned in the arts metaphors discourse. Noteworthy in all instances is how frankly the respondents talk about moments of confusion or apparent

failure and the ways in which these reactions were subsequently addressed, thereby offering insights for learning from their cases.

Part VI. Reflections

The final section looks both backwards and forwards. In our concluding chapter, we as editors of the volume consider what we learned from the chapters and share our sense for what has changed vis-à-vis the overview of the literature that we offered at the outset of the volume. Then we identify concerns we have about the field, gaps that we encourage others to address in the years to come, and additional discourses we believe need to be engaged to enrich the field – but we do not want to reveal more here before you have had a chance to embark on the learning journey through this book. A fitting send-off for such a volume is the ever-challenging and surprising Barbara Czarniawska. She offers a delightfully irritating Postlude, which the impatient or contrary reader might even choose to start with.

References

Adler, N. (2006) 'The arts & leadership: Now that we can do anything, what will we do?', *Academy of Management Learning & Education*, 5(4), pp. 486–499.

Adler, N. (2010) 'Going beyond the dehydrated language of management: Leadership insight', *Journal of Business Strategy*, 31(4), pp. 90–99.

Adler, N. (2011) 'Leading beautifully: The creative economy and beyond', *Journal of Management Inquiry*, 20(3), pp. 208–221.

Anderson, J., Reckhenrich, J., and Kupp, M. (2011) *The fine art of success: How learning great art can create great business*. Chichester, UK: Wiley.

Artlab (n.d.) *15 Cases Arts and Business: People in the Innovation and Experience Economy*. Copenhagen, Denmark: Artlab. Retrieved from http://artlab.dk/wp-content/uploads/2012/09/artlabcases_uk.pdf (Accessed January 15, 2015).

Austin, R., and Devin, L. (2003) *Artful making: What managers need to know about how artists work*, Upper Saddle River, NJ: Financial Times Prentice Hall.

Barrett, F. (1998) 'Creativity and improvisation in jazz and organizations: Implications for organizational learning', *Organization Science* 9(5), pp. 605–622.

Barry, D., and Meisiek, S. (2010) 'Seeing more and seeing differently: Sensemaking, mindfulness, and the workarts', *Organization Studies*, 31(11), pp. 1505–1530.

Berthoin Antal, A. (2009) Transforming organizations with the arts. A research framework for evaluating the effects of artistic interventions in organizations – Research Report. Gothenburg: TILLT. Retrieved from www.wzb.eu/sites/default/files/u30/researchreport.pdf (Accessed January 24, 2015).

Berthoin Antal, A. (2012) 'Artistic intervention residencies and their intermediaries: a comparative analysis', *Organizational Aesthetics*, 1(1), pp. 44–67.

Berthoin Antal, A. (2013) 'Seeking values: Artistic interventions in organizations as potential cultural sources of values-added'. In Baecker, D., and Priddat, B.P. (eds.) *Oekonomie der Werte* [Economics of Values]. Marburg, Germany: Metropolis-Verlag, pp. 97–128.

Berthoin Antal, A. (2014) 'When arts enter organizational spaces: Implications for organizational learning'. In Meusburger, P. (series ed.) and Berthoin Antal, A., Meusburger, P., and

Suarsana, L. (volume eds.), *Knowledge and space: Vol. 6. Learning organizations: Extending the field*. Dordrecht, The Netherlands: Springer, pp. 177–201.

Berthoin Antal, A., and Strauß, A. (2013) *Artistic interventions in organizations: Finding evidence of values-added*. Creative Clash Report. Berlin, Germany: WZB. Retrieved from http://www.wzb.eu/sites/default/files/u30/effects_of_artistic_interventions_final_report.pdf/ (Accessed September 25, 2014).

Berthoin Antal, A., Taylor, S. S., and Ladkin, D. (2014) 'Arts-based interventions and organizational development: It's what you don't see'. In Bell, E., Schroeder, J., and Warren, S. (eds.), *The Routledge companion to visual organization*. Oxon, UK and New York, NY: Taylor & Francis, pp. 261–272.

Biehl-Missal, B. (2011) *Wirtschaftsästhetik: Wie Unternehmen Kunst als Instrument und Inspiration nutzen* [Business aesthetics: How companies use art as an instrument and inspiration]. Wiesbaden, Germany: Gabler.

Brellochs, M., and Schrat, H (eds.). (2005) *Raffinierter Überleben: Strategien in Kunst und Wirtschaft* [Sophisticated survival techniques: Strategies in art and economy]. Berlin, Germany: Kadmos.

Buren, D. (2010) 'The function of the studio'. In M.J. Jacob and M. Grabner (eds.), *The studio reader: On the space of artists*. Chicago: University of Chicago Press, pp. 156–162. (Originally published in French in 1971; translated by Thomas Repensek and published in *October* Vol. 10/Fall 1979: 51–58).

Carlson, S. (2007) *INTERACT Artists in Industry placements, Evaluation Report*. Arts Council England, Interdisciplinary Department. Retrieved from http://www.artsactive.net/descargas/11-3-2008-1710342_INTERACT%20REPORT_SCarlson_jan2007.PDF (Accessed January 26, 2015).

Carr, A., and Hancock, P. (2003) *Art and aesthetics at work*. New York, NY: Palgrave Macmillan.

Carr, A. and Hancock, P. (eds.) (2007) 'Arts and aesthetics of the unconscious' [Special Issue]. *Tamara*, 6(1/2) pp. 5–202.

Clark, T., and Mangham, I. (2004) 'Stripping to the undercoat: A review and reflections on a piece of organization theatre', *Organization Studies*, 25(5), pp. 841–851.

Darsø, L. (2004) *Artful creation: Learning tales of arts in business*. Frederiksberg, Denmark: Samfundslitteratur.

Darsø, L. (2014) 'Setting the context for transformation towards authentic leadership and co-creation'. In Gunnlaugson, O, Baron, C., and Cayer M. (eds.), *Perspectives on Theory U: Insights from the field*. Hershey, PA: Business Science Reference, pp. 97–113.

Eriksson, M. (2009) Expanding your comfort zone – the effects of artistic and cultural intervention on the workplace. A Study of AIRIS 2005–2008 (Including Genklang Vara 2006–2008). Göteborg, Institute for Management of Innovation and Technology.

Ferro-Thomsen, M. (2005) *Organizational art – A study of art at work in organizations*. University of Copenhagen. Retrieved from http://www.ferro.dk/academic/orgart.htm (Accessed January 24, 2015).

Florida, R. (2002) *The rise of the creative class: And how it's transforming work, leisure, community and everyday life*. New York, NY: Perseus Book Group.

Friedman, M. (2007) 'The social responsibility of business is to increase its profits'. In Friedman, M., *Corporate ethics and corporate governance*. Berlin Heidelberg: Springer, pp. 173–178. (Originally published in *New York Times Magazine*, September 30, 1970).

Grzelec, A., and Prata, T. (2013) Artists in organizations: Mapping of European producers of artistic interventions in organizations. Creative Clash report. Gothenburg, Sweden: TILLT Europe. Retrieved from http://www.creativeclash.eu/wp-content/uploads/2013/03/Creative_Clash_Mapping_2013_GrzelecPrata3.pdf/ (Accessed October 12, 2014).

Guerard, A. (1936) 'Art for art's sake'. *Books Abroad*, pp. 263–265.

Guillet de Monthoux, P. (2004) *The art firm: Aesthetic management and metaphysical marketing.* Stanford, CA: Stanford University Press.

Harris, C. (1999) *Art and innovation: The Xerox PARC artists-in-residence program.* Cambridge and London: MIT Press.

Hatch, M.J. (1998) 'Jazz as a metaphor for organizing in the 21st century', *Organization Studies*, (5), pp. 556–558.

Hatch, M.J. (1999) 'Exploring the empty spaces of organizing: How improvisational jazz helps redescribe organizational structure', *Organization Studies*, 20(1), pp. 75–101.

Hatch, M.J., and Yanow, D. (2008) 'Methodology by metaphor: Ways of seeing in painting and research', *Organization Studies*, 29(1), pp. 23–44.

Ibbotson, P. (2008) *The illusion of leadership: Directing creativity in business and the arts.* London: Palgrave MacMillan.

Jacobson, M. (1994) *Art for work.* Cambridge, MA: Harvard Business School Press.

Jacobson, M. (1996) 'Art and business in a brave new world', *Organization*, 3(2), 243–248.

Jahnke, M. (2013) *Meaning in the making: Introducing a hermeneutic perspective on the contribution of design practice to innovation,* Gothenburg: Gothenburg University Press.

Johansson, U. (2012) 'Artists as organizational development facilitators – evaluation of six projects', Paper presented at the Cumulus conference, Helsinki, May 24–26.

Koivunen, N., and Wennes, G. (2011) 'Show us the sound! Aesthetic leadership of symphony orchestra conductors', *Leadership*, 7(1), pp. 51–71.

Ladkin, D. (2008) 'Leading beautifully: How mastery, congruence and purpose create the aesthetic of embodied leadership practice', *Leadership Quarterly*, 19, pp. 31–41.

Linstead, S., and Höpfl, H. (2000) *The aesthetics of organizations.* London: Sage Publications.

Nissley, N. (2002) 'Arts-based learning in management education', In Wankel, C., and DeFillippi, R. (eds.), *Rethinking management education for the 21st century.* Greenwich, CT: Information Age Publishing, pp. 27–62.

Normann, R., and Ramirez, R. (1993) 'Designing interactive strategy', *Harvard Business Review*, 71(4), 65–77.

Osburn, J., and Stock, R. (2005) 'Playing to the technical audience: Evaluating the impact of arts-based training for engineers', *Journal of Business Strategy*, 26(5), pp. 33–39.

Rae, J. E. (2011) *A study of the use of organizational theatre: The case of forum theatre.* Durham University, Durham. Retrieved from http://core.ac.uk/download/pdf/176829.pdf (Accessed November 5, 2012).

Schiuma, G. (2011) *The value of arts for business.* Cambridge, UK: Cambridge University Press.

'Schumpeter: The art of management – Business has much to learn from the arts'. (2011, February 17) *Economist.* Retrieved from http://www.economist.com/node/18175675/ (Accessed March 15, 2015).

Seifter, H. and Buswick, T. (eds.) (2005) 'Arts-based learning for business' [Special Issue]. *Journal of Business Strategy*, 26(5), pp. 6–68.

Seifter, H. and Buswick, T. (eds.) (2010) 'Arts-based learning for business' [Special Issue]. *Journal of Business Strategy*, 31(4), pp. 6–99.

Springborg, C. (2012) 'Perceptual refinement: Arts-based methods in managerial education', *Organizational Aesthetics*, 1(1), pp. 116–137.

Stephens, K. (2001) 'Artists in residence in England and the experience of the year of the artist', *Cultural Trends*, 11(42), 41–76.

Steveni, B. (2001) 'Organization and imagination (formerly APG, the Artist Placement Group)', \seconds, 2(4). Retrieved from http://www.slashseconds.org/issues/002/004/articles/bsteveni2/index.php (Accessed September 12, 2011).

Stockil, T. (2006) *Creative development: Report*. London: Arts & Business.
Strati, A. (1992) 'Aesthetic understanding of organizational life', *Academy of Management Review*, 17(3), pp. 568–581.
Strati, A. (1996) 'Organizations viewed through the lens of aesthetics', *Organization*, 3(2), pp. 209–218.
Strati, A. (1999) *Organizations and aesthetics*. Thousand Oaks, CA: Sage Publications.
Strauß, A. (2009) 'Context is half the work: an intercultural perspective on arts and business research'. Paper presented at Standing Conference for Organizational Symbolism. 8–11 July 2009. Copenhagen, Denmark.
Strauß, A. (2013) *Researchers, models and dancing witches: Tracing dialogue between art and business*. Unpublished doctoral thesis, University of Essex, UK.
Styhre, A., and Eriksson, M. (2008) 'Bring in the arts and get the creativity for free: A study of the artists in residence project', *Creativity and Innovation Management*, 17(1), pp. 47–557.
Sutherland, I. (2013) 'Arts-based methods in leadership development: Affording aesthetic workspaces, reflexivity and memories with momentum', *Management Learning*, 44(1), pp. 25–43.
Taylor, S.S., and Hansen, H. (2005) 'Finding form: Looking at the field of organizational aesthetics', *Journal of Management Studies*, 42(6), pp. 211–231.
Taylor, S.S., and Ladkin, D. (2009) 'Understanding arts-based methods in managerial development', *Academy of Management Learning & Education*, 8(1), pp. 55–69.
Teichmann, S. (2001) *Unternehmenstheater zur Unterstützung von Veränderungs-prozessen. Wirkungen, Einflussfaktoren, Vorgehen* [Corporate theater to support change processes: effects, factors, processes]. Wiesbaden, Germany: Deutscher Universitäts-Verlag.
Thompson, N. (2012) *Living as form: Socially engaged art from 1991–2011*. New York, NY, & Boston, MA: Creative Time Books / MIT Press.
Vail, P. (1989) *Managing as a performing art: New ideas for a world of chaotic change*. San Francisco, CA: Jossey-Bass.
Vondracek, A. (2013) *Support schemes for artistic interventions in Europe: A mapping and policy recommendations*. Creative Clash report, Brussels. Retrieved from http://www.creativeclash.eu/wp-content/uploads/2013/03/Creative_Clash_Support_Schemes_Vondracek_2013.pdf (Accessed January 11, 2014).
Zander R.S., and Zander, B. (1998) *Leadership: An art of possibility*. Cambridge, MA: Harvard Business Press.

2 Arts-in-business from 2004 to 2014

From experiments in practice to research and leadership development

Lotte Darsø

Arts & Business: an emergent field

In 2000 I discovered an area that was new to me: Arts & Business. Two years later I was involved in an international research project on Arts-in-Business that led to 53 interviews with people around the world engaged in the field, and in the summer of 2004 I published the book *Artful Creation: Learning-Tales of Arts-in-Business*, in which I set out to answer the research question: What can Business learn from the Arts? (Darsø 2004). Another aim was to map the emergent field of Arts-in-Business and, indeed, try to find out if this was actually a field at all.

Those were exciting days! There was a great optimism and lots of initiatives in motion. Many people saw an enormous potential and dreamt up bold projects. This enthusiasm manifested itself vividly in Davos at the World Economic Forum in 2004, where I had been invited to facilitate a workshop called "What if an Artist Ran Your Business?" When the sign-up procedure started in the morning, this workshop was one of the first to be sold out. The Forum takes place over a period of three to four days with a mixture of plenum sessions and smaller workshops in different formats, and people can only attend the workshops if they get a confirmation, which they have to show in order to get into the session. My workshop included some famous artists, such as music producer Quincy Jones, actor Chris Tucker, photographer Yann Arthus-Bertrand, and film producer Shekhar Kapur.

When I arrived at the workshop people were gathering outside the door begging to get in, but the room was already full. I asked the participants whether it would be OK to include the people outside the door; they approved and we let them in. It was a rather chaotic workshop. I introduced the agenda and I had carefully prepared some questions for discussion at the tables and a process alternating between table conversations, briefings and short plenum recaps. Each table had one of the invited artists to guide the conversations, and I had sent them a mail beforehand with the agenda. However, it did not go at all as planned! Of course, the process worked at some tables, but it certainly did not work at other tables. The artists more or less followed their own agenda, participants hijacked the conversation and turned it into something else, and when

I asked people to report back from their tables, it was messy and chaotic. I had opened 'Pandora's Box'. Fortunately, the workshop lasted only an hour and a half, and most people liked it anyway, because it was so amazingly different from what they had experienced earlier.

Why do I tell this story? Because I want to try to convey this incredibly mad sense of enthusiasm that surrounded the Arts-in-Business field in its early days. Everything seemed possible; there were no barriers; everything was in flux. Companies were rich and powerful, and at least some of them had surplus energy and time for trying out new approaches such as artistic interventions in organizations. One of the most ambitious Arts-in-Business projects at the time was Catalyst at Unilever, UK (Darsø 2004) (Buswick, Creamer and Pinard 2004). This artist-led project started in 1999 with an annual budget of £240.000. I visited several Unilever sites in London for three full days, observed and participated in some sessions with artists, and interviewed seven people, among them the chairman, James Hill, who had brought the artist into Unilever. He had initiated the project in order to change the organizational culture towards more creativity and inspirational initiatives. The Unilever projects explored 20–25 art forms, some of which worked better than others. Failure was considered part of the package because it was an experiment, but overall, it was highly successful. People and spaces radiated infectious enthusiasm and energy.

In 2004 the future looked bright, growth seemed endless, and there was a general agreement that capitalism had proved itself as the 'best' economic system. Certainly, there were lots of problems and challenges in the world also then, and these were also discussed in Davos by important politicians, royalties and CEOs, but the general feel was still a bubbling optimism. Arts & Business was thus in the rising, riding the wave of endless growth. At least this was how it seemed at the time.

Important initiatives

Several initiatives for developing the relationship between Arts & Business were taken during that time. Among the earliest were the Arts & Business conferences that Miha Pogacnik and friends held at Castle Borl in Slovenia every summer from 1997 to 2006. The focus here was on bringing people from the art world together with people from the business world and people from academia in order to explore, experience and reflect on the potential of artistic approaches in organizations. The methods were primarily interactive in order to share and learn together (VanGundy and Naiman 2003).

As this was a formative period for Arts & Business, research was emergent and in the making. An important initiative for inspiring more research was the Art of Management and Organization Conferences, which started in 2002 in London, and have continued since then with conferences every second year. This initiative later resulted in the creation of an online journal, *Organizational Aesthetics*. In 2003 a group of passionate people saw a need for more dialogue

and research and created the research network, AACORN (Arts, Aesthetics, Creativity, and Organization Research Network, www.aacorn.net). In 2014 there were over 250 members of this network.

In 2008, an important research initiative was taken by scholars at the Wissenschaftszentrum Berlin für Sozialforschung (WZB), who subsequently managed to expand and enrich the field with extensive studies, from both a business perspective and an artist viewpoint (Berthoin Antal 2012, 2013a, 2013b, 2014, 2015; Berthoin Antal and Strauß 2013). This research program, together with the Art of Management and Organizations conferences and the AACORN community, has provided a major contribution towards the most important difference between 2004 and 2014: *an increased and multifarious research arena.*

At the beginning of the twenty-first century, several Scandinavian governments subsidized organizations and projects with focus on the business side, such as TILT (Sweden), NyX (Denmark), Forum for Culture and Business (Norway) and many others. Other institutions, such as Artlab (Denmark) and SKISS (Sweden) had focus on preparing and supporting artists for working with organizational development through artistic interventions and projects (in this volume see Johansson Sköldberg and Woodilla). This gave rise to several entrepreneurial start-ups of small artist consultancies. In the US and UK, The Arts & Business Council of Americans for the Arts, US, founded in 1965, and Arts & Business, UK, founded in 1976, both originally had the aim of building relationships between Arts & Business, but only in a one-way format of business transferring skills and resources to the arts. At the beginning of the twenty-first century, they began seeing the potential of a two-way exchange of skills and they began delivering arts experiences by developing programs for matching artists with business, and offered training to artists for working in business settings (Darsø, 2005).

The impact of the financial crisis

Regrettably for the development of the field of artistic interventions in practice, the financial crisis of 2008 brought business to a temporary halt. Optimism quickly turned into pessimism. People lost their pensions, houses and jobs, and people in jobs feared losing them. Companies cut back, and everything was stalled that did not directly contribute to the bottom line. Consequently, whole innovation departments and business development units were closed down, executive education was put on hold, and development projects were stopped or put on the back burner. Artistic interventions, of course, would belong to these categories because they take time, are uncertain, and generally cannot guarantee a specific outcome, let alone directly add to the figures of the bottom line. Even though there are several examples in this book of how artistic interventions have succeeded in ways that generate value for the involved organizations, the point here is that there is no guarantee. From a business perspective defined only in terms of the 'rational logic', perhaps the most convincing approach presented in this book would be the structured process proposed by Schiuma and Carlucci, because it is analytical and follows an operational model.

Here consultants are driving the process and artistic intervention is applied only towards the end. In other cases trying to transfer artistic creativity to organizations was not possible, as selling creativity as a commodity 'escaped' those efforts (see Raviola and Schnugg, in this volume). In yet other cases a more 'artistic logic' is applied with bumps on the road but succeeding at the end. For example, Brattström's chapter in this volume highlights the theatre director's skills as an analytical method for facilitating and merging different perspectives. In several cases artists were both facilitators and in charge of designing and carrying out the whole project together with the participants (such as Jahnke, in this volume).

Looking back at 2004 I now realize that what seemed to be a promising business adventure with a lot of potential did not happen as expected. The financial crisis contributed to this, but, in fact, it seems that most top managers in business never saw the need for drawing on the arts in relation to organizational development and innovation. I thus wonder if business was ever really interested in learning from and with the arts or if the arts are, in fact, still seen as too strange and too different?

Drivers of artistic intervention

Obviously, there are various possible explanations regarding the lack of interest from business. If we examine who have been the main drivers for establishing these collaborative projects, it seems that the answer to this would be the intermediaries (Berthoin Antal 2012; in this volume Johansson Sköldberg and Woodilla). They emerged exactly for this purpose, both because they believe in it and because the funding bodies often stipulate involving both arts and business. Governments, municipalities, regional institutions or European Union agencies hoped to work through these organizations to support and grow business, public organizations and creative industries. However, most of these projects have had to be 'sold' to business and public organizations, and partial subsidies have often been an important incentive.

Another driver of artistic interventions in organizations has been leaders and managers with an interest in art. In the Unilever case mentioned above, James Hill's meeting with the artist awakened a longing for the arts that he had hidden away a long time ago, because his life was focused on business. Now he realized how much he had missed art and how enriching the artistic interventions were for everyone involved. As Zambrell presents in this volume, leaders and managers are important gatekeepers for letting the arts into organizations. She found that leaders who had engaged in artist-in-residence projects had an aesthetic-inspired leadership approach, which was characterized, among others, by an interest in art.

Energy and motivation

The impact of the economic crisis is related to the fact that an economic paradigm still rules the world. It is an extrapolation of the industrial paradigm

with its focus on resources and efficiency, combined with a belief in capitalism and growth as the way forward. So when artistic interventions take considerable time, when the impacts are emergent and subtle, and when the results cannot be seen to have a direct influence on the bottom line, artistic interventions are perceived as superfluous. In a 'flat world' perspective this is correct (Wilber 2000). But there is growing evidence that employees need more than numbers as motivation. Based on many years of research, Harvard professor Teresa Amabile emphasizes intrinsic motivation as the most powerful influence on people's performance (Amabile 1998). The findings of the Good Business project also demonstrated that the best leaders provide visions for their employees of making a difference in the world (Csikszentmihalyi 2003). People need spiritual food, such as inspiration, social relationships, and a greater purpose in their work.

A relevant term in this context is "artful work" as Richards suggested. He found that "the fundamental substance of organizations is the energy of people" (Richards 1995, p. 6), and he proposed four types of energy: physical, mental, emotional and spiritual. My own slightly different term for this is "artful creation", which I define as: "Artful means 'full of art', e.g., art experiences that initiate an inner transformation, which again open up for a special kind of consciousness" (Darsø 2004, p. 31). The concept of artfulness encompasses body, mind, heart and spirit. It underlines the important perspective of being whole human beings, also at work. People are not machines; people need meaning and purpose in their work life. Unless managers realize this, their organizations will not thrive. Art brings out human emotions; it touches our humanity (Eisner 2008).

Constructive disturbance

If it is correct to assume that the potential of artistic interventions has not yet been acknowledged by organizations, it might be helpful to return to the pivotal question that the authors ask in several of the chapters in this volume: What is the real value of artistic interventions in organizations? I will argue in the following that the most prominent value is encompassed in the term *constructive disturbance*. This concept illustrates the inherent tension that is characteristic of meetings between artistic and rational logics. Constructive disturbance is also an overall theme that weaves a thread throughout this book, for example as "creative abrasion" (introduced by Leonard and Straus 1997; see also Styhre and Fröberg in this volume). The success or failure of artistic interventions depends on the dynamic balancing of the tension between what is constructive and what is disturbing. The tension must be held in this dynamic balance throughout the entire project. If it tips towards the constructive arena, the outcome could be inspirational, but not transformational. If it tips towards disturbance, the project will often be dismissed as failure. In the following I will analytically separate the two concepts in order to elaborate on what they entail and how they have been and can be applied in practice. In order to do that I will have to

generalize somewhat while acknowledging that thereby some differences and nuances may be lost.

Constructive

The term *constructive* comes before disturbance for important reasons. The key to any collaborative effort is developing relations of trust and respect (Darsø 2001). The general perception is that artists belong to the art world and that they can be as strange and provocative as they want at art exhibitions or in art performances. In those contexts such behaviour is considered interesting. But artists in organizational contexts are still perceived as strange and therefore they are received with feelings ranging from surprise to fear and scepticism. Misunderstandings can arise in artistic interventions, which can be disruptive or generative. At the beginning of a project misunderstandings are mostly disruptive and can jeopardize the project. Later they can be highly generative. The surprise can result from the artist's language, methods and open approach towards the process. Also the artist as a role model can be surprising, however mostly inspirational, because artists radiate a lot of energy and passion. The surprise is also apprehensible when employees move from a daily routine of performance measurement, shortage of time and resources, stress, bureaucracy and control to an open-ended process that is playful and emergent, and where there is no guarantee for what will come out at the end. Comparing these two approaches, the latter can easily appear to be a waste of time. The key to channelling employees' perplexity into something constructive lies in formulating a clear purpose for the project and communicating it consistently. A clear purpose is not a specific goal; it is a much broader vision expressing the wishes and intentions of the project and explaining why the process will be open-ended for a while.

As for fear, it is usually fear of overstepping individual comfort zones, of having to make art, and of looking foolish when doing so. To overcome these feelings of fear, trust is needed, both between the artist and participants, and among participants. The quality of relationships is key here. Another response is scepticism, which stems from negative attitudes towards artists in general or to the whole idea of artistic interventions in organizations. When scepticism takes the form of cynical remarks, it can become highly counterproductive and can easily ruin the atmosphere, so also here it is important to be clear about the purpose of the project. Mutual respect must be established. In the numerous interviews I have conducted I have repeatedly asked about the obstacles to applying arts in business settings. Scepticism came up as one of the top impediments, but fortunately, people also had suggestions for overcoming it, based on their experience. One recommendation is that the artists early in the project find ways to show people – without showing off – that they are competent and skilled artists in order to gain respect from the participants. It is equally important for the participants to get the opportunity to demonstrate their competence and skills to the artists in order to feel comfortable in exploring new methods and new ways of using their body or voice. Mutual respect must thus be created along

with trust at the beginning of the project in order for it to gain momentum. The essence of respect is building a sense of equality between the parties. Thus trust and respect constitute a constructive foundation of artistic intervention projects, and research shows that artists are skilled at building this rapport (Berthoin Antal 2015).

Disturbance

Now let's examine the elements of *disturbance*. Disturbance is inevitable when two worlds meet. Artists use a different language and different methods; they have different priorities, different focus, different values, and different perspectives from those that dominate the world of business, but most of all: Artists are skilful in asking questions that provoke. In fact, this is how I discovered the field of Arts & Business. I was conducting research on the birth of innovation in groups of knowledge workers, and I had just analysed my data and discovered the power of questions that were born out of ignorance (Darsø 2001). Such questions could challenge the taken for granted and open up for new possibilities. Innovation feeds from diverse perspectives and artists tend to present angles that no one has considered, because people tend to think within the limits of their knowledge field (Berthoin Antal 2013a). By defamiliarizing the familiar artists disturb people enough that they can get new perspectives on their work, their company or on themselves (see Jahnke in this volume). Artists can give people a mental kick that jiggles their mind-set so that they are suddenly able to see differently. In the literature and training on creativity this is called change of perspective (de Bono 1994). But whereas de Bono's approach is mostly analytical, the superb power of the arts is in truly sensing instead of making sense through analysis (Springborg 2010) and in affecting emotions (Eisner 2008). Therefore, impressions and provocations through the arts have strong impact on people, both at the personal level and in relation to organizational change.

Another feature of artistic interventions is that they foreground aesthetics in the organizational context. This implies activating and engaging people's senses in different ways (Guillet de Monthoux, Gustafsson and Sjöstrand 2007; Strati 2000). Often this happens through the use of artistic materials that the participants would not normally use. Aesthetics activate the senses through materials, colours, texture, sound, taste or smell, such as by listening to music in new ways (www.mihavision.com); singing with people from diverse backgrounds or producing music together as a way of creating community and managing conflict (see Ippolito and Adler in this volume). Other artistic methods include moving and sensing with the body (see Bozic Yams in this volume), theatre rehearsal methods (Ibbotson 2008), and photography, storytelling, or painting together (see examples in Darsø 2004). All these modalities can serve as constructive disturbance. But, of course, they need to be adapted to the participants and support the purpose.

Spaces of constructive disturbance

One of the ways in which constructive disturbance can exist in organizations is through the creation of interspaces, which Berthoin Antal and Strauß (this volume) define as "temporary social spaces within which participants experience new ways of seeing, thinking, and doing things that add value for them personally. In the interspace, doubt and organizational norms are suspended to enable experimentation". When an interspace also becomes physical, we can talk about organizational studios as spaces for inquiry, as Meisek and Barry propose in this volume.

Artistic interventions in educational contexts

Where would artistic interventions have the most promising effect? I would argue that this would be in education and leadership development. According to Mintzberg, management relies more on art than on science, because art is related to intuition and insights and "managing is neither a science nor a profession; it is a practice, learned primarily through experience, and rooted in context" (Mintzberg 2009, p. 9). Creating engaged executive learning spaces through aesthetic agency (Sutherland and Ladkin 2013), aesthetic reflexivity (Sutherland 2013) and the appropriate design of affording contexts for transformation (Darsø 2014) introduce new approaches and formats for experiential learning. Education could thus be a shortcut towards acceptance of artistic interventions in organizations, because (as documented by Berthoin Antal and Strauß in this volume), one of the most significant effects of artistic intervention projects is personal learning and development. When enough people have experienced the power of learning through artistic and aesthetic approaches, scepticism will decrease and the application may come more naturally. The following two examples of aesthetic and artistic interventions in educational settings help illustrate how and why they can work.

The sensuous school

The first example is a new approach towards renewal of education. As a member of the school Advisory Board, I have followed this project closely. The following is based on written material, conversations, observations, websites and blogs, and email correspondence with one of the sisters. The sensuous school is part of a large-scale Nordic project that has been running since 2011 and will continue into the future, manifesting in a series of Nordic countries. The aim is to experiment with how a school would look in a society governed by aesthetic premises – from a sensuous and poetic way of knowing the world – instead of from the economic and rational premises that have dominated the institutions of society since the industrial age and the Enlightenment, respectively. The idea is to create a parallel universe, in which performance art and activism merges with pedagogy and research. The project, initiated by Sisters Hope (www.

sistershope.dk), is called Sisters Academy (http://sistersacademy.dk/); and it has recently been tested in a Danish high school. The project explores creative courses, such as drama, music and art, not only as important subjects by themselves, but also as input to other courses, such as mathematics, physics, language and biology. According to educationalist Sir Ken Robinson there is left too little space for aesthetic knowing in education even though this is one of the most important resources of the modern world (Robinson 1982). Sisters Academy can be understood as a physical manifestation of an aesthetic-pedagogical approach to learning.

The manifestation in Denmark ran from March 2013 to May 2014 and was performed by the twin sisters (alias Anna Lawaetz and Gry Worre Hallberg), who materialized as head mistresses of the academy. It started with a presentation for the teachers in March 2013, then a performance dinner, where the teachers encountered the fictive universe performatively for the first time by dressing up for a candle light dinner and eating delicious food with their fingers. Afterwards they had a meeting with the Sisters to clarify the dinner performance through dialogue. In October 2013 the teachers worked out a document together with the Sisters in order to share responsibility for different practical tasks, because the budget was minimal. This concerned scenography, lighting and sound as well as logistics such as food, transportation and beds for the twin sisters to stay at the school from Monday through Friday during the project's two week run. In October and December 2013 the sisters and the teachers engaged in one-on-one dialogues in order to clarify questions and doubts and to help the teachers identify how they would teach inspired by the aesthetic and poetic universe. Twenty teachers ended up being involved together with 200 students.

The Sisters Academy ran from February 24 to March 7, 2014. The twin sisters started building the scenography a week before together with thirteen performance artists and set-, light-, and sound designers and the teachers, but it was left partly unfinished, leaving room for the students' input. On the first day the students arrived at the changed school and the twin sisters, who were temporarily head mistresses of the academy, invited them into the universe in order to continue building the scenography. The aim was for the students and teachers to transform themselves during the process by non-acting, or in other words, acting naturally on the stage (metaphorically speaking). Instead of speaking their native Danish, the artists and teachers used English to de-familiarize the familiar, and they were invited to write a personal diary and blogs, separated into a teachers' blog and a students' blog. The first Friday was a showcase where family, friends, researchers and the press had the opportunity to experience and participate in the universe. The second Friday ended with several rituals. The teachers posed in front of all teachers, students and the head of school sitting at a desk with one of the sisters and made promises of three commitments to how they would integrate the learning and insights into their teaching during the next two years. There was a musical ritual and a flag exchange ritual, symbolizing that the sisters returned the leadership to the head of school.

In May 2014 there were follow-up dialogues with the teachers in order to understand which elements and pedagogical approaches had worked especially well. Apparently, the teachers immersed themselves into the universe to varying degrees. Some were reluctant to leave their comfort zones as professionals; others were more daring and explored new possibilities. One teacher wrote on the blog that this was a unique opportunity that was partly wasted, because some teachers held back: "The whole point of making a full-blown *unheimlich* [the German word *unheimlich* means "not homely", and the idea is that by creating a universe that is the opposite of homely, we come home] universe with strict obstructions is to challenge the way we think, act, plan, communicate, etc. If you do not accept the challenge, you will not gain new experiences" (http://sistersacademy.dk/how-much-will-you-risk-at-the-academy/).

Another teacher had an experience of "exploring emotional moments". She had given the students an assignment of having someone whisper a poem or lyric of the heart in the ear. Afterwards they were to note down what kind of impression the sensuous experience gave them. In class they shared their notes, which gave rise to a special emotional atmosphere. The teacher wrote on the blog:

> Much to my surprise, I was deeply touched by the students' descriptions. The memories the experience had invoked, the subtle descriptions, and the earnestness in which it was shared completely took me aback.
>
> I felt that it was important, in that particular moment, to share my emotion with them – not being completely overwhelmed, I simply stated that I was very happy that we had done this exercise, and that it had moved me deeply to hear of their experiences and feel their earnestness.
>
> Afterwards, I let the class fall silent. It sprung from the moment – I believed everybody had to give this experience (of sharing, and of moving someone unexpectedly) some thought, and I demanded the time for that, simply by staying immobile in front of the class, looking about the room.
> (http://sistersacademy.dk/exploring-emotional-moments/)

A student also described his learning experience with the Sisters Academy:

> The first day of Sisters Academy met me with great surprise. The very first thing that I did after stepping into the universe, was to communicate with a man named The Silence. We sat with him for a very long time chatting, and the funny thing about it was; we didn't say a word! After this I was hungry after more. I found it extremely fascinating, as if I was in a whole other universe, away from everyday life, away from responsibilities. When you walked around you could hear all kinds of different sounds, some of them relaxing, some of them soothing, some of them even a little scary. This was a part of the experience I think. To sense it all. I sat down with The Gardener, and we started talking. He was wonderful to be around, and he had a very calm aura around him. When you sat there, and you listened

to him, you fell into a sort of trance. I could sit for thirty minutes and listen to this man, and this comes from a guy that can't sit on chair for five minutes before getting distracted. He talked about everything, he opened a whole new chain of thoughts in my head. He opened doors I didn't think I could ever open. I asked him one day, what do you think the answer will be? What's your conclusion? He looked up, stared into my eyes and after some time, he simply answered: There is none. This answer defined the whole thing for me. I understood Sisters Academy right at that moment, like I got the answer, by getting no answer. For me this will be in my mind for a very long time. . .

(http://sistersacademy.dk/my-experience-with-sisters-academy-mads-baltzer-stanley/)

Sensuous learning

This experiment definitely made impressions on teachers and students, both positively and negatively. It was constructive and inspirational – even transformational – for some, and it was disturbing and provoking for others by taking them way out of their comfort zone. For teachers the constructive and inspirational part was being invited or gently pushed into a sensuous universe that provided new ideas and new perspectives on the subject and on the teaching approaches. They tried out things with the students that they would never have imagined on a normal school day, and some of these processes were so meaningful that these teachers felt touched (for example, when exploring emotional moments) and energized (one teacher wrote on the blog, 'My heart was dancing') and, they also learned something. The more disturbing part concerned the teacher role, which changed from being a professional expert, who knows all the answers, towards a more uncertain inquiring novice, who is unfamiliar with the aesthetic universe, the language (English) and the explorative attitude. This experience can be highly uncomfortable for someone who usually feels in control.

For the students the Sister Academy was a breath of fresh air that engaged them in a different way than on a normal school day. One of the greatest challenges for teachers nowadays is to hold the students' focus and attention. Teachers often complain that students are on Facebook or other social media during the sessions. This was obviously not the case during the project. To his own amazement one student (see above quote), who would normally have a very short attention span and would not be able to sit still for five minutes, sat for a half hour with The Gardener, who had this "very calm aura around him". Their dialog had a strong quality of engagement and presence. Furthermore The Gardener did something that a normal teacher would not do, he provided no answers. This was an important learning for the student, something that "would be in his mind for a very long time". It is interesting to note that questions and unfinished topics have a tendency to keep the mind going, whereas answers often tend to put an end to speculation.

Arts-in-business from 2004 to 2014 29

The project continues in 2015 at Inkonst, an international art centre in Malmö, Sweden, featuring music, theatre, dance, performances, film, literature and art all under the same roof (http://www.inkonst.com/sisters-hope-sisters-academy-nedslag-01%E2%80%B3/). This project is large scale and has two parts, thanks to a generous funding from the Swedish Culture Foundation. The first part will manifest as a Sisters Academy – The Boarding School of a sensuous society – an immersive, interactive and durational performance-installation at Inkonst in September 2015 where everyone can sign up as students, potentially become teachers or substitute teachers, researchers- and artists-in-residence. The second part is an intervention into a Swedish upper secondary school; with the objective of transforming the school into a sensuous society to explore new more poetic and sensuous modes of knowledge production and learning environments.

Reflecting and learning through artful approaches

The second example is a first-person account from my own practice, illustrated with quotes from some of the involved students. Since 2006 I have been the director of an international executive Master's program in Denmark called LAICS: Leadership and Innovation in Complex systems (www.laics.net). One of its distinguishing features is that artistic intervention constitutes an important part of the learning approach. We work with theatre directors and actors, with music, both a classical violinist and jazz improvisation, with a ceramist, a visual artist, nature as art, mindfulness, drawing, graphic facilitation, prototyping, journal writing, storytelling and design approaches.

Here I focus on one specific seminar, which has a particularly strong impact on people's personal leadership. It takes place in the Canadian Rocky Mountains at the Banff Centre, which is situated in a large nature reserve. The aim of the four-day seminar is for the participants (about 20) to reflect on their personal leadership through a variety of artistic interventions and to enable them to articulate their leadership story at the end of the seminar. On the first day the students go into the mountains to reflect on the landscapes that have influenced their lives, particularly during childhood. Later that day they communicate with clay. One of the exercises concerns silent communication in groups of four or five participants, who are allowed to work with only one hand on a shared piece of clay. The task is to co-create something that makes sense and can be recognized by outsiders. The whole session takes two hours and the tasks become more and more abstract or metaphorical, such as creating a tableau on authentic leadership. The session ends by inviting people to create their own leadership icon in clay. These are fired in a kiln and three days later glazed and fired in a Raku kiln on the last day as part of the closing ceremony. The participants reflect through exercises such as these, interrupted by presentations on leadership theory and art-based research. During the seminar the participants also embody leadership through theatre rehearsal techniques and exercises on storytelling, they

walk and reflect in nature doing breathing and sensing exercises, and they work with natural materials in the forest trying to express their leadership values metaphorically.

The following is an excerpt from a master thesis on psychological innovation. It illustrates an individual experience of reflecting and learning through artistic processes and natural materials. The author, who had been going through a mid-life crisis that had lasted a few years, experienced several personal insights that helped him identify his way forward:

> First practice after arriving in Banff was shaping 'my personal leadership' in clay. There were time constraints and no time for reflection. Just do it. I chose the first thing that came into my mind – the symbol of a thriving heart. Afterwards I was surprised that this simple little symbol contained the essence of all the questions I had. It was as if things were fused into a single expression. . . . My next question was about how I got on with the insights I had gained through the heart metaphor. My experience was that I got in touch with nature and that it replied back with a speed and accuracy, which was surprising. The answer was meaningful, profound and surprisingly rewarding. As if the answer unfolded from an immanent truth emerging through my wordless question and my intense listening for meaning. My response was clear – aha – that things fell into place in my consciousness. This was a very rewarding and moving experience . . .
>
> (Kunze 2011, p. 4)

Other students described (in the reflection reports they write in the third module of the course) how the theatre rehearsal exercises have taught them lessons about their leadership that arise from their bodily sensations. It has made them aware of understanding bodily sensations better, such as queasiness and gut feelings in general, and it has also been a lesson for some to pay more attention to their inner voice. One student wrote that an exercise in which he had to walk like his most admired leader gave him several insights about body language. First, he had to walk like a female leader. This made him intensely aware of how he would normally carry his own body, something he had never considered before. Second, his new consciousness made him change his way of walking, because he found his earlier appearance to be counterproductive to whom he authentically was and wanted to be. Another student wrote that the artistic intervention opened him up for another source of knowing. His hands knew the answer before his mind could follow or could formulate it verbally. Artistic interventions thus seem to convey different and more immediate insights than theoretical presentations (Berthoin Antal 2013b; Taylor and Ladkin 2009).

Artful learning

These examples suggest that learning through artistic intervention is different than studying by reading. I would argue that artistic approaches can help

us discover what we do not know that we know. Our body absorbs lots of information that never enter our conscious mind unless we make space for this to happen, for example, through reflection or meditation practice. Our hands know things that may come out in artistic materials (such as clay or natural materials) and our bodies give us signals and impulses that we may easily overhear and not take action upon until we discover the richness of the information (see Bozic Yams, this volume). Through embodiment we discover "the body as a site of knowledge" (Pelias 2008, p. 186). The keyword here is *insights*, insights from our own intuition, paying attention to bodily sensations and impulses, or listening to our inner voice. In my experience this is an important part of developing *innovation competency*, which I define as the ability to create innovation by navigating effectively together with others in complex contexts (Darsø 2012, p. 110).

Innovation competency consists of a foundation of knowledge about innovation, but this is far from enough. Two meta competencies must be developed as well, and these can only be acquired through experience and practice. Socio-innovative competency covers the aspect of leading or facilitating innovation processes in diverse groups. Intra-innovative competency concerns learning about oneself, becoming conscious about strengths and talents, knowing how to motivate oneself and what kind of reflection works, and learning to use intuition (Darsø 2012, pp. 110–111). Aesthetic and artistic approaches are particularly effective for developing intra-innovative competency.

Conclusion

Reflecting on what has happened in the field of Arts & Business since 2004 makes me conclude that the biggest difference since then is the increasing amount of research being carried out around the world, as documented by Berthoin Antal and Strauß in this volume. This is, indeed, the good news. Despite the financial crisis, artistic interventions are also still being explored in the fields of business, organizations and education, and as evident from the chapters of this book, the development has been evolutional – not revolutional. It has not given rise to the steep curve of growth that I, perhaps naïvely, imagined in 2004. I have argued that one of the major strengths of artistic intervention in organizations can be expressed as the tension inherent in *constructive disturbance*. Organizations need to be disturbed regularly, because they have a tendency to freeze into a culture of homogeneity and complacency, but as various experiments and 'failures' have demonstrated throughout this book, disturbance must be underpinned by creating trusting and respectful relationships between all people involved. One of the ways to escape a closed culture and daily humdrum is to create interspaces or physical studios, as suggested in this book. Unquestionably, there is great potential in artful approaches, but it takes a lot of experience and practice to obtain the competency for understanding the needs of the organization and link it to the overall strategy, in order to create a worthwhile artistic intervention that is meaningful to the people involved,

adequately provocative, and at the same time effective for the organization. Artists are generally not equipped to take on this role because they want to focus on their art, so some kind of intermediary will be necessary here, such as an internal or external consultant.

Besides the importance of more research and more evidence on the values added through artistic intervention, I believe that the greatest potential for artful approaches lies in the field of education, in particular in leadership development. As McGill Professor of Management, Nancy J. Adler, has expressed it: "Twenty-first century society yearns for a leadership of possibility, a leadership based more on hope, aspiration, and innovation than on the replication of historical patterns of constrained pragmatism" (Adler 2006, p. 487). Education as an institution is still far behind. And Professor of Law and Ethics, Martha Nussbaum states: "All over the world, programs in arts and the humanities, at all levels, are being cut away in favor of the cultivation of the technical" (Nussbaum 2009, p. 8). Education, in general, has not been able to adapt or change to better fit the demands of a global "Knowledge Society" (Drucker 1993). When contemplating that new social media platforms have given rise to new types of economy, such as Airbnb and crowdsourcing, and that the creative industries have developed and grown considerably during the last decade (even during the economic crisis), then it becomes obvious that education must change too. The twenty-first century calls for different competencies, like innovation competencies, which is why creative, aesthetic and artistic interventions are both needed and justified. The aesthetic dimension opens up for experiencing, exploring and knowing the world in a different way than logical thinking does. It adds value in introducing diverse sensuous modes of knowing, which make a difference both as inward reflection leading to new insights and outward construction of artful communication and new ways of engaging people.

Reflecting and learning through artful approaches have great potential, in particular in leadership development, but in general also as a way of renewing education in a broader sense. Therefore, the way forward for artistic intervention to become recognized as powerful and value-adding in organizations will be through people who have themselves experienced, practiced and learnt from these during their education. Leaders with artful insights in their bodies, minds, hearts and spirits are intra-innovatively competent and will be more prone to welcoming artistic interventions in their organizations. And with increasing research the field will slowly but surely continue its evolution.

References

Adler, N.J. (2006) 'The arts and leadership: Now that we can do anything, what will we do?', *Academy of Management Learning and Education*, 5(4), pp. 486–499.

Amabile, T.M. (1998) 'How to kill creativity', *Harvard Business Review*, 76(5), pp. 76–87.

Berthoin Antal, A. (2012) 'Artistic intervention residencies and their intermediaries: A comparative analysis', *Organizational Aesthetics*, 1(1), pp. 44–67.

Berthoin Antal, A. (2013a) 'Art-based research for engaging not-knowing in organizations', *Journal of Applied Arts and Health*, 4(1), pp. 67–76.

Berthoin Antal, A. (2013b) 'Seeking values: Artistic interventions in organizations as potential cultural sources of values-added'. In Baecker, D. and Priddat, B.P. (eds.), *Oekonomie der Werte /Economics of Values*. Marburg, Germany: Metropolis-Verlag, pp. 97–128.

Berthoin Antal, A. (2014) 'When arts enter organizational spaces: Implications for organizational learning'. In Meusburger, P. (series ed.) & Berthoin Antal, A., Meusburger, P. and Suarsana, L. (volume eds.), *Knowledge and space: Vol. 6. Learning organizations: Extending the field*. Dordrecht, The Netherlands: Springer: pp. 177–201.

Berthoin Antal, A. (2015) 'Sources of newness in organizations: Sand, oil, energy, and artists'. In Berthoin Antal, A., Hutter, M. and Stark, D. (eds.), *Moments of valuation: Exploring sites of dissonance*. Oxford, UK: Oxford University Press, pp. 290–311.

Berthoin Antal, A. and Strauß, A. (2013) *Artistic interventions in organizations: Finding evidence of values-added*. Berlin: Wissenschaftzentrum Berlin für Sozialforschung.

Buswick, T., Creamer, A. and Pinard, M. (2004). (Re)educating for leadership: How the arts can improve business. Retrieved from http://www.aacorn.net/members_all/buswick_ted/ReEducating_for_Leadership.pdf (Accessed March 19, 2015).

Csikszentmihalyi, M. (2003) *Good business leadership, flow and the making of meaning*. London, UK: Hodder & Stoughton.

Darsø, L. (2001) *Innovation in the making*. Frederiksberg, Denmark: Samfundslitteratur.

Darsø, L. (2004) *Artful creation: Learning-tales of arts-in-business*. Frederiksberg, Denmark: Samfundslitteratur.

Darsø, L. (2005) 'International opportunities for artful learning', *Journal of Business Strategy*, 26(5), 58–61.

Darsø, L. (2012) 'Innovation competency – an essential organizational asset'. In Høyrup, S., Hasse, C., Bonnafous-Boucher, M., Lotz, M. and Møller, K. (eds.), *Employee-driven innovation*. Basingstoke, UK: Palgrave Macmillan, pp. 108–126.

Darsø, L. (2014) 'Setting the context for transformation towards authentic leadership and co-creation'. In Gunnlaugson, O., Baron, C. and Cayer, M. (eds.), *Perspectives on Theory U: Insights from the field*. Hershey, PA: Business Science Reference/IGI Global, pp. 97–113.

de Bono, E. (1994). *De Bono's thinking course* (revised edition). New York, NY: Facts on File.

Drucker, P.F. (1993) *Post-capitalist society*. Oxford, UK: Butterworth-Heinemann.

Eisner, E. (2008) 'Art and knowledge'. In Knowles, J.G. and Cole, A.L. (eds.), *Handbook of the arts in qualitative research: Perspectives, methodologies, examples and issues*. Thousand Oaks, CA: SAGE Publications, pp. 3–12.

Guillet de Monthoux, P., Gustafsson, C. and Sjöstrand, S.E. (2007) *Aesthetic leadership. Managing fields of flow in art and business*. New York, NY: Palgrave Macmillan.

Ibbotson, P. (2008) *The illusion of leadership. Directing creativity in business and the arts*. Houndmills, UK and New York, NY: Palgrave Macmillan.

Kunze, K. (2011) *Development of human causality*. Unpublished thesis. LAICS Master in Leadership and Innovation in Complex Systems, University of Aarhus, Copenhagen, Denmark.

Leonard, D. and Straus, S. (1997) 'Putting your company's whole brain to work', *Harvard Business Review*, 75(4), pp. 176–187.

Mintzberg, H. (2009) *Managing*. San Francisco, CA: Berrett-Koehler.

Nussbaum, M.C. (2009) 'Education for profit, education for freedom', *Liberal Education*, 93(3), 5–13.

Pelias, R.J. (2008) 'Performative inquiry: Embodiment and its challenges'. In Knowles, J.G. and Cole, A. L. (eds.), *Handbook of the arts in qualitative research*. Thousand Oaks, CA: Sage Publications, pp. 185–194.

Richards, D. (1995) *Artful work: Awakening, joy, meaning, and commitment in the workplace*. San Francisco, CA: Berrett-Kohler Publishers.

Robinson, K. (1982) *The arts in schools: Principles, practice and provision*. London, UK: Calouste Gulbenkian Foundation.

Springborg, C. (2010) 'Leadership as art – leaders coming to their senses', *Leadership*, 6(3), pp. 243–258.

Strati, A. (2000) 'The aesthetic approach in organization studies'. In Linstead, S. and Höpfl, H. (eds.), *The aesthetics of organization*. London, UK & Thousand Oaks, CA.: SAGE Publications, pp. 3–34.

Sutherland, I. (2013) 'Arts-based methods in leadership development: Affording aesthetic workspaces, reflexivity and memories with momentum', *Management Learning*, 44(1), pp. 25–43.

Sutherland, I. and Ladkin, D. (2013) 'Creating engaged executive learning spaces: The role of aesthetic inquiry'. *Organizational Aesthetics*, 2(1), pp. 105–124.

Taylor, S.S. and Ladkin, D. (2009) 'Understanding arts-based methods in managerial development', *Academy of Management, Learning and Education*, 8(1), pp. 55–69.

VanGundy, A.B. and Naiman, L. (2003) *Orchestrating collaboration at work: Using music, improv, storytelling, and other arts to improve teamwork*. San Francisco, CA: Jossey-Bass/Pfeiffer.

Wilber, K. (2000) *A brief history of everything* (2nd ed.). Boston, MA: Shambhala.

Part II
Assessment and evidence

3 Multistakeholder perspectives on searching for evidence of values-added in artistic interventions in organizations

Ariane Berthoin Antal and Anke Strauß

Over the past 15–20 years the world of the arts and the world of organizations have extended their interactions beyond philanthropy, sponsorship and public relations activities to explore learning-oriented forms of engagement, namely artistic interventions in organizations (Berthoin Antal 2009; Brellochs and Schrat 2005; Darsø 2004; Hansen 2004; Harris 1999). Explicitly or implicitly, they appear to share the belief expressed by leading management scholars like Nancy Adler (2006) and Ed Schein (2001) that such interactions will help to find new ways of seeing, thinking and doing business. Artistic interventions are aesthetic experiences that engage people's senses, enabling members of (organizations to discover how to tap into feelings and bodily ways of knowing such as gut-feeling) to guide their decisions and actions, a competence that is particularly important in situations of uncertainty and ambiguity (Berthoin Antal, 2013a). Interactions with artists at work can develop people's capacity for mindful organizing required to deal with the unexpected that has become the hallmark of the "age of uncertainty", namely to "make fewer assumptions, notice more, and ignore less" (Weick and Sutcliffe 2007, p. 95).

The field is maturing and the body of research on whether and how bringing "people, products or practices from the world of the arts" into the world of organizations (Berthoin Antal 2012, p. 45) actually fulfils such hopes has been growing. The primary drivers for studies on the effects of artistic interventions are the intellectual curiosity of organizational scholars (e.g., Berthoin Antal, Taylor and Ladkin 2014; Biehl-Missal 2011; Strauß 2007, 2009, 2013) and the practical interest of the diverse stakeholders in obtaining external analyses of these activities. They include policy makers at the European and national levels as well as leaders of business associations who want to know whether or not to promote such initiatives. Other stakeholders who want to have research undertaken are the intermediaries who are producing artistic interventions (Berthoin Antal [in collaboration with Gómez de la Iglesia and Vives Almandoz] 2011) and the artists involved in them. Both are providing access to researchers to conduct studies on their projects out of a mix of interest in learning from the analysis in order to improve their processes and a need to provide evidence of values-added in order to secure future funding.

As a result of these multiple research drivers, the past few years have seen the publication of studies attempting to evaluate the impacts[1] of artistic interventions in organizations, sometimes with public funding (such as Arts&Business 2004; Barry and Meisiek 2004; Berthoin Antal 2009; Berthoin Antal and Strauß 2013a; Carlson 2007; Heaney 2004; Schiuma 2009; Styhre and Eriksson 2008). A positive sign for the research field is that doctoral students are conducting independent academic projects requiring rigor in the treatment of the literature and of the data (for example, Rae 2011; Schnugg 2010; Strauß 2013; Teichmann 2001), and some empirically-based masters' theses are also becoming available (for example, Bessière 2013; Müller 2014; Rodríguez Fernández 2008; Rusch 2012; Weller 2009).

This contribution provides an overview of the documented effects of artistic interventions by presenting findings from a meta-analysis of publications that included empirically-based evaluations of artistic interventions (Berthoin Antal and Strauß 2013a), supplemented by the results from our current field work. In a nutshell, our analysis indicates that (a) the effects of artistic interventions in organizations are primarily found at the personal and interpersonal levels because that is where the interactions actually occur; (b) the learning outcomes are generated in what we call "interspaces" in which the participants experience a wider range of possible ways of seeing and doing things than the norms and rules of the organization usually enable; and (c) there is also some evidence of effects spilling over from the personal and interpersonal levels to the organizational level (see also Schiuma 2009). Furthermore, (d) our research reveals that the emergence of organizational level effects depends largely on the extent to which leadership actively supports the learning generated in the interspace; and (e) some studies also indicate unintended positive impacts of such interventions extending beyond the boundaries of the organization to creating or enriching relationships with the external stakeholders.

At first glance, for readers interested only in data proving direct effects of artistic interventions with traditional business measures, such a summary of documented impacts may well be disappointing because there is little quantified evidence of organizational level impacts. Does it mean that the investment in such activities does not pay off for the organization? Or is it an indication of the lack of maturity in research in this area? We suggest a different reading of the situation because we concur with François Matarasso (2005), who suggests that the kinds of value that the interactions with arts can add in society cannot be captured adequately by commonly known business indicators. As he points out, evaluation requires both a better understanding of the interaction and more imaginative approaches to such research. We observe a striking discrepancy between what the participants (employees at all levels of the organization, managers responsible for projects, and participating artists) value from the experience, and the types of impacts policymakers or managers without experience in the area expect such evaluation studies to document. Our conclusion is that values added cannot simply be *found* by looking for them, rather they must be

generated in a co-creative process with members of the organization. Taking the documented evidence expressed by the participants seriously lays the groundwork for recognizing what kinds of value can grow out of experiences with artistic interventions in organizations and also for designing generative evaluation processes.

The chapter first introduces the concept of "interspace" to explain the embedding of artistic interventions in organizational dynamics. It then describes the database and method. The third section presents the impacts documented at the personal, interpersonal, and organizational level, using illustrations from the published studies in the database as well as some additional examples from our current research. In the fourth section we propose "making space" as the complementary concept to temporary interspaces, in order to create and sustain values-added. In the conclusion we outline remaining challenges for evaluation.

Artistic interventions as interspaces in organizations

From our analysis of the research-based texts and our ongoing studies in this area, we propose that the power of artistic interventions in organizations resides in the opening of spaces of possibility, which we call interspaces. These are temporary social spaces within which participants experience new ways of seeing, thinking and doing things that add value for them personally. In the interspace, doubt and organizational norms are suspended to enable experimentation. It is from the experimentation in the temporary interspace that values-added can flow out to influence processes and practices in the organization thereafter. Energy and emotions are key ingredients in the interspace that artistic interventions open in organizations. As a manager in a Danish company explained, "One thing that we achieved was learning to say 'Yes!' – the art of being open to even the wildest stories, examples and opportunities" (Artlab 2009, p. 16). The extent to which artistic interventions can generate values-added depends both on the quality of the interspace and on the organizational follow-up to the experience.

Challenging basic assumptions in an organization and deviating from routine behaviours require a sense of psychological safety. Participants feel anxious about opening up towards new ways of expressing and doing things if experimenting with culturally deviant behaviour in an artistic intervention is not explicitly legitimised and valued by the management (Berthoin Antal and Strauß 2014a). Hence, although it is countercultural to the managerial logic of control, management's willingness to "trust the process" (McNiff 1998) and the people involved is a key factor that enables "collectively creat[ing] a space that allows great things to happen" (Artlab 2009, p. 23).

Interspaces also have physical dimensions that connect them to the organization and can extend beyond the temporary life-span of the artistic intervention. For example in a Swedish hospital the artist noticed that employees were so involved in their work that they did not engage with each other. The artist

therefore created "a pleasure garden where the employees can sit and exchange thoughts with each other" (Hellgren 2011, p. 116, our translation). When an artistic intervention entails the creation of artefacts, these can become part of the organizational space and remain as a memorable trace of the artistic intervention, stimulating conversations even years later, as a French case study documented (Bessière 2013).

Data and methods

In the Creative Clash project (supported by the European Commission from 2011 to 2013), we conducted a meta-analysis of research-based publications to find documented empirical evidence on the impacts of artistic interventions in organizations (Berthoin Antal and Strauß 2013a). We opened the search net wide, collecting 268 academic, practitioner and policy publications about arts and business, and about the social impacts of the arts. A few publications had appeared before 2000 (for example Matarasso 1997; Harris 1999), then the field grew rapidly, particularly after 2004, possibly inspired by Lotte Darsø's (2004) ground-breaking book, *Artful Creation: Learning-Tales of Arts-in-Business*, as well as under the pressure to provide evidence of values-added for all kinds of activities in the private and public sectors, including the arts (for example Arts&Business 2004). These publications are predominantly in English and German, some also in French, Spanish and Swedish.[2] However, of the 268 publications we collected, only 72 addressed the value of the arts in organizations. Closer examination revealed that just 53 of those publications were based on some empirical evidence, but even these did not always indicate how the data had been collected. For the meta-analysis we retained the 47 publications that were explicit about their empirical database and how these data were obtained.

The research data is based entirely on case studies. Almost all the studies reported on several cases. For instance the Artlab (2009) study in Denmark covered 15 organizations; Janet Rae (2011) studied interventions in 5 organizations in London; and studies on TILLT projects in Sweden encompassed over 50 organizations from 2002 to 2007 (Lindqvist 2005; Styhre and Eriksson 2008) and six more in 2012 (Johansson 2012). This chapter includes findings from our current studies in 60 organizations in Spain that were not available when we conducted the meta-analysis (for example, Berthoin Antal and Debucquet 2013; Berthoin Antal and Nussbaum Bitran 2014a, 2014b). So the data encompasses experiences in some 300 organizations of different sizes and diverse sectors, primarily in Denmark, France, Germany, Spain, Sweden and the United Kingdom.

The types of artistic interventions covered in these studies differ greatly, which is not surprising because organizations are experimenting with diverse formats, ranging from a few hours or days (Rae 2011; Sutherland 2012), to several months (for example, those produced by the intermediaries TILLT in Sweden and Disonancias or Conexiones improbables in Spain lasted around 10

months) and even years (Berthoin Antal 2011) using all forms of arts (Berthoin Antal 2009, 2014).

All the studies use qualitative research methods, and around 80 per cent of them use a mix, such as interviews and participant observation. A few studies include surveys with established instruments on organizational climate (such as Eriksson 2007a and 2007b) or with specifically designed instruments for artistic interventions (for example, Berthoin Antal 2011). A handful of cases are also documented with video recordings and artefacts created during the artistic interventions, such as art works, or illustrations of ideas and activities (for example, Meisiek and Barry 2005). Nearly half of the studies involved data collection at several points in the process (pre-experience, during the intervention, post-experience). A welcome improvement in the research is that 87 per cent studies draw upon multiple stakeholder perspectives to identify effects of artistic interventions in organizations, usually employees, the commissioner in the organization, and/or the artists involved.

In order to do justice to the variety of perspectives in the research-based publications, we took a grounded approach (Charmaz 2008; Strauss and Corbin 1994). Two assistants helped to code the impacts found in the publications and organize them into categories. The iterative process with separate coders who compared their analysis and agreed on categories permitted us to (a) test the suitability of our categories, (b) develop a sense for the possibilities and limitations of these categories as well as the boundaries that distinguish one category from the other, and (c) create new categories when necessary. This process resulted in the specification of 23 categories of effects (for a broader systematization, see Schnugg 2010), which we then organized into eight groups, as presented in the following section.

Documented kinds of values-added of artistic interventions in organizations

It is useful to differentiate between effects at the personal, interpersonal, and organizational level, and level-spanning kinds of impacts. The eight groups of impacts we identified are:

- At the personal level: (1) Personal development and (2) Seeing more and differently;
- At the inter-personal level: (3) Relationships and (4) Collaborative ways of working;
- At the organizational level: (5) Strategic and operational; (6) Organizational development;
- Level-spanning effects: (7) Artful ways of working and (8) Activation

These groups comprise 14 impact categories. We describe and illustrate each of these categories below. For a better orientation, we use capital letters for the groups and italics to highlight the subsumed categories.

Effects experienced on a personal level

In our meta-analysis, the most frequently mentioned level at which people report effects of artistic interventions is personal (225 entries). This category encompasses two large groups, namely Seeing More and Differently (117 entries) and Personal Development (93 entries).

Seeing more and differently

With 117 entries, Seeing More and Differently is the most frequently mentioned effect of participating in artistic interventions in our meta-analysis. This group includes three categories that deal with experiencing art as enabling people to tilt their perspective: *awareness of the present conditions, reflection* and *widen perspectives*. Whilst the first two categories are linked to the past and present, the category 'widen perspectives' is more visionary in character because it introduces alternative conceptions of how everyday organizational life and practices could also be.

Awareness of present conditions usually implies cultural or tacit aspects of organizational life. Sometimes participating in an artistic intervention brings frustrations to the surface, as employees reconsider their work situation in a different light. For example, researchers in Sweden reported that the staff gained new insights about themselves and their work environment, and they cited an employee who said: "It wasn't only pleasant feelings and thoughts with the Skiss-project. I think they made our work situation quite obvious, the daft work situation we had. . . I realized what caused it and why I was so stressed" (Augustinsson and Ericsson 2011, p. 147, our translation).

Reflection is closely related to *awareness of present conditions*, however it implies a more active engagement of the participants to dig deeper into what they became aware of. In the evaluative interviews conducted during and after six projects at Unilever's division Lever Faberge, the researchers found that several organization members "speak of how arts programs have led them to question their values", and they cite an employee who summarized how the interaction with the artists had affected him: 'Seeing their passion for their work made me question my integrity and values and wonder how much I'd put at stake for what I believe in' (Buswick, Creamer and Pinard 2004, p. 10). Artistic interventions that include aesthetic-material representations, including performing bodies, appear to be particularly effective in helping participants reflect in a new way because such representations differ markedly from the way organizational life is usually shown (in this volume see Bozic Yams; Brattström; Ippolito and Adler). Theatre-based interventions are often mentioned in this context. For example, when Rae analysed the interviews she had conducted with the consultants, actors, facilitators, commissioners and participants involved in forum theatre in organizational settings in the UK, she found that "it was the dramatic representations, which have the potential to provide 'a . . . powerful space for challenge, reflection and instruction' (Mangham 2001, p. 296), which were the

most memorable and thought-provoking part of the sessions for participants" (Rae 2011, p. 161).

Widen perspectives: The materiality of such unusual representations also plays a crucial role for the third category (51 entries) in the group of Seeing More and Differently. It refers to expanding the way people see the organization's environment, its products or practices as well as its possible futures (in this volume see Jahnke). For example, an action evaluation study in the UK of 12 artistic intervention projects over 8 months found that "five of the twelve participating organizations report a fundamental shift in the way they see their futures" (Robinson and Dix 2007, p. 35). Cristina Rodríguez Fernández's thesis about artistic interventions in two organizations in Spain generated similarly rich data, showing not only that people found impacts on their daily work because, as a manager explained, "the project helps you to address daily common projects from another point of view" (2008, p. 66, our translation). It also enabled them to perceive their environment in a different way. A participant explained that "there is greater openness to other ways of doing things and you are more alert to new things that are happening around you" (Rodríguez Fernández 2008, p. 67, our translation).

Personal development

The group Personal Development includes impacts on *personal growth*, *leadership*, and learning *new skills* or developing *new tools*.

Personal growth is the most frequently cited personal development effect. Sixteen studies mentioned this effect for one or several cases (with 30 entries in total). For instance, a Danish project manager stated: "We have a group of young people whose growth was visible both during the process and afterwards, when they returned to daily life. They started to make some choices and take on things they would never have dared before. That generates self-esteem" (Artlab 2009, p. 19).

Leadership development is a specific kind of Personal Development. Although it also has an organizational-level dimension, we include it in this group because of the very personal work that artistic interventions can entail for participants (Katz-Buonincontro 2008). For example, after a session in an executive MBA program that involved conducting a choir, the 24 managers wrote reflective essays on the experience, which the researcher then analysed. He found that the participants developed reflexivity in their approach to leadership: "Trevor... develops a music metaphor, seeing himself as an interactive conductor and his activity as listening to the rhythm of employees and harmonising activity. This aesthetic–reflexive work has afforded him new conceptual structures in which to understand leadership, a new vocabulary with which to express it, and a momentum to plan future action" (Sutherland 2012, p. 14).

Studies also cite evidence of impact on practical dimensions of personal development, such as acquiring *new skills* or developing *new tools* – the most straightforward being those needed for presentation.

It is not surprising that the literature documents more effects at the personal level than at other levels. Art-related experiences are aesthetic experiences that are inevitably made on a personal level that only subsequently can be shared and thereby made available as an opportunity for organizational learning (Berthoin Antal and Strauß 2013b). A decade ago this emphasis on personal development was considered problematic because it might encourage "the pigeonholing of arts-based work... [that] makes it difficult for the arts to break out of this narrow silo of activity" (Arts&Business 2004, p. 15). We agree that such pigeonholing is misleading, but are less worried about its effect in practice because our meta-analysis reveals that in the meantime there is evidence that artistic interventions are valued for their potential effects on an interpersonal level.

Effects experienced on an interpersonal level

Effects on an interpersonal level are mentioned 152 times in our database, and we grouped them under the subheadings of Relationships (63 entries) and Collaborative Ways of Working (89 entries). They are closely related, but the first describes the quantity and quality of connections, the latter denotes processes.

Relationships

The group Relationships comprises the categories *internal relationships* (45 entries) and *external relationships* (18 entries). We consciously use the term relationship to denote the rather personal aspect of relating to others.

Internal relationships: Not surprisingly, effects on relationships within the organization are much more prominent in the stakeholders' statements about the experiences they value in an artistic intervention than those referring to external relationships. Participating in an artistic intervention often implies that people interact with employees from other departments who they would normally never have met. It also enables them to discover surprising or exciting new sides of colleagues that sometimes even change their minds about them. In the Artlab (2009) study, an artist reported that the participants in the intervention were able to see new aspects of each other, and experienced a basic human connection that enables them to look one another in the eye and be more open in their future co-operation. One participant had been seen as the 'complainer' of the group for over 15 years. After the workshop, both he and his manager said that he was now seen in a new light, and that their co-operation has significantly improved (Artlab 2009, p. 23).

Although the majority of studies found similarly positive statements about improved relationships by different stakeholders, artistic interventions are not like a magic wand that can be relied on to resolve all problems. "[O]ne of the participants felt that some of his colleagues' interpretations of the play confirmed his negative idea of them. Just like they behaved in everyday work life, these interpretations reflected his colleagues' inability to be flexible in their thinking" (Teichmann 2001, p. 158, our translation).

Compared to *internal relationships*, the category *external relationships* plays a minor role. Neither managers nor employees want artistic interventions to be used to support PR campaigns. In fact, participants tend to discover these effects as unexpected benefits when artistic interventions expanded or enriched their relationships with external stakeholders. For example, several studies reported that participants appreciate how the artistic intervention added new dimensions to their relations with clients and with the local community because there is more to talk about than just the business itself (Berthoin Antal 2011; Berthoin Antal and Nussbaum Bitran 2014a, 2014b).

Collaborative Ways of Working

The group of effects Collaborative Ways of Working emphasizes a qualitative shift in the way of working together that is closely linked to the effects found in Relationships. In organizations, working together is primarily arranged through its formal structure that determines the different functions that employees carry out as well as how these different functions are interconnected in the workflow. Such a structural determination produces collective ways of working. Experiencing an artistic intervention often leads to a qualitative shift from simply collective to collaborative ways of working, in which the participants emphasize experiencing a more meaningful interaction. Under the heading Collaborative Ways of Working are the impact groups with evidence on the *quality of working together* (45 entries) and on the *quantity and quality of communication* (44 entries).

The frequency with which stakeholders mentioned an enhanced *quality of working together* as an effect of their participation in an artistic intervention in their organization mirrors the number of times they reported on a positive impact on the category *internal relationships*. The reports mention finding "new ways of collaborating and interacting between people" (Grupo Xabide 2008, p. 194) and "increased cooperation and solidarity" (Eriksson 2009, p. 23).

Collaborative Ways of Working are associated with a different *quantity and quality of communication* than people usually have at the workplace, both verbal and non-verbal. The studies contain numerous findings that people have conversations they had not otherwise engaged in. By expanding the range and depth of conversations, people developed better working relationships. For example, a year-long study of ten projects produced by TILLT in Sweden found connections between increased communication, collaborative ways of working, and better working relationships. "In the survey it is mentioned that Genklang [the artistic intervention project] contributed in a high degree to improve working climate and cooperation. In the qualitative data collection some mention an increased feeling of togetherness: 'You talk more to one another', 'We appreciate each other more in everyday life', 'Increased solidarity'" (Eriksson 2007a, p. 18, our translation).

This increase in communication also has the potential to enable people to address topics that had not been perceived as discussable before (in this volume see Meisiek and Barry). Another study on a case in Sweden based on

interviews, observations, and email exchanges found that significant changes at work followed from such conversations: "They appreciated that the project got conversations going between the two plants that had not been possible beforehand. There had been 'invisible walls' even 'wars' between shifts – people did not help each other out. They can now address issues that had not been discussable beforehand (like sharing shifts), which makes the work process easier all around for the employees" (Berthoin Antal 2013b, pp. 110–111).

In summary, the number and kinds of effects reported on an interpersonal level are evidence that the arts have managed to escape the silo of personal development schemes and to increase their scope of influence in organizations. For example, in the Swedish company cited above, the employees started helping each other out across shifts, a practice that had previously been inconceivable because of the animosity between groups. Such changes towards collaborative behaviour can spill over into organizational level effects, such as improvements in productivity and turnover, the category we will report on in the next section.

Effects on the overall organization

Effects at the overall organizational level appear in 82 entries in the research-based texts that we analysed. This level includes Strategic and Operational Impacts (37) and Organizational Development (45).

Strategic and Operational Impacts

The earliest evaluation studies conducted on the TILLT projects in Sweden already laid out the conundrum clearly: although external observers want hard data in traditional business terms, managers involved in artistic interventions do not feel a need to measure the effects on the organization (Lindqvist 2005; Styhre and Eriksson 2008, pp. 53–54). When managers were asked to provide numbers on the performance of their organization after an artistic intervention took place, a few spoke of improvements in turnover or productivity, or a drop in absenteeism, but they were quick to point out that establishing a direct causal link with the artistic intervention would be too simplistic. For example, a Danish manager explained: "This year we have seen an increase in our turnover of just over 30 per cent. Of course, there may be many factors that explain this improved efficiency. But one of them is that this group works fantastically well together. Firstly, this group is a unit, such that if one of them says something, then the rest stand by it – this means clear and unambiguous communication. Secondly, if one of them has a problem, then the group have been able to disregard their personal interests to help the person in question" (Artlab 2009, p. 13).

In one of our current studies the German CEO of a manufacturing company responded to our request for evidence of impact on his organization in terms of classical business indicators by explaining,

> Of course I could give you numbers, for example indicating a drop in absenteeism in the year we conducted an artistic intervention on leadership with

all the top management and our entire workforce. But you know what? There is high unemployment in Germany, and that is the most important factor in reducing absenteeism today.

Such responses indicate a healthy awareness of the multiplicity of factors that affect organizational outcomes and an appropriate reluctance to attribute changes to a single kind of input. Organizations are always affected by external factors in the market, like the arrival of new competitors or economic downturns, as well as other internal factors, including changes in leadership or the launch of change programs, so an artistic intervention is never the only different ingredient.

That artistic interventions can be a valuable ingredient is evident from the multiple types of effects identified in our meta-analysis. Findings from our current study of 60 cases in Spain support this conclusion and document additional kinds of organizational level effects. Over 95 per cent of project owners indicate that they believe the artistic intervention had an impact on the organization and they cite new ways of organising work, new projects and higher employee engagement at work as evidence they observe (Berthoin Antal and Nussbaum Bitran 2014a, p. 3).

Organizational Development

Artistic interventions in organizations may represent a new form of organizational development, sharing the humanistic orientation at the origin of that field (Berthoin Antal, Taylor and Ladkin 2014). In our meta-analysis we found 45 references to effects relating to Organizational Development, and they fall into two categories, namely *working climate* (25 entries) and *organizational culture* (20 entries). The research-based texts that we analysed reveal that there is a mutually conditioning relationship between the arts and the organizational context. These categories are discussed in two ways: (a) artistic interventions can be part of a process to address the values and norms in an organization and to improve the working climate; and (b) the organizational culture and working climate can help or hinder the capacity of the organization and its members to benefit from the experience with the artistic intervention. For instance, a Danish manager addressed how an organization sustains an enhanced working climate experienced in an artistic intervention: "After the workshop, we defined some rules relating to presence, expectations and conflict resolution. So now we are working according to collectively agreed rules that enable us to continue to focus on recognition of each other. It doesn't cost a great deal and there is much to be gained." (Artlab 2009, p. 9).

Of course, artistic interventions do not automatically and inevitably lead to an enhanced working climate and a change in the organization's culture. Stefanie Teichmann documented such a situation in one of the German organizations she studied for her doctoral thesis. The company had used theatre-based artistic interventions for organizational development, but

> Without exception, the employees interviewed were sceptical as to whether the play would lead to concrete changes in their colleagues'

behaviour, even if the play had initiated processes of self-reflection. Their scepticism, however, was not so much due to doubts about the potential of the theatre play but much more to the leadership culture in [the organization]. "I do believe that the play initiates thoughts in some minds here. But we do not see management's intention to really change something. And as long as this does not happen, people do not see any sense in changing themselves."

(Teichmann 2001, p. 240, our translation)

Such observations from employees underscore the responsibility that management bears for enabling the organization to reap benefits from an artistic intervention experience (Berthoin Antal and Strauß 2014b; in this volume see Zambrell). Without management support for integrating the learning into formal and informal structures, processes and practices, the personal and interpersonal level learning are likely either to wash away by everyday organizational life routines, or to turn into cynicism (Clark and Mangham 2004). This conclusion is also confirmed by findings of other studies: "The result indicates... that it is important that the process doesn't cease but that after the finished contribution of the artist the management in the participating units takes over the baton and carries on with the new approach" (Eriksson 2007a, p. 21, our translation).

Certainly, such overall effects are most difficult to document because change in organizations takes time and often comes in subtle ways, reflected in atmospheres, practices or self-descriptions. Furthermore, in our research we have encountered some strong resistance from employees and managers to attempts to attribute changes in the organization directly to artistic interventions. They consider the very idea of instrumentalizing art for organizational ends to be unacceptable (Berthoin Antal 2011 and 2013b).

Level-spanning effects

Two more categories of impacts emerged from our meta-analysis, Artful Ways of Working and Activation. They span the three levels on which we found evidence of artistic interventions adding value in organizations. We present them together because their combination may be the essential difference between art-based interventions and other kinds of interventions in organizations.

Artful Ways of Working

Artful Ways of Working (64 entries) complement Collaborative Ways of Working identified above as an effect at the interpersonal level. Whilst the latter is a qualitative shift in the nature of cooperative behaviour in everyday processes of working together, Artful Ways of Working are practices that constitutively differ from routine and institutionalized ways of working in organizations. We organized the data in this category under three headings: *dealing*

with the unexpected and being open to the new, adopting artistic formats and *trusting the process*. All three are important for innovation and performance under conditions of ambiguity and change, but are difficult to introduce in an organizational environment usually characterized by a preference for routines.

Many of the studies refer to the potential of artistic interventions in organizations to provide organization members with the experience of *dealing with the unexpected and being open to the new* (49 entries). The effect is indirect, but literature offers some examples, such as the French organization in which employees said that the experience with their CEO in an artistic intervention made them better able to deal with a crisis that occurred months later (Berthoin Antal, Taylor and Ladkin 2014, p. 265). Certainly, a difficulty for providing evidence of an organization's ability to deal with the unexpected and be open to the new as an effect of an artistic intervention lies in the rather elusive character of the category itself. However, there are some indications that artistic ways of working have found their way into the practices in everyday organizational life. For example, statements in interviews illustrated and confirmed the effects documented in the quantitative analysis of TILLT cases in Sweden: "increased creativity; more open for new things; an allowing atmosphere... [were confirmed and specified by statements, such as], 'we don't do any longer just what is expected of us, nowadays we even discuss things that go beyond the usual.' Or, 'in the internal discussions we have nowadays a bigger focus on the substance/the topic and not only how to earn money (which in the end would lead to a meaningless bubble)'" (Eriksson 2008, p. 15, our translation). To date, however, few studies have confirmed and specified the impact category dealing with the unexpected and being open to the new on such a practical level.

Adopting artistic formats (12 entries) is closely related with the impact category new *tools* that can be found on a personal level, but we treat it as a level-spanning effect because it extends to practices that became an integrative part of everyday organization activities, such as problem-solving processes. For example, in an evaluation of six cases in Sweden (combining participant observation, interviews with commissioners in the organization and artists, and an employee survey) Ulla Johansson found that some participants "acquired an (artistic) tool to use in daily practice, [which was] mentioned by everyone as very important. Here 'tools' referred to the role-play they learned and which some employees now use quite often to catch new perspectives on how to resolve a situation. In addition, the CEO also mentioned that one of the management teams started to literally 'paint their feelings,' both when they started and when they ended a meeting" (Johansson 2012, p. 6).

Working with artistic formats can take people out of their comfort zone, so evaluations of the immediate experience reflect that some people may not like what they perceive as strange and irritating new ways of working, although trying out different approaches is necessary for innovation. A study of three artistic intervention projects in Denmark (based on interviews with artists and representatives of the participating organizations)

showed that sometimes tension emerges between the "explicit organizational objective of interrupting established ways of doing things and some employees' sense that the unusual approaches were alienating" (Rusch 2012, pp. 70–71). Such frustration may be temporary, for example when participants discover after a while that the new practices do make sense and are indeed helpful (e.g., Berthoin Antal 2013b, p. 110). However it may be important critical feedback that artists, managers, and researchers need to understand and address.

Trusting the process (McNiff 1998) is an approach to work that artists refer to often but is rarely used in business texts. It entails having the courage to move out of the comfort zone and put the new methods into practice. Although it is mentioned less frequently than the other items (3 entries), the examples provided in the literature are quite concrete. A manager in a Belgian manufacturing company explained:

> I'm not someone to take risks for the sake of it, but this project motivated me to follow my gut feelings even more. . . . I have the feeling now that my engineers are listening better and working together better by having to think about problems in another way for once and not following standard processes that are always based on operational or mathematical considerations.
>
> (van den Broeck, Cools and Maenhout 2008, p. 586)

In summary, the effects we characterize as Artful Ways of Working reflect how discoveries made in an artistic intervention can interrupt institutional routines and change the way an organization operates. We now turn to the other group of effects that span the three levels and seem to be unique to artistic interventions in organizations, namely Activation.

Activation

With 114 entries, Activation is the second largest group in our meta-analysis after Seeing More and Differently. This finding is not self-evident, because employees are often initially sceptical about getting involved with an artist at work (in this volume see Styhre and Fröberg). Responses to the pre-experience surveys in our current research show that there are three primary sources of scepticism and reluctance to engage: some employees worry at the outset that they might feel incompetent if expected to do unusual things or reveal something personal; some are concerned that the experience will take time away from work without being relevant; and some suspect that management wants to manipulate them by means of the arts. Studies show that a significant emotional shift happens over the course of an artistic intervention. The activation effects can occur almost immediately when the employees meet the artist if the artist is experienced as embodying a high level of energy and is perceived as breaking the mould of institutionalized management-employee relations (Berthoin Antal

2013b, 105). The impact on levels of energy is apparent both at the personal and the collective levels and serves as a catalyst for action.

Although we organised the data relating to Activation in four categories, namely *stimulation* (41 entries), *positive experience* (29 entries), *energy* (25 entries), and *emotions* (19 entries), in practice the respondents often connected them when describing their experience. For instance, one of the first studies on TILLT projects in Sweden found that

> most employees. . . seem to describe the meeting with the artist and the exercises they do as extremely *stimulating* and exciting, they were really glad, in high spirits and got more energy which left its marks in their work and in their relations to the others at their workplace.
> (Lindqvist 2005, p. 27, our translation, emphasis added)

Lotte Darsø identified *energy* as one of the surprising concepts that emerged from her study as a unique quality that business can pick up from working with the arts (2004, p. 152). Our research confirms and develops this finding by noting that whereas employees frequently report feeling the energy of the artist in such expressions as "she was the energy," the artists tend to speak about unleashing the energy that they sense in the organization, including when energy takes the form of resistance to trying out a new approach (Berthoin Antal 2015). Projects often entailed going through difficult phases of irritation or frustration. As an artist explained: "Working together in artistic interventions cannot be reduced to harmonious agreement: creative resistance ignites energy and sparks ideas." (Berthoin Antal 2013b, p. 111) A study of 60 cases in Spain found that by the end of an intervention participants almost always reported that the *experience was positive* and they would recommend it to their peers (Berthoin Antal and Debucquet 2013).

Participants also report appreciating that artistic interventions also stimulate them to reflect on their *emotions* at work, such as being stressed or anxious about the possibility of failure, and to address them more openly and directly than they usually feel they can in the organizational context (Berthoin Antal 2011).

The activation impacts have the potential to complement the impacts relating to seeing and thinking differently by leading into action, that is, doing differently. Using the energy generated during an artistic intervention can contribute to organizational learning and change if the effects generated in the process are valued and sustained. Unfortunately, studies reveal that the energy released in the interspace of artistic intervention projects are seldom used for initiating further processes of organizational learning and change. For example, in a German study:

> Only one of ten interview partners of different organizational units reported upon a follow-up. This interview partner was a manager who, on his own initiative, scheduled in the team meeting a discussion of the intervention. For

him it was clear that such a follow-up had to be carried out by the line manager personally... 'Already during the play, I realised that I cannot leave my employees alone with the rather negative feelings that the play generated. Otherwise I lose the opportunity... to transfer [what was shown in the play] to the everyday life of one's own activity area. For me, it is important to follow up on joy but also on disappointment'.

(Teichmann 2001, p. 232, our translation)

Making space beyond the interspace

The positive effects of artistic interventions are likely to be ephemeral if no attention is paid to sustain them. Worse still, if employees do not feel that there is support for the innovative spirit of possibility that they experienced in the interspace afforded by the artistic intervention, the positive energy may turn to disappointment and cynicism (Teichmann 2001; Strauß 2013). Keeping artefacts from the artistic intervention can serve as a prompt to recall the experience in the interspace and to stimulate the re-questioning of current ways of seeing and doing things (Berthoin Antal 2011; Bessière 2013). However, this is not enough if organization members do not find that sharing these reflections is a legitimized and valued activity (Berthoin Antal and Strauß 2014a).

Our data highlight two kinds of follow-ups to sustain the learning that artistic interventions trigger in an organization: listening to people and undertaking visible changes (e.g., in evaluations, incentives, processes). Both of these activities require *making space*. Similar to an artistic interspace for which management's support is needed to legitimise participation in an artistic intervention to allow employees to take some time for trying out something else at work, making space for learning from this experience also needs support, care and resources. Space is needed within the organization for the effects of artistic interventions to settle into everyday ways of working, structures and rituals.

Making space means making time, allowing employees to shift their focus from short-term results to long-term orientation. All-too often employees share the experience reported by a participant in Spain: "I learned a different way of working, other ideas and perspectives on things. However, in the context of a company that is oriented more on the short term and on economic results, in the day to day you do not have much time to apply all this the way you would like to" (Rodríguez Fernández 2008, p. 75, our translation).

Making space sometimes entails making things possible by providing financial support. The cost of not attending to this factor is high, as illustrated by a study in Denmark:

> All corporate representatives who were interviewed were positive or very positive about the artistic intervention, although they distinguished between the process and the result of the artistic intervention: Two out of three product development ideas generated in the workshops were not

carried forward due to financial reasons, which was dissatisfying for both: artists as well as organizational representatives.

(Rusch 2012, p. 42; our translation)

Making space for follow-up can happen in various different intensities and with various different results. The scope of space-making is connected to the organization's interests that can vary considerably. A study in the UK identified two kinds of groups:

> The first group talk about new kinds of induction processes; fresh approaches to staff and board development and team building; more playful, less defensive evaluation models; operating more openly "everyone is much more open and a lot more sharing of creative processes now"; richer, process based project design; creative learning based consultation techniques. The second group are already redesigning the entire way they shape what they do and how they do it.
>
> (Robinson and Dix 2007, p. 34)

Conclusion: creating values-added from artistic interventions in organizations

Our analysis of research-based texts on effects of artistic interventions in organizations shows that many kinds of values-added have been documented at the personal, interpersonal and organizational levels, and to level-spanning processes. This is quite an achievement, considering the difficulties that researchers have in providing evidence of post-experience effects of well-established intervention practices in organizations (Blume, Ford, Baldwin and Huang 2010). However, while experiences with artistic interventions may indeed affect classical business dimensions, such as productivity and innovation, these are not the kinds of categories the stakeholders emphasize when they express the values-added. Most of the effects that the studies reported on refer to the personal level, which is not surprising because artistic interventions create aesthetic experiences that first and foremost address individual perceptions. In the last decade artistic interventions have broken out of the silo of personal development schemes to generate valued effects on interpersonal relationships and to foster collaborative ways of working. There is some evidence of organizational level changes in mind-sets and routines, but none in organizational structures.

We conclude that although artistic interventions in organizations can offer a rich source for organizational learning and change, they do not automatically add value. Participants report on a lack of follow-up activities in the organization after the intervention. Leadership is required to support actively integrating the learning from those experiences in organizational structures and practices. In other words, artistic interventions do not absolve management

of its leadership responsibility. This finding coincides with the conclusion of a meta-analysis of learning transfer studies which found that transfer climate in the organization, and in particular the support from leaders, were the most significant factors in successful transfer of learning to the workplace (Blume et al. 2010, p. 1092).

Having shown with our analysis the generative power of the interspace that is co-created in an artistic intervention, we conclude that translating those experiences into the organization requires a complementary kind of space that encompasses reflection and action. Management interested in results needs to shift from asking for post-hoc evaluations to *find* the value of an intervention towards actively participating in *creating* value from the interspace. Making space entails (a) sharing the insights, feelings and skills developed during an artistic intervention, (b) taking the time to apply what has been learned to everyday organizational practices, and (c) taking forward ideas co-developed with the artist. Making space is what prepares the ground for organizational learning and change. It is in the interspace and the post-experience reflective-action space that the value of artistic interventions for organizational learning and change is created.

A decade ago François Matarasso observed a problem in the field that "muddles evaluation, or even research, with advocacy, so that the process becomes a hunt for proof of value, rather than an honest enquiry into what has taken place and the results it has produced" (Matarasso 2005, p. 8). Overall, the quality of publications on the effects of artistic interventions has improved over the past decade, particularly with the advent of more doctoral theses. Nevertheless, the pressure to provide proof of value has not disappeared, and it accounts for the relative paucity of evidence about problematic effects of artistic interventions in organizations (for exceptions see Berthoin Antal and Strauß 2014b; Berthoin Antal, Taylor and Ladkin 2014; Clark and Mangham 2004; Rae 2011; Strauß 2013).

Enhancing the capacity to harvest and sustain the potential values-added that artistic interventions in organizations can offer to employees, artists, organizations and society poses challenges to other stakeholders too. Policy- and decision-makers need to learn how to use qualitative and process-oriented research findings that reflect indirect effects and contextual factors, rather than limiting themselves to established quantitative indicators that were not designed for these kinds of learning processes.

Such a review as this one is bound to reveal many gaps in knowledge. Particularly evident is the absence of evaluation results differentiating between the values-added according to art forms: do certain art-forms have longer or richer effects than others, or do other factors matter more, such as the chemistry between the artist and the organization, as the experienced intermediaries believe (Berthoin Antal 2012; Berthoin Antal, Gómez de la Iglesia and Vives Almandoz 2011)? It is also time to understand the cultural embeddedness of artistic interventions in organizations: are artistic interventions more likely to add value in certain national or organizational cultural contexts than in others? Possibly the most exciting gap that remains to be addressed in this

vein of research is how to make more use of arts-based methods to study, analyse and report on the experiences and values-added that artistic interventions afford. Taking up this challenge would entail developing new skills in the research community, and helping our readership achieve a new kind of literacy that includes aesthetically richer material than is commonly used in management publications (such as Warren 2012; Vince and Warren 2012). The research agenda is likely to be particularly stimulating if it is undertaken collaboratively with artists, employees, managers, intermediaries and, possibly, even policy-makers.

Notes

1 The research has focused largely on the impacts in organizations. Little attention has been paid so far to the artists' perspectives on the value to them of participating in such interventions (for exceptions see Berthoin Antal 2015; Brattström 2012 and in this volume).
2 There may well be publications in other languages to which we did not have access. For example, we are aware through our networks that there have been artistic interventions in Belgium, Denmark and the Netherlands, but we could only work with the languages our team can read.

References

Adler, N.J. (2006) 'The arts and leadership: Now that we can do anything, what will we do?' *Academy of Management Learning and Education*, 5, pp. 466–499.

Artlab (2009) *15 cases artists & businesses: People in the innovation & experience economy*. Copenhagen: Artlab. Retrieved from http://Artlab.dk/wp-content/uploads/2012/09/Artlab cases_uk.pdf (Accessed January 26, 2015).

Arts&Business (2004) *Art works. Why business needs the arts*. Report. London, Arts & Business. Online report. Retrieved from http://www.aandbcymru.org.uk/uploads/Arts_Works.pdf (Accessed February 24, 2015).

Augustinsson, S. and Ericsson, U. (2011) 'Mellanrummet' [The gap]. In Widoff, A. (ed.) *SKISS – konst – arbetsliv – forskning – nio rapporter* [SKISS – art – working – life – research – nine reports]. Stockholm: Konstfrämjandet, pp. 140–157.

Barry, D., and Meisiek, S. (2004) *NyX Innovation Alliances Evaluation Report*. Copenhagen: Learning Lab Denmark.

Berthoin Antal, A. (2009) *Transforming organisations with the arts. A research framework for evaluating the effects of artistic interventions in organisations – Research Report*. Gothenburg: TILLT. Retrieved from http://www.wzb.eu/sites/default/files/u30/researchreport.pdf. (Accessed January 24, 2015).

Berthoin Antal, A. (2011) 'Manifeste, corporel et imprévisible: L'apprentissage organisationnel de la Résidence d'artistes' [Manifest, corporeal and unpredictable. Organisational learning in the artists' residency programme]. In *La Résidence d'artistes Eurogroup Consulting, Catalogue 5*. Puteaux: Eurogroup Consulting, pp. 10–19.

Berthoin Antal, A. (2012) 'Artistic intervention residencies and their intermediaries: A comparative analysis', *Organisational Aesthetics*, 1(1), pp. 44–67.

Berthoin Antal, A. (2013a) 'Art-based research for engaging not-knowing in organisations', *Journal of Applied Arts & Health*, 4(1), pp. 67–76.

Berthoin Antal, A. (2013b) 'Seeking values: Artistic interventions in organisations as potential cultural sources of values-added'. In Baecker, D. and Priddat, B.P. (eds.), *Oekonomie der Werte /Economics of Values*. Marburg, Germany: Metropolis-Verlag, pp. 97–128.

Berthoin Antal, A. (2014) 'When arts enter organisational spaces: Implications for organisational learning'. In Meusburger, P. (series ed.) and Berthoin Antal, A., Meusburger, P. and Suarsana, L. (volume eds.), *Knowledge and space: Learning organisations: Extending the field*. Vol. 6. Dordrecht, The Netherlands: Springer, pp. 177–201.

Berthoin Antal, A. (2015) 'Sources of newness in organisations: Sand, oil, energy, and artists'. In Berthoin Antal, A., Hutter, M. and Stark, D. (eds.), *Moments of valuation: Exploring sites of dissonance*. Oxford: Oxford University Press, pp. 290–311.

Berthoin Antal, A. (in collaboration with Roberto Gómez de la Iglesia and Miren Vives Almandoz) (2011) *Managing artistic interventions in organisations. A comparative study of programmes in Europe*, 2nd edition, updated and expanded. Gothenburg: TILLT Europe. Retrieved from http://www.wzb.eu/sites/default/files/u30/report_managing_artistic_interventions_2011.pdf (Accessed January 15, 2015).

Berthoin Antal, A., and Debucquet, G. (2013) *Artistic interventions in organisations as intercultural relational spaces for identity-development*. Paper presented at the 29th EGOS Colloquium, Montreal, July 4–6, 2013.

Berthoin Antal, A. and Nussbaum Bitran, I. (2014a) *¿Qué valoran los participantes de las intervenciones artísticas en organisaciones realizadas por Conexiones improbables 2011–2013?* [What the did the participants value in artistic interventions produced by Conexiones improbables 2011–1013?] Online report. Retrieved from http://www.conexionesimprobables.es/docs/Que%20valoran%20los%20participantes_feb2014.pdf (Accessed January 15, 2015).

Berthoin Antal, A. and Nussbaum Bitran, I. (2014b) *Beneficios personales y organisacionales de las intervenciones artísticas realizadas por Conexiones improbables 2011–2013*. [Personal and organizational benefits experienced in the artistic interventions produced by Conexiones improbables 2011–2013] Online report. Retrieved from http://www.conexionesimprobables.es/docs/Beneficios%20personales%20y%20org_marzo2014.pdf (Accessed January 15, 2015).

Berthoin Antal, A. and Strauß, A. (2013a) *Artistic interventions in organisations: Finding evidence of values-added*. Creative Clash Report. Berlin: WZB. Retrieved from http://www.wzb.eu/sites/default/files/u30/effects_of_artistic_interventions_final_report.pdf (Accessed January 15, 2015).

Berthoin Antal, A. and Strauß, A. (2013b) 'Record, replay, shuffle and switch: How to see more and differently with artists in organisations', *International Journal of Professional Management*, 8(5), pp. 17–28.

Berthoin Antal, A. and Strauß, A. (2014a) 'Not only art's task. Narrating bridges between unusual experiences with art and organisational identity', *Scandinavian Journal of Management*, 30(1), pp. 114–123.

Berthoin Antal, A. and Strauß, A. (2014b) *Leadership as the alpha and omega of artistic interventions in organisations?* Paper presented at the 30th EGOS Colloquium, EGOS 2014, Rotterdam.

Berthoin Antal, A., Taylor, S.S. and Ladkin, D. (2014) 'Arts-based interventions and organisational development: It's what you don't see'. In Bell, E., Schroeder, J. and Warren, S. (eds.), *The Routledge companion to visual organisation*. Oxon, UK, and New York, NY: Taylor & Francis, pp. 261–272.

Bessière, J. (2013) *Transformer l'organisation avec l'art. Etude rétrospective pour évaluer l'impact résiduel dans le temps des démarches artistiques sur l'organisation. Le cas d'Eurogroup Consulting*

[Transforming the organisation with art. Retrospective study to evaluate the residual impact of artistic interventions in an organisation. The case of Eurogroup Consulting]. Unpublished Master thesis, Université Paris Dauphine, France.

Biehl-Missal, B. (2011) *Wirtschaftsästhetik. Wie Unternehmen Kunst als Instrument und Inspiration nutzen* [Business aesthetics. How companies use art as an instrument and inspiration]. Wiesbaden, Germany: Gabler.

Blume, B., Ford, K., Baldwin, T. and Huang, J. (2010) 'Transfer of training: A meta-analytic review', *Journal of Management Studies*, 36(4), pp. 1065–1105.

Brattström, V. (2012) *Artistic knowledge and its application in organisational change: Reflections on using my artistic knowledge in the KIA-project*. Paper presented at the Cumulus conference, Helsinki, May 24–26, 2012.

Brellochs, M., and Schrat, H (eds.). (2005) *Raffinierter Überleben. Strategien in Kunst und Wirtschaft* [Sophisticated survival techniques: Strategies in art and economy]. Berlin: Kadmos.

Buswick, T., Creamer, A. and Pinard, M. (2004) *(Re)educating for leadership. How the arts can improve business*. Arts & Business. Retrieved from http://www.aacorn.net/ members_all/ buswick_ted/ReEducating_for_Leadership.pdf (Accessed January 26, 2015).

Carlson, S. (2007) *INTERACT artists in industry placements, evaluation report*. Arts Council England, Interdisciplinary Department. Retrieved from http://www.artsactive.net/descargas/11-3-2008-1710342_INTERACT%20REPORT_SCarlson_jan2007.PDF (Accessed January 26, 2015).

Charmaz, K. (2008) 'Reconstructing grounded theory'. In Alasuutari, P., Bickman, L. and Brannen, J. (eds.), *The Sage handbook of social research methods*. London: Sage, pp. 461–478.

Clark, T. and Mangham, I. (2004) 'Stripping to the undercoat: A review and reflections on a piece of Organisation Theatre', *Organisation Studies*, 25(5), pp. 841–851.

Darsø, Lotte (2004) *Artful creation: Learning-tales of arts-in-business*. Frederiksberg, Denmark: Samfundslitteratur.

Eriksson, M. (2007a) *Genklang 2006–07. Forskningsrapport*. [Echo 2006–2007. Research Report]. Göteborg: Institute for Management of Innovation and Technology (IMIT).

Eriksson, M. (2007b) *Vilken effekt har en intervention baserade på konst och kultur på arbetsplatsen? En studie av Skådebanan Västra Götalands projekt AIRIS år 2006* [What effects do artistic interventions have on the workplace? A study on Skådebanan Västra Götalands AIRIS project in 2006]. Göteborg: Institute for Management of Innovation and Technology (IMIT).

Eriksson, M. (2008) *Vilken effekt har en intervention baserade på konst och kultur på arbetsplatsen? En studie av Skådebanan Västra Götalands projekt AIRIS år 2007* [What effects do artistic interventions have on the workplace? A study on Skådebanan Västra Götalands AIRIS project in 2007]. Göteborg: Institute for Management of Innovation and Technology (IMIT).

Eriksson, M. (2009) *Expanding your comfort zone – The effects of artistic and cultural intervention on the workplace. A study of AIRIS 2005–2008 (Including Genklang Vara 2006–2008)*. Göteborg: Institute for Management of Innovation and Technology.

Grupo Xabide (2008) *Disonancias 2007/08 — Artist research in R&D units: Nine experiences*. Donostia – San Sebastián: Grupo Xabide.

Hansen, K. (2004) *Cross-entry to transaction- a theoretical outline of practical experience in relation to art in a business context*. Paper presented at the conference Organising Authenticity: a new perspective on Artists in Residence, Bramstrup, June 6–9, 2004.

Harris, C. (ed.) (1999) *Art and innovation: The Xerox PARC Artist-in-Residence Program*. Boston, MA: MIT Press.

Heaney, M. (2004) *The creative toolkit – an evaluation of the MAP Consortium's Workshop Programme of Arts-based Training for 'Embedding Creative Lewisham'*. London: The MAP Consortium.

Hellgren, C. (2011) 'Reflektioner om hälsa, arbete och kultur' [Reflections on health, work and culture]. In Widoff, A. (ed.), *SKISS – konst – arbetsliv – forskning*. Stockholm: Konstfrämjandet, pp. 104–123.

Johansson, U. (2012) *Artists as organisational development facilitators – evaluation of six projects*. Paper presented at the Cumulus conference, Helsinki, May 24–26, 2012.

Katz-Buonincontro, J. (2008) 'Using the arts to promote creativity in leaders', *Journal of Research on Leadership Education*, 3(1), pp. 1–27.

Lindqvist, K. (2005) *Att göra det främmande till sitt. Konstärer och arbetsplaster i samarbetsprojekt. Erfarenheter från AIRIS, fas I och II (2002–2004)* [Accommodating the unfamiliar. Artists and workplaces collaborating]. Stockholm: Stockholm University.

Mangham, I. (2001) 'Afterword: Looking for Henry', *Journal of Organisational Change Management*, 14(3), pp. 295–304.

Matarasso, F. (1997) *Use or ornament? The social impact of participation in the arts*. Stroud, Glos: Comedia. Retrieved from http://www20.gencat.cat/docs/ CulturaDepartament/SGEC/ Documents/Use%20or%20Ornament.pdf (Accessed January 26, 2015).

Matarasso, F. (2005) How the light gets in: The value of imperfect systems of cultural evaluation. Unpublished paper. Retrieved from http://parliamentofdreams.files.wordpress. com/2012/03/2005-how-the-light-gets-in.pdf (Accessed April 14, 2014).

McNiff, S. (1998) *Trust the process: An artist's guide to letting go*. Boston & London. Shambhala.

Meisiek, S. and Barry, D. (2005) *Who controls the looking glass? Towards a conversational understanding of organisational theatre*. FEUNL working paper (478). Lisbon: Universidade Nova de Lisboa, Faculdade de Economia, Portugal.

Müller, M.J. (2014) *Vom Nutzen der Zweckfreiheit. Künstlerische und ästhetische Praxis in der Entwicklung von Führungskräften* [On the benefits of freedom from utility: Artistic and aesthetic practices in management development]. Unpublished Master thesis, Zeppelin University, Friedrichshafen, Germany.

Rae, J.E. (2011) *A study of the use of organisational theatre: The case of forum theatre*. Unpublished Doctoral Thesis, Durham University, Durham, UK.

Robinson, S. and Dix, A. (2007) *EVOLVE: The evaluation*. London: The MAP Consortium, Creative Partnerships Thames Gateway (CPTG), Arts Council England East (ACEE).

Rodríguez Fernández, C. (2008) *La creatividad colaborativa en el proyecto Disonancias, cuando artistas y empresas se unen para innovar* [Collaborative creativity in the Disonancias project: When artists and companies unit to innovate]. Unpublished Master thesis. Complutense University Madrid, Spain.

Rusch, B. (2012) *Artists in Business – Untersuchung künstlerischer Interventionen zur Innovationsförderung in Unternehmen* [Artists in business. A study of artistic interventions for promotingn innovation in companies]. Unpublished Master thesis, Zeppelin University, Friedrichshafen, Germany.

Schein, E., (2001) 'The role of art and the artist', *Reflections*, 2(4), pp. 81–83.

Schiuma, G. (2009) *The value of arts-based initiatives*. Research report. London: Arts&Business. Retrieved from http://artsbiz.org/wp-content/uploads/2011/08/Arts-Based-Initiatives-in-the-Workplace.pdf (Accessed May 5, 2014).

Schnugg, C. (2010) *Kunst in Organisationen. Analyse und Kritik des Wissenschaftsdiskurses zu Wirkung künstlerischer Interventionen im organisationalen Kontext*. [Art in organisations. Analysis and critique of the scientific discourse on the effects of artistic interventions in organisational contexts]. Unpublished doctoral thesis, Johannes Keppler Universität Linz, Austria.

Strauß, A. (2007) *Artists in organisations. Artistic intervention and cultural hacking.* Unpublished Master thesis, Universität Witten/Herdecke, Germany.
Strauß, A. (2009) *Context is half the work: An intercultural perspective on Arts and Business Research.* Conference Paper presented at the Standing Conference of Organisational Symbolism (SCOS), Copenhagen July 8–11, 2009.
Strauß, A. (2013) *Researchers, models and dancing witches: Tracing dialogue between art and business.* Unpublished doctoral thesis, University of Essex, UK.
Strauss, A.L. and Corbin, J. (1994) 'Grounded theory methodology: An overview'. In Denzin, N.K. and Lincoln, Y.S. (eds.), *Handbook of qualitative research.* Thousand Oaks, CA: Sage, pp. 273–285.
Styhre, A. and Eriksson, M. (2008) 'Bring in the arts and get the creativity for free: A study of the Artists in Residence Project', *Creativity and Innovation Management*, 17(1), pp. 47–57.
Sutherland, I. (2012) 'Arts-based methods in leadership development: Affording aesthetic workspaces, reflexivity and memories with momentum', *Management Learning*, 44(1), pp. 25–43.
Teichmann, S. (2001) *Unternehmenstheater zur Unterstützung von Veränderungs-prozessen. Wirkungen, Einflussfaktoren, Vorgehen* [Corporate theatre to support change processes: Effects, conditional factors, approaches]. Wiesbaden, Germany: Deutscher Universitäts.
van den Broeck, H., Cools, E. and Maenhout, T. (2008) 'A case study of Arteconomy building a bridge between art and enterprise: Belgian businesses stimulate creativity and innovation through art', *Journal of Management & Organisation*, 14(5), pp. 573–587.
Vince, R. and Warren, S. (2012) 'Qualitative, participatory visual methods'. In Cassell, C. and Symons, G. (eds.), *The practice of qualitative organizational research: Core methods and current challenges.* London: Sage, pp. 275–295.
Warren, S. (2012) 'Having an eye for it: Aesthetics, ethnography and the senses', *Journal of Organizational Ethnography*, 1(1), pp. 107–118.
Weick, K.E. and Sutcliffe, K.M. (2007) *Managing the unexpected: Resilient performance in an age of uncertainty*, 2nd edition. San Francisco, CA: Jossey Bass.
Weller, S. (2009) *Kunst als Entwicklungskonzept im New Management: Das Beispiel dm-drogerie markt* [Art as a development approach in new management. The case of dm-drogerie markt]. Unpublished Master thesis. Berlin: Free University, Germany.

4 Assessing the business impact of Arts-Based Initiatives

Giovanni Schiuma and Daniela Carlucci

The opportunity and the challenge

Increasingly managers in organizations acknowledge that the arts are a powerful tool to enhance their capacity to compete and innovate. A fundamental argument supporting this view is that through the adoption of Arts-Based Initiatives (ABIs) it is possible to manage those organizational aesthetic dimensions that can build new differentiating competitive factors in today's complex business landscape. In particular, the deployment of ABIs can represent a powerful instrument to handle new strategic organizational value drivers, such as passion, emotions, hope, moral, imagination, aspirations and creativity both at the individual and organization level.

Practitioners who have experience with artistic interventions (managers, artists, consultants and producers) acknowledge that the use of the arts in organization can produce a wide range of benefits (in this volume see also Berthoin Antal and Strauß). The implementation of managerial initiatives based on the arts encompasses experiential and emotional aspects that are increasingly central at the workplace and can help employees to develop new ways of seeing and doing things. The exploitation of arts in organization can contribute to renew routines, processes, values, identity, image, brand and culture; to stimulate new ways of thinking; to challenge established mind-sets, and to develop new skills, competences and behaviours (Darsø 2004; Schiuma 2009; Styhre and Eriksson 2008). This, in turn, can enhance organization's competitiveness and innovation capability.

Practitioners advocate the use of artistic interventions as a tool to enhance organizational performance. However, the assessment of the impact of ABIs on business performance still remains an open question that needs to be studied in depth. In the past few years there has been an increasing number of studies attempting to provide some evidences of the potential benefits of artistic initiatives in organizations in order to establish whether the high expectations from these initiatives are justified (for example, Berthoin Antal 2009; Berthoin Antal and Strauß 2013; Styhre and Eriksson 2008). However, most of the empirical evidence tends to be anecdotal on the basis of practitioners' practices with a great emphasis on the positive experience that

employees report during their immersion in such initiatives. Also, the definition of structured approaches to provide guidelines to assess the potential value-added of ABIs in organizations still remains a major research challenge. The longer-term impacts of ABIs, their critical features and their assessment still require investigation (in this volume see Styhre and Fröberg). It is quite rare to encounter ABIs for which practitioners have defined success criteria in advance as a basis for evaluating effects on organizational performances and have defined structured methods to understand how ABIs impact on the organizational value creation mechanisms. In practice, ABIs are generally evaluated on the basis of practitioners' semi-structured feedback forms as well as their personal and intuitive observations of the produced interventions' manifestations.

Therefore, the understanding of how ABIs affect organizational working mechanisms and outcomes and, particularly, the kinds of value that they can generate represents a fundamental issue and a challenge to be tackled. Two critical questions are: How can ABIs be designed and implemented to enhance an organization's value creation capacity? How can the impacts generated by ABIs be comprehensively evaluated?

Building on the framework of the Arts Value Map (Schiuma 2011), this chapter aims to shed light on how to integrate ABIs in the operation and strategy of an organization, and offers some insights to understand how these initiatives can turn into the desired business performance results. In addition, the chapter provides indications on how to apply the Analytic Hierarchy Process (Saaty 1980), as an expert method to support the practical implementation of the Arts Value Map as a framework to analyse and assess the impact of ABIs on organizational working mechanisms and business performance.

ABIs and organizational value creation

In today's complex and volatile economic scenario decision makers in private and public organizations are challenged to seek new approaches in response to changes in society and economic pressures. Increasingly this search entails trying out new ways of framing and dealing with the management of uncertainties, needing to continuously enhance the value embedded in products and services, creating new competencies capable of driving business growth and new business solutions, and spurring resilience and innovativeness.

The role and relevance of the arts in organizations can be approached in accordance with different perspectives. We acknowledge, in particular, the arts as a means to develop the human-side dimensions of an organization and, consequently, as an instrument to affect organizational behaviour recognizing an organization as a techno-human system, that is, a composite and integrated system of technology- and human-intensive features (Schiuma 2014). The arts can drive the 'humanization' of an organization, that is, the development organizational phenomena that are related to the human-specific characteristics,

particularly emotions and experiences. Through the arts an organization can engage and shape its emotional and experiential properties and processes, which ultimately influence how stakeholders perceive, interact and engage with the operations, outputs and outcomes of the organization. As a result the planned managerial use of the arts in the form of ABIs can contribute to organizational development and performance (Schiuma 2009).

The focus of an ABI is not the work of art in itself, but rather the emotions, experiences and energy that the arts can catalyse, trigger and develop. From an operational point of view an ABI is intended to use the arts as a means to develop the organization's employees and/or the tangible and intangible infrastructure that affects the organizational value creation capacity. This is equal to extending the extant view of artistic interventions, mainly distinguishing the leadership and organizational learning literature, advocating the arts as a way to engage the passion, hope, moral, imagination, aspirations and creativity of employees (Boyatzis, McKee and Goleman 2002; Bruch and Ghoshal 2003; Cross, Baker and Parker 2003; Gratton 2007; Steers, Mowday and Shapiro 2004).

Undoubtedly, the value generated from arts-based experiences is extremely difficult to quantify using money as the unit of measurement. Although artworks can also represent investments and their value can be measured through their price in the art market, assessing the outcomes of ABIs is challenging. This is because any arts experience tends to meet different needs that are subjective, idiosyncratic, context-specific and time-related. In addition, their effects on individual and organizational change are basically intangible in nature, elusive and hard to quantify, especially in economic terms.

The analysis of the adoption of ABIs within organizations has led to the definition of two essential assumptions for the assessment of the organizational value of ABIs (Schiuma 2009; 2011). The first assumption is that ABIs do not have a clear and direct link to the bottom line. Except those cases in which ABIs either correspond to specific business activities in the cultural sector aimed to generate cash flow, or equal to real estate investments, it is extremely difficult if not impossible to draw a direct link between ABIs and economic returns. The second assumption is that the benefits of ABIs will be found fundamentally within the positive impacts that they have on individual and organizational behaviours and on developing business value drivers. These mainly refer to intangible and knowledge-based assets, grounding business competencies and affecting the efficiency and effectiveness of business processes. In particular, an ABI can have an impact on two fundamental dimensions of a business: (1) the organization's employees, and (2) the infrastructure, that is, the tangible and intangible structural assets grounding the working mechanisms of an enterprise business model. Therefore, the assessment and the design of an ABI has to take into account both dimensions of a business: the impact on people development and the value-added of organizational infrastructure.

Assessing the business impacts of the arts

In practice, the arts in organizations can be described and applied through 'four Ps' defining the pillars of the design and implementation of ABIs. They are: people, practices, products and principles. Indeed, the arts in companies can take the form of one or a combination of the following dimensions: artists or creative *People* in companies who can act as a catalyst for change and creative thinking; creative *Practices* with the aim of both renewing how extant organizational processes are carried out and of unlocking people's imagination and creativity as well as to develop new ways of thinking; artistic *Products* in the form of artworks or creative artefacts that become part of the workplace or are ingrained into the products and services; and finally by using *Principles* from the art-world with the aim of celebrating and focusing attention on how to humanize organizations and develop their raison d'être.

The assessment of the impact of ABIs in companies is challenging and undoubtedly extremely difficult to quantify using money as unit of measurement. The arts in business work primarily and fundamentally as an experience-based process involving and engaging people both rationally and emotionally through either active or passive participation. Such experiences tend to meet different needs that are subjective, idiosyncratic, context- and time-related. In addition, their effects on individual and organizational development are fundamentally intangible in nature, elusive and hard to quantify. However, their positive impacts can be tracked revealing their influence on individual and organizational behaviour as well as on the development of business value drivers, that is, the company's knowledge-based assets, grounding business competencies and affecting the efficiency and effectiveness of business processes.

The assessment of the arts in organizations has to take into account both the impact on people change and on infrastructure development. For this reason two main assessment approaches can be adopted: an index- or indicator-based approach vs. a narrative-based approach. The first adopts indicators, metrics and algorithms as proxies to provide information, mainly quantitative in nature, about a phenomenon under observation. This is the mainstream approach adopted in companies to measure performance and inform decision-making. The second approach aims to depict cognitive patterns and represent hypothesis as the basis of an evaluation. The scope is not to directly quantify the variable under investigation, but rather to understand what are the dimensions, characteristics and relations of the variables distinguishing the phenomenon under assessment. Although companies can adopt an index-based approach to assess the arts in business, this approach lacks the ability to inform the management about the mechanisms that translate the arts into organizational value creation capacity development. For this reason, we propose the mapping-based method as an effective approach to define an assessment narrative. In particular, to measure the impact of the use of the arts in companies we propose the use of mapping techniques.

Assessing through maps: a narrative approach to measurement

Mapping visualization techniques can help chart the paths through which ABIs convert into business impacts. The use of maps for visualizing, describing and understanding phenomena and 'reality' is not new. Maps represent one of the oldest forms of nonverbal communication. They have a high descriptive power. In particular, they provide a valuable visual representation of a phenomenon or reality that highlights the relationships among its elements/dimensions. Wood (1992) points out that a map does not just reflect a reality, it also helps to shape it; however, maps need to be read carefully as contextualized documents. Maps are made at a particular moment in time by people who are embedded within a social and personal context that influences the map. For example, maps of the earth's surface have changed significantly over the centuries. This is an important aspect to consider in relation to the nature of the contents presented by a map.

Maps have been used in various fields, such as psychology, education, planning and management. Their wide use can be related to their two main functions. The first one is the descriptive function. A map provides a visual representation that can help individuals to elaborate a problem statement, to transform its ambiguous status into an explicit condition, to constrain unnecessary cognitive work, and, eventually to create possible solutions (Larkin 1989; Scaife and Rogers 1996; Vekiri 2002). The second function is related to the use of a map as a 'thinking tool' to support processes of generating and elaborating ideas, not necessarily connected to an explicit focused question or context frame.

The usefulness of maps becomes particularly evident in light of the enormous capacity of the human brain dedicated to visual processing. Building maps, and in particular causal maps, makes it possible to develop a dynamic representation of managerial cognitions. A causal cognitive map is a graphical representation where nodes represent concepts, and links (arcs or lines) represent the perceived causal relationships between concepts. The arcs may indicate only the presence or absence of a relationship or may indicate the strength of the relationship between two nodes. Such maps enable ideas to be linked together and their relationships explored in causal way.

The result of a mapping process is a visual representation that: (1) facilitates the description and communication of ideas, also from several viewpoints in the case the mapping process involves multiple participants, (2) supports the identification and the interpretation of information, by providing a picture of the phenomenon under investigation, (3) facilitates the consultation and codification among individuals (for example, managers, researchers, consultants and decision makers), and (4) stimulates mental associations, improving the quality of conversation and decision making process. Another useful aspect of a mapping process is as a facilitation device. Maps, and in particular causal cognitive maps, can facilitate debate and reflections in an interactive investigative approach.

In strategic management research where a wide range of techniques has been applied to map the mental representations of decision-makers and to stimulate a thought or decision-making process, causal maps are used by managers: (1) to focus attention on the root causes of a problem, (2) to find critical control points, (3) to guide risk management and risk mitigation efforts, (4) to formulate and communicate strategy (for example, the Strategy Map proposed by Kaplan and Norton [1996]), and (5) to analyse the critical causal relationships in a complex system.

As rich representation tools, causal maps are also useful for evaluation purposes. The evaluation is a continuous and a dynamic process that can take different forms corresponding to a problem of 'choice' or 'description of consequences' of activities, projects or programs. Evaluating helps users make decisions about planning, monitoring and assessing. Causal maps can support evaluation processes by providing a visualization of how different variables in a system or project under investigation are interrelated.

- During the planning stage maps can help decision makers to better define their objectives, the changes they hope to see, the resources they intend to use, and the ways to achieve the desired results.
- For ongoing monitoring, maps can provide information on the results of a change process, in terms of behavioural changes, actions or relationships, intermediate results.
- As an assessment tool, maps can provide a frame to collect data on immediate, basic changes that lead to longer transformation, and allow for a reasonable assessment of the activity's contribution to targeted desired results.

The Arts Value Map

In order to measure the impact of the use of the arts in organizations we propose the use of causal maps. Causal maps can support the assessment process providing a visualization of how the different variables of the phenomenon under investigation are interrelated. Specifically, a framework that can be used to assess the impact of the arts in companies is the 'Arts Value Map' (Schiuma 2011). This model traces the direct and indirect cause-and-effects relationships linking the implementation of creative processes or ABIs and the impact on organizational value drivers. It offers a visualization of the relationships between the adoption of the arts in companies with the transformation of organizational components and their potential business performance outcomes. The Arts Value Map visualizes the pathways through which the adoption of ABIs affects the development of the knowledge-based, competence-based and process-based dimensions of an organization and improves business performance.

The fundamental assumption at the basis of the model is that the growth of knowledge assets operates as a key driver to activate value creation dynamics (Carlucci, Marr and Schiuma 2004; Carlucci and Schiuma 2007). The

development of organizational knowledge domains improves organizational capabilities enabling a better execution of business processes that in turn allows an improvement of organizational performance and, more generally, the achievement of business and strategic objectives. ABIs can contribute to developing organizational knowledge domains thus sustaining the crucial processes of value creation in organization (see Figure 4.1).

The Arts Value Map gives practitioners a clear line of sight into how artistic initiatives can be linked to performance objectives by enabling them to better understand why arts can be integrated with strategy and can be deployed to get desired business results. The framework can be applied both with a top-down and a bottom-up approach.

Adopting a top-down approach, the framework is implemented starting with a clear identification of the organization's value proposition and performance objectives to be targeted, then charting the routes that will enable their achievement. The Arts Value Map can support the planning process of creative processes in companies making sure that the arts in business are designed in a way that they can make an impact on the knowledge assets of an organization and in turn develop those organizational capabilities linked to the targeted business performance objectives and aligned with organizational strategy. Adopting a bottom-up approach, the framework can be used as an assessment tool. Indeed, it allows verifying what the implemented ABIs have produced in terms of development of knowledge assets and how the development of such knowledge assets has driven the achievement of performance objectives.

The Arts Value Map is a useful platform for the application of methods and techniques (for example, decision support methods and statistical techniques) to further enrich the understanding of how ABIs impact and drive organizational

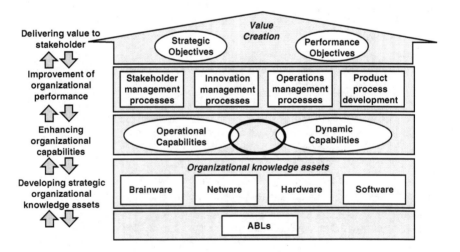

Figure 4.1 The Arts Value Map (Adapted from Schiuma 2011, p. 202)

Business impact of Arts-Based Initiatives 67

value creation. For example, these methods can provide an estimation of the relative weight of components and relationships represented in the map by disclosing information about the value creation dynamics grounding the adoption of ABIs for organizational development and business performance improvements. This additional information can support both planning and assessing of ABIs.

In the following section a case example in a small company illustrates the application of the Arts Value Map as a tool to assess the impact of ABIs in organization. The operative implementation of the Arts Value Map has been integrated by the use of a decision support method, the Analytic Hierarchy Process, in order to define the role and relevance of the links connecting ABIs to organizational knowledge assets, processes and business performance. The company's owner-managers were the main actors of the project. The authors acted as facilitators and observers. We introduced managers to the rationale underlying the Arts Value Map and the practicalities of how to deploy the Analytic Hierarchy Process as a way to build an assessment map.

An application of the Arts Value Map

In this section a case example of application of the Arts Value Map is introduced. The project context was a small company in the construction sector in Italy. Its core business is the design and selling of residential compounds. The construction activities are outsourced. The management is committed to achieving quality and excellence and the company is a leader in its regional market. The focus on customer care and the continuous increase of the value embedded in its products and services has contributed to differentiating the company from competitors. At the time of the application of the Arts Value Map the management was engaged in a substantial re-examination and codification of its strategy with the aim of improving the company's capability to compete and achieve better business results. The enlargement of the market share was particularly important.

Mapping the links between ABIs and business performance

The management decided to implement some ABIs as part of the organizational development. The design and assessment of the artistic initiatives was based on the implementation of the Arts Value Map. We worked closely with top management to identify the elements of the map and their relationships in a series of facilitated workshops aimed to define and design the ABIs (see Table 4.1).

Starting with the destination, managers first formulated the company's value proposition, namely "Improving our stakeholders' life". The top management identified as a priority the superior quality of life in the house as a way to deliver high value to customers; as a consequence they committed the company to operating in such a way to guarantee high-quality products addressing well-being to all its customers.

Table 4.1 From designing Arts Value Map to planning Arts-Based Initiatives: the main phases of the process in the company

Phase	Working methods/tools
Designing Arts Value Map	Three-day workshops including interactive interviews with managers, use of card techniques, presentation of causal mapping, discussion. (Participants: top managers, researchers)
Applying the Analytic Hierarchy Process to the Arts Value Map	One-day workshop including interactive interviews, short presentation of the Analytic Hierarchy Process, discussion. (Participants: top managers, researchers)
Planning ABIs	Three-day workshops including the discussion of the Analytic Hierarchy Process findings, a presentation of some artistic interventions in similar contexts, a description of the main organisational and cultural features of the company, discussion. (Participants: top managers, researchers, actor consultants)

The research team conducted interactive interviews with the management to identify the remaining elements and related linkages of the map. A card technique was used to support idea generation and collection as well as to develop a definition of a common shared perspective regarding the most important strategic and process performance objectives and related capabilities to be addressed through the ABIs.

Managers identified two key strategic objectives: "creation and transfer of value' and 'continuous and customized assistance". After an analysis of the strategic relevance of the identified objectives, managers proposed to focus attention especially on the "creation and transfer of value", perceived as a crucial objective for company's competitiveness. This was followed up by a second round of interviews that the research team conducted in order to identify the process' performances required to assure "creation and transfer of value" to customers and to specify the most important capabilities for the achievement of those performances.

Enhanced "efficiency of the design process" and "effectiveness of pre/post sales assistance" arose as crucial "process performance objectives" to be achieved in order to get satisfied customers. Improving the efficiency of the design process entailed taking into account and harmonizing all project elements (such as architectural features, technical choices, rules, customers' and community well-being, costs) during the design and planning of new product offers. The management acknowledged these factors as fundamental in order to satisfy customers and to remain competitive in the market. In addition, they identified

two main capabilities considered as influential for the targeted processes' performances objectives, namely "capability in managing customers' relationships" and "capability in problem solving". They acknowledged the fundamental importance to better understand their customers and their needs in order to optimize company's interactions with them. Moreover, they appreciated that problem-solving capability is a key factor to drive decision making, to support customers' relationship management and design process.

Afterwards, through a reflection on the organizational knowledge assets that mostly activate the development of the specified organizational capabilities, managers identified human resources as the category of knowledge assets on which to focus. The skills to be developed were: "Communication skills", "Relationships among employees" and "Technical expertise". These competences were acknowledged as important assets to be leveraged due to their relevance for the development of a better customer relationship management as well as because their role in the organization's problem solving capacity. Figure 4.2 depicts a simplified version of the map resulting from the analysis of the key business benefits addressed by the company and the knowledge assets value drivers whose development was assumed critical for the development of the company's value creation capacity. This visual representation offered the management with an informative basis to design the ABIs.

Using analytic hierarchy process method to make the Arts Value Map operative

In order to make operative the Arts Value Map, the Analytic Hierarchy Process method was applied to evaluate the reciprocal importance of the map's elements and provide an assessment of the weight of each element. Following the Analytic Hierarchy Process procedure (see Saaty 1980), the management with the support of the research team evaluated all elements of the map by

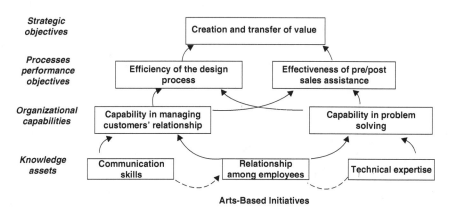

Figure 4.2 A simplified version of Arts Value Map illustrating the expected benefits to be achieved through Arts-Based Initiatives

comparing them to one another, two at a time, considering their impact on an element above them in the hierarchy. To determine the relative importance of the elements, managers responded through a series of pairwise comparisons with Saaty's nine-point scale. This scale requires the decision maker to assign relative ratings by expressing his/her preference between each pair of elements, namely as equally important, moderately more important, strongly more important, very strongly more important, and extremely more important. For example, a question used for pairwise comparison process was: Which is the knowledge asset that has the most influence on the "Capability in managing customers' relationships", and how strongly – "Communication skills" or "Relationships among employees"? and "How strongly?"

The collected judgments were analysed in order to obtain the priority weights for each decision element. First the geometric mean was used to aggregate the managers' judgments. The geometric mean method is one of the most commonly used and suitable methods in the Analytic Hierarchy Process for aggregating individual judgments in a group into a single representative judgment for the entire group (Saaty 2008; Xu 2000). Then the aggregated judgments were inserted into Expert Choice software. This tool calculated the priority weights for every element in each level of the map, checked the consistency and ranked the elements.

Then the relative importance of the elements of the maps were represented. The relative importance of each knowledge asset against the strategic objective was visualized in the map through the size of the nodes. The width of the arrow linking two elements stands for the importance of an element for the achievement of the upper element in which the arrow ends (see Figure 4.3).

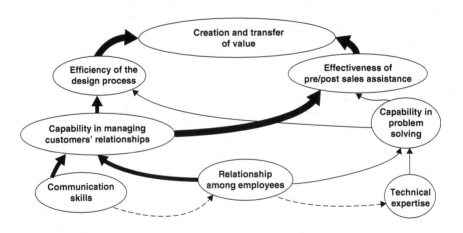

Size of node: importance of each element against the goal at the top width of the arrow: importance of each element for the achievement of the upper element in which the arrow ends.

Figure 4.3 An example of the application of Analytical Hierarchy Process

The application of Analytic Hierarchy Process allowed the identification of those knowledge assets that significantly (high weight assigned) support the achievement of processes' performance objectives and then drive value creation. In this case they were "Communication skills" and "Relationships among employees". This kind of information was particularly important because it enriched managers' view about the kind of knowledge assets to develop through the implementation of ABIs.

Towards the planning and assessment of ABIs

The research team worked with the management in order to design the most suited artistic interventions to develop "Communication skills" and "Relationships among employees". For this reason the arts-based approach initiative of the 'forum theatre' was adopted. Forum theatre is a type of theatre conceived as a forum to let people 'feel' and 'understand' how to change their world. During the process, audience members can stop a performance when they think it necessary, in order to suggest a different action in an attempt to change the outcome of what they were seeing. At other times the actors themselves can stop the action, and ask for help. Through the forum theatre actors, researchers and facilitators can work alongside employees, helping them to focus on the key issues that inhibit an organization's progress.

The company's managers believed that it was the right approach to reveal all the tensions and problems among employees in an enjoyable and captivating way and to open employees' minds about the need for change. They thought this approach would also help to compare their managerial views of the organization with the concrete experiences and perceptions of employees.

The focus was on raising awareness among employees of the importance of sharing information and knowledge within teams, enhancing self-expression as well as managing effective relationships with customers. Role-play scenarios stimulated employees to consider their own behaviours and their impact as well as how they relate to other people, especially to customers. This method also provided valuable insights for the improvement of knowledge management and work practices for the management team.

After the implementation of the ABI, a series of meetings was managed by the research team in order to evaluate the impact of the artistic interventions. Using the Arts Value Map the management was invited to reflect on their initial hypothesis and on the expected organizational and business performance improvements results. Managers reported their own observations about the changes occurred within the organizations after the ABI implementation. Informal feedback from employees engaged in the ABI was also collected. Overall, it emerged that the arts-based experience contributed to improve team-working as well as the quality of the communication among designers, engineers and salespeople. Employees felt more able to understand and deal with customers' needs and wants as well as more engaged in the organization. This contributed to improve the efficiency of the design process and customer care (for example,

better harmonization of all project elements and increased focus on customers' requests and needs), and thereby, to reduce customers' complaints. These results were reported both from managers and employees. In doing this, they did not refer to specific performance indicators, but to their perception about daily design experience and customers' management.

Conclusions

The evaluation of the business impacts of ABIs presents multiple challenges such as: (1) the difficult understanding of the individual and organizational dynamics they set in motion; (2) the variety of stakeholders' perspectives and interests involved in artistic initiatives and, then, of the perception of the kind of value that the initiatives may have added; (3) the difficulty of isolating the effects of artistic initiatives from those ones of other management initiatives. Undoubtedly these challenges are difficult to address. However the adoption of the Arts Value Map as a guiding framework can support the assessment and thus a better understanding of what, why and how ABIs impact on organizational business performance. The 'what' corresponds to the identification of the organizational knowledge assets that can be affected by ABIs. The 'how' explains the impact of organizational knowledge assets development on the organizational value drivers as well as on the enhancement of organizational competences and processes. Finally, the 'why' codifies the reasons for the implementation of the ABI and identifies the achieved benefits.

Field results show that the implementation of the Arts Value Map, particularly when complemented with decision support methods such as the Analytic Hierarchy Process, offers insights into the kind of knowledge assets to be developed through ABIs in order to achieve the desired performance objectives. This, in turn, can drive the definition of the ABIs to be designed and implemented to generate the best impact with a focus on people change and/or organizational infrastructure development.

The Arts Value Map is a narrative assessment approach that can be deployed as a complementary framework into other approaches and tools to understand the benefits of bringing the arts in companies as innovative managerial instruments to face business challenges. It can provide useful insights before, during and after the implementation of ABIs. The use of the Arts Value Map is not simply intended to track the cause-effect links connecting the ABIs and the organizational impacted dimensions, but most importantly to support the design, implementation and understanding of the arts in business.

References

Berthoin Antal, A. (2009) *Transforming organizations with the arts. A research framework for evaluating the effects of artistic interventions in organisations – Research Report*. Gothenburg: TILLT. Retrieved from www.wzb.eu/sites/default/files/u30/researchreport.pdf (Accessed January 24, 2015).

Berthoin Antal, A. and Strauß, A. (2013) *Artistic interventions in organisations: Finding evidence of values-added*. Berlin: Creative Clash Report. Retrieved from www.wzb.eu/sites/default/files/u30/effects_of_artistic_interventions_final_report.pdf (Accessed January 24, 2015).

Boyatzis, R., McKee, A. and Goleman D. (2002) 'Reawakening your passion for work', *Harvard Business Review*, April, pp. 87–94.

Bruch, H. and Ghoshal, S. (2003) 'Unleashing organizational energy', *MIT Sloan Management Review*, Fall 45(1), pp. 45–51.

Carlucci, D., Marr, B. and Schiuma, G. (2004) 'The knowledge value chain – How intellectual capital impacts business performance', *International Journal of Technology Management*, 27(6–7), pp. 575–590.

Carlucci, D. and Schiuma, G. (2007) 'Assessing and managing knowledge assets for company value creation'. In Yoosuf, C. (ed.), *Knowledge management integrated*. Heidelberg: Heidelberg Press, pp. 27–46.

Cross, R., Baker, W. and Parker, A. (2003) 'What creates energy in organizations?', *MIT Sloan Management Review*, Summer 44(4), pp. 51–56.

Darsø, L. (2004) *Artful creation: Learning-tales of arts-in-business*. Frederiksberg: Samfundslitteratur.

Gratton, L. (2007) 'Hot spots: Why some companies buzz with energy and innovation – and others don't', *Harlow: Financial Times*, May, p. 56.

Kaplan, R. and Norton, D. (1996) *The balanced scorecard*. Boston, MA: Harvard Business Press.

Larkin, J.H. (1989) 'Display based problem solving'. In Klahr, D. and Kotovsky, K. (eds.), *Complex information processing: The impact of Herbert A. Simon*. Boston, MA: MIT Press, pp. 319–341.

Saaty, T.L. (1980) *The analytic hierarchy process*. New York, NY: McGraw-Hill.

Saaty, T.L. (2008) 'Decision making with the Analytic Hierarchy Process', *International Journal of Services Sciences*, 1(1), pp. 83–98.

Scaife, M. and Rogers, Y. (1996) 'External cognition: How do graphical representations work?' *International Journal of Human–Computer Studies*, 45, pp. 185–213.

Schiuma, G. (2009) *The value of Arts-Based Initiatives: Mapping Arts-Based Initiatives*. London: Arts&Business.

Schiuma, G. (2011) *The value of arts for business*. Cambridge: Cambridge University Press.

Schiuma, G. (2014) 'Shaping creative organizational environments through the arts'. In Bilton, C. and Cummings, S. (eds.), *Handbook of management and creativity*. Cheltenham, UK: Edward Elgar Press, pp. 346–366.

Steers, R.M., Mowday, R.T. and Shapiro D.L. (2004) 'Introduction to special topic forum: The future of work motivation theory', *Academy of Management Review*, 29, pp. 379–387.

Styhre, A. and Eriksson M. (2008) 'Bring in the arts and get the creativity for free: A study of the Artists in Residence Project', *Creativity and Innovation Management*, 17(1), pp. 47–57.

Vekiri, I. (2002) 'What is the value of graphical displays in learning?', *Educational Psychology Review*, 14(3), pp. 261–312.

Wood, D. (1992) *The power of maps*. New York, NY: Guilford Press.

Xu, Z. (2000) 'On consistency of the weighted geometric mean complex judgement matrix in AHP', *European Journal of Operational Research*, 126, pp. 683–687.

Part III
Learning from success and failure

5 A newspaper changes its identity through an artistic intervention

Marcus Jahnke

Setting the scene

The editorial offices of Tidaholm's local daily newspaper are housed in an old wooden building, just behind the town square. Ever since it was established in 1906, the editorial office has had direct contact with the populace of the small Swedish town. There is no code lock or intercom needed for accessing the building – people can just walk straight in. Once inside, the visitor sees a cluster of small workrooms, all with open doors. Boxes and equipment line the walls. One room holds an old table tennis set. The editorial atmosphere is one of comfortable chaos. People drop by the newspaper's offices on a daily basis to chat, often older people who might be somewhat troubled by changes in the community, or someone who has a news tip or some gossip. Locals might arrive with a meal recipe or a photo from an anniversary celebration that they want mentioned in the newspaper.

Working at this newspaper involves being a fixture in the community and taking an interest in the large and small things in life. It would be no exaggeration to suggest that the editorial staff represents an almost forgotten version of the newspaper world in these times of Web news and advertising-financed newspapers. The atmosphere among the editorial staff is family-like, characterized by openness and a large dose of humour.

But while the atmosphere at the newspaper is good, for the past several years the editors have seen a declining trend in the number of readers. The current circulation is roughly 3,500. The typical reader is an older man who is interested in sports. This type of reader does not provide a foundation for the future, especially when the younger generation increasingly get their news on the Internet. The editors' ambition was to make the newspaper attractive to the younger generation as well, and especially to women. This ambition formed the background to the artistic intervention that was produced by TILLT, an intermediary that connects the world of the arts to the world of organizations (see also in this volume Johansson Sköldberg and Woodilla; Styhre and Fröberg; Zambrell). But it is one thing to do an analysis and another to bring about actual change.

The chapter is structured as follows. After a brief explanation of the research method, I invite the reader to follow an artistic intervention process with the

objective of changing the identity of this newspaper. The story of the intervention process unfolds in four parts: preparations, getting started, being in the process, and breakthrough. I then show how the process can be understood from the perspective of hermeneutic meaning making and discuss why this is a relevant perspective for understanding the artist's contribution.

Method

The study encompassed several kinds of data collection. I observed and recorded conversations during three of the eight workshops that were conducted during the artistic intervention in the newspaper. In addition I interviewed the artist on two occasions about her experiences in the project, and the news director, who acted as the internal project manager of the intervention project, on one occasion. I also observed and recorded the meeting TILLT held at the end of the project with the editorial team and the management of the newspaper to reflect on their experiences of the process. I transcribed the recordings from the interviews with the artist and the news director, and the recording from the final meeting. These recordings were analysed along with the field notes I took during observations. For the analysis, I draw on the theoretical foundation that I developed in my doctoral thesis (Jahnke 2013), in which I studied and presented five similar cases with the same narrative format as I apply here.

The artistic intervention process

Preparations – a winter of raised expectations and setbacks

In the late autumn of 2009 TILLT contacted the management of the media company that owns the Tidaholm newspaper to suggest working with an artist in one of their operations. The opportunity arose because TILLT had secured funding from the European Union for several artistic interventions in the context of the pan-Nordic project called KIA (*Kreativa Innovationer i Arbetslivet*: Creative Innovation in Working Life), coordinated by University of Aalborg in Denmark.

The timing of this proposal to the media company was fortunate because the CEO and her management team had recently identified the need to attract a younger readership and reach out to more women. She believed that the organization needed a thorough transformation with the active participation of the editorial staff, both to utilize their knowledge and to create a foundation for the changes that needed to take place. The CEO had had prior experience with TILLT's artistic interventions and felt that this kind of approach would be an appropriate impetus for change (in this volume see Zambrell). But she was also aware that suggesting an artistic intervention could be a sensitive issue, so she decided to start with the editorial team that she felt would be most open to this kind of approach, the editorial team of newspaper in the town of Tidaholm. In

the final review meeting arranged by TILLT she explained: "We weren't sure that this would be well received everywhere. It can be seen as somewhat 'too crazy', as you know. But we felt that the people in Tidaholm were sufficiently mature and open".

The first steps in getting the project launched were bumpy because potential key people changed. The process leader at TILLT suggested that a dancer, who had previously worked on another TILLT-intervention, would be suitable. She also developed a problem definition for the project together with the news director of the newspaper and the editor-in-chief. But the artist went on sick leave before she had the chance to meet the editorial team. This worried the news director, who was the project manager for the artistic intervention. He had been working on generating buy-in and positive expectations for the project. Now he was afraid that nothing would come of it and that the air would drain out of the project before it had even begun. But TILLT's process leader found another artist who she considered suitable for the project – a visual artist, graphic designer and author. However, just after that, the process leader also went on sick leave, and another TILLT representative took over as process leader.

Getting started – meeting the artist and redefining the brief

The first opportunity that the news director and his colleagues in the editorial team would have to meet the artist would be the conference for all the participants in the KIA project. Up until this point, their information was limited rumours about a project at a fire station in a neighbouring city, as the news director said in the final review meeting when he reflected on their initial attitude. "Firemen dancing in the town square in Skövde – in rubber boots. Is this what we are going to be doing in Tidaholm, dancing in rubber boots in the square?"

A few of their fears were confirmed at the kick-off conference for the KIA program when other projects with an emphasis on art as performance were described. However, when the news director and the editor-in-chief met the artist they would work with, all of their worries vanished. They quickly developed a sense of trust with the artist, as the news director communicated to the rest of the editorial team back in Tidaholm: "Wonderful, we got a graphic designer. We could have wound up with a dancer or something . . . "

But perhaps the news director was a bit too confident. Yes, the artist was a graphic designer, but the intervention process would involve much more than what the news director and the editor-in-chief had imagined at their meeting with the artist at the KIA kick-off meeting.

For the news director the task of composing a project team was not so difficult, if a little sensitive. At that time, the editorial staff consisted of eight people and the assumption was that the people who were going to be part of the project would be those who "had a burning desire" to join, as described by the news director. Two people chose not to participate; they seemed to share

the scepticism about the project of some people at the media company's head office, where they initially described the project team as "the watercolour gang in Tidaholm". This "gang" consisted of the news director (middle aged, also reporter), three female reporters (two younger and one older), the editor-in-chief (middle-aged), and a man (young) responsible for classified and graphic design.

The artist's first step was to review the original problem definition that the editor-in-chief had formulated with TILLT's first process leader, which focused the goal on making the newspaper more attractive to younger, and especially female, readers. But when she arrived at the editorial offices for the first time in May she made her own analysis. Her first impression was one of a stagnant workplace that was not particularly creative. There was no dedicated space for creative work, where staff could hang up things to look at and discuss together – no whiteboards, and particularly, no common meeting room worth mentioning, just a small corner of the second, attic-like floor beside a small filing cabinet, just beside the well-frequented snack area with soft, inviting sofas. What the editorial staff described as "homey" and gave them the opportunity to "be themselves" was something that the artist found somewhat suffocating. It was a little too easy to sink into the sofa and start joking and chatting. But where did future development take place? Did it go on at all? The artist didn't see much sign of that. So, as an extension to the initial problem definition, she added the problem of lacking creativity in the organization. This was something that she felt needed to be addressed in the process.

The artist also wondered how eager the editorial team really was to make changes. On the one hand, there were the rational arguments that sales numbers had declined and that research findings showed that women make buying decisions more often than men, hence it is more important to reach them with both news and advertisements. These were arguments that everyone seemed to trust. But at the same time she had the impression that the editorial team was rather happy with their "little guy's newspaper", as expressed by the artist, and did not seem particularly interested in challenging the prevailing image and understanding of the newspaper, cemented as it was in the smallest detail, for example, in which pictures were selected, and how headlines were composed. Here the artist identified a second problem, a lack of perspective. This became another area for development that the artist added – getting to the editorial team to "gain a perspective on their newspaper", as described by the artist, and getting them to see how it was viewed by others as a foundation for possible change.

In order to succeed with these two added ambitions, as well as with the original problem definition, the artist decided to keep a certain distance from the original problem definition. She felt that there was a real risk that the editorial team would otherwise try to solve the problem without actually creating the practical or emotional conditions that were required for real change. And further, had the right problem even been identified? Was it really renewal and more female readers that were necessary? The artist decided to allow this to remain an open question for a while.

The artist thus created her own informal problem definition, which was much more extensive than the original one. This made it necessary to also create a process that would be able to simultaneously expand the editorial team's work methods and understanding as well as develop the newspaper's image – a process that would be more open, or uncertain, than a restricted focus on the original problem of attracting more women subscribers would have been. The artist was not sure herself where this would lead. She recognized that "it could go anywhere". But in contrast to the editorial team she was not worried about this, as she said, "you have to trust in the process". She was used to that from her own artistic work processes. But she felt uncertain about involving other people into that process, particularly non-artists that were not experienced in this way of working. At the final review meeting she described that the support from TILLT's process leader had been invaluable to coach her through this inherently social artistic process.

Being in the process – tolerating openness and avoiding the sofa

The active work started with a first workshop in the beginning of May. The artist initially felt that the editorial team was not taking the work seriously enough. They sank down into the nice sofa in the snack area and started chatting about whatever was on their minds. There was a lot of talk, there was joking, they switched topics, maybe not because they were uninterested, but it seemed that this was how they were used to being social together. The artist had to be somewhat forceful in order to get the editorial team to take the workshop more seriously (in this volume see also Meisiek and Barry).

The artist first wanted to understand "who they were to get a sense of the situation", as she described it. During the first workshop exercise, she asked everyone to answer a few questions, such as: What was their favourite piece of clothing? Where was the best place to work? And what kind of incentives did people have at work? Then she let everyone describe how they felt about the project by choosing pictures from a pile of humorous postcards that she had brought with her – to show the picture and describe the feeling. The news director remembered:

> There were tons of postcards with various motifs. We were supposed to choose three cards to represent expectations and three to represent fears. And since the pictures were so funny, the exercise became a lot of fun and it was a good atmosphere. It felt like a good start to the project. It was really important not to leave the first day feeling like, what was that all about? Using humour helped us get over our fears.

The artist then insisted that the team also question the original problem definition of reaching women between the ages of 20 and 40 – was this what really mattered? Or was there another, more relevant question or problem to work on? After discussing the matter for a while, the editorial team decided that this was indeed the most important challenge.

After lunch, the reflective exercises continued. The artist took the editorial team to the spring art exhibit of a local art school. She asked everyone to select their own piece of art that had a connection to their role at work, and to explain why. This was a way to get people to illustrate their own work practice. The work continued at the editorial offices with a brainstorming exercise on the question: How can we significantly increase sales of the newspaper to young people between 20 and 40 in 2011? The participants wrote up a number of new ideas on a board. Now one might think that the next step in this exercise would be to prioritize these ideas. But to the team's surprise the artist said that these results would be put on hold for a later workshop. Instead she asked everyone to each identify one person whom they could interview about the newspaper, a person who could potentially be a member of the new target audience, about how this person perceived the newspaper. The results of these interviews would flow into the next workshop.

Between the first and second workshop the artist consulted TILLT's process leader about the tendency of the group to get too cosy on the sofa. She decided that during the exercises, in order to get the editorial team on track, she would forbid *fika*, the Swedish tradition of drinking coffee with work colleagues twice a day. She also decided that the work would take place in the little meeting room instead of in the snack area in order to avoid the comfortable sofa.

At the second workshop these new rules were implemented. Surprisingly to the artist, the participants did not object to these rules, quite the contrary, and the real work could begin. The artist felt that as a basis for continuing work, it was important to analyse the newspaper's image in relation to other newspapers, so that the team could gain an outside-in perspective on their product. She had brought a number of international newspapers and other materials that the editorial team could work with as contrast material for analysing the newspaper's layout, content, details, typeface, images and overall feel. The artist also asked the editorial team to analyse the physical space of the offices in order to get them to see things with fresh eyes. She instructed members of the editorial team to enter the office 'as if they had never been there before'. In the discussion that followed, she stimulated them to create metaphors for the newspaper. If the newspaper was a person, what kind of person would it be? Or what type of animal, food dish, job or clothing would it be? A picture quickly emerged that was not completely flattering. As one reporter said, the picture of the newspaper was of "an old man or a little old lady, who was as old-fashioned as possible. I wasn't prepared for that. I had another image of the newspaper".

Before the third workshop the artist composed two collage pictures that represented two personas, a man and a woman – Bertil and Berit (typical names of elderly people in Sweden) – who fit the image of the newspaper that had appeared during the previous workshop. She now asked the editorial team to imagine how Bertil, 75 years old, who ate boiled macaroni and sausage, and who had a golden retriever that he took on walks in cloudy weather, compared with the new target audience of young women. The team discussed

how the newspaper would have to become much more curious, more bold and more stylish.

The artist stimulated the team to use other metaphors and analogies to better frame this new understanding. For example, should the new newspaper be a computer or a pen? A tractor or a Porsche? The editorial team also practised listing what characterizes popular brands like Apple and IKEA. Then the work continued by defining the newspaper's brand in relation to the new target audience. As a final step in the workshop the artist asked the editorial team to define a number of questions that could be used in a survey among the persons identified for the new reference group for the newspaper.

At this point the artist felt that the editorial team needed to be challenged more individually. The editorial team still easily fell into their old habit of chatting about "this and that", as the artist described it. Therefore, during the fourth workshop, she introduced the editorial team to free association exercises, where each person drew abstract drawings with a magic marker of what first came to mind in relation to questions such as: "What do you currently think about the newspaper? What do you wish it was like? What is a boring story like? What is an interesting story like?"

In another exercise the artist asked everyone to use acrylic paint, brushes and rollers to paint their "best dream ever". The artist later confided to me that this exercise was a turning point when something started to open up within the editorial team. After an initial reaction, where several people complained that they could not paint, something happened that was important for the rest of the work. Each person understood that they could and were even allowed to express themselves, that work could actually be both fun and serious at the same time, that what was expressed personally in the workshops was both welcome and really meant something important to the process. The artist felt that the editorial team now started to understand what the process was all about.

At the end of the workshop, the artist asked each person to go out in the town with a disposable camera to photograph what they could see as a front page picture for a more youthful and female-oriented newspaper. The pictures from the disposable cameras were displayed at the next session and the editorial team analysed them together with the artist and selected the best photo. Between the workshops, the editorial team also conducted interviews with the people from the town whom they had invited to be the editorial reference group. It was clear that the reference group's opinion of the newspaper was in line with the Bert-persona that the editorial team had developed, namely a "middle-aged man who ate steak, listened to oldies but goodies, and walked around in a tweed cap". In order to try to break out of that image quickly, the artist asked the editorial team to paint the feeling of their new, dream newspaper. They displayed pictures in the meeting room so that people could look at them. These were pictures of a colourful, bold and happy newspaper.

The fifth workshop was held in late June. At the end of the previous workshop, the artist had asked each person in the editorial team to give two examples

of what inspires them at work and why, and to bring them to this workshop. There were lively discussions that sparked a lot of energy when the examples were presented. After this introduction, the brainstorming from the very first workshop in May continued – the brainstorming exercise that had been put on hold. Now experience-based understanding had replaced the rather distanced conclusion of the first workshop. The editorial team was now both convinced and concerned that this was indeed what needed to be done to reach the new target audience and to transform the newspaper. The artist felt that at this point, with this achieved, it was time to make the process more problem-solving oriented than explorative and open.

At the last workshop before the summer holiday the editorial team discussed the results of the brainstorming session and made a more concrete plan for continuing the work. Among other things, this involved focusing on the newspaper's first and second pages. The editorial team felt that these two pages set the tone for the rest of the newspaper, and that they would either attract or repel the reader from continuing. As it now stood, the second page was filled with editorials that the editorial team felt did not attract the attention of younger readers or women. The idea was to make the page more personal with a greater emphasis on lifestyle. In order to create this type of material, they decided to continue working on the idea of a cooking column, preferably written by young women who would represent the new readers.

Furthermore, they decided to shake up the design of the newspaper. The analysis of the international newspapers made it clear to them that the newspaper had a slightly old-fashioned image. But since the editorial team had difficulty describing what kind of image they wanted, the artist asked them to create two sketches of an updated image to show different options. In order to make the newspaper more attractive to a younger audience, they also decided to launch a Facebook page for the newspaper.

The news director expressed a certain sense of relief that the plans were now becoming concrete. But he also noticed how important the open process was for continuing the work. There was no longer any doubt about what needed to be done, everyone was on board and thoroughly understood what they wanted to achieve. As the news director said in the final review meeting:

> When we really got into it, it didn't take long at all to come up with some kind of common vision. And this had to do with the fact that we had had a month of start-up exercises with a little more free-association exercises that opened up our senses. In any case, I think this is why we all quickly came up with something that we all felt was good, that we all felt was important.

Breakthrough – time to solve problems and implement solutions

At the workshop after the summer holidays, the news director, together with the artist and the editorial team, presented the work to the CEO, TILLT's

process leader and to the editor-in-chief. The artist also presented her sketches for the new redesigned front page. Although the group applauded the sketches, this proposal turned out to be a bit problematic, because they took the sketches too literally as finished proposals rather than as sketches that could be used to develop the context further. It took a while for the artist to make the group see that more work would have to be done, and that it was not necessarily up to her to do it. If she were to do it, it would be an assignment outside of the artistic intervention project, for which a separate contract was required. After this discussion, when it was decided that the artist would also be given the assignment of developing the concept further, the news director presented his ideas about the new content on page two, as well as the idea of creating a page on Facebook. The CEO and the editor-in-chief liked the suggestions and gave the go-ahead to continue with the work.

In the final workshop the artist got the editorial team to repeat the exercise of defining personas, this time for the updated newspaper. The artist calls this step a big breakthrough. Now an image appeared of a new, self-assured persona who was considerably more youthful, a persona the entire editorial team shared. Everyone could articulate the persona precisely. At that point, for the artist, the process was finished. The editorial team had taken over the practical work of implementing the plan as well as the new understanding that they had created together, aided, but not directed, by the artist.

At the final review meeting that TILLT's process leader arranged, the CEO of the media group emphasized that she had noticed that the Tidaholm editorial team had not just achieved a result in terms of a plan to revitalise the newspaper, they were now working *together* in a completely different way than previously. She was also happy that the action plan indicated that the editorial team would continue to focus on development-work every Wednesday – the day that had been the workshop-day during the artistic intervention.

The CEO, the artist and the employees in the editorial team also commented at the final review meeting that they had observed how the news director had grown as a manager during the work. At the start of the project the news director had admittedly been quite good at generating enthusiasm for the project among the editorial team, but then had become somewhat uncertain when the process had become more open than he had anticipated. This was when he had joined the others in joking around, rather than supporting the artist. But as the process continued and his trust in the artist grew, a "new" news director appeared – a news director who retained his fun-loving attitude, but who also clearly took responsibility for the way the editorial team worked and for their process. According to his colleagues at the meeting, he had become more of a listener than before. At the meeting the artist said that this was probably the clearest sign that her process had worked, and she later said in an interview that this development in the management style of the news director was perhaps the most important result of the process (in this volume see Zambrell).

Everyone in the editorial team also emphatically agreed that the artist's way of guiding the process had been fantastic. But had she been a project *leader*, as the group insisted calling her? TILLT's process leader said that she felt uncomfortable when the editorial team talked about the artist in this way. She wanted to emphasize that the newspaper was responsible for the process, that *they* had done the work, and that they should not expect the artist to take responsibility for continuing the work. The artist also emphasized that it was important that the editorial team owned the process. The news director came up with an alternative description for the artist's role:

> You used subtle tools to keep us going in the right direction when we sometimes got stuck. Then you got us back on track again, and in a good way, with very small and gentle tools, so to speak. It wasn't that you pointed the way forward out to us, rather you functioned more as a type of chairman of the board.

The artist herself highlighted the importance of the support she received from TILLT's process leader (in this volume see Johannson Sköldberg and Woodilla). When the artist had felt insecure, primarily when introducing the project and during the final phase of the open process, the process leader had given concrete actionable advice and reassurances that the artist was on the right path. The process leader indicated that in order to be able to support the artist in this way, she had had regular meetings with the news director to, as she described it, "take the temperature" of the process. These meetings had been important, so she could function as a "bridge" and "balancing factor" between the artist and the newspaper, as she put it, making it easier for the artist to concentrate on the process work. The process leader also believed that it was important that the project took place under TILLT's leadership and within the framework of a research project. These factors had generated a sense of seriousness and trust in the otherwise unknown artistic process on the part of the newspaper's editorial team. These project conditions had also given the artist the opportunity to meet other artists in similar situations in the two KIA-conferences, something that the artist said had been inspiring to her, and had given her more confidence by knowing that she was not alone as an artist in doing this kind of work, difficult as it was.

Meaning-making discussion

How can we understand the process that the newspaper went through together with and directed by the artist? In my analysis I draw on the notion of meaning making for understanding artistic practice (Jahnke 2012), and more specifically, the philosophy of hermeneutics to forward aspects that may otherwise be clouded, especially when a focus on individual creativity is favoured as is often the case when the contribution of art to organizations is discussed.

Hermeneutics focuses on interpretation rather than creativity, on what it means practically to interpret something unfamiliar and develop an understanding of it. It originated in attempts to interpret the Bible (exegesis). In the 1900s, hermeneutics was expanded by philosophers such as Hans Georg Gadamer as a complement or alternative to the dominant, rational and objective approach to knowledge that was based on the natural science model. According to Hans Georg Gadamer (2004), interpretation always starts with a person's own pre-understanding, and requires a willingness and ambition to challenge that understanding, to expand one's "horizon of understanding", as Gadamer describes, by drawing on Husserl (Gadamer 2004, p. 237). By engaging in such interpretative processes one submits to a process that has a lot of similarities with play, it requires active participation and presence (in this volume see Brattström). Developing an understanding also requires actively switching between asking and responding. Gadamer uses Heidegger's metaphor of the "hermeneutic circle" (Gadamer 2004, p. 268) for this process, an oscillating movement between suggestion and solution, between the parts and the whole, and between questions and answers. In the words of the Swedish philosopher Johan Asplund, "The problem and the solution, the question and the answer, are posed at the same time, so to speak, in the same complex act of creation" (Asplund 1970, p. 48, my translation).

I argue that the artist in this particular case engaged the editorial group in a process that can be understood as interpretative, or hermeneutic. She helped activate the group's meaning-making related to the existing and possibly changed identity of the newspaper. She did this by taking the group through a process that consisted of a series of exercises that alternatingly involved interpretation and expression. In some exercises she emphasized the articulation of the current understanding that I characterize as the pre-understanding. To help employees break free from this understanding she used different exercises for seeing the newspaper in a new light, both verbal (typically analogical or metaphorical) and visual (material). She drew from her practical artistic experience to a great extent. But in order to be able to do this she also had to create the necessary conditions, for example, by building trust in herself and in the process, and banning the comfortable sofa and instead creating a dedicated space for the work (see also in this volume Berthoin Antal and Strauß; Bozic-Yams; Brattström).

Sometimes the members of the group wondered exactly why they were doing a particular exercise, or as one of the reporters said at the final interview: "We were sitting there doing drawings for the sake of drawing, without really knowing why (laughs). I remember the feeling when we started this exercise. But then when we finished, it was like, a-ha! But not in the beginning". Inside the process there were no easy answers about the reason for a specific isolated exercise, and the process may seem abstract and illogical (in this volume see also Styhre and Fröberg). The trust in the process lies in trusting the complex weave of activities and emerging understanding that perhaps only the artist could fathom. But as the work progressed, the group's revised vision of the newspaper

gradually came together and by the end, the new image of the newspaper understanding was logical and obvious. In the words of the news director:

> Seeing the results was really exciting, when things became concrete. That is when I felt that something really happened. It went really quickly then. That's when the fruits of the process ripened. And the lesson we draw is that it is equally important to have an open process as well as having concrete goals.

Final thoughts on interpretation versus creativity

This description in many ways challenges the prevailing image of creative processes. There was no sudden insight or immediate thinking outside of the box. Instead it was a long arduous journey of trying to understand the newspaper in a new way, through a series of many exercises involving different formats and sense: some verbal, some visual and some involving touch. Not until this different, experience-based understanding had been achieved could new ideas and solutions also make sense – as a direct result of this developed understanding. Thus, being interested in the creation of meaning and understanding, as I am, as a foundation for understanding the character of creative practices, means questioning myths connected with creativity. Certainly, ideas do come up – but they come from a process of deep interpretation, a process that takes time. The result appears between people, rather than in one person's head, and in this type of process everyone is equally important – everyone can contribute their perspective and experiences. Instead of believing that we can understand creativity based on the often spectacular and emotional exhibitions of artistic processes, I believe that we need to continue studying the actual process in action (in this volume see also Brattström; Raviola and Schnugg). This will make it clear that the results do not just come out of thin air, or are sudden spurts of inspiration. Rather, they make up a clear and logical response to a question that is posed.

If anyone were to ask whether the process that the artist involved the editorial team in is an artistic process, my answer would be a resounding "Yes". It entails both active interpretation and creation, and it includes visual, emotional and poetic elements. But this artist's process is not the only one possible. Each situation can result in different types of processes, not only because each artist has his or her own methods, emphases, feelings and experiences, but also because the meeting between "precisely this artist" and "precisely this situation" is always unique. What all of these processes have in common is that they involve some form of meaning-making. From this perspective, it is also clear why the news director was wise to only include people who were committed and interested, and how his own leadership grew into a more listening approach. A reporter who had been with the newspaper for a long time reflected on the experience: "I have been here for 75 years or whatever ... But this is something completely different. So much fun. It is some kind of foundation for what should be done ... On the job or in life in general".

References

Asplund, J. (1970) *Om undran inför samhället* [On wondering about society]. Lund: Argos.
Gadamer, H-G. (2004) *Truth and method* (2nd ed. rev.), translation revised by Weinsheimer, J.C., & Marshall, D.G. London: Sheed & Ward.
Jahnke, M. (2012) 'Revisiting design as a hermeneutic practice: An investigation of Paul Ricoeur's critical hermeneutics', *Design Issues*, 28(2), pp. 30–40.
Jahnke, M. (2013) *Meaning in the making: Introducing a hermeneutic perspective on the contribution of design practice to innovation*. Gothenburg: Gothenburg University Press.

6 Fostering creativity through artistic interventions

Two stories of failed attempts to commodify creativity

Elena Raviola and Claudia Schnugg

Over the last 15 years, artists and social scientists have noted that creativity has become a buzzword to suggest that if somebody is creative, s/he is also economically successful (McRobbie 2001; Rothauer 2005). Many scholars and management gurus who have studied the role of creativity in society or for organizations, and claimed the rise of the so-called creative industries have underpinned this widespread belief (for example, Florida 2002; Leadbeater and Oakley 1999; Ray and Anderson 2000). The "contemporary fascination with the concept of creativity", as Rehn (2009, p. 249) puts it, has led to a political focus on the "creative industry" or "creative economy" in which creativity is presented "as a force of its own" (Rehn 2009, p. 251). It has also given rise to scholarly and practical questions of how these so-called creative people's work can transform "normal" businesses and industries into more innovative ones (Townley, Beech and McKinlay 2009).

The notion of "organizational creativity" emerged from this discourse. Common elements to the various definitions of this notion are the ability to come up with some kind of "valuable, useful new product, service, idea, procedure, or process" (Woodman, Sawyer and Griffin 1993, p. 293), and the centrality of this ability for organizational success (Rehn and De Cock 2009). In the dominant view, organizational creativity has become the inseparable companion of innovation, aimed at contributing to economic growth and coping with changing environments (De Filippi, Grabher and Jones 2007; Koivunen and Rehn 2009; Thompson, Jones and Warhurst 2007). Moreover, organizational creativity has been defined as a substantial "subset of the broader domain of innovation" (Woodman et al. 1993, p. 293), and as the first stage in the innovation process (Amabile 1996; Oldham and Cummings 1996). In tandem with innovation, organizational creativity has thus come to be perceived as a necessity for business, public administration and society in general.

One way to improve organizational creativity, increasingly practiced over the last 15 years, is to invite artists to intervene in organizations (Barry and Meisiek 2010; Berthoin Antal 2009; Gilmore and Warren 2007; Schnugg 2010). Among the examples documented in the literature is the PAIR project in the late 1990s at Xerox PARC in the USA, where artists were paired

with scientists who were working on similar interests. For example, a media artist worked with a scientist interested in the visualization of a specific media (Harris 1999); the German consulting agency Droege&Comp used artists and their so-called creative techniques as a model for consultants' own creative work (Bockemühl and Scheffold 2007); in the AIRIS project in Sweden, which started in 2002 and still continues to this day, the intermediary organization TILLT brings artists into business organizations to help employees think in new ways and to foster organizational creativity (Styhre and Eriksson 2008; for more insights on TILLT in this volume see also Brattström; Johannson Skölberg and Woodilla; Styhre and Fröberg; Zambrell).

The cases

In this chapter we present two artists-in-residence projects: Big meets small in Sweden (2010–2012), and five artistic interventions at Reklam in Austria (2006–2010). The Big meets small project was designed to offer residence and work space to 100 creatives (in Swedish *kreatörer*, a term that includes among others artists, designers and other cultural creators) in 100 established companies in West Sweden. The project was managed first by a manager working for the regional public administration and then by a second manager working for an intermediary organization specializing in artistic interventions. These project managers made sure that creatives and established companies would find each other and meet, but they did not intervene in the everyday residence. At Reklam in Austria the CEO wanted five artistic intervention projects to increase creativity in the organization. An intermediary managed the projects by finding the artists suitable for this initiative and setting up the practicalities of their work. Like the Swedish case, the intermediary was not directly involved in the interventions.

Although the national context and the formats were different, in both cases the objective was for arts and artists to intervene for a certain period of time in an organization's culturally engrained routines and perspectives (Berthoin Antal 2012), and the artists and "creatives" entered the business organizations to work on their own artistic and creative projects. Another commonality is the basic assumption that underpinned management's objectives in both cases, namely that the creativity inherent to the artist can be transferred to an organization by means of more or less structured encounters and often in exchange for money, space or other resources.

The Swedish case is based on 15 face-to-face unstructured interviews the first author conducted in Swedish with the artist who developed the idea of the project, two project managers, three creatives, two senior business managers and two employees during 2011 and 2012. The Austrian case draws on 10 interviews the second author conducted in German with the CEO, the intermediary (several meetings and two focused interviews with her), two employees, and informal telephone and email conversations with four of the five artists

between summer 2010 and spring 2011. In both cases, the interviews were taped and transcribed, whereas the informal conversations were not taped and transcribed. For confidentiality reasons, we disguised the cases by changing the names of the companies and individuals.

In the next section we describe the cases and show how the actors involved conceived organizational creativity, how organizational creativity is practiced in each case, and how the participating parties (artists, creatives, intermediaries, managers) evaluate the results. We document how these projects were accompanied by attempts to commodify creativity by packaging it as an exchange between the artist's creativity and the company's money or space. However, our analysis shows also that such attempts are bound to fail because creativity escapes commodification.

Conceiving and practicing organizational creativity: big meets small

How big meets small was conceived: a simple package

Big meets small (hereafter Bms) aimed to bring creatives into established businesses in order to accommodate the former and inject creativity into the latter. Creativity was central to the project, as defined in the official report:

> Creativity implies the creation of original and useful ideas. Creativity has become an increasingly important competitive asset for many companies together with increased international competition. Research has shown that creativity mainly emerges through interaction among people, which is influenced by social factors and physical environment at work.
>
> (Bms Official report 2011, p. 4)[1]

The report framed the project in relation to creativity, and defined the latter consistently with the functionalist-reductionist view dominant in the organizational literature: "useful" and "original" ideas are mentioned (see Rehn and De Cock 2009), as well as the influence of the social and physical workplace environment (Amabile 1996; Amabile, Conti, Coon, Lazenby and Herron 1996; Shalley and Gilson 2004). Bms aimed to set up the interactions among people – particularly between "creative" and "uncreative" people – and influence social factors and physical working environments in order to boost the emergence of creativity. The artist who developed the idea for the project said:

> There is a lot of talk about exchange of competences nowadays. I believe in creating the conditions rather than prescribing behaviours for exchange. I believe in creating conditions for the natural meeting of different competences rather than creating artificial situations like seminars where people are supposed to meet and competences exchanged.

By accommodating creatives in established businesses, and thus creating a "natural meeting" between them, the project would solve several problems: creatives' "difficulty to find cheap and suitable working spaces" and "to develop contacts with the industry" and the industry's inability to exploit "the creative competence in the region" (Bms Working document 2011, 2). This project document depicted a view of the world in which creatives have creativity, yet no working space or contact with the industry, while established businesses have resources and contacts but lack creativity (Rehn 2009). This seems to be in line with the dominant view of organizational creativity, which simplifies the idea of creative types versus uncreative businesspeople (Florida 2002). Continuing this line of simplification, "Big meets small should be packaged in a way that is understood as simple, clear, attractive and inclusive" and be as autonomous as possible, by means of a digital matchmaking platform (Bms Working document 2011, p. 2).

With this "genial idea and simple concept" (second project manager), the role of the project manager was to pull down all the barriers between the two parties:

> There is a gap between the two, the big and the small, the young and the old.... So we need to do it as simply as possible, to put it this way. I thought that what we should do is to pull down all the thresholds in order for them to meet. And we [project management] are only being a support function. (First project manager)

When pairing businesses and creatives, the project managers did not look for a perfect overlap of interests, because they believed differences would stimulate the desired exchange. In the literature, difference is highlighted as a stimulus for organizational creativity: contact with people "who see the world differently is a logical prerequisite to seeing it differently ourselves" (Kanter 1988, p. 175).

After a year, the project managers had a list of 25–30 interested creatives; however, they found it more difficult to get the commitment of established businesses. According to the second project manager, reluctance was due to the perception that pairings entailed having a "a strange guest. Shall I let a stranger sleep on my sofa?" Despite their efforts, only three matches were made. The most successful one was the pilot case, which we describe in the next section.

How Bms was practiced: creativity inside four walls?

The Bms project manager had met the founders of Creactivity and the owner of Recyclable in two *Pecha Kucha*[2] events in Gothenburg. He had perceived Recyclable's owner as a visionary leader who would be suitable for Bms. Thus, when Creactivity, with neither an office nor money, communicated to the

project manager their interest in Bms, the first project manager made the connection and "indeed, as soon as they met, they clicked".

At the beginning of Creactivity's residency at Recyclable the company owner, one of the designers and the first project manager tried to write a contract for the collaboration, specifying that Creactivity would work 10 per cent of their time for Recyclable in exchange for free space. However, they were soon overwhelmed by the difficulty of measuring Creactivity's work and of keeping track of the percentage, so they dismissed the idea in favour of a simpler responsibility agreement, focused especially on security issues (keys, Internet connections and computers).

Recyclable offered Creactivity a small conference room and a storage room on the first floor of its premises in the suburbs of Gothenburg. They furnished the conference room with two unused desks and a third one especially bought by the company for the designers. Thus, the newcomers became colleagues for old-timers on the company's premises. They participated sometimes in the company breakfast, which took place every morning at 9:15 in the kitchen on the ground floor, and sharing kitchen facilities and common spaces.

From his tidy and clean office on the first floor of the headquarters, Recyclable's owner pointed out the visible differences between them and Creactivity: disorder and chaos in the creatives' office; order and tidiness on the other side. Recyclable employees who walked down the corridor stopped and looked in. The owner claimed that they were inspired just by walking by: "When one sits here [in his office], one loses the visionary form. It is therefore very good to have these fellows". The initial reactions of the employees to these new fellows were sceptical, as the first project manager remembered: "In the beginning they wondered why they should sit there and it was tough. Then, they changed their mind. . . . Now they think it is very much fun!"

After a while the differences that had been irritating at first inspired people, as one of the employees explained:

> Not everybody was very positive. In order to overcome this, it was important that everybody got information both by e-mail and at breakfast. It was also important to underline that this was a temporary solution. Now they are work colleagues for us. (Recyclable's business assistant)

As the company owner confirmed, after the first complaints about the increased costs for having the creatives in-house, the employees and the managers started thinking that it made sense business-wise: "The next step is that they cannot move out. And they will do some projects with us". Creactivity received attention through some initiatives organized by Recyclable. When Recyclable hosted Creactivity at its stand at several fairs in Gothenburg and Stockholm, the stand attracted a great deal of attention because the designers made products from waste material, using the production machine that Recyclable had purchased for them. Recyclable's owner recalled that "People love it! They do 're-use'. We do re-cycling. It is not strange to have them in the stand".

Over time the in-house creatives felt and behaved like welcome guests. They kept their chaos within the limits of the four walls of their office space during the regular employees' working hours, so much so that one of the employees happily argues it is not even visible:

> There is so much movement when Erik and Oskar [two designers in Creativity] run out with their paper stuff. And also when they need to pack them. They have their chaos in their office, but only there. It is not possible to see it. They are careful not to disturb. They try their new ideas and things in the evening when nobody is here. (Recyclable's business assistant)

The creatives' daily routines – with late breakfasts, late lunches and late nights – ensured that they were barely seen by the regular employees. Recyclable's owner and the economic assistant handled the practicalities of Creactivity's stay at the company, and were the organizational members with whom they had the most intensive relationship, because they "talk more strategy than anything else" with the company (Designer). The other employees saw them sometimes at breakfast or during occasional displays of Creactivity's products, but as one of the designers said, "some time soon they really should have an exhibition, a presentation, or a workshop, where they can try out. We sell workshop, they have a living workshop in-house with us".

When asked about how Creactivity and Recyclable meet and about the existence of routines, it is difficult for them to answer. One of the designers said:

> We do pretty much the same work as we did before moving here. We do not have any routine. We are very bad at that. We should have a structure. We are actually trying to hire a CEO so that [one of us] can only do the talking [taking care of external communication] and [the other two] can only create. I wonder actually if this office is the best for our creativity.

While speaking, the designer pointed at their small office and untidy desk, full of things and with little space to draw. During normal office working hours, the creatives kept themselves and their chaos mostly within their space, during the evening and on weekends they expanded into the corridor. They tried their new products there and experimented on new ideas, having all the space and freedom possible in the absence of the other employees.

Outcomes of big meets small: making organizational creativity visible

The match between Recyclable and Creactivity received general and specialized media attention and it attracted a number of visitors. They were asked to present their case at a *Pecha Kucha* session in Gothenburg, and several local and specialized newspapers and online news publications have written about them. Creactivity appeared on television morning news, and the Chamber of

Commerce published a report entitled "Become roommate with a creator – get new energy" in its newsletter.

In addition to these joint activities, Creativity and Recyclable benefitted from each other's publicity on a number of occasions. For example, the Singapore School of Management included Creativity in a study visit to Gothenburg, together with Volvo, Lego and SKF. Recyclable received attention because it hosted the visitors and as one of the designers pointed out, they could have never held the meeting in such a room if they had not been hosted in the company. On another occasion, one of the Creativity designers dedicated his prize for Entrepreneur of the Year at the Swedish Recycling Award Gala to his mother and one of the owners of Recyclable.

Conceiving and practicing organizational creativity at Reklam

How artistic interventions at Reklam were conceived: the role of the intermediary

The artistic interventions at Reklam primarily aimed at working with artists to understand their artistic process, as the CEO explained:

> It is the (artistic) process and collaboration with interesting people that we are interested in. We think that it is necessary to have interesting partners in such projects, well-known artists that do this on a professional basis. . . . It is about the development of a project based on our initiative and participation. This is what is interesting for us. To provide our employees with this knowledge and experience.

The rationale of Reklam was to follow the artists during one art project and to get in touch with how they work. In exchange, the artist worked on an art project that both parties had decided on, received help, financial support concerning material and/or technical equipment, or used the organization's knowledge about advertising campaigns or organizing events, and employees' technical and media art skills. The CEO's view seems to be in line with the "creative role model" (Shalley and Perry-Smith 2001; Simonton 1984; Zuckerman 1977): artists are different and creative per se (Florida 2002; Leadbeater and Oakley 1999; Ray and Anderson 2000) and are the source of "knowledge and experience", as the CEO refers to the intended effects of the projects, for the company's employees. Therefore, he believed that it was important to work with artists who are experienced, well-trained and, if possible, already have an international audience. The CEO had a specific definition of who is suitable as an artist:

> The mandatory requirement is that we work with an artist, a professional artist. That does not mean that s/he maybe has to work as something else to

earn money, but this person mainly makes art, for about 80 per cent or 90 per cent of the time. If somebody works 80 hours a week, then s/he works 60 hours as an artist. That is a main point, because otherwise it is difficult to define what is art and what is not with all these art definitions.

After an initial encounter with the arts at Reklam when the CEO bought some pictures by a local artist and gallery owner for the office, he talked to her about his idea. He hired her as an intermediary who had the responsibility to find artists and set up artistic projects at Reklam. The intermediary searched for artists within her artistic community who were interested in working with the company. She believed it was important to find artists who were interested in projects that could somehow be relevant for a media company:

> [T]hey should be interested in web, digital media or the advertising branch, or artists who want some digital versions of their work, or artists who think that working with professional experts from this business could bring some development for their own work or are interested in digital media.

The intermediary tried to find a link between the artist and the company on either a tool or a content basis, so that both sides could benefit from each other in a "useful" and "valuable" way. The intermediary's idea of a suitable artist was consistent with the idea that people coming from different backgrounds can "spark new ideas and aid in the generation of additional creative insights" (Perry-Smith and Shalley 2003, p. 90).

How artistic interventions at Reklam were practiced: organizational creativity at distance?

The artists visited the company and were in contact with a few employees, mainly those who worked with or for them on company-owned technical equipment, those who coordinated the cooperation and those who were responsible for gathering the material needed. In the later projects, contact between employees and artists were more intense and regular, or involved contact with a bigger group of employees.

In the first project, the artist painted a series of self-portraits, on which Reklam and its clients could buy space for their logos, with the aim of questioning the artist's role in society and business. In the end, they organized an exhibition of painted self-portraits, and three of seven portraits were exhibited at the company-owned Media Loft in Vienna. The process and the idea were explained in the final exhibition. In this project mainly the CEO and intermediary were involved. There was not much interaction between artist and employees.

In the second project, the artist developed a tool for visual online diaries, diagram journals and weekly plans, with different colours for tasks and emotions

that could be read at one glance in a chronological order to see what had happened. They planned to develop a tool for a website in cooperation with the media experts at Reklam, and present the result at an international art fair. They intended to include the employees' knowledge on media tools, but the different time schedules of the two parties made the direct collaboration rather difficult and the project got stuck in the draft version.

In the third project the artist used experimental photography to create light sculptures, which were afterwards used to produce a film in cooperation with Reklam employees. In the development of the artwork, the artist worked with a few employees, who brought in technical and procedural knowledge, also using technical equipment and material bought by the company. The film was presented at a European festival.

In the fourth project, the artist spent time in the company, observing office life and interviewing employees about their daily work routines. Based on this material, the artist developed a performance with two dancers demonstrating the hectic business world. When the employees were confronted with the performance, they recognized their work-life, but the consequences of this recognition are unclear.

In the fifth project the artist made a collaborative video whose "purpose ... is to question the prevalent unreflected mass consumption". Reklam contributed the technical equipment, the artist used the company's advertising campaign know-how and worked with filming and video expert employees there. The cooperation between the artist and the employees on the project (developing a professional advertising campaign, filming, cutting the film) was intermittent or via communication media because the artist did not live in Austria. Again only a few employees with the requisite technical and advertising knowledge were involved in the whole process.

All five projects were announced and communicated on the company's website. The plan included presentations of each project at different occasions to the (international) artistic and/or media art community. The artists spent varying amounts of time in the organization, sometimes working in collaboration with employees of the advertising company or using company-owned equipment and material. The CEO explained:

> We are involved in various ways, but we are always involved. It depends on the artist, how secure or insecure s/he is and how s/he wants to involve us and the team ... Some artists have a clear vision, some want to develop their ideas with us because it is also interesting for them to engage in such a process. The curator [intermediary] is sometimes more observing, helping, documenting and sometimes more managing and controlling.

The interaction with artists should have led the organization to something new, and provoked artistic thinking in the organization in exchange for the material

and equipment provided to the artist. Commenting on the realization of these projects, the CEO and the employees used similar parameters for evaluation, although they came to different conclusions. One of the issues brought up explicitly in evaluating the artistic interventions was their effect on organizational creativity. Respondents expressed their reflections on the difference between workers' creativity and artists' creativity, and judged artistic interventions at Reklam on the basis of this difference. For the CEO, it was a success, even if nothing measurable had changed visibly:

> In our team, as we are creative workers within the digital media branch, we often work very far from reality. Yet as the art world is far from reality in another way, we get back with our feet on the ground, but also learn new ways of thinking and creative processes. These collaborations help us learn to think and work like the artists do, see things that we have to do professionally in their ways and therefore enrich our own processes. Thus, these projects help us. . . . I cannot say that something changed immediately through these projects, something that can be measured.

The employees of Reklam experienced the projects differently. For example, one reported:

> Many of them [other employees], including me, studied art. But this is not art what we do there, it is our job. What should we learn from other artists? We know artistic processes. Yet, we are designers or creative workers in the company, so that is what we do. . . . I think it is only art if it is free, if I get money and there is some interest from a third party, it is only some creative work.

The employees repeatedly pointed out that seeing artistic processes is nothing new for them. As one of them explained, there is a big difference between her artistic work and her creative work as a designer within a media company, and therefore there is a difference in how she approaches her artistic work and her work for the company: one is goal-oriented and has to work out in the end, and the other is based on her own interests. Thus, she thought that although she and her colleagues were open to working with artists, they did not learn anything new that could be useful in approaching their work at the company.

Outcome of artistic interventions at Reklam: money, time and reputation

Although officially the focus of the projects was on the process, not on the product or on specific organizational or economic goals, all participating parties evaluated them in terms of outcome: artwork, money, time and communication.

The first two projects in particular did not turn out as planned, but the CEO was satisfied with the projects themselves. Referring to the first project he explained:

> Well, I would call this project successful because of the focus on the process of the execution of the project from the initial plan to the presentation of the project. This project had a great potential, yet neither we nor the intermediary-artist had enough time to push the project continually.

The same is true – from the CEO's standpoint – for the second project. The creative employees did not hold the same opinion as their boss. One employee noted in a conversation that they are used to creative processes and artistic processes, and they already know what they do. The artists and the intermediary also had a different opinion. They had higher expectations for the presentation and communication of the artworks. The artist participating in the first project hoped that there would have been more interest in his paintings by more companies, although the intermediary considered the project "basically ... successful for the artist because he sold two or three paintings". The intermediary tried to point out the positive aspects of the first project, although she knew that the artist "was not so happy" with the outcome because there had not been many requests for paintings and the series has not been as extensive and exhibited as planned. She was generally disappointed about the other projects' development.

Money was a big topic in the evaluation of the five projects. For each step during the projects, there had to be a discussion about its economic feasibility for the company. The CEO often mentioned how much money the company put into the projects for material, technical equipment and employees' time:

> With [the fifth artist], we work on a video campaign because she had this idea that she always wanted to realize and our team is able to do this. We give her financial support and manpower. With our production team she can realize her idea and stories. . . . But one has to realize what an hour of manpower costs and the material and technical equipment we provide. . . . There are no budget restrictions, but we work out of a budget on the basis of a project idea, every artist and project as different needs. . . . But a project must stay within the budget.

Even the employees mentioned the aspect of money and expensive working hours invested in these projects. However, the artists did not get wages, and nobody ever mentioned how much time the artists put into the projects, nor the amount of time they spent with the company, nor what these projects were worth.

Another big topic was communication to a wide audience. Communicating the projects seemed to be important for the CEO, the intermediary and the artists. The CEO stressed that he wanted to work with well-known professional

artists who were interconnected in the local and/or international artistic community. He also talked about how exciting it was to work with international artists. He emphasized that it is great to be represented all over Europe and have an international audience for this project, and that he planned to keep this "quality" for possible future projects. The intermediary commented on the CEO's expectations:

> It is not only about the production or realization of an artwork; it is about so much more. It is about publicity, advertisement, showing of such an idea, of such a project. . . . And I think Reklam expects this kind of work from me.

The intermediary and the artist in the first project were not satisfied with the small presentation of the paintings because they expected to organize a bigger exhibition of the whole series. As members of the art world, they emphasized the communication of the finished artworks within the artistic community because it was important to have positive feedback from peers on a project that was developed and conducted within a business context and in cooperation with a business organization.

Discussion

Three main findings emerge from our case studies: (1) the projects were packaged and sold in a way that was explicitly or implicitly consistent with management's idea of organizational creativity; (2) the assessment and communication of the results of these projects were consistent with the prevalent notions of organizational creativity which value the supposedly inherent creativity of artists and its transfer in terms of money, time, space, organizational reputation or business deals; but (3) the realization of these projects involved practices which were "something else, something more powerful", or perhaps ironically something less than the buzzword "organizational creativity" (Rehn 2009, p. 249). In any case, they involved something that escaped the package.

Our study of Bms revealed a clear process aimed at packaging the idea of organizational creativity and making it into an exchangeable good. The project creator and the managers had an explicit theory of organizational creativity, which was in line with the functionalist-reductionist view. They conceptualized it as creating something novel and useful (Ford 1995) and as inherently belonging to a category of people, namely artists, while lacking in established organizations. Exchange of valuable goods – creativity to the same extent as space and money – was at the basis of the project management. The project creator talked about "competences exchanged"; the first project manager talked about "pull[ing] down the thresholds in order for [creatives and established businesses] to meet" and give each other what they "need" – namely, space and creativity; the second project manager talked about their "concrete needs". Bms packaged creativity as an object of exchange "in a way that is understood as simple, clear,

attractive and inclusive" (Bms Working document 2011, p. 2). As Thrift (2006) showed, the autonomous state of this package made it suitable for transfer and communication.

The case of artistic interventions at Reklam showed a less coherent packaging process with different opinions about what creativity was exchanged for. When the CEO presented the projects he focused on the creative process and on the exposure of employees to the artistic work as a source of inspiration for their own creative work; the intermediary emphasized the projects as a way for the company to generate publicity. Despite this fragmented packaging, our analysis revealed a consistent set of parameters in which they were evaluated. Money spent by the company, time used by the employee, communication to the external world and sales of artworks were the parameters used by the actors involved in order to evaluate the success of the projects. These parameters cut across the formulations of all the actors – artists, the intermediary, CEO and employees – and made it difficult to recognize the efforts of measuring the exchange value of organizational creativity as an exclusive practice of a specific actor. Artists considered the projects successful when they sold and made visible its outcome (their artwork), whereas the CEO considered the projects successful when the company generated enough international publicity for them. Measuring the exchange value of creativity implies considering (and maybe performing) a market where creative labour produces value within the framework of more or less explicit contractual conditions (Lee and LiPuma 2002). The evaluation of the artistic interventions at Reklam focused on their exchange value. Our finding that the ways of evaluating the outcome of the projects do not distinguish businesspeople from artists is consistent with recent work on the complex and increasingly intimate relationship between art and business in modern cities (Lloyd 2010).

Thus, our results point to deliberate efforts of packaging creativity into an exchangeable good and by so doing of commodifying it. By commodification we refer to the process by which something becomes the object of an exchange, and in so doing, loses its use value, that is to say the value as object that can be used by its maker, and acquires exchange value, that is to say the value as object that can be traded or exchanged in a market (Marx 1867/1976). This process reminds us of the more widely recognized process of commodification of knowledge. In "The Postmodern Condition" (1984), Lyotard noted that

> Knowledge is and will be produced in order to be sold, it is and will be consumed in order to be valorized in a new production: in both cases, the goal is exchange. Knowledge ceases to be an end in itself, it loses its "use-value".
> (1984, pp. 4–5)

However, whereas knowledge is objectified in routinized and codified products (Suddaby and Greenwood 2001), our cases show that creativity does not work in the same way and does not lend itself to commodification in practice,

even if project managers try to package it as such. It seems that being bound to specific people and specific processes makes creativity escape the exchange in practice. In our cases, creativity is framed as an object of exchange against other commodities and is evaluated on the basis of a price ("free" space for Creactivity, costs and time for Reklam, publicity and visibility in both cases), but it seems that it can hardly become detached from its producers in practice and really lend itself to objectification. This dynamic of attempt and escape to it are made visible also by the role and practices of the different actors involved in our cases.

Intermediaries play a key role in the commodification attempts in these cases. They work as experts in both fields and at the same time guarantors of appropriate packaging (Bartelme 2005). They are translators that package the creative process in order for it to travel to another world (Latour 2005; Czarniawska and Sevón 2005). The two worlds not only work in different ways, they also have somewhat different measurement criteria: money in one world, artistic goals in the other, and visibility in both. Intermediaries have to be able to understand thinking and language in both worlds, to be equally knowledgeable and credible (Berthoin Antal 2012). They also need to create a common object around which artists and companies can gather from their different perspectives – some scholars would call it a boundary object (for example, Star 1988). Based on these abilities, the intermediaries in our cases succeeded in balancing the difference and similarities between creatives and companies as well as finding participants who were willing to cooperate in such a project.

In the interventions at Recyclable and Reklam, the artists found ways of working while decoupling themselves from the packaging that had brought them into the organizations. The stories of the life and work of Creactivity at Recyclable and of the different artists at Reklam showed that, despite the intermediaries' efforts of packaging and selling, creativity escaped the package in practice. Creativity is the ability of an individual who is committed to the creation of a project or event and it leaks out of the commodification frame of the projects. Traces of this escape might be found in the difficulty to evaluate the changes and the legacy left in the companies beyond the immediate monetary, time and publicity measurements and in the freedom the artists took in both cases, even to leave the project unfinished. Employees at Reklam did not immediately see any new and useful learning their work at the company. At Bms, Creactivity designers were understood to be somehow inspiring as they reminded others of earlier times, but it was impossible to capture their work in the format of a usual business contract because it is unclear what it consisted of.

In conclusion, our findings reveal efforts to commodify organizational creativity by trying to package, own and sell creativity as a commodity, and they show how creativity escapes those attempts. There is evidence of intermediaries successfully packaging the projects by framing creativity as a commodity similar to the way knowledge is commodified (see Suddaby and Greenwood 2001; Thrift 2006). However, artistic and other work practices equally successfully

escape those efforts and make creativity leak out of the designed package in unexpected and unplanned ways.

Notes

1 *Big meets small* is a pseudonym for one of the companies so this report is not included in the reference list.
2 Pecha Kucha is a happening format that has spread from Japan to other countries, and is now performed in 550 cities around the world. Its motto is 20 x 20, and it is a popular public weekly gathering at which creative ideas, projects, businesses and initiatives can be presented in the format of 20 slides of 20 seconds each. Having experienced Pecha Kucha in Tokyo, the first project manager imported it to Gothenburg.

References

Amabile, T.M. (1996) *Creativity in context*. Boulder, CO: Westview Press.
Amabile, T.M., Conti, R., Coon, H., Lazenby, J. and Herron, M. (1996) 'Assessing the work environment for creativity', *Academy of Management Journal*, 39(5), pp. 1154–1184.
Barry, D. and Meisiek, S. (2010) 'Seeing more and seeing differently: Sensemaking, mindfulness, and the workarts', *Organization Studies*, 31(11), pp. 1505–1530.
Bartelme, L. (2005) 'The view from the trenches: An interview with Tim Stockil and Harvey Seifter', *Journal of Business Strategy*, 26(5), pp. 8–13.
Berthoin Antal, A. (2009) *Transforming organisations with the arts. A research framework for evaluating the effects of artistic interventions in organisations – Research Report*. Gothenburg: TILLT. Retrieved from http://www.wzb.eu/sites/default/files/u30/researchreport.pdf. (Accessed August 27, 2014).
Berthoin Antal, A. (2012) 'Artistic intervention residencies and their intermediaries: A comparative analysis', *Organizational Aesthetics*, 1(1), pp. 44–67.
Bockemühl, M. and Scheffold, T. (2007) *Das Wie am Was. Beratung und Kunst. Das Kunstkonzept von Droege & Comp* [The how and the what. Consulting and art. The art concept of Droege & Comp] (Bilingual edition in English and German). Frankfurt/Main, Germany: Frankfurter Allgemeine Buch.
Czarniawska, B. and Sevón, G. (2005) *Global ideas: How ideas objects and practices travel in the global economy*. Malmö, Sweden: Liber.
De Filippi, R., Grabher, G. and Jones, C. (2007) 'Introduction to paradoxes of creativity: Managerial and organizational challenges in the cultural economy', *Journal of Organizational Behavior*, 28(5), pp. 511–521.
Florida, R. (2002) *The rise of the creative class: And how it's transforming work, leisure, community and everyday life*. New York, NY: Perseus Book Group.
Ford, C.M. (1995) 'Creativity is a mystery'. In Ford, C.M. and Gioia, D.A. (eds.), *Creative action in organizations: Ivory tower visions and real world voices*. Thousand Oaks, CA: Sage, pp. 12–52.
Gilmore, S. and Warren, S. (2007) 'Unleashing the power of the creative unconscious within organizations: A case of craft, graft and disputed premises', *Tamara Journal of Critical Postmodern Organization Science*, 6(1), pp. 106–122.
Harris, C. (ed.) (1999) *Art and innovation: The Xerox Parc Artist-in-Residence program*. Cambridge, MA: MIT Press.
Kanter, R.M. (1988) 'When a thousand flowers bloom: Structural, collective, and social conditions for innovation in organizations'. In Staw, B.M. and Cummings, L.L. (eds.), *Research in organizational behavior*, Vol. 10. Greenwich, CT: JAI Press, pp. 169–211.

Koivunen, N. and Rehn, A. (2009) *Creativity and the contemporary economy*. Malmö, Sweden: Liber.

Latour, B. (2005) *Reassembling the social: An introduction to actor-network-theory*. Oxford: Oxford University Press.

Leadbeater, C. and Oakley, K. (1999) *The independents*. London: DEMOS.

Lee, B. and LiPuma, E. (2002) 'Cultures of circulation: The imaginations of modernity', *Public Culture*, 14(1), pp. 191–213.

Lloyd, R. (2010) *Neo-bohemia: Art and commerce in the postindustrial city*. New York, NY: Routledge.

Lyotard, J.F. (1984) *The postmodern condition: A report on knowledge*. Translated by G. Bennington and B. Massumi. Minneapolis: University of Minnesota Press.

Marx, K. (1867/1976) *Capital: A critique of political economy*, Vol. 1. Translated by Ben Fowkes. New York, NY: Vintage.

McRobbie, A. (2001) 'Everyone is creative: Artists as pioneers of the new economy?' *Opendemocracy*, August 31. Retrieved from http://opendemocracy.net/node/652. (Accessed September 1, 2009).

Oldham, G.R. and Cummings, A. (1996) 'Employee creativity: Personal and contextual factors at work', *Academy of Management Journal*, 39, pp. 607–634.

Perry-Smith, J.E. and Shalley, C.E. (2003) 'The social side of creativity: A static and dynamic social network perspective', *Academy of Management Review*, 28(1), pp. 89–106.

Ray, P. and Anderson, S.R. (2000) *Cultural creatives*. New York, NY: Three Rivers Press.

Rehn, A. (2009) 'After creativity'. In Koivunen, N. and Rehn, A. (eds.), *Creativity and the contemporary economy*. Malmö, Sweden: Liber AB, pp. 249–258.

Rehn, A. and De Cock, C. (2009) 'Deconstructing creativity'. In Rickards, T., Runco, M. and Moger, S. (eds.), *The Routledge companion to creativity*. London: Routledge, pp. 222–231.

Rothauer, D. (2005) *Kreativität & Kapital. Kunst und Wirtschaft im Umbruch* [Creativity and capital. Art and economy in transformation]. WUV Vienna, Austria: Facultas.

Schnugg, C.A. (2010) *Kunst in Organisationen. Analyse und Kritik des Wissenschaftsdiskurses zu Wirkung künstlerischer Interventionen im organisationalen Kontext*. [Art in organisations. Analysis and critique of the scientific discourse on the effects of artistic interventions in organisational contexts]. Doctoral dissertation, Johannes Kepler University Linz, Austria.

Shalley, C.E. and Gilson, L.L. (2004) 'What leaders need to know: A review of social and contextual factors that can foster or hinder creativity', *Leadership Quarterly*, 15, pp. 33–53.

Shalley, C.E. and Perry-Smith, J.E. (2001) 'Effects of social-psychological factors on creative performance: The role of informational and controlling expected evaluation and modeling experience', *Organizational Behavior and Human Decision Processes*, 84(1), pp. 1–22.

Simonton, D.K. (1984) 'Artistic creativity and interpersonal relationships across and within generations', *Journal of Personality and Social Psychology*, 46, pp. 1273–1286.

Star, S.L. (1988) 'The structure of ill-structured solutions: Boundary objects and heterogeneous distributed problem solving'. In Huhns, M. and Gasser, L. (eds.), *Readings in distributed artificial intelligence*. Menlo Park, CA: Kaufman.

Styhre, A. and Eriksson, M. (2008) 'Bring the arts and get the creativity for free: A study of the artists in residence project', *Creativity and Innovation Management*, 17(1), pp. 47–57.

Suddaby. R. and Greenwood, R. (2001) 'Colonizing knowledge: Commodification as a dynamic of jurisdictional expansion in professional service firms', *Human Relations*, 54(7), pp. 933–953.

Thompson, P., Jones, M. and Warhurst, C. (2007) 'From conception to consumption: Creativity and the missing managerial link', *Journal of Organizational Behavior*, 28(5), pp. 625–640.

Thrift, N. (2006) 'Re-inventing invention: New tendencies in capitalist commodification', *Economy and Society*, 35(2), pp. 279–306.

Townley, B., Beech, N. and McKinlay, A. (2009) 'Managing in the creative industries: Managing the motley crew', *Human Relations*, 62(7), pp. 939–962.

Woodman, R.W., Sawyer, J.E. and Griffin, R.W. (1993) 'Toward a theory of organizational creativity', *Academy of Management Review*, 18(2), pp. 293–321.

Zuckerman, H. (1977) *Scientific elite: Nobel laureates in the U.S.* New York, NY: Free Press.

7 Artistic interventions as *détournement* and constructed situations

Alexander Styhre and Jonas Fröberg

Arts management and the use of art and artists in managerial activities have become a source of increased interest (Adler 2011, 2006; Barry and Meisiek 2010; Chong 2000; García 2004; Gibson 2002; Guillet de Monthoux 2004; Guillet de Monthoux, Gustafsson and Sjöstrand, 2007; Macnaughton 2007). In the contemporary economy, dominated by aesthetics, creativity and style, the arts and artistic competencies play a more central role in creating and constituting economic value (Postrel 2003; Townley, Beech and McKinlay 2009). Artists-in-residence projects are one such arena where regular organizations and workplaces host an artist who engages in some kind of collaborative work together with the organization's members (Certeau 1984; Styhre and Eriksson 2008). While artists-in-residence and other kinds of artistic interventions have been organized for a long time, such collaborations are still under-theorized in organization studies (Berthoin Antal 2009, 2014). The artists are brought into organizations to open employees to new ways of thinking and interacting and they are therefore not part of the regular standard operating procedures in the workplace. But neither do they conduct conventional artwork. Artists-in-residence are in what van Gennep (1960) and subsequently Turner (1969) call a "liminal position", betwixt and between the arts world and the world of industry and public sector organization. This site of liminality is where genuine entrepreneurial activities take place, in a space created to actively escape taken-for-granted beliefs regarding how the work is to be organized and accomplished (in this volume see Berthoin Antal and Strauß; Jahnke; Meisiek and Barry). The entrepreneurial spaces opened up by artists-in-residence still need to be anchored in a theoretically integrated model to make sense of them, and ultimately to be justified by both the community of artists and industry representatives.

This chapter introduces the work methods and terminology of the Situationist International movement that was active from 1957 to 1972, when it was dissolved. The Situationist International was a loosely coupled network of artists, activists and theorists who jointly wanted to counteract what Guy Debord, the movement's foremost theorist and leader, called the "society of the spectacle" (Debord 1977), a mass-consumption society in which humans

are increasingly taking the role of passive spectators rather than active agents. The activists of the Situationist International developed methodologies and terms for how to intervene into everyday life and urban settings to make people aware of their life conditions. Terms such as *détournement*, *dérive* and *constructed situations* denote different methods – the "design thinking and skills" that Adler (2011, p. 214) calls for. Their objectives were to generate new creative ways of thinking that called attention to the passivity imposed on members of society in the contemporary era. These methods and terms are helpful in understanding the liminal spaces developed by artists in artistic interventions and are helpful in theorizing what artists in fact are capable of accomplishing. The two key notions of *détournement* and *constructed situations* are particularly useful for theorizing the collaborative work between artists and industry representatives.

The remainder of this chapter is structured as follows: First, we present the Situationist International and their programme to serve as an active force vis-à-vis the society of the spectacle. Second, we introduce AIRIS,[1] the artistic intervention programme created by a Swedish intermediary organization in 2002 (in this volume see Johansson Sköldberg and Woodilla). Third, we discuss a particular case of an AIRIS project to demonstrate how *détournement* and constructed situations can be used in actual collaborative work in industry. Finally, we address some practical and theoretical implications.

The Situationist International and its programme

The Situationist International was founded in 1957 and dissolved in 1972 (Wark 2011). The group included artists, activists and theorists who sought to counteract the increased passivity of the post–World War II period, the era of mass-consumption and mass-communication. They wanted to return to what the French social and Marxist theorist Henri Lefebvre (1995) speaks of as "everyday life" defined as "whatever remains after one has eliminated all specialized activities" (Debord 1956/1981, p. 69; see also de Certeau 1984). The Situationist International drew on a Marxist theoretical analysis of modern and late-modern capitalism as that which through its inner workings serves to alienate human beings from their true inner nature, and consequently to ossify the innovative and creative faculties of the salaried worker. However, unlike orthodox Marxist theory, the Situationist International emphasized life in the public sphere and the possibility of criticizing, playing with, and ultimately overturning the symbolism and art of the capitalist economic system rather than focusing on the control over production resources as a vehicle for liberation. For the Situationist International, it was not the factory but the street that was the primary site of a fruitful defamiliarization of the capitalist ideology and ethos that always privileged capital accumulation. The daily and mundane elements of life were thus targeted by the Situationist International from the beginning: life can only change from the bottom up when

individuals gain the insight that they may change their lives precisely where they stand. The Situationist International's various activities, campaigns, and events were grounded in its intellectual leader Guy Debord's (1977) theorizing about what he referred to as the society of the spectacle. In Debord's view, classical capitalism was concerned about not wasting time that could be devoted to "production, accumulation, saving" (1981, p. 73), where "time equals money", as Benjamin Franklin once famously put it. Debord speaks of "an unexpected turn of events in modern capitalism", when consumption needs to be increased; the supply needs its demands, and consequently there is a strong emphasis on consumption and entertainment as principal constitutive elements of society. Debord's view of the society of the spectacle is filled with grandiose terms and formulations that easily obscure the underlying message, namely that in the late-modern capitalist regime of production, consumption and spectacle are institutionalized as social pillars that render the members of society passive recipients of messages and images. Barnard points out, "In Debord's scathing critique and analysis, modern consumer society is seen as the accumulation of images and the domination of images in modern life", (2004, p. 106). He continues:

> People have become divorced from authentic experience, are passive spectators of their own lives and no longer communicate or participate in the society of the spectacle . . . for Debord the spectacle has thoroughly penetrated everyday life. The illusory and the real, the fragmented and unified experience of human life, are experienced as something separated, distanced and passive.
>
> (Barnard 2004, p. 107)

In this new life situation, where humans are increasingly alienated from their everyday life world and its mundane daily practices, structured around the cycle of production and consumption, the Situationist International actively seek to increase awareness and critical thinking. The most well-known term in the Situationist International's vocabulary is perhaps *détournement*, defined in English as "the reuse of preexisting artistic elements in a new ensemble" (Knabb 1981, p. 55). He adds that "the French word *détournement* means diversion, deflection, turning aside from the normal course or purpose (often with an illicit connotation)" (Knabb 1981, p. 371). Perhaps the term is defined best in the secondary literature on the Situationist International. Kaufman (2006, p. 35) says that *détournement* is a form of "diversion, misappropriation, seduction"; Barnard (2004, p. 107) argues that *détournement* is "the ironic 'rearrangement of pre-existing elements'"; while Wark (2009, pp. 145–146) speaks of *détournement* as "a diversion, a detour, a seduction, a plagiarism, an appropriation, even perhaps a hijacking" when images and messages are placed in a new setting or context. *Détournement* thus means that one take a message and place it in a new situation wherein the message is overturned and acquires new meanings.

As Wark (2009, pp. 145–146) makes clear, *détournement* is not just a matter of appropriating images but "to appropriate the power of appropriation itself". He explains:

> *Détournement* as a critical practice is the opposite of quotation, of an authority invariably tainted if only because it has become quotable, because it is now a fragment torn away from its conditions of production, from its own movement, and ultimately from the overall frame of reference of its period and from the precise option that it constituted within that framework.
>
> (Wark 2009, p. 146)

Seen this way, *détournement* is a non-ideological practice to the extent that it "restores collective social authority to meaning-making" (Wark 2009, p. 151). Meaning is not only instituted from the top in order to support and legitimize social beliefs, it is also what is collectively accomplished and maintained. Consequently Wark (2009) suggests that *détournement* is the exact opposite of what Foucault (1972) speaks of as statements or enunciations, utterances based on the authority of a discourse (say, political science or psychoanalysis). Instead it serves as a form of anti-statement: For the Situationist International, "the very act of un-*authorised* appropriation is the truth content of *détournement*" (Wark 2009, p. 151).

The second key concept in the Situationist International vocabulary of interest for understanding artistic interventions and artist-in-residence programs is *situations*. Perhaps less widely recognized than the term *détournement*, situations are the elementary constitutive activities of everyday life in the contemporary society. An editorial in the Situationist International's journal in 1964 presents the concept of situation as follows: "Since man is a product of situations he goes through, it is essential to create human situations. Since the individual is defined by his situation, he wants the power to create situations worthy of his desires" (cited in Barnard 2004, p. 112). He continues: "As such, situations provide a model for new forms of working and living. They engage people in participatory acts of creativity that are not governed by external demands. They become arenas of self-directed activity that fulfill individual and collective needs" (Barnard 2004, p.112).

The Situationist International aimed at providing "constructed situations" in which art and culture are used to invent new passions outside of the production-consumption matrix of the society of the spectacle. This places art and culture as a central social resource to be used actively in de-familiarizing everyday life. "Instead of merely translating and representing life, art and culture are used to extend life's boundaries in order to create new situations of creative resistance to the spectacle" Barnard (2004 p. 112) says. He warns, however, that constructed situations are a complicated practice as they may also confuse groups and communities. At the same time, art and culture have the capacity to entice new perspectives on everyday life.

The Situationist International thus introduced two powerful methodologies and concepts: The practices of *détournement*, the overturning of inherited and assumed meanings of images and phrases, and *constructed situations*, the creation of sites and encounters where people are invited to actively question their life situation or perceive it differently. The theoretical work articulated primarily by Guy Debord was written in a traditional critical theory discourse anchored in Marxist thinking, but when complemented by active uses of art and aesthetic, the members of Situationist International were capable of providing a more comprehensive tool-box for social critique. Naomi Klein's (2000) best-selling critique of the consumer society and her discussions of the Ad-buster movement from the early years of the new millennium need to be understood against the backdrop of the Situationist International's work that preceded these phenomena by several decades. The success of street art such as the work of British artist Banksy, which actively undermines the images of British police officers and others by placing them in unexpected and humorous situations, is also evidence of the relevance of artistic interventions and art's capacity to actively criticize and de-familiarize the everyday life.

Artistic interventions in organizations, unlike the work of Ad-busters or Banksy, are not an underground activity but are rather designed to create meaningful and mutually rewarding collaborations across the divide between the art world and industry. Artistic interventions are therefore not inherently subversive but, on the contrary, serve as shared grounds where industry representatives and artists can open themselves up for new ways of thinking and collaborating. To bring the terminology of the Situationist International into the study of artistic interventions thus means that terms that were originally formulated in an antagonist setting are now being used in a more value-neutral sense of the term, whereby *détournement* and constructed situations are tools in the hand of the artists collaborating with other professional and occupational groups. Such an appropriation of critical terms may be considered problematic in some quarters. If, however, we assume that the value of a term lies in its use (Wittgenstein 1953) or its performativity (Pickering 1993), the transfer or transposition (Friese and Clarke 2012) of these two Situationist International terms to a new setting testifies to their relevance of meaning in today's late-modern society.

In the following section, the case of an AIRIS artistic intervention project in a multinational manufacturing firm in the automotive industry will demonstrate how the terms *détournement* and constructed situations can be used to understand when artists intervene into the everyday work life of the operators. The artist in the case was the co-author of this chapter, Jonas Fröberg. Overall, the artist largely perceived the project as a failure based on what he regarded as lack of support from top management – a key prerequisite for any AIRIS project – and the sceptical attitude shown by the operators both during the project and after its termination; many operators were willing to participate in the writing project initiated by the artist. Nevertheless, while the process was complicated, some very fruitful collaborations emerged during the project.

Artistic interventions in the automotive industry

Background

Since 2002, the intermediary organization Skådebanan, renamed TILLT in 2009, has organized different kinds of artistic interventions, including AIRIS projects, in collaboration with industry and public sector organizations and practicing artists (Berthoin Antal 2012; in this volume see Johansson Sköldberg and Woodilla; Zambrell). AIRIS projects run for eight months and encompass several phases. The basic idea is that an artist uses his or her competence and experiences to organize a joint project of relevance for the organization. At the time of this project, the organization paid a fee of approximately 30,000 Euros to cover the salary for the artist as well as some coordination costs. TILLT negotiates and sells projects, and conducts the "match-making" between artists and organizations. The ability to understand the needs, demands and expectations and what artists that may have the capacity to respond to such demands is a key competence of TILLT as an intermediary between the world of the arts and the world of organizations. Recently, TILLT and similar organizations working in other countries such as Denmark, the Netherlands and Spain have gained attention from the European Commission as being part of the strengthening of Europe as an economic zone with innovative capacities and as being at the forefront of creative thinking. TILLT is also part of various international research projects in the field of arts management (see for example Berthoin Antal 2009; Grzelec and Prata 2013).

For over a decade, TILLT has produced more than 80 AIRIS projects, but only once has a project been terminated because of difficulties in the collaboration. This project is presented in the case below.

The case

The setting

Sweden, for many years governed by the Social Democrat party, has a long tradition where employers, unions, the worker community and academic researchers all collaborate, and the ambition to "give voice" to people working in the manufacturing industry must therefore be understood against this idiosyncratic Swedish history. At the beginning of the new millennium, manufacturing industry was no longer treated with the same degree of veneration and many neoliberal media pundits and economists spoke of the need to revitalize Swedish industry amid the inevitable off-shoring and outsourcing of manufacturing industry work to the Baltic States, China and South East Asia. In 2006, the Social Democrats lost the election and a right-wing government led by the conservative party took office. Despite its undisputed importance for the Swedish economy and its welfare systems, manufacturing, concentrated in the Western part of the Sweden, was gradually perceived

as an antiquated form of production, associated with the first decades of the post–World War II period.

In this case, an actor and playwright, Jonas Fröberg, was invited to participate in an AIRIS artistic intervention project in an automotive company in 2006. Jonas decided that he wanted to engage the operators in a writing project that he hoped would lead to the publication of a book in which the operators would tell their story about the nature of everyday work-life on the factory floor.

Jonas began by working on the shop-floor for four weeks to understand what the everyday work in the factory was like. The operators were friendly and helped him master at least a few elementary work processes. After this learning period, the artistic activities began. Jonas wanted to offer an alternative view of the operators' work life and invited a group of operators to participate in a writing project. He was experienced at using writing as a method for self-expression, having completed previous projects with adolescents and other groups. He hoped to engage the operators in the project.

Such aspirations quickly came to an end when an operator stood up during one of the first meetings and publically and with great contempt declared that he would not be part of "writing a damn book!" Many of the operators were either hostile towards Jonas's project or somewhat sceptical. Nevertheless he managed to recruit a small group of operators who were intrigued by his ideas. They wrote texts and commented on them, went to the theatre, and engaged in conversation about the nature of work.

During the process, Jonas started to receive small notes and poems jotted down by some of the operators who had previously declined to participate but now wanted to be part of the process "undercover". Many of these texts testified to the ordeal of everyday work life in the factory, the boredom of monotonous and repetitive work, the loss of faith in top management and their lack of concern for the operators' work situation, and the endemic and tedious sexism some of the women encountered on an everyday basis. The texts were filled with melancholia and a sense of belonging to a social community that was not represented by anyone in the political system or in media and public discussions. Just as Jonas initially proposed, some of the operators had a great need for the opportunity to express themselves. Over time and as the project proceeded, Jonas collected several such texts.

After several months the project was terminated. Jonas perceived it basically as a failure because the company representative hosting the artistic intervention project did not really collaborate with him as planned and because many of the operators refused to participate. After the project ended, one of the operators agreed to read some of the texts as part of a theatrical performance that Jonas organized with his theatre company. In 2008 and 2009 Jonas and his newfound partner, a former operator, toured Sweden and received positive reviews in the press. In 2011, Jonas published a book with the title "We're not writing no damn book!" (*Vi skall inte skriva någon jävla bok!* in Swedish), inspired by the hostile declaration of one of the operators a few years earlier. As authors, we

might say that Jonas lost the war but won the peace. The manufacturing company, however, has distanced itself from his work, and refused to contribute to funding the publication of the book.

Examining the AIRIS artistic intervention project

Jonas's writing project in collaboration with the operators in the manufacturing company contains some of the elements introduced by the Situationist International, beginning with the concept of *détournement*. Writing has always been the privilege of authorities and influential groups (Dallery 1989; Goody 1986; Hoffman 1989; Innes [1950]1972; Ong 1986). People whose principal activity is to write can demand silent and peaceful workplaces, in sharp contrast with the noisy shop floors in the manufacturing industry. "Silence is the prerogative of the elite. They live in silent surroundings and work in quiet atmospheres" (Kaulingfreks 2010, p. 45; see also Bijsterveld 2008, p. 38). The written text, *pace* Plato, is more credible than the spoken word and the reason that tyrants and dictators burn books is that the written word is inscribed *sub species aeternis* – once in print, always in print. Few practices are so closely associated with the middle classes and the intellectuals as writing; it is a privilege, a way of life, a form of subjectification (Blanchot 1982; Deleuze 1997) that can never be fully displaced by the spoken word. When Jonas introduced the idea of writing about the everyday work life experiences on the shop floor, he engaged in a form of *détournement* of the bourgeoisie and scholarly privilege of "writing the self" that also created a significant amount of stress for some of the operators. Having spent significant periods of their working life in manufacturing work, perhaps not all of them were ready to fully apprehend the idea of becoming writers. The *détournement* of writing the self as a general possibility rather than a specific privilege eventually proved to be only partially successful because many of the operators' refused to participate and only a handful endorsed the project in public.

The second Situationist International element in the AIRIS project is that it provided a constructed situation in which the operators, top management and the artist himself encountered their own ambitions, assumptions, worries and fears. In short the situation called into question what Alfred Schutz (1962, p. 231) referred to as "the social world as taken for granted". Individual operators in the manufacturing company may have been writing prior to Jonas's arrival, and some of them started to do so after he presented the idea of writing a book, while other operators refused to participate altogether. For all of them, the presence of the artist served the role of defining a shared space and constructing a situation where a proposal (in this example, to be part of a writing project) may be accepted, negotiated or rejected. Such constructed situations, as Barnard (2004) emphasizes, may be quite stressful or even perceived as intimidating when their taken-for-granted comfort zone of the social world is gradually called into question or de-stabilized. The operator who stood up to declare his refusal to participate may have struggled with writing for many years

in school. He might remember all too well how teachers and classmates were critical or even condescending towards his attempts to express himself. Given such experiences, it is little wonder that there was a strong wish to refuse to undergo the same procedure again. But the operators may also have assumed that Jonas, as the artist-in-residence, would take on the role of a teacher or tutor, some kind of authority "correcting" and "editing texts", rather than considering him a potential interlocutor and a partner in giving voice to what had previously been inarticulate. Constructed situations are thus not necessarily liberating and inherently rewarding in the short-run. Instead, they may be perceived as problematic and stressful because they undermine taken-for-granted beliefs and worldviews.

As an analogy, Nike's *Just Do It* slogan uses familiar marketing vocabulary that overflows with enthusiasm over what people like you and I are in fact capable of accomplishing. But its overturned version, *Just Don't*, is more complicated because it is regressive and refuses to instruct the reader by not pointing in any direction: "Just don't what?" you may ask yourself. The *détournement* (the shift from a positive to a negative message) and the constructed situation (the encountering of the Ad-buster billboard or image) are combined and presuppose one another. A constructed situation by definition includes *détournement*, and *détournement* without an accompanying constructed situation becomes impotent; they are part of the same process and presuppose one another.

Discussion

In AIRIS and other artistic intervention projects, artists enter into new settings where they are expected to interact with new categories of collaborators. What these artists produce in such settings is not art per se, at least not according to experts like Luhmann (2000), for whom art is the further differentiation of an autopoetic art system and where art is always of necessity a new combination of art codes. Artists produce artworks in their own domains or in collaboration with other artists. By contrast, in artistic intervention programs, it is the artist himself or herself and his or her competence that are being explored. Leonard-Barton (1995) uses the term creative abrasion in an innovation management setting to denote the minimum level of tension between different domains of expertise needed to produce innovative and creative thinking. All successful artistic intervention projects are based on the capacity to mutually create such creative abrasion. An artistic intervention is not simply a matter of "putting art into work"; it is about exploring and exploiting the artistic know-how of the participating artists in order to open up for new collaborative relations.

The actual collaborative process between artists and other professional and occupational communities has received little attention in the arts and management literature. In order to develop an analytical theoretical model of artists-in-residence programs, this chapter has introduced the vocabulary and methodology

of the Situationist International. The members of the movement nourished an ambition to wake up the silent majority from its slumber through various campaigns and events designed to counteract the passivity of the mass-consumption society in which individuals are increasingly assigned the role of spectators and consumers rather than active and enterprising agents. Although one may have a great deal of sympathy for such counterculture movements and ambitions, they are often embedded in art worlds (in Becker's [1982] phrasing) and student cultures that exist and flourish outside of industry and public sector organizations. Artistic intervention programs, in contrast, are immediate, actual long-term collaborations between artists and members of organizations located in workplaces like shop-floors, clinics, regulatory institutions and offices. The projects are to some extent designed and promoted to accomplish certain instrumental goals but at the same time they are intended to accommodate and promote unexpected outcomes and learning. Despite the differences between the Situationist International's activities and artistic interventions in organizations, the concept and methodologies of *détournement* and constructed situations are helpful for theorizing (see Swedberg 2012) what actually happens in such projects. Generally, artists do not get their collaborators in organizations to produce art; instead they make use of their skills and know-how to get employees to call into question and criticize their work life situation or entice them to come up with creative solutions to perceived problems.

In the case of Jonas's use of writing exercises, he invited the operators to express their work life experiences because he believed that such an activity would potentially be perceived as meaningful for the operators. He thought it could help unearth some of the concerns and challenges in the workplace rarely addressed in conversations and during formal meetings. In a way, Jonas orchestrated a *détournement* of the Situationist International's own *détournement*, the work to bring the discontentments of the factories to the streets, as he brought this dissent even further. Jonas's project was to help the workers first translate their work life experiences into literary discussions on the basis of joint reading, and thereafter into a book, which eventually became the basis of the reading performance by Jonas and a former operator touring Sweden. In this case, the movement from the factory to the streets and further back into the artistic field thus pushed the idea of *détournement* beyond its original conception.

The combination of the *détournement* of the genre of writing of the self and the constructed situation provided the operators with the opportunity to participate in a collective activity that could lead to many outcomes. The combination of *détournement*, the active overturning or playing with a specific symbolic order, and constructed situations, the *mise-en-scène* and staging of particular activities in an artistic project, are two elementary processes in any artistic intervention project. Berthoin Antal and Strauß (2013 and in this volume) introduce the concept of interspace to denote the domain that opens up when artists engage in activities that cut across the organizational, occupational and professional boundaries constitutive of everyday working life. In most artistic interventions, artists do not produce art but neither do they just add an element

to the regular production in organizations; they are located in a liminal space – an interspace – a space betwixt and between production and consumption, that they construct for their collaborators and themselves. Similar to the Situationist International, the artist's principal concern is how to invite and entice the public (in the case of the Situationist International) or the collaborators (in the case of artists) to actively de-familiarize their situation to be able to critically reflect on everyday life practices and its underlying norms, beliefs and ideologies.

This chapter contributes to the ongoing discussion on arts management and artistic interventions by stressing the need for developing a comprehensive theoretical framework that enables an understanding of how art and artists can play an active role in both maintaining and changing organizations. Second, the paper introduces and advocates the Situationist International's two concepts or methodologies of *détournement* and constructed situations, two procedures for creating liminality in the workspace, domains where other norms and rules apply than those structuring the regular workday. Third, the paper provides an empirical illustration of how an actual artistic intervention (AIRIS) project in a Swedish manufacturing company led to conflicts and controversies and also to innovative and unexpected outcomes. Further research studying actual artistic interventions is most welcome and needed.

Conclusion

This chapter has introduced the Situationist International's concepts of *détournement* and constructed situations and has argued that these terms are useful in understanding how artistic interventions are capable of creating a shared liminal space where the artists' know-how and the practitioners' expertise and experience intersect and mutually fertilize one another. Too much writing on arts and management sings the praise of the arts as some kind of untapped resource in organizations (for example Adler 2011), and there is an unfortunate shortage of detailed, ethnographic accounts of actual artistic interventions (for an overview, see Berthoin Antal and Strauß, in this volume). Such studies *in situ* demand some theoretical framing. To this end, the activist work of the Situationist International, who aimed at encouraging self-reflexivity and critical thinking in a population, is helpful inasmuch as it is based on the idea of active participation. No artistic intervention can accomplish very much without the collaborative efforts of the organization members, just as the Situationist International's various events would fall flat if they were not attended to. However, while the members of Situationist International were activists operating outside of regular organizational fields, artistic interventions are part of companies' and public sector organizations' change programs. It is important to recognize the difference between these two forms of interventions. Under all conditions, more studies or arts management projects and more theorizing of the field are welcome. If arts, style, aesthetics and creativity are the new principal production factors in the new millennium (Postrel 2003; Howkins 2002), students of organizations and management practice need to

develop solid and robust theories capable of explaining and predicting the actual use of such social resources.

Note

1 AIRIS originally was an acronym for Artists-in-Residence, but the Swedish intermediary TILLT discovered that managers found this term confusing because they associated it with the creation of art for the art market rather than a collaborative process between artists and employees in the organization, so it retained the AIRIS label but dropped the expression artist-in-residence.

References

Adler, N. (2006) 'The arts & leadership: Now then we can do anything, what will we do?', *Academy of Management Learning & Education*, 5(4), pp. 486–499.

Adler, N.J., (2011) 'Leading beautifully: The creative economy and beyond', *Journal of Management Inquiry*, 20(3), pp. 208–221.

Barnard, A. (2004) 'The legacy of the Situationist International: The production of situations of creative resistance', *Capital and Class*, 84, pp. 103–124.

Barry, D. and Meisiek, S. (2010) 'Seeing more and seeing differently: Sensemaking, mindfulness, and the workarts', *Organization Studies*, 31(11), pp. 1505–1530.

Becker, H.S., (1982) *Art worlds*. Berkeley, Los Angeles & London: University of California Press.

Berthoin Antal, A. (2009) *Transforming organisations with the arts. A research framework for evaluating the effects of artistic interventions in organisations – Research Report*. Gothenburg: TILLT. Retrieved from www.wzb.eu/sites/default/files/u30/researchreport.pdf (Accessed January 24, 2015).

Berthoin Antal, A. (2012) 'Artistic intervention residencies and their intermediaries: A comparative analysis', *Organisational Aesthetics*, 1(1), pp. 44–67.

Berthoin Antal, A. (2014) 'When arts enter organisational spaces: Implications for organisational learning'. In Meusburger, P. (series ed.) and Berthoin Antal, A., Meusburger, P. and Suarsana, L. (volume eds.), *Knowledge and space: Learning organisations: Extending the field*. Vol. 6. Dordrecht, The Netherlands: Springer, pp. 177–201.

Berthoin Antal, A. and Strauß, A. (2013) *Artistic interventions in organisations: Finding evidence of values-added*. Berlin: Creative Clash Report. Retrieved from www.wzb.eu/sites/default/files/u30/effects_of_artistic_interventions_final_report.pdf (Accessed January 24, 2015).

Bijsterveld, K. (2008) *Mechanical sound: Technology, culture and public problems of noise in the twentieth century*. Cambridge, MA, & London: The MIT Press.

Blanchot, M., (1982) *The space of literature*. Lincoln: University of Nebraska Press.

Certeau, M., de (1984) *Practices of everyday life*. Berkeley, Los Angeles & London: University of California Press.

Chong, D. (2000) 'Why critical writers on the arts and management matter', *Studies in Culture, Organization and Societies*, 6, pp. 225–241.

Dallery, A.B. (1989) 'The politics of writing (the) body: Écriture féminine'. In Jaggar, A.M. and Bordo S.R. (eds.), *Gender/body/knowledge: Feminist reconstructions of being and knowing*, New Brunswick & London: Rutgers University Press, pp. 52–67.

Debord, G. (1977) *Society of the spectacle*. Detroit, MI: Black & Red.

Debord, G. (1956/1981) 'Methods of *détournement*'. In Knabb, K., (Ed., 1981) *Situationist International anthology*. Berkeley, CA: The Bureau of Public Secrets.

Deleuze, G. (1997) 'Literature and life', *Critical Inquiry*, 23, pp. 225–230.
Foucault, M., (1972) *An archaeology of knowledge*. London & New York, NY: Routledge.
Friese, C. and Clarke, A.E. (2012) 'Transposing bodies of knowledge and technique: Animal models at work in reproductive sciences', *Social Studies of Science*, 42(1), pp. 31–52.
Fröberg, J. (2011) *Vi ska Vi ska inte skriva nån jävla bok! Texter från verkstadsindustrin 2006–2010 [We're not writing no damn book! Texts from the engineering industry 2006–2010]*, Göteborg, Sweden: Teater Spira.
García, B. (2004) 'Urban regeneration, arts programming, and major events: Glasgow 1990, Sydney, 2000 and Barcelona 2004', *International Journal of Cultural Policy*, 10(1), pp. 103–118.
Gennep, A., van (1960) *The rites of passage*. London & New York, NY: Routledge.
Gibson, L. (2002) 'Managing the people: Art programs in the American depression', *Journal of Arts Management, Law, and Society*, 31(4), pp. 279–291.
Goody, J. (1986) *The logic of writing and the organization of society*. Cambridge: Cambridge University Press.
Grzelec, A. and Prata, T. (2013) 'Artists in organisations: Mapping of European producers of artistic interventions in organisations', Creative Clash report. Gothenburg, Sweden: TILLT Europe. Retrieved from www.creativeclash.eu/wp-content/uploads/2013/03/Creative_Clash_Mapping_2013_GrzelecPrata3.pdf (Accessed January 24, 2015).
Guillet de Monthoux, P. (2004) *The art firm: Aesthetic management and metaphysical marketing from Wagner to Wilson*. Stanford, CA: Stanford University Press.
Guillet de Monthoux, P., Gustafsson, C. and Sjöstrand, S.-E. (eds.) (2007) *Aesthetic leadership: Managing fields of flow in art and business*. Basingstoke, UK: Palgrave Macmillan.
Hoffman, E. (1989) *Lost in translation: A life in a new language*. London: Minerva.
Howkins, J. (2002) *The creative economy*. Harmondsworth, UK: Penguin.
Innes, H.A. ([1950] 1972) *Empire and communications* (2nd ed.). Toronto: University of Toronto Press.
Kaufman, V. (2006) 'The lessons of Guy Debord', *October*, 115, pp. 31–38.
Kaulingfreks, R. (2010) 'Managing noise and creating silence', *Philosophy Today*, 54(1), pp. 40–54.
Klein, N. (2000) *No logo*. New York, NY: Fontana Press.
Knabb, K. (ed.) (1981) *Situationist International anthology*. Berkeley, CA: The Bureau of Public Secrets.
Lefebvre, H. (1995) *Introduction to modernity: Twelve preludes September 1959–May 1961*. London: Verso.
Leonard-Barton, D. (1995) *Wellspring of knowledge: Building and sustaining the sources of innovation*. Boston, MA: Harvard Business School Press.
Luhmann, N. (2000) *Art as a social system*. Trans. by E.M. Knodt. Stanford, CA: Stanford University Press.
Macnaughton, J. (2007) 'Art in hospital spaces: The role of hospitals in an aestheticised society', *International Journal of Cultural Policy*, 13(1), pp. 86–101.
Ong, W.J. (1986) 'Writing is a technology that restructured thought'. In Baumann, G. (ed.), *The written word: Literacy in transition*. Oxford: Claredon Press, pp. 23–50.
Pickering, A. (1993) 'The mangle of practice: Agency and the emergence in the sociology of science', *American Journal of Sociology*, 99(3), pp. 559–589.
Postrel, V. (2003) *The substance of style: How the rise of aesthetic value is remaking commerce, culture and consciousness*. New York, NY: Harper Perennial.
Schutz, A. (1962) *Collected papers, Vol. I: The problem of social reality*. The Hague: Martinus Nijhoff.

Swedberg, R. (2012) 'Theorizing in sociology and social science: Turning to the context of discovery', *Theory and Society*, 41, pp. 1–40.

Styhre, A. and Eriksson, M. (2008) 'Bring in the arts and get the creativity for free: A study of the artists in residence project', *Creativity and Innovation Management*, 17(1), pp. 47–57.

Townley, B., Beech, N. and McKinlay, A. (2009) 'Managing the creative industries: Managing the motley crew', *Human Relations*, 62(7), pp. 939–962.

Turner, V. (1969) *The ritual process: Structure and anti-structure*. London: Routledge & Kegan Paul.

Wark, M. (2009) '*Détournement*, an abuser's guide', *Angelaki: The Journal of the Theoretical Humanities*, 14(1), pp. 145–153.

Wark, M. (2011) *The beach beneath the street: The everyday life and glorious times of the Situationist International*. London & New York, NY: Verso.

Wittgenstein, L. (1953) *Philosophical investigations*. Oxford: Blackwell.

Part IV

Experiences with different art forms

8 From aspiration to evidence

Music, leadership and organizational transformation

Linda M. Ippolito and Nancy J. Adler

> *Transforming ourselves, our relationships, or our culture need not await the intervention of some expert, a set of laws, public policies or the like. As we speak and write at this moment we participate in creating the future for good or ill. If we long for change, we must also confront the challenge of generating new meanings, of becoming poetic activists.*
>
> Kenneth Gergen (1999 p. 12)

Art transforms apathy into action.[1] Social scientist Ken Gergen (1999 p.12) invites us all to become "poetic activists". Perhaps there is no better label for the use of musical interventions in global and organizational crises than that of poetic activism. Activists, great artists and great leaders share three fundamental perspectives (Adler 2006, 2010). They all demonstrate the courage to see reality the way it is. They all exhibit the courage to imagine possibility – positive futures – even when the world labels such imagination as naïve for daring to express optimism. And they all have the courage to inspire people to move from current reality back to possibility.

Over the past half century, with no singular organized movement or unifying philosophy to guide them, artists and other people using artistic processes have attempted to transform reality in numerous contentious situations. In particular, music has been used to address extreme conflict and the possibility of conflict, along with the dysfunction and degradation that conflict so often causes (see Tongeren 1999; Urbain 2008). Extreme cases are often valuable in revealing phenomena that are camouflaged in less extreme, more common, and therefore more familiar, circumstances (Cohen and Crabtree 2006; Mills, Durepos and Wiebe 2010). Music, most often when combined with other approaches, appears to have produced generative outcomes in some, although certainly not all, situations in which it has been introduced. In many circumstances, musical interventions, and their direct participants, have inspired the broader community (see Cohen, Gutiérrez Varea and Walker 2011; Ippolito 2008; Tongeren 1999; Welch and LeBaron 2006). Many such initiatives exemplify the frame-breaking perspectives and approaches that music has the potential to offer.

Poetic activism: going beyond the dehydrated approaches of economics, politics and war

> *The radical shift in the structure of the world begs for creativity; it asks us to rethink who we are as human beings... It may be that writers, painters, and musicians have an unprecedented opportunity to be co-creators with society's leaders in setting a path. For art, after all, is about rearranging us, creating surprising juxtapositions, emotional openings, startling presences, flight paths to the eternal.*
>
> Rosamund Stone Zander and Benjamin Zander (1998, p. 7)[2]

Musicians and musical ensembles have a history of poetic activism – of acting as leaders by revealing the truth of reality and by giving shape, form, and sound to 'the possible'. The act of creating music and the music itself inspire people to go beyond ugly, dysfunctional and all too often brutal reality to create possibility, thus offering the beauty inherent in newly-found opportunity. Musicians and ensembles do not rely simply on intellectual constructs and commitments, but rather powerfully influence situations through emotions and strong subconscious dynamics (see Benzon 2001; Freeman 2000, pp. 417–419; McNeill 1997).

Musical interventions have not been universally successful, no matter how broadly success is defined (Bergh 2010, 2011; Bergh and Sloboda 2010). What is universal is aspiration: the aspiration to do better than we have done previously; to return to the best of what humanity is capable of; to move from ugliness back to beauty (Adler 2011). Examples in this chapter highlight collaborative musical interventions among both like-minded people and adversaries. With the former, music inspires, motivates, supports and encourages people in their quest to collectively achieve goals that are of the utmost importance to them and their society. With the latter, musical initiatives bring foes together to attempt to heal the seemingly insurmountable divisiveness that prolonged conflict produces. The selected examples are not meant to be exhaustive, but rather illustrative of how musical interventions are used in response to individuals', organizations' and societies' very human desire not just to function better, but to thrive. The caveat, of course, is that whereas such exemplars reveal an apparent universal yearning, they neither represent a catalogue of successful endeavours nor a step-by-step guide for guaranteeing such achievement. Unfortunately, the world has yet to discover such an assured approach – arts-based or otherwise – which is but one of the reasons why this is a time for research, and not just for action – poetic or otherwise.

The brief descriptions that follow present musical initiatives that have been used in situations of extreme tension. Those in Venezuela, the United States, Estonia and South Africa highlight proactive attempts by unified groups of people to transform aspects of society. Those in the Middle East, the former Yugoslavia, Cyprus and Northern Ireland reveal multicultural initiatives that are attempting to heal society by bringing together opposing factions.

Venezuela: music providing the potential to escape poverty

Venezuela's El Sistema program provides a powerful example of music-based societal development, focusing on offering young people a route out of poverty. Founded in 1975 by economist and musician, Jose Antonio Abreu, El Sistema now involves almost 400,000 young people, many from Venezuela's poorest communities, in a network of 500 choirs and orchestras across the country. El Sistema offers young people quality music education along with the individual discipline and community values that come with ensemble music-making. Thus beyond excellent musical training, the program provides participants with the skills to escape poverty and an explicit alternative to the country's endemic crime and drug culture. "Children engaged in the programme attain above-average results in school and show a tremendous capacity for collective community action. The orchestra and the choirs, the heart of the programme, help create a sense of solidarity. Involvement becomes a weapon against poverty and inequality, violence and drug abuse" (Abreu as quoted in Burton-Hill 2012). According to Abreu, music teaches "citizenship, social awareness, and an aesthetic sense of life" (as quoted in Apthorp 2005) and "transmits the highest values – solidarity, harmony, [and] mutual compassion" (as quoted in Tunstall 2012, p. 273). Ensemble music-making helps to build a culture of cooperation and mutual respect (Uy 2012).

The El Sistema model is neither culture-specific nor limited to a particular age cohort. The model is now being used not only in Venezuela, but in more than 50 countries worldwide (http://www.elsistemausa.org/el-sistema-around-the-world.htm). In addition to young people, the El Sistema model is also being employed with adults, including in the Venezuelan prison system (Asuaje 2008). The original pilot project involved three jails, with each jail constituting a different section of the orchestra – strings, winds and percussion. The prison-musicians practiced by exchanging CD recordings of each other's sections, and then came together for the first time as a unified ensemble when they performed in concert. In spite of handcuffs and two guards per inmate, the response was enthusiastic. Based on the success of the pilot, the program was expanded to include seven prisons with plans to add three more (Grainger 2011). El Sistema, whether involving young people or adults, demonstrates how community – and a respectful collaborative culture – can be built through ensemble music-making.

United States: music humanizing incarcerated prisoners

El Sistema is not the only program that has brought music into extremely challenging organizational settings. The Carnegie Hall-Weill Institute's Musical Connections Program (2014) in the United States, for example, also supports the offering of musical experiences to prison inmates. Composer Daniel

Levy facilitates one such initiative at New York's Sing Sing Correction Facility, a maximum security prison. This unique music composition program assists inmates with an interest and aptitude in music to compose works that the inmate-composers subsequently perform together with professional musicians. Concerts showcasing the compositions are held in and for the community (http://www.carnegiehall.org/MusicalConnections/). Experts contend that artistic interventions in correctional systems offer inmates a form of creative engagement that is educational, therapeutic and rehabilitative (Cohen 2009; Djurichkovic 2011). Given that traditional prison philosophies are typically based on punishment and pain, advocacy for positive, arts-based programs requires enormous courage on the part of those who attempt to bring beauty, empowerment and happiness into the lives of incarcerated individuals (Johnson 2008, p. 115). As program director Levy explains in the 2012 video "Behind Bars: Music in Sing Sing",

> [Prison] Superintendent Heath said when these men get out of prison they're going to be your neighbours. Who do you want to have as your neighbour? Someone who's been through a process where they're learning to think and work and engage with life or someone who has just been left in their cell for 15 or 20 years. That's a pretty potent argument.
> (available at: http://www.carnegiehall.org/MusicalConnections/)

In addition to arts-based interventions assisting in educating, improving and rehabilitating incarcerated individuals, Djurichkovic's (2011, p. 26) review of studies from multiple countries suggests that such programs reduce inmate incident rates, decrease recidivism, enhance general well-being and create opportunities for positive transformative change. Such efforts have been found to benefit inmates, correctional institutions and ultimately the society to which former prisoners return (Cohen 2009, p. 58). The Musical Connections programme, among numerous prison projects around the world, underscores the potentially transformative nature of music and collaborative music-making under the most extreme conditions.

Estonia's singing revolution: intense conviction and harmonized will lead to freedom

Among initiatives that aim at societal transformation, numerous examples exist in which collaborative group music-making has promoted unity and solidarity, empowering members of the general public to persevere during times of extreme duress while working together toward desired change. Aspirational anthems and protest songs, sung by large groups of people, have a history in almost every culture (Whitehead 2008). In the United States, for example, the spiritual "Wade in the Water" supported the slaves during the 1800s when they endured enormous hardship fighting for their freedom. A century later,

"We Shall Overcome" became the anthem of the U.S. Civil Rights Movement (Whitehead 2008).

Choral singing as a form of non-violent protest during the Soviet occupation of the Baltic States provides a powerful example of a successful music-based societal initiative. Referred to as "The Singing Revolution",[3] song inspired Estonians to persevere against Soviet oppression, to find their united voice and to sing until they achieved freedom. Estonians have always had a strong singing tradition. Since 1869, Estonia has held a national song festival every five years to celebrate the folk traditions of each region, with thousands of Estonians of all ages gathering to sing in mass choirs. While the Soviets permitted the festival to continue throughout their almost 50-year occupation, they required the Estonians to sing pro-Soviet songs. In response, the Estonians adopted their own folk songs as de facto national anthems, musical symbols of their fight for freedom. In 1988 with the rise of *glasnost* ("free speech"), singing became an essential form of non-violent protest. In June 1988, 100,000 people spontaneously gathered for seven nights to sing songs that had previously been banned by the Soviets. Confident that the Soviet military would not attack the gathered singers, particularly while the world watched, the Estonians realized the real power of their voices. Three months later, 300,000 Estonians held a massive demonstration on the song-festival grounds in Tallinn, singing protest songs and listening to political speeches demanding the restoration of Estonian sovereignty. After years of oppression and struggle, Estonia achieved independence in 1991. Music succeeded in binding Estonians together in a community of intense conviction and harmonized will. Through song, they not only found the sustaining power of hope but also the motivating strength that ultimately led them to freedom.

South Africa: "a revolution in four-part harmony"[4]

Similar to Estonia, music united and sustained Black South Africans during the repressive Apartheid regime. For 50 years, song formed a powerful narrative in their struggle against oppression. Referred to as "a revolution in four-part harmony", musicians, singers and composers – poetic activists – became the voices of leadership, confronting the State with their lyrics and powerfully advocating political change. Songs, chants and the *toyi-toyi* war dance served to mobilize millions of South Africans. As one activist described, "The *toyi-toyi* was our weapon. We did not have the technology of warfare, the tear gas and tanks, but we had this weapon" (Blackstone 2008). Music, as a form of underground communication, united the oppressed and gave them inspiration to continue fighting. At a visceral level, the Apartheid regime understood the *Amandla* – power – of music. As Plato expressed it in *The Republic* more than two millennia earlier, "Any musical innovation is full of danger to the whole State, and ought to be prohibited. . . . [W]hen modes of music change, the fundamental laws of the State always change with them" (Book IV, p. 115 http://classics.mit.edu/Plato/republic.5.iv.html).

The South African police and military constantly arrested musician-activists, revoked their passports and censored their songs and radio broadcasts. Music and the courage of South Africa's poetic activists played an instrumental role in shaping the political struggle and, ultimately, in ending Apartheid (see Makky 2007; Schumann 2008; among others).

Music healing society: multicultural ensembles composing friendship out of enmity

Whereas the previous examples from Venezuela, the United States, Estonia and South Africa describe musical interventions among like-minded people, the following examples reveal how music can bring people together from multiple cultures that are publicly perceived to be enemies. In these examples from the Middle East, Cyprus, Northern Ireland and the former Yugoslavia, the musical interventions aim to heal the damage and divisiveness that both causes conflict and that conflict causes.

In each example of poetic activism, one must respect the profound courage it takes for musicians to publicly crossover and be seen together with 'the enemy', often in ways that previously would have been unimaginable. History is littered with cases of individuals who have paid the ultimate price for such forward-thinking displays of courageous community building, perpetrated not just by 'the enemy' but all too often by extremists on their own side who view the artists as traitors for collaborating with the enemy. In all cases, whether involving world-renowned political leaders or completely unknown poetic activists, the act of joining with 'the other' to co-create music and a better world is inherently risky and requires profound courage.

Israel–Palestine: West–Eastern Divan Orchestra performing the poetry of peace

Whereas the initiatives in Estonia and South Africa aimed at influencing and engaging the general public, the West–Eastern Divan Orchestra primarily targets a subset of the population, elite Arab and Israeli musicians. The Orchestra focuses on high-profile collaborative music-making to create communication and relationship bridges among people from opposing cultures in the Middle East conflict. This world-class orchestra of 19–25 year olds was the inspiration of Israeli pianist-conductor Daniel Barenboim and the late Palestinian literary scholar Edward Said. The orchestra has both an Israeli and an Arab concertmaster and players from opposing sides of the conflict on each music stand. Every summer since 1999, orchestra members have met for a three-week intensive rehearsal workshop. Throughout the workshop, the musicians eat, sleep and share their daily lives together. Each evening they join in social and political discussions. The supposed enemies then tour as a unified orchestra. The goal is for participants to take home positive experiences of engaging with the "enemy" and for those experiences to subsequently have a cascading impact on

their family and friends. In viewing "music as social medicine", physician David Washington notes that

> ... permanent healing in [the Middle East]... can occur only with the institution of social structures that provide a stable source of positive and novel interaction; that is, peace depends on activities that can construct society rather than destroy it. The [West–Eastern] Divan Orchestra does just that.
> (Washington and Beecher 2010, p.131)

Admittedly, critics have questioned the ability of the West–Eastern Divan Orchestra to achieve its non-musical goals, regarding it as a "problematic utopia" (Beckles Willson 2009a, p. 21). To date, however, evidence suggests that attitudes and behaviours toward fellow musicians have, in fact, become more positive, but that similar positive changes have rarely extended beyond the members of the orchestra (Beckles Willson 2009a, 2009b; Riiser 2010). Supporting the contact hypothesis on which the West–Eastern Divan Orchestra was founded, Barenboim recalls a personal performance he gave in Ramallah for 300 Palestinian children. After the concert, a young girl told Barenboim how happy she was that he was in Ramallah. When asked why, she responded that he was the first "thing" from Israel she had ever seen in Ramallah that was neither a soldier nor a tank. While no individual concert can end the conflict, as Barenboim states "at least for a couple hours, it managed to reduce the level of hatred to zero" (Barenboim, as quoted in Smaczny 2005; see also Barenboim and Said 2004).

Greek and Turkish Cypriots' Bi-Communal Choir daring to sing across the Green Line

The Bi-Communal Choir for Peace in Cyprus provides yet another example of collaborative music-making. Exhibiting distinct moral courage, Greek and Turkish Cypriot musicians crossed the Green Line, a demilitarized zone that divides the country, to rehearse and perform together (Ungerleider 1999). By singing traditional songs of Cyprus, performed in both languages, and by commissioning works by Greek composers and Turkish lyricists, and *vice versa*, these musician-activists present a powerful message reflecting their unique identities and interconnected roots. The symbolism and embodiment of their plea for trust, reconciliation and affirmation became highly visible once again in 2014 when the Choir joined cultural, religious, business and trade-union groups to sing at the 40th-anniversary effort aimed at achieving reunification (see http://www.unitedcyprusplatform.org/activities.php).

Northern Ireland: Different Drums symbolizing synergies born in unique identities

Similarly reflecting courage, Different Drums of Ireland (see http://www.differentdrums.net) brings together musical instruments carrying immense

symbolism from both sides of the conflict. The group purposely uses the *lambeg*, a large military-style Protestant/Unionist drum, and the *bodhran*, a smaller stick-played Catholic/Nationalist hand-drum. During the conflict in Northern Ireland, referred to as "The Troubles", the consequences of playing the 'wrong drum' in a public venue could result in being beaten or even killed. Members of Different Drums have not been immune to such threats as their music-making confronts deeply held prejudices. Once, for example, when Different Drums played at a Belfast festival to a working class Protestant audience, all their *bodhrans* were smashed. Despite such hostility, the group continues its efforts to divest the drums of their divisive political connotations and invest them with a new symbolism of coexistence that comes from co-creation. By uniting the distinct voices and rhythms of the two drums, the ensemble shows how unique identities can be used to create harmony.

Former Yugoslavia's Pontanima Choir: singing sacred synergy

The former Yugoslavia's Pontanima Choir provides an example of collaborative music-making being used for reconciliation and healing following conflict. In Latin, *pontanima* means 'soul bridge'. The Pontanima Choir was founded in 1996 during the Bosnian war when a Catholic church in Sarajevo could not find enough members for its choir. Choir director Josip Katavić asked the parish priest, Father Marković, if it might be possible to invite 'the others' to augment his choir's vocal ranks. That courageous frame-breaking request resulted in a choir made up of Christians, Jews, and Muslims who sang each other's sacred music to the alternating outrage and support of their respective communities. In reflecting on the unorthodox approach, Father Marković understood that the Choir was encouraging the most important form of communication. Singing each other's sacred music "... doesn't mean we lose our identity, [but rather] that we all win. We have a new mirror" (Marković as quoted in Gienger 2003). "The diversity forms a beautiful, ecumenical mosaic, which eliminates mistrust and xenophobia, and restores communication, cooperation, dialogue, coexistence, pluralism, empowerment and enculturation" (Marković 2004).

The Choir has not only become an accomplished ensemble but also a dynamic community that models the possibility of an integrated society for all of Bosnia-Herzegovina. The choir does not just "talk ecumenism", it lives it. Their music spreads a message of enlarging the self by embracing the other. As Father Marković (2004) explains,

> The song of our neighbour affects us and we receive it and grow through it. Likewise, our song becomes our neighbour's heritage and impacts their growth. In that interwoven spirituality and in the discovery of our own reflection in the other, no one loses, but instead it is the only way to grow.

The Pontanima Choir has won numerous peace prizes, despite opposition that continues to this day. By singing their aspirations, the choir inspires participants and audiences alike with their message of unity, synergy and the possibility of a shared future.

Sarajevo: a cellist reclaims humanity in the face of war

A final example of particularly potent musical leadership and individual courage took place in Sarajevo during the Bosnian War. In response to sniper and mortar attacks on civilians during the siege of Sarajevo, cellist Vedran Smailović, formally dressed in his tails and defying sniper fire, positioned himself in the ruins of the National Library and played. People gathered to listen. Uplifted and encouraged by his music, they repeatedly asked him to play. Smailović returned to this and other sites and played again and again in honour of the people who had been killed in the conflict (CBC News 2008; Sharrock 2008; Smailović 1998).

Smailović's actions caught the attention of the world press. During a lull in the shelling, a journalist probed, "Aren't you crazy for playing music while they are shelling Sarajevo?" (Lederach 2005, p. 156). Smailović replied, "Playing music is not crazy. Why don't you go ask those people if they are not crazy shelling Sarajevo while I sit here playing my cello?" (1998 cited in Lederach 2005, p. 156). Smailović's cello was not a tool to end war. Rather, his music reclaimed life in the face of war. Music reminds us that there is life beyond war – humanity beyond degradation. Scholar and poet Swati Chopra (2007) captures the profound meaning and impact of Smailović's poetic activism, "Smailović played to ruined homes, smouldering fires, [and] scared people hiding in basements. He played for human dignity that is the first casualty in war. Ultimately, he played for life, for peace, and for the possibility of hope that exists even in the darkest hour".

Music transforming mind-sets: from aspiration to initial evidence

The real voyage of discovery consists not in seeking new landscapes, but in having new eyes.
Marcel Proust

To date, poetic activism, including music-based interventions, has been rooted primarily in aspiration, not in evidence. As the examples in the prior section highlight, people worldwide yearn for better societies, organizations and leadership, but fail to have sufficient evidence that artistic initiatives are efficacious – that they lead to desired outcomes or even have the potential to do so. To address this critical need, research was conducted to begin to ascertain if and how individuals' abilities to address conflictual situations could be enhanced and transformed by music. Whereas a wealth of studies demonstrates the positive impact of arts-based interventions on children (see, for example, Bamford 2006; Catterall 1998, 2002; Deasy 2002;

Rooney 2004; and Ruppert 2006), extensive and systematic research on adults, including those working in organizations, is only now beginning to be conducted (Berthoin Antal 2009, 2011; in this volume, see an overview of past studies in the chapter by Berthoin Antal and Strauß, and new examples in most other chapters).

Music and the musical-ensemble metaphor

According to linguist Deborah Tannen, language

> invisibly molds our way of thinking about people, actions, and the world around us. Military metaphors train us to think about – and see – everything in terms of fighting, conflict, and war. This perspective then limits our imaginations when we consider what we can do about situations we would like to understand or change.
>
> (1998, pp. 7–8)

Metaphors act as cognitive frames dictating how people think, feel and ultimately respond to situations. If conflict and the ways of resolving it are perceived as war then we think, feel and act accordingly. If, however, we break frame and apply a new metaphor to our view of conflict, our perceptions and behaviours should similarly shift. Experts in arts and management like Ted Buswick contend that "the arts can . . . open up the mind in such a way that it can change behaviour" (quoted in Amundson 2011, p. 7). Buswick argues that

> By using or observing creative skills . . . [people] are taken out of a purely analytical framework, and that helps them view not only business issues, but the world at large, from a different perspective. That changes the way they see things, and ultimately the way they do things.
>
> (quoted in Amundson 2011, p. 7)

Initial research on the use of music in resolving disputes

The first author of this chapter conducted research to study an arts-based approach to learning how to achieve desired outcomes in solving problems and resolving disputed situations (Ippolito 2015). Replacing traditional competitive and combative metaphors, the study used the musical ensemble as an overarching metaphor for collaboratively negotiating and solving problems. Conducted at a leading North American law school, the study employed three distinct music-based experiences to attempt to alter perceptions of conflictual and contentious situations as well as to change how people would behave within such situations.

Research objectives

The study engaged participants in music-based experiences designed to take them beyond relying primarily on a cognitive approach – a purely rational analytical framework – and provide them with an integrated cognitive-affective-and-behavioural approach to solving problems and resolving disputes (Alexander and LeBaron 2013, p. 544; Goleman and Senge 2014; LeBaron, MacLeod and Acland 2014). Thus, the research utilized musical experiences to develop participants' emotional and social intelligence. Whereas numerous researchers have identified such intelligence as essential to organizational and managerial effectiveness, it remains an under-developed competence among most professionals and absent from most professional training programs (Boyatzis 2008a, 2008b; Boyatzis and Saatcioglu 2008; Goleman 1995, 2006; Goleman and Boyatzis 2008; Goleman and Senge 2014).

The set of music-based experiences, including the creation of playlists, an interactive workshop with a String Quartet, and team-based music-making, were designed to support participants in exploring the nuances of communication and in building effective collaborative communities. In this study, music served not only for "skills transfer, projective technique, illustration of essence, and making" (Taylor and Ladkin 2009, p. 56), but also as an explicit tool within a complex negotiation. For comparison, the researcher offered an alternative, traditional set of experiences to a separate group of participants using non-music-based collaborative metaphors and experiences.

In summary, the research focused on discovering (1) whether the negotiation and problem-solving skills and behaviours of ensemble music-making can be learned by adults who are not musicians; (2) whether such skills learned in a musical environment are transferrable to non-musical environments in which there are complex conflictual situations; and (3) if so, whether these practices, once learned, can change cognitive frames and affect, and thus lead to more effective behaviour and more desirable outcomes.

Structure of the study

All participants engaged in a series of experiential exercises in dyads, triads and multi-party ensembles, culminating in simulated negotiations and problem-solving exercises. In addition to recording the outcomes of each exercise and negotiation, participants regularly recorded their reactions in reflection papers and on questionnaires using both open- and close-ended questions. The researcher then used a modified grounded theory methodology to analyse the observational and self-report qualitative and quantitative data.

Collaborative metaphors, in place of more traditional competitive and combative metaphors, were introduced to both the music and non-music-groups in the first week. The concepts of collaborative negotiation and a team approach to solving problems and resolving disputes were then reinforced throughout the

three-month study. In addition, the researcher presented the musical ensemble, as a new metaphoric frame, to the music-group in the first week. During the second week, participants in both groups engaged in a reflective exercise that allowed them to explore their personal cognitive and affective responses to conflict and its handling. As a part of this reflective exercise, the music-group created a playlist of music as an adjunct to their verbal responses, while the non-music-group responded by using words only. In the fifth week, music-group participants attended an interactive workshop with a String Quartet. At the same time, the non-music-group engaged in an interactive talk on cross-cultural negotiations with senior legal counsel from a major financial institution. In the seventh week, the music-group engaged in a series of hands-on group music-making activities, while the non-music-group attended an interactive session with a judge and the director of a mediation clinic and also took part in a series of verbal question-asking and active-listening exercises. During the eighth week, both groups took part in the Ugli Orange negotiation. In the tenth week, both groups participated in the World Trade Center Redesign, a complex multi-party negotiation. As a part of this multi-party negotiation, the music-group chose a piece of music to bring to the negotiation that they believed would help them in achieving a satisfactory outcome.

The musical interventions

Critical thinking must be balanced with the development of emotional and social intelligence for effective performance in most fields (see Boyatzis 2008a, 2008b; Goleman 1995, 2006, 2014). In keeping with other researchers' observation, namely that "[r]ational analytical competencies are obviously valuable but insufficient by themselves" (Nissley 2010, p. 14), the study included activities to engage participants in reflective practice and to help them to consider conflict from an emotional as opposed to strictly a cognitive perspective. The music-based experiences provided a consistent arc during the three months, first emphasizing reflection, then observation, and then doing (in this volume see Bozic Yams' exploration of a choreography-based arc).

Creating playlists: developing an expressive lexicon

The intention of the first exercise was to foster the development of a lexicon for expressing the sensed and felt dimensions of conflict. To explore the role of emotions in conflict and its impact on people's responses to conflict, the researcher asked both groups to recall a conflict situation in which they had been involved and then reflect on how the conflict had made them feel. The music-group then composed a playlist of three songs that not only expressed their feelings but also could act as a vehicle to communicate their feelings to their colleagues. Participants in the non-music-group engaged in the same

reflection, but without associating their feelings to music. Both groups subsequently described their conflict-related feelings to their colleagues.

Observing the String Quartet: viewing collaboration in action

Both groups received lectures on the importance of communication, community-building and interpersonal connection for successfully negotiating. Music-group participants then took part in an interactive workshop with the Cecilia String Quartet. Watching the rehearsal provided them with a unique opportunity to observe how the Quartet communicated, collaboratively approached solving problems, utilized rotating leadership and engaged in consensus decision-making. The Quartet provided a musical-metaphor-in-action and illustrated the essence of the collaborative negotiation process. At the same time, the researcher introduced the same concepts to the non-music-group, but without the use of music or musical metaphors.

Group music-making: moving from knowing to doing

In the final musical intervention, which aimed at behavioural integration, music-group participants composed and performed music themselves. Using a variety of percussion instruments, participants attempted to incorporate the concepts of communication, team building and interpersonal connection into their individual and team behaviour. Rather than simply observe, as they had done previously, the ensemble music-making required them to 'perform' their understanding of the dynamics of communication, including finding a tempo and rhythm within their work as a team. At the same time, the non-music-group engaged in a parallel, equally-engaging series of verbal questioning-and-listening exercises.

The simulated negotiations

After participating in the three previously described experiences, both groups took part in the same two simulated negotiations. By comparing the two groups' process and performance, it was possible to assess both groups' overall learning as well as the relative impact of the music-based interventions.

Direct two-person negotiation

The Ugli Orange is a classic two-person negotiation in which each party needs the same finite resource (all the oranges) to save people from catastrophic harm. When negotiators use open communication, demonstrate trust and employ an interest-based negotiation strategy, the potential win/win solution – that one party needs the juice and the other the rind – readily becomes apparent. By contrast, when parties engage in traditional positional zero-sum bargaining and fail to build sufficient trust and rapport to discover why each party needs

the orange, the results are disastrous, with at least some people hypothetically perishing.

Complex multi-party team negotiation

In the World Trade Center Redesign, participants representing five stakeholders engage in a time-limited negotiation to reach consensus on four critical issues needed for the post-September 11 fallen towers' site. Prior to the negotiation, all participants receive a list of possible resolutions to each issue. At the same time, the researcher asked music-group participants to bring a piece of music to the negotiation that exemplified their resolution goals, which they could then use in any way they chose during the negotiation. For example, they could use the music as an initial ice-breaker, as a tool for addressing an impasse, or as a ritual to mark progress or resolution. Non-music-group participants prepared for the negotiation without incorporating music into their planning or actual negotiating.

Initial results: music-group outlearns and outperforms non-music-group

The results from this initial study are encouraging. It appears that non-musicians in non-musical environments are able to learn from musical metaphors and ensemble music-making and that such learning translates into changed and more effective behaviour. Moreover, professionals exposed to musical metaphors and other music-based learning appear to outperform colleagues who do not participate in similar music-based learning. Overall, the results of the study indicate:

- **Cognitive learning.** All music-group participants, as compared to less than three-quarters (71 per cent) of those in the non-music-group, reported a shift in their perceptions regarding conflict and how it could be handled;
- **Affective learning.** None of the non-music-group participants, as compared to almost half (47 per cent) of the music-group participants, described feeling differently about the importance of emotions and relationships in dispute resolution processes;
- **Behavioural learning.** Both when acting individually and collectively, music-group participants embodied more of the new learning (80 per cent as compared to 40 per cent–60 per cent). When compared with the non-music-group, music-group participants communicated more effectively, formed more efficient negotiating teams, and generated more creative outcomes; and
- **Learning transfer.** Music-group participants were clearly able to transfer concepts and skills from the music to the non-music domain.

Both groups' initial descriptions of how problems should be solved and disputes resolved revealed deeply entrenched, very traditional assumptions

about professional norms and behaviours, including how success is defined and achieved. After three months, participants in both groups reported a better appreciation of the collaborative approach to managing conflict; however, the music-group participants incorporated the learning in practice, not just in theory.

Both groups reported: (a) a shift away from an adversarial mind-set, (b) an expansion away from a limited self-orientation to encompass a focus on 'the other' and on the process, and (c) an increased awareness of the role and importance of emotions and relationships in resolving disputes. The extent of the shifts, however, differed markedly between the two groups:

- More than three-quarters (76 per cent) of the music-group reported a **shift away from adversarial thinking** as compared to only 17.6 per cent of the non-music-group. For example, music-group participants reported:

"A massive shift, actually. I used to be 100 per cent convinced that a more aggressive, 'zealous advocate' approach to conflict was the way to get what you wanted...The relationships and other dynamics seemed 'touchy feely' and impractical...I feel that emphasizing common interests and approaching conflicts in a way that is open to compromise will benefit me hugely, both as a lawyer and in my life outside work."

"It is clear that there are a number of things that go into good conflict resolution skills. It is not all about fighting for your client but about understanding the needs of both sides and then using that to come to a mutually beneficial agreement."

- More than half (57 per cent) of music-group participants reported a **shift away from a self-orientation** to a perspective that encompassed 'the other' and the process, while not even a third (29 per cent) of the non-music-group reported an equivalent shift. Music-group participants described personal insights they gained as well as having enhanced their personal awareness. Their descriptions revealed an increased subjective awareness of the importance of skills acquisition related to self, others, and process for successfully managing conflict and resolving disputes:

"I've learned that knowing one's own interests is not as important as gathering information from the other side because the former leads to a narrow set of acceptable results while the latter leads to a broader value-creating [set of] results."

- Almost half (47 per cent) of the music-group reported an **increased awareness of the importance of emotions and relationship** in resolving disputes. In comparison, no one in the non-music-group described a similar awareness. Non-music-group participants, in describing their learning, more

frequently restricted themselves to describing their acquisition of practical and analytical skills and to having gained new theoretical perspectives regarding the conflict and dispute resolution process. As one music-group participant reported:

"In the beginning, I was more pessimistic on the true possibility of both parties leaving the table feeling satisfied with the outcomes. However ... most of the parties had a great deal of their interests met. I discovered the importance of understanding the interests and values of the parties in order to create a feeling of community and trust. The more people feel that you are taking into account their interests the more they are being heard and respected. This allows for a positive and collaborative approach to the discussions. My understanding changed most in this regard."

The following section describes how participant learning grew during the series of musical experiences and negotiations.

Creating playlists: developing an expressive lexicon

Already after having been introduced to just the first musical experience, the music-group differed markedly from the non-music-group in both their self-reflective insights and their demonstrated depth of understanding. Compared with the non-music-group, the music-group expressed greater insight relative to:

- **diversity:** the extent of diversity among people and the importance of developing an awareness of differing values, beliefs and worldviews;
- **the role of emotions:** the role that one's own and others' emotions play in contentious situations; and
- **the uniqueness of each negotiation:** the need to respond to the uniqueness of each conflict situation, including to the unique parties and issues involved.

Music-group participants indicated that the music gave them an expanded expressive lexicon with which to describe the sensed and felt dimensions of conflict. Some participants found that music provided them with an outlet that they did not usually have to express feelings about conflict situations. Music thus expanded their expressive lexicon by providing a way for them to communicate "where words cannot go" and where words, in the past, had fallen short. In contrast, non-music-group participants restricted their descriptions to reporting external observations rather than more subjective self-reflections. They tended not to use their own words and meanings, but rather relied primarily on existing standardized categories (such as the standard Thomas–Kilmann [1974] conflict modes) to label themselves, others, and the negotiating process itself.

Music-group participants reported that their learning was enriched through the use of the music playlists. Creating playlists helped them to access their inner emotions and to see the significance of such emotions to the context. They stated that creating playlists was particularly relevant and meaningful as it drew on their personal, real-life experience and required them to use their own creativity and imagination. Participants' observations fit with experts' understandings that arts-based reflection is a form of "problem-solving from within" (Adler as quoted in Amundson 2011, p. 7), and thus a way to help people develop "'from the inside-out" (Purg as quoted in Amundson 2011, p. 7). By creating playlists, the music-group not only gained a greater depth of cognitive comprehension but, more important, that depth encompassed emotional, social and interpersonal learning not expressed by those in the non-music-group.

Learning from the String Quartet: collaboration in action

Following their meeting with the Quartet, participants easily translated their learning from the music to their own professional domains. They quickly identified similarities between musical and non-musical negotiations, including the need to try out all ideas without a priori negative evaluation and the importance of working toward an overarching common goal. One observer noted that for the Quartet to perform at a high level,

> disputes had to be resolved throughout, which required a consideration of alternatives and agreement. This is highly analogous to the negotiation process, where the goal is agreement, which requires a consideration of alternatives and decision-making throughout.

Another participant observed the similarity in communication styles:

> [The] same principles apply to a negotiation: Tone, pitch, tempo, dynamics. . . . When negotiations go well they are harmonious and creative and transforming; when they do not, there is discord. [The Quartet] . . . adjusted tone and volume when criticizing to make it clear that the idea was a non-threatening, non-accusatory suggestion.
>
> I loved that one of the violinists described herself as being a trapeze artist in saying that her fellow musicians know when to "catch" her, even if she "jumped" at the wrong time. This demonstrates the importance of being present in the "here and now". I think that this is just as important in the legal field because if you are not present to catch another party after they try to communicate with you, this may very well botch the entire negotiation process.

As documented in their reported reflections, the Quartet heightened participants' cognitive and affective understanding of collaborative negotiation skills and behaviours.

Group music-making: moving from knowing to doing

Following the third musical experience, the group music-making participants described an array of learnings that they believed would not have occurred without the musical interventions. They reported further deepening their understanding of collaborative negotiation and problem-solving concepts and practice skills. They believed that the music-making had enabled them to experience the full range of understandings and skills needed for successfully resolving conflict, including the nuances of communication, team-building, and individual and group behaviours such as risk-taking, option generation and evaluation, and the development of group strategy, trust and rapport. In addition, they perceived that they had increased their ability to deal with the unknown, be spontaneous and flexible, adapt to change, and be present ("in the moment"). They described learning the feeling of re-establishing a group goal upon encountering unexpected challenges. Likewise, they reported understanding the impact on the group of mistakes and failure and learning to recover from such potentially undermining, unintended occurrences. Participants in the non-music-group who took part in the active listening and curious-questioning exercises appear to have learned less and incorporated less of what they learned into their own behaviour in the subsequent negotiations.

Impact of music on performance in simulated negotiations

Behaviour in the simulations that followed the musical interventions demonstrated the extent to which: the learning that was introduced through music was translated for use in a non-music professional domain, the learning was internalized, and the actual negotiating behaviours changed.

Two-person negotiation

The differences in outcomes between the music and non-music-groups in the Ugli Orange negotiation were striking. In the music-group, 60 per cent (12 of 20 negotiators) reached win-win solutions. The majority uncovered the key fact that both parties could achieve their goal by sharing all of the resource and thus arrived at an integrated solution. In the non-music-group, 87.5 per cent (14 of 16 negotiators) failed to make the same discovery and thus failed to achieve a win/win solution. Based both on outside observation and participants' own reflections, music-group negotiators approached their communications and engagement from a collaborative perspective, whereas the non-music-group defaulted to using more conventional, competitive approaches. Non-music-group negotiators appeared unable to transcend the limitations of the traditional win/lose perspective and behaviours despite being aware of those limitations.

The results of this two-person negotiation indicate that interacting with music more effectively reinforced the core concepts that had been introduced to both groups in the preparatory presentations on communication,

community-building, and interpersonal connection, and more successfully enhanced skill development. Music-group participants disproportionately realized that neither side could achieve the superordinate goal of resolution without the cooperation of both sides; that is, that a win/lose dichotomy would never support a satisfactory resolution.

Complex multi-party team negotiation

Similar to the outcome of the two-party negotiation, the results of the more complex multi-party World Trade Center Redesign negotiation were striking. First, the music-teams were more efficient. All three music-teams completed the negotiation within the allotted time whereas two of the three non-music teams failed to reach consensus by the deadline. Second, in comparison to the non-music teams, the music-teams demonstrated more creativity in crafting their own resolutions to the issues. Two of the three music-teams rejected all pre-set options in favour of inventing their own resolutions to each of the four issues. The remaining music-team accepted two of the pre-set options while creating two options of its own. In contrast, non-music teams resorted to using all or most of the pre-set options in formulating their resolutions. Only one non-music team invented its own resolution to more than half (three of four) of the issues.

Third, the music-teams demonstrated a greater ability to translate learned concepts into behaviour. Non-music teams appeared to have more difficulty putting what they had learned into practice, defaulting to prior commonly-accepted adversarial, position-based bargaining and persuasive-argument habits. Strikingly, the non-music teams reported being aware of their short-comings and possessing a desire to improve, however, the standard lectures and skills-training failed to produce the hoped-for changed behaviour in the actual negotiations.

Fourth, the non-music teams limited themselves to a narrower range of process options. Music-teams used multiple modalities to address the issues in the negotiations: they talked, used their computers, drew diagrams and engaged in multiple parallel discussions within the main negotiating room. In contrast, non-music-teams either just talked, or used their computers but not interactively, and went outside to caucus rather than hosting multiple simultaneous discussions within the main room.

Fifth, the music teams appeared more able than their non-music counterparts to recognize and translate into action difficult-to-grasp concepts. Having seen process-in-action through the lens of the Quartet, as opposed to simply observing mediation and negotiation sessions, provided the music-group with a new and dynamic perspective on how to resolve disputes. When they then engaged personally in music-making, they experienced the concepts of communication, team building and interpersonal interactions first-hand. The music-making allowed the concepts to come alive through embodied learning, with the depth of their assimilation revealed in how the music-teams negotiated. In contrast, non-music participants, who had received standard dispute resolution training and had interacted with legal professionals to learn

the process of negotiating, displayed a less complete assimilation of concepts. Non-music-group negotiators were less able to apply the concepts and to effectively obtain desired results.

In addition, after watching the Quartet rehearse and then making their own group music, music-group participants embraced the ensemble concept that the overall goal is more important than the sum of the individual parts and negotiating positions. Participants also reported that using a more cooperative, team-oriented approach enabled them to work more effectively toward achieving mutually beneficial outcomes:

> I realized that communication and getting all team members on the same page is key ... [F]eelings of personal and group responsibility can arise and strategies to solve the problems and minimize risks. Trust can develop once the team is collaborative, comfortable with each other, and participates in the strategies we all helped develop.
>
> In the end you learned that other person's catching was often based on how good your throw to them was. It was interesting putting trust into both the person throwing to you and catching your throw to make you look good ... The biggest takeaway was seeing just how much the slightest change can mix you up.

Music-group participants were clearly more willing to abandon an argument-approach and to repeatedly ask and answer the question "Why?" They also appeared more willing to risk revealing information and therefore less likely to withhold information.

Emerging patterns from the initial research

Taken together, the results from this study indicate that people not only learn from music and ensemble music-making, but they are also able to transfer that learning to their main non-musical domains of professional work (in this volume see also Bozic Yams' results on learning from contemporary dance). Moreover, the specific learnings appear to be commensurate with much of the learning considered most important for twenty-first-century success (Delors 1996; Goleman and Senge 2014). In summary, the study reveals that:

- the metaphor of ensemble music-making and music-based experiences appear to have the potential to shift perceptions, cognitive frameworks, emotional responses and behaviour away from competitive positional bargaining and zero-sum distributive approaches toward more collaborative, interest-based approaches to solving problems and resolving disputes;
- music-based experiences appear to support deeper understanding of abstract concepts and the complexities inherent in conflict and its management;

- music-based experiences appear to support the development of emotional and social intelligence which, in turn, can lead to more effective performance and better outcomes in resolving disputes and solving problems; and
- engagement with music appears to reconnect people to their creative potential and lead them to see the efficacy of employing creative thinking in professional environments where analytical and critical thinking have generally been over-emphasized (in this volume see Jahnke; Raviola and Schnugg).

Although the sample size was too small to generalize the outcomes, the study offers encouraging evidence of the potential for our aspirations to become tangible reality.

Hope for the future

The world is rife with challenges that so seriously and pervasively threaten the stability and sustainability of the planet that the future of civilization, as we know it, is in question. Faced with such a reality, we cannot help but appreciate Albert Einstein's prescient observation that is as true today as it was more than a half century ago when he first stated that "we cannot solve problems by using the same kind of thinking we used when we created them". Society needs new approaches that can only be found "outside of the mainstream of international political traditions, discourse, and operational modalities" (Lederach 1997, p. 25). Contemporary society, and the challenges it faces, demands innovation; it urgently requires "the development of ideas and practices that go beyond the [conventional] negotiation of substantive interests and issues" (Lederach 1997, p. 25).

Based on the range of important and impressive societal interventions, music-based approaches would appear to offer hope for transforming conflict, developing more generative organizational and societal cultures, and ameliorating serious world challenges. Rather than repeating past approaches and expecting different results,[5] music-based interventions go beyond previous approaches, and their repeated failures, to explore the potential for future success. The stakes are very high. Notwithstanding, guarantees of success are non-existent or fraudulent (see for example, Beckles Willson 2009a; Bergh 2007, 2008, 2010, 2011; Bergh and Sloboda 2010).

This chapter has presented a range of music-based societal interventions that highlight the hope that the dynamics of music and ensemble music-making are robust enough to transform both major and day-to-day organizational and societal dysfunction. The new research summarized in the chapter demonstrates that the promise of positive outcomes from musical interventions is neither strictly idiosyncratic nor based only on the aspiration inherent in 'wishful thinking', but rather, appears to be grounded in demonstrable shifts in cognitive frameworks, attitudinal change and behavioural outcomes (in this volume see also Berthoin Antal and Strauß; Bozic Yams).

Notes

1 Title of Adler's 2009 art exhibition at the Banff Centre, where she was an artist in residence.
2 Ben Zander conducts the Boston Philharmonic and serves as a guest conductor for orchestras worldwide.
3 The Singing Revolution is commonly used to refer to events between 1987 and 1991 that led to the restoration of independence in Estonia, Latvia and Lithuania (Ginkel 2002; Thomson 1992). The term was coined by Estonian "poetic activist" (activist and artist), Heinz Valk, and published in an article a week after the June 10–11, 1988, spontaneous mass night-singing demonstrations at the Tallinn Song Festival Grounds (Vogt 2004, as cited at: http://en.wikipedia.org/wiki/Singing_Revolution. Also see Vesilind (2008) and *The Singing Revolution* the 2006 documentary film by James Tusty and Maureen Castle Tusty.
4 From the 2002 documentary *Amandla! A Revolution in Four-Part Harmony*, written and directed by Lee Hirsch, which presents interviews, archival footage, and filmed performances highlighting the role that music played in South Africa's struggle against apartheid. Singer-activists include such voices as Vuyisile Mini, Miriam Mekeba, Dorothy Masuka and Roger Lucey. Also see the 2013 BBC documentary by Canadian filmmaker Jason Bourque, *Music for Mandela: A Legacy with a Backbeat*, depicting the same history and impact.
5 The saying, as it is often reiterated, is: "Insanity is repeating the same course of action while expecting different results". Available at: https://answers.yahoo.com/question/index?qid=20120718134727AAaL4rX (Accessed August 14, 2014). Alternatively stated as "Insanity is repeating the same mistakes and expecting different results" attributed to Benjamin Franklin, Albert Einstein, Rita Mae Brown and an old Chinese proverb (see http://www.en.wikiquote.org/wiki/Insanity) or "Insanity: doing the same thing over and over again and expecting different results" Albert Einstein at http://www.brainyquote.com/quotes/quotes/a/alberteins133991.html#f2UVmkWTGLbEZbKg.99.

References

Adler, N.J. (2006) 'The arts and leadership: Now that we can do anything, what will we do?' *Academy of Management Learning and Education*, 5(4), pp. 466–499.
Adler, N.J. (2010) 'Going beyond the dehydrated language of management: Leadership insight', *Journal of Business Strategy*, 31(4), pp. 90–99.
Adler, N.J. (2011) 'Leading beautifully: The creative economy and beyond', *Journal of Management Inquiry*, 20(3), pp. 208–221.
Alexander, N., and LeBaron, M. (2013) 'Embodied conflict resolution: Resurrecting role-play based curricula through dance'. In Honeyman, C., Coben, J. and Wei-Min Lee, A. (eds.), *Educating negotiators for a connected world*. St. Paul: DRI Press, pp. 539–567.
Amundson, W. (2011) 'MBAs and the arts', *MBA Innovation*, Summer/Fall, pp. 4–11.
Apthorp, S. (2005) 'Classical escape from life on the mean streets', *Financial Times*, August 1. Retrieved from http://www.ft.com/intl/cms/s/0/c4d1458c-0228–11da-9481–00000e2511c8.html#axzz1qVxTRJCc (Accessed June 29, 2014).
Asuaje, L. (2008) 'El Sistema in penitentiaries', *El Nacional*, May 25. Translated from Spanish by José Bergher. Retrieved from http://tipom.wordpress.com/2008/05/27/8/ (Accessed August 14, 2014).
Bamford, A. (2006) *The wow factor: Global research compendium on the impact of the arts in education*. Munster, Germany: Waxmann Publishing House, GMBH.
Barenboim, D., and Said, E.W. (2004) *Parallels and paradoxes*. New York, NY: Vintage Books.

Beckles Willson, R. (2009a) 'Whose utopia? Perspectives on the West–Eastern Divan Orchestra', *Music & Politics*, 3(2), pp. 1–21.
Beckles Willson, R. (2009b) 'The parallax worlds of the West–Eastern Divan Orchestra', *Journal of the Royal Musical Association*, 134(2), pp. 319–347.
Benzon, W. (2001) *Beethoven's anvil*. New York, NY: Basic Books.
Bergh, A. (2007) 'I'd like to teach the world to sing: Music and conflict transformation', *Musicae Scientiae*, 11 (Suppl. 2), pp. 141–157.
Bergh, A. (2008) 'Everlasting love: The sustainability of top-down vs. bottom-up approaches to music and conflict transformation'. In Kagen, S. and Kirchberg, V. (eds.), *Sustainability: A new frontier for the arts and cultures*. Bad Homburg, Germany: VAS-Verlag, pp. 351–382.
Bergh, A. (2010) *I'd like to teach the world to sing: Music and conflict transformation*. PhD dissertation, University of Exeter, UK.
Bergh, A. (2011) 'Emotions in motion: Transforming conflict and music'. In Deliege, I. and Davidson, J.W. (eds.), *Music and the mind (Essays in honour of John Sloboda)*. Oxford: Oxford University Press, pp. 363–378.
Bergh, A. and Sloboda, J. (2010) 'Music and art in conflict transformation: A review', *Music and arts in action*, 2(2), pp. 2–17.
Berthoin Antal, A. (2009) *Transforming organisations with the arts*. Gothenburg: TILLT Europe. Retrieved from http://www.wzb.eu/sites/default/files/u30/researchreport.pdf (Accessed August 18, 2014).
Berthoin Antal, A. (2011) *Managing artistic interventions in organisations: A comparative study of programmes in Europe*. Gothenburg: TILLT Europe. Retrieved from http://www.wzb.eu/sites/default/files/u30/report_managing_artistic_interventions_2011.pdf (Accessed August 18, 2014).
Blackstone (2008) 'The Toyi-Toyi of South Africa', *Power to the People*, [blog] February 18. Retrieved from http://power-2-people.blogspot.ca/2008/02/toyi-toyi-of-southern-africa.html (Accessed August 18, 2014).
Boyatzis, R.E. (2008a) 'Competencies as a behavioral approach to emotional intelligence', *Journal of Management Development*, 28(9), pp. 749–770.
Boyatzis, R.E. (2008b) 'Competencies in the 21st century', *Journal of Management Development*, 27(1), pp. 5–12.
Boyatzis, R.E. and Saatcioglu, A. (2008) 'A 20-year view of trying to develop emotional, social and cognitive intelligence competencies in graduate management education', *Journal of Management Development*, 27(1), pp. 92–108.
Burton-Hill, C. (2012) 'José Antonio Abreu on Venezuela's El Sistema miracle', *Guardian*, [online] June 14. Retrieved from http://www.theguardian.com/music/2012/jun/14/abreu-el-sistema-venezuela-interview-clemency-burton-hill (Accessed August 18, 2014).
Carnegie Hall, Weill Music Institute, (2012) *Behind bars: Music in Sing Sing*. [video online] Retrieved from: http://www.youtube.com/watch?v=TBYRMgPny-k (Accessed August 18, 2014).
Catterall, J.S. (2002) 'The arts and the transfer of learning'. In Deasy, R. (ed.), *Critical links: Learning in the arts and students achievement and social development*. Washington, DC: Arts Education Partnership, pp. 151–157.
Catterall, J.S. (ed.) (1998) 'Involvement in the arts and success in secondary school', *Americans for the Arts Monographs*, 1(9), pp. 1–10.
CBC News (2008) 'Famous cellist claims story stolen by Canadian author', *CBC News*, [online] July 17. Retrieved from http://www.cbc.ca/news/arts/famous-cellist-claims-story-stolen-by-canadian-author-1.730813 (Accessed August 10, 2014).

Chopra, S. (2007) *The cellist of Sarajevo* [online]. Retrieved from http://www.lifepositive.com/the-cellist-of-Sarajevo (Accessed August 4, 2014).

Cohen, M.L. (2009) 'Choral singing and prison inmates: Influences of singing in a prison choir', *Journal of Correctional Education*, 60(1), pp. 52–65.

Cohen, C.E., GutiérrezVarea, R. and Walker, P.O. (eds.) (2011) *Acting together: Performance and the creative transformation of conflict*. New York, NY: New Village Press.

Cohen, D. and Crabtree, B. (2006) *Qualitative research guidelines project*. [online] Princeton: Robert Wood Johnson Foundation. Retrieved from http://www.qualres.org/HomeExtr-3808.html (Accessed July 18, 2014).

Deasy, R.J. (ed.) (2002). *Critical links: Learning in the arts and students achievement and social development*. Washington, DC: Arts Education Partnership.

Delors, J. (1996) *Learning: The treasure within: Report to UNESCO of the International Commission on Education for the Twenty-first Century* [PDF]. Paris: UNESCO Education Sector. Retrieved from http://unesdoc.unesco.org/images/0010/001095/109590eo.pdf (Accessed August 18, 2014).

Djurichkovic, A. (2011) *Art in prisons: A literature review of the philosophies and impacts of visual arts programs for correctional populations*. University of Technology, Sydney (UTS), Shopfront Student Series 3, UTS e-PRESS.

Freeman, W. (2000) 'A neurobiological role of music in social bonding'. In Wallin, N.L., Merker, B. and Brown, S. (eds.), *The origins of music*. Cambridge, MA: MIT Press, pp. 411–424.

Gergen, K.J. (1999) *An invitation to social construction*. Thousand Oaks, CA: Sage.

Gienger, V.G. (2003) 'Interfaith choir builds "spiritual bridges to heal division of war"', *Religion News Service*, [blog] January 1. Retrieved from http://archives.religionnews.com/search/YTo1OntzOjg6ImtleXdvcmRzIjtzOjc6ImdpZW5nZXIiO3M6MTE6InN1YXJjaF9tb2RlIjtzOjM6ImFsbCI7czoxMToicmVzdWx0X3BhZ2UiO3M6N joic2VhcmNoIjtzOjU6ImxpbWl0IjtzOjI6IjEwIjtzOjc6Im9yZGVyYnkiO3M6N DoiZGF0ZSI7fQ (Accessed August 18, 2014).

Ginkel, J. (2002) 'Identity construction in Latvia's "Singing Revolution": Why inter-ethnic conflict failed to occur', *Nationalities Papers*, 30(3), pp. 403–433.

Goleman, D. (1995) *Emotional intelligence*. New York, NY: Bantam.

Goleman, D. (2006) *Social intelligence*. New York, NY: Bantam.

Goleman, D. and Boyatzis, R.E. (2008) 'Social intelligence and the biology of leadership', *Harvard Business Review*, 86(9), pp. 74–81.

Goleman, D. and Senge, P. (2014) *The triple focus: A new approach to education*. Florence, MA: More Than Sound.

Grainger, S. (2011) 'Venezuela prison orchestra gives hope to inmates', *BBC News*, [online] August 7. Retrieved from http://www.bbc.com/news/world-latin-america-14050825?print=true (Accessed August 10, 2014).

Ippolito, L.M. (2008) *Collaborative vocal music-making – an innovative approach to conflict resolution and peacebuilding*. Masters thesis York University, Toronto, Canada.

Ippolito, L.M. (2015) *Changing our tune: A music-based approach to teaching, learning and resolving conflict*. PhD dissertation York University, Toronto, Canada.

Johnson, L.M. (2008) 'A place for art in prison: Art as a tool for rehabilitation and management', *Southwest Journal of Criminal Justice*, 5(2), pp. 100–120.

LeBaron, M., MacLeod, C. and Acland, A.F. (eds.) (2014) *The choreography of resolution: Conflict, movement and neuroscience*. Chicago, IL: American Bar Association.

Lederach, J.P. (1997) *Building peace: Sustainable reconciliation in divided societies*. Washington, DC: United States Institute of Peace Press.

Lederach, J.P. (2005) *The moral imagination: The art and soul of building peace.* New York, NY: Oxford University Press.

Makky, N. (2007) *Song in the Anti-Apartheid and Reconciliation Movements in South Africa.* Masters. Ohio State University.

Marković, I. (2004) *The history of Pontanima is a short story of reconciliation in Bosnia-Herzegovina.* Report on the Workshop 'Conflict Resolution from below'. *ASEM People's Forum V Hanoi*, [online] September 6–9. Retrieved from http://www.asienhaus.de/pub likationen/detail/the-history-of-pontanima-is-a-short-story-of-reconciliation-in-bosnia-herzegovina-report-on-the-workshop-conflict-resolution-from-below-asem-peoples-forum-v-hanoi-6-9-september-2004/ (Accessed August 4, 2014).

McNeill, W.H. (1997) *Keeping together in time.* Cambridge, MA: Harvard University Press.

Mills, A.J., Durepos, G. and Wiebe, E. (2010) *Encyclopedia of case study research.* Thousand Oaks, CA: Sage.

Musical Connections Program (2014) *Carnegie Hall-Weill Institute* [online]. Retrieved from http://www.carnegiehall.org/MusicalConnections (Accessed August 18, 2014).

Nissley, N. (2010) 'Arts-based learning at work: Economic downturns, innovative upturns, and the eminent practicality of arts in business', *Journal of Business Strategy*, 31(4), pp. 8–20.

Plato (360 BCE) *The Republic.* Translated by B. Jowett. Retrieved from http://classics.mit.edu/Plato/republic.html (Accessed August 18, 2014).

Riiser, S. (2010) 'National identity and the West–Eastern Divan Orchestra', *Music and Arts in Action*, 2(2), pp. 19–37.

Rooney, R. (2004) *Arts-based teaching and learning: Review of the literature* (report prepared for VSA Arts). Rockville, MD: WESTAT.

Ruppert, S.S. (2006) *Critical evidence: How the arts benefit student achievement.* Washington, DC: AEP.

Schumann, A. (2008) 'The beat that beat Apartheid: The role of music in the resistance against Apartheid in South Africa', *Stichproben. Wiener Zeitschrift für kritische Afrikastudien (Vienna Journal of African Studies)*, 8(14), pp. 17–39.

Sharrock, D. (2008) 'Out of the war, into a book and in a rage', *Australian*, [online] June 17. Retrieved from http://www.theaustralian.com/au/arts/out-of-the-war-in to-a-book-and-in-a-rage/story-e6frg8n6-1111116651859?nk=9283ac771ece8bb05308 8de1d6329b93 (Accessed August 8, 2014).

Smaczny, P. (director) (2005) *Knowledge is the beginning.* Documentary film.

Smailović, V. (1998) 'Memento Mori Albinoni Adagio'. In *Sarajevo Belfast* [sleeve notes] West Chester, PA: Appleseed.

Tannen, D. (1998) *The argument culture.* New York, NY: Random House.

Taylor, S. and Ladkin, D. (2009) 'Understanding arts-based methods in managerial development', *Academy of Management Learning & Education*, 8(1), pp. 55–69.

Thomas, K.W. and Kilmann, R.K. (1974) *Thomas–Kilmann conflict mode instrument.* Tuxedo, NY: Xicom.

Thomson, C. (1992) *The Singing Revolution: A political journey through the Baltic States.* London: Joseph.

Tongeren, P. van (ed.) (1999) *People building peace, 35 inspiring stories from around the world.* Utrecht, The Netherlands: European Centre for Conflict Prevention.

Tunstall, T. (2012) *Changing lives: Gustavo Dudamel, El Sistema, and the transformative power of music.* New York, NY: W.W. Norton & Company.

Ungerleider, J. (1999) 'My country is cut in two'. In van Tongeren, P. (ed.), *People building peace, 35 inspiring stories from around the world.* Utrecht, The Netherlands: European Centre for Conflict Prevention, pp. 297–301.

Urbain, O. (ed.) (2008) *Music and conflict transformation: Harmonies and dissonances in geopolitics*. New York, NY: I.B. Tauris.

Uy, M. (2012) 'Venezuela's National Music Education Program El Sistema: Its interactions with society and its participants' engagement in praxis', *Music and Arts in Action*, 4(1), pp. 5–21.

Vesilind, P. (2008) *The Singing Revolution*. Tallinn, Estonia: Varrak.

Vogt, H. (2004) *Between utopia and disillusionment*. New York, NY: Berghahn Books.

Washington, D.M. and Beecher, D.G. (2010) 'Music as social medicine: Two perspectives on the West–Eastern Divan Orchestra', *New Directions for Youth Development*, Spring Issue (125), pp. 127–140.

Welch, D. and LeBaron, M. (2006) *Arts, creativity and intercultural conflict resolution literature and resource review*. Vancouver: University of British Columbia.

Whitehead, B. (2008) 'We shall overcome: The roles of music in the US Civil Rights Movement'. In O. Urbain (ed.), *Music and conflict transformation: Harmonies and dissonances in geopolitics*. London, UK: I.B. Tauris, pp. 78–92.

Zander, R.S. and Zander, B. (1998) *Leadership: An art of possibility*. Cambridge, MA: Harvard Business Press.

9 Choreographing creative processes for innovation

Nina Bozic Yams

A personal experience working with choreographers allowed me to understand creative processes used by dancers, besides helping me discover my own body as a source of creativity and making me feel and see the world around me in new ways. This meeting with contemporary dance practice made me realize that experimenting with the body through creative movement gives access to hidden material, emotions, ideas, fantasy and other sources of creativity that are hard to access through cognitive processes and language alone. It also led me to discover a wide variety of concepts, strategies and tools offered by contemporary dance and choreography that can be used for facilitating creative processes and bringing new ideas into life. How could I put this insight into practice? This chapter presents an answer in the form of a conceptual model and empirical study.

Using dance and choreography as an artistic intervention

Knowledge from contemporary dance can become a source of inspiration for innovation in organizations (Bozic and Olsson 2013; Harrison and Rouse 2014). Many researchers have discussed (Adler 2006; Ladkin and Taylor 2010) and documented the positive effects of art-based approaches on organizational innovation (Barry and Meisiek 2010; Berthoin Antal and Strauß, 2013, and in this volume; Darsø 2004; Schiuma 2011, Schiuma and Carlucci in this volume). Many different art forms, especially organizational theatre, have been widely applied in organizations, but examples of artistic interventions using contemporary dance are rare. Meisiek and Barry (2014) suggest that taking into account embodiment can enrich theory in management and organization, which often assumes disembodied and purely cognitive actors.

In this chapter I contribute to the field of management and art-based work in organizations by exploring how contemporary dance and choreography could be used in organizations to help managers innovate in their own working practice and environment. After presenting a simple model of choreographic creative process and tools, I describe how I used them in an empirical study with employees from business and public sector organizations.

Contemporary dance and choreography

Contemporary dance raises important questions about new uses of body, space and time (Banes 1987/2012). It explores movement in many different dimensions without the limitations of one specific form, style or technique, but rather with the focus on the 'natural' and 'real' body (Hrvatin 2001). Contemporary dance is therefore accessible to people who have no previous training in a specific dance technique.

Spångberg (2013) suggests that choreography is a generic set of tools, a technology or a field of knowledge that can be used as expanded practice in other fields of life. Choreography deals with design of procedures that regulate creative processes and also organizes many heterogeneous elements in motion (Cvejic 2013). Thus it has the potential of being transferred into an organizational context, especially if it is seen as "the creative act of setting humans, actions, ideas and thoughts in relation to one another, to create order, channel energies, explore dynamics and create the conditions for something to happen" (Gormly and Klien 2005, p. 3).

Choreography and the dancers' creative process

Drawing on empirical data from semi-structured interviews with 20 choreographers (for more detail see Bozic and Köping Olsson 2013), and my practical experiences of working with choreographers in organizations, I developed a simple model of the logic behind dancers' creative process. It visualizes why, as Tim Etchells, a multidisciplinary artist and founder of Forced Entertainment, an experimental performing arts company, says, choreography can be defined as "organization of movement in time and space" (Corpus 2013). The model (see Figure 9.1) depicts four core choreographic tools (body and movement, space, time, and composition), which support and facilitate different stages in dancers' creative process depicted in the inner circle (tuning-in, exploration, reflection and sharing).

The figure has a circular form because dancers do not see their creative process from idea to final product or performance as a linear procedure, but rather as an iterative cycle in which all four stages are constantly present and shift between each other. Nevertheless, in different periods of the process there might be more focus on a specific phase. For example, even though tuning-in is a part of everyday preparation for creative work, it is more extensive and important in the beginning, when the group and common intention are still forming. Sharing predominates in the last part of the process when a performance is staged for the audience, but it also happens while work-in-progress is shown to smaller audiences to collect feedback. The generation and exploration of different ideas occur throughout the process, helping them to move towards the final composition of a dance piece. Choreographer and dancer Gregor Kamnikar (2012) stresses the importance of creative exploration and critical reflection by proposing that contemporary dance is the art of creating

Choreographing creative processes 151

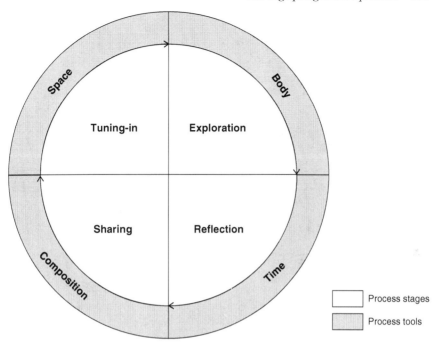

Figure 9.1 Dancers' creative process and tools

movement with a critical attitude of questioning people's understanding and experience of the world.

Tuning-in

Tuning-in or warming-up is used at the beginning of every workday and as the first phase in the creative process of contemporary dancers. When dancers start working on a project together, it is important that they tune into a common purpose or topic they are exploring. Group members also need to get to know each other and establish a feeling of trust and safety that will allow them to work in explorative ways, supporting each other to take risks in the process. In everyday work practice, tuning-in allows dancers to switch off existing thoughts and worries and brings them in connection with their mind, body and feelings, with the other group members and with the space or context in which they are working. It calms the mind, opens the group's creativity and helps focus on the present moment. Tuning-in can be done in many different ways, such as periods of silence, meditation or massage, as well as active interactions like a group coffee and dialogue, a very physical warming-up class or creative exercises and games. The method chosen depends on the needs of the group in each particular moment or stage of the process.

Exploration

Exploration is the core of dancers' practice that involves generating new ideas, trying out new things, testing, experimenting, learning, questioning and researching all the time. Most choreographers I interviewed use improvisation as the main strategy for building their explorative practice. They come to the studio with some proposals, but remain open to the group's needs and new ideas that emerge in the process. They can accept contributions from any of the group members. Some of the basic principles that dancers use to enable improvisation are openness and availability for new things that come, and a high sense of awareness or being present in the moment (in this volume see Brattström). The body and mind need to be curious and alert, trying to create from an empty space and forgetting about the judgments, expectations and patterns of the past. Listening is particularly important so that dancers can instantly act upon any signals they notice. Joyful traveling into unknown and risk taking are also important in improvisational practice. Everybody participates actively and builds on ideas of the others, following the principle of 'yes, and. . .'. This approach can create a feeling of creative flow in the group where different ideas and perspectives meet, merge and enrich each other.

Reflection

Reflection helps dancers move forward towards the final product in the creative process. It is practiced both individually and in the group in order to look back at the improvised material and understand what happened, why and what it means. An important part of reflective practice is giving and receiving feedback, both one-on-one and within the whole group. Such feedback must be constructive and focused on potential in the material so it does not kill the openness and trust in the process. Dancers say that sometimes giving feedback through body and movement can be much more constructive than with words because it avoids letting people fall back in their usual pattern of critical thinking.

Sharing

Sharing is the last stage in the dancers' creative process, partly occurring after the premiere of a performance. It is only once the dancers have completely invested themselves in their work and shared it with other people that they start to understand what the show is lacking and how they can make it better. But sharing also happens in earlier stages of the process when dancers invite feedback from outsiders they trust to give them a fresh perspective, unfettered by insider relations, goals and expectations. For dancers it is thus important to share not only their final product but also the process of creating it.

Choreographic tools

Space

Dancers are aware that a body always exists and moves in space, and is contained by space (Blom and Chaplin 1989), and also that the physical space they work in significantly influences their process (Schaeffer, Bozic and Backström, 2012). They may create or perform in different types of spaces, for example, a dance studio or playground or industrial hall, knowing that the particular space can bring new ideas into material and create different conditions for work or interaction with the audience. Dancers also use components of the space when experimenting with different levels of movement: high (jumping), middle (standing, *plié*, *relevé*) and low (lying, crawling, sitting) (Blom and Chaplin 1989).

Time

Choreographers use time as a matrix for coordination, measurement and calculation of things (Blom and Chaplin 1989). They play with tempo, which is the speed of the beat, and the duration or length of the movement. They use different accents, regular and irregular beats, momentum, and even stillness to create the dramaturgy in the flow of movement.

Composition

Composition provides the internal logic that holds both the creative process and the final piece of art together and makes it work (Blom and Chaplin 1989). Important elements of composition include transitions between movements, phrases and sections as well as sequencing, or combining phrases into larger units, with beginning-middle-end and climax (Blom and Chaplin 1989). Choreographers may use repetition, using the same movement backwards or turning it upside-down, condensing or expanding it, fragmenting it, changing its force or quality, changing the scenography or position of the audience; they also use compositional structures as frameworks to determine the structure of the entire dance performance (Blom and Chaplin 1989).

I now illustrate how we used the model of the dancers' creative process and basic choreographic tools in an action research project to enable innovation in organizations.

Action research project: applying a choreographic approach in organizational context

In 2013 I undertook a half-year action research project at Mälardalen University in Sweden together with a researcher in design, Jennie Andersson Schaeffer, and five choreographers from Sweden and Slovenia. In accordance with the principles of action research, where the goals are to generate new knowledge

to achieve action-oriented results and to educate both the researcher and participants (Herr and Anderson 2005, p. 54), we communicated to participants that the project was both a research study and a practice-based university course called "Culture and space for innovation". My objective as a researcher was to develop a new method for enabling practitioners from organizations to innovate, using choreographic understanding of innovation process and tools to test if and how they could be applied in organizational setting. The goal for participants in the course was to develop practical knowledge about innovation and create more innovative working environments for their teams through an experiential learning process.

Twenty-seven employees (eighteen women, nine men) from global companies Volvo, ABB and Outokumpu, local company Leine & Linde, the municipality of Eskilstuna, as well as our university, participated in the project. Most organizations were represented by small teams of three to four employees who voluntarily participated in the project with the support of a top manager. Participants were between 27 and 60 years old and had different levels of responsibility within their organizations. More than half of them had a management role.

During the half-year process there were six full-day workshops, held monthly, which represented the core events of both the research study and the course. After each workshop we collected data in the form of reflection stories written by all 27 participants as well as the members of the design and facilitation team (the two researchers and the five choreographers). In the last workshop participants also responded to a questionnaire in which they evaluated their experience of the whole course. An additional data source for my research are the notes I took throughout the project, covering my thoughts and observations as a co-designer and co-facilitator as well as my feelings as a participant in exercises led by the choreographers. After the workshops were finished Jennie and I read all the reflection stories and identified the topics that recurred most frequently in the stories. I also analysed the data from the questionnaires to see if it coincided with the reflection stories or added new perspectives.

Project design: principles and practice

We designed the course according to the choreographic model of creative process. It consisted of workshops and different activities between workshops. Because I wanted the process to enable change in participants' thinking and behaviour, I planned it to run for several months instead of as a one-time intervention. The intention was also to have enough time between workshops for participants to take in the knowledge and reflect on their learning. Each workshop started with some sort of tuning-in and then evolved into exploration of a specific innovation topic where creative exercises were balanced with reflection and discussion to help participants make sense of ideas and experiences gained through experimentation. My colleague Jennie facilitated the workshop dealing with the physical space for supporting innovation,

which is her area of expertise. The other workshops were facilitated by me and five different choreographers, with whom I developed exercises using their knowledge from dance in a way that would make sense for practitioners from organizations. I also tried to hold the whole process together by introducing the workshop topic, facilitating reflection sessions between more explorative artistic exercises and supporting participants in developing their own tools for stimulating innovation in their work environment after each workshop.

After each workshop we gave participants four homework assignments.

1 To perform a creative task that would challenge them to leave their comfort zone and practice creative thinking in everyday life. For these tasks participants received cards with creative tasks written by artists from the Fluxus movement from the 1960s and 1970s (Friedman, Smith and Sawchyn, 2002).
2 To test an idea or tool from the workshop in their daily work.
3 To write a personal reflection story about the experience from the learning process that had the greatest impact on them and to represent it with a picture or photograph.
4 To read a text related to the topic of the next workshop.

Throughout the process we encouraged participants to use not only their mind, but also body, movement, intuition and feelings. Participants reflected that the use of body and movement helped them engage in a more personal way and brought about different emotions. Often it was joy and passion but in some cases it was also fear, anger and frustration when an exercise felt too uncomfortable or when they could not understand how a specific exercise or activity made sense in their work context. Using body and movement also helped them to discover ideas and material that would not be possible to access only on cognitive level, and hence deepened their learning process. As one participant wrote in her reflection story: "what one learns with the body, stays in the body", and another wrote: "I learned a lot about myself – about my own limits and my hidden resources".

Throughout the process we also played with the concepts of space and time in different ways. Workshops moved from a theatre studio to the creative office space of a consulting company, to a factory site and an art museum. When possible, we varied the lighting and different objects or installations in the space to fit the topic of each workshop. Timing and rhythm were used in various ways, sometimes giving participants very short time spans of just a few seconds or minutes per task. The purpose was to stimulate action based on intuition and feeling, and to bring about unexpected ideas and material that would not be possible if people had time for analytical thinking. On other occasions we repeated the same activity or movement for a long time, so the participants would start to get bored and question why we were doing it, which would provide space for reflection and sense-making.

Examples of exercises inspired by choreographic practice

Two exercises illustrate how dance-inspired tools can be used in the organizational context: one connected to tuning-in and the other to exploration and reflection. In each workshop I welcomed the participants, introduced the choreographer and then switched roles to being a participant in some of the exercises. I draw here on responses from the participants as well as on my personal experience of the exercises, combining the description of exercises I wrote while I was designing the workshops with choreographers and my reflections after each workshop (which I present in italics).

Tuning-in through stop-and-go exercise

The purpose of the first exercise, which choreographer Dejan Srhoj facilitated, was to get to know each other in a new way, to tune into our innovation process and to form feelings of a group, common space, trust and safety. We also led a discussion around the importance of tuning-in as a part of every innovation process.

> *I could see some surprised faces when participants first entered our workshop space and found out it was not a usual university classroom, but a big empty theatre studio with a lot of space, some cosy corners with sofas and a big circle of chairs in the middle. After everyone found their place in the circle and Jennie and I had introduced the course, Dejan, the choreographer that day, asked everyone to put chairs on the side and to remove our shoes and any uncomfortable clothes. He invited us to walk through the space with a clear intention of where we were going so everyone would feel our intention and respond accordingly. At the beginning there were sceptical faces, and I could imagine questions like, "Aren't we here to learn about innovation and not to move around?" But after a short while everyone seemed to be absorbed by the simple movement tasks Dejan assigned. We first tried to become aware of our body and feelings. Then we shifted our focus to the physical space, exploring its qualities while moving around. We tried to observe details we wouldn't normally notice and look at them from different angles. Afterwards we brought attention to other participants, first on individual level, and then by observing the movement dynamics on the group level, while we were asked to walk forward, stop, walk backward, increase or lower the tempo or squat.*
>
> *After a while Dejan invited us to continue with the same movements, but now without a leader giving verbal instructions about when we should all stop, go forward, backward or squat. It took a while before we could make a group decision by using our feelings and intuition and not just by following a person who decided to make the first move. Then we explored a similar dynamic in small groups, which created a certain choreography of different groups moving in the same space, each having its own story yet at the same time meeting each other as one big group and creating a common flow.*

At the end of the exercise we shared our thoughts and feelings, and how experiences from the exercise connected to our daily work in organizations.

One of the participants wrote in his reflection that he was fascinated by how quickly a strong connection and openness was established in the whole group. He thought that doing something unusual together (like moving) and feeling a bit awkward actually helped group members to feel they were on the same boat. The fact that participants did not know each other also created less pressure and lowered their expectations to perform. He wanted to learn more about the mechanisms that enabled collaboration in the workshop and translate the same feeling of connection to the team in his company.

Participants' reflection stories and course evaluations showed that the tuning-in concept was one of the most common workshop activities that they tested in their work environment. Many of them wrote they learned that creating an innovative working environment and stimulating creativity in a team is not something that just happens or can be forced by the management. Tuning-in at the beginning of a workday or a meeting can help people connect, open-up and access their creativity. One participant described her experience of trying out the tuning-in idea with employees in production in her company: "They surprised me so much. They really trusted me to bring them through it. And they became different people. They went from being stressed people in their expert roles towards becoming team players and being ready to share ideas. I was happy, it worked!"

Action-reflection exercise

During our fourth workshop, which took place in a local factory, the choreographers Gustaf Iziamo and Alexander Hall facilitated an exercise that integrated creative exploration and reflection.

> *I felt a certain excitement about a workshop at a manufacturing site, being able to put on a yellow helmet and ride a train around the robots, machinery and different production workstations. Our day started calmly, in a peaceful room next to an internal courtyard. We began by writing individual reflections on our current situation in life and work and how they connected to our experiences in the course. Afterwards everyone was invited to take a walk in the nature around the factory site, staying silent and continuing with the personal reflection. When we returned, we each wrote a personal resolution or an action statement that described something we would like to do ourselves to encourage our creativity and innovative behaviour at work. I wrote on my post-it note: "Dare to take more risks!"*
>
> *Then Gustaf and Alex placed colourful objects like tape, scissors, post-it notes, balls, little animals and stickers around the room. They asked us to look at the statement on our post-it note for a minute and reflect what it meant to us and then start moving in the space and doing spontaneous actions connected to the statement on our post-it without thinking or analysing what we should do, just doing the first thing that came to us instinctively. We could also interact with and use the objects that were around us. I started to do all sorts of actions that I would usually not dare to do in a*

professional setting, like screaming, singing, destroying the objects – anything I associated with taking risks. Suddenly I realized that everyone was engaged in their own thing, some started to build little installations out of the objects, others were making strange movements or sounds . . . After three minutes we were instructed to stop and reflect for a minute about our actions and their connection with the statement on our post-it note. We continued by repeating the same short intervals of 3-minute explorative actions and 1-minute reflections five times. Gustaf and Alex encouraged us to focus on performing one clear action, so if someone observed us they could see our intention. I wrote different messages encouraging risky actions on post-it notes and stuck them on other participants.

After the action-reflection intervals we were divided in two groups and performed our actions for each other. Later we each chose a person from the other group, interpreted that person's movements, then reflected on the whole process with the person we chose to mirror. Finally we were asked to decide about a specific activity related to our statement on the post-it that we would do in our daily work to encourage innovative behaviour. I decided to write challenging notes and place them in public places at our university (like restrooms, kitchen, on copying machines) to encourage my colleagues and myself to take more risks and do surprising things. For example I placed one note in a kitchen cupboard that said: "What would happen if you turned round and sang a song to your colleagues?"

Although it felt that we were doing crazy things in the explorative process, in the end most people came up with very concrete ideas they could use in their work. The iterative process of action-reflection through movement helped us access new material and ideas in ourselves that we most probably would not come up with if we were engaged just on the cognitive level. One participant wrote that the experience made her think that people reflect far too little in new ways. She thought that when people get stuck in their thinking patterns they could use the body more to let thoughts flow like we did in the workshop. By giving space to imagination and letting it fly freely through movement, just doing something one feels like, things that are unconscious and normally not be accessible would come up to the surface. Through reflection people could then make sense of these experiences and get new ideas or see things in new ways.

Participants' evaluations of the process showed that the course made them step out of their comfort zone, thinking and behaving more innovatively, and it encouraged them to take more time for reflection, which they were missing in their daily work routines and packed schedules. Some comments illustrated how the course helped the participants develop explorative behaviour and reflection at work: "The course has made me dare go out of my world and take in me the world from outside"; "I now contribute to new solutions in different contexts by having a more open mind-set and the 'yes, and . . . attitude'"; and "I have become better at stopping and reflecting in my work and life, even when I'm stressed".

Participants' stories of dancing innovation in organizations

Two stories show how participants translated the choreographic tools into their work environment: a participant from a global manufacturing company tested the tuning-in concept in a meeting, and a manager from the local municipality facilitated an exploration for her team to stimulate new idea generation by moving through the city.

Tuning-in through Mozart

> I chose to test the idea of tuning-in at a meeting where I was the meeting leader. I decided to start the meeting with classical music. I'm not a big fan of classical music, so I searched YouTube and found a relaxing piece, Mozart's "Turkish March". There were five people attending the meeting: one was typing on his computer, one was closing the curtains and two were in a discussion. I told everyone to get some coffee and sit down and listen to me. Then I told them about the purpose of the meeting and asked them to listen carefully to the music and relax, reflecting on the purpose of the meeting, leaving all other things behind.
>
> At first they were laughing and making funny faces. I shut my eyes for a minute, listening to the music, and when I opened them again nobody was laughing anymore and there was a calm feeling in the room. When the music was over I asked them to reflect over the start of the meeting and how they felt about it. Their reflections were all positive: one said that this was just what he needed to calm down; another said he laughed at first, but then relaxed and enjoyed it; and the third person said that he would use this exercise since he often attends meetings with people who cannot concentrate. I decided I would try this again in the future – not at all meetings, but occasionally to create energy and get everyone in the same mood! And how did the meeting go? It was a success! We decided about something that we had been struggling with for two months.
>
> (Course participant 1)

Generating ideas through a city exploration

> One Friday morning the staff from the social services department gathered for a coffee break. I (their boss) invited them to something new that I called 'Idea break' (*Idéfika*) that would occur about once a month. I previously explained that our team would try out new approaches and that they would be subjected to various experiments during my participation in the course Culture and Space for Innovation. So everyone wondered what this would mean ...
>
> After the coffee break I asked the 15 people present in the staff room to sit comfortably in their chairs and try a relaxation exercise to let go of

their everyday worries. We closed our eyes and began to breathe slowly in through the nose and out through the mouth. . . . A feeling of calmness spread across the room. It was completely silent and we could only hear the sounds of our breathing. It was unusual, but it felt good to be quiet together, allowing everything be as it was. I sensed that everyone felt safe and good relaxing together.

After we 'woke up' again I spoke about the course and the basic idea behind innovative thinking and experimentation, and how we would try to work with it in our team. Then I gave everyone the task to divide into small groups of 2–3 people, go out to the city and take a creative walk. The assignment was to choose a public space or object in the city that caught their attention during the walk. Then they should think of how different kinds of people or animals could use the space or the object in new ways. The question was how we could add something unexpected, transform or give a new function to a park bench, bus stop, bicycle rack or to an entire square.

I wondered how my team would react to the task I gave them and whether they would think I was crazy. But I really shouldn't have worried because the groups came back excited and full of energy. The most amazing ideas emerged in our discussion afterwards, from very practical ones, such as an imaginative new design for the sandboxes, to a brand new concept for a square in which different parts would be rebuilt and used in new ways. The reflection afterwards showed that everyone enjoyed the exercise and it was fun to unleash their imagination. I was impressed by the inventiveness and abundance of ideas everyone contributed. I discovered a new side of my colleagues I didn't know and found out I shouldn't be worried about the creative potential of employees in our municipality.

(Course participant 2)

Discussion

The examples from workshops and stories of how employees translated their experiences into their working environment show how knowledge from contemporary dance can be applied in an artistic intervention. By using the dancers' model of the creative process and choreographic tools, employees gain another way of experiencing and thinking about innovation in organizations.

The participants realized that creativity and innovation were hard to steer or demand, but it is possible to create conditions that enable them. One way is by taking time to start a process with tuning-in and continuously practicing improvisational ways of working in a group. Many participants tested different tuning-in exercises, especially in meetings. They received generally positive feedback from colleagues and reported that they reached better results than usual. Reflection stories contained examples of using the iteration of exploration and reflection in creative process, as the case of idea generation through city exploration shows. Participants appreciated being challenged to dare to

go out of their comfort zone to explore ideas in new ways, followed by taking time for reflection. They missed both these activities in their work and started to practice them more after their experience in our study. A follow-up study should document how long participants are able to maintain these innovative behaviours.

The results also reveal limitations to applying the choreographic model and tools in organizations. The examples of how employees tried to use the body, space and time in new ways show that they did not dare to go very far in their experiments, especially in terms of using creative body movement. Although many used physical space and body positions in new ways in their experiments, for example by having a meeting or planning session in a garden, sitting in a circle instead of around a table, brainstorming while walking through a city, nobody tried out exercises that used the body and movement in such free and creative ways as we tried it in the workshops. Even in workshops I felt we were often limited by specific goals or the expectation that everything we did needed to be applicable in everyday work.

In my previous personal experience, the immersion in dance processes helped me move radically away from my usual work practice as a manager and achieve a personal transformation that in turn influenced my work practice. It resulted also in reconsidering my future career options and starting my own company to be able to work more freely and in the way I wanted. However, I think such changes are harder to reach in artistic interventions in organizations. It takes time for people to really open up, learn to work with a new medium (body and movement) and dare to go radically beyond established work practices. But long-term artistic interventions on strategic level that strive towards organizational transformation are still quite rare.

Conclusion

The results of my research show that concepts and tools from contemporary dance and choreography can provide new insights and concrete suggestions for enabling innovation in organizations. The uniqueness of dance compared to other art forms is that there is no external medium, such as pencil, musical instrument or film, through which meaning is produced: the body itself is the medium, and as such is in immediate relation to the self (Monnier and Nancy 2005/2012, p. 68). The body in contemporary dance is not subdued to a role, imitating a character, as it is in theatre, but is anonymous (Badiou 1993/2001). Many theatre-based artistic interventions in organizations stage problematic situations in organizations and then try to find new solutions by acting out various scenarios. By contrast, dance-based interventions can help practitioners connect with their creativity and intuition by using body and movement freely in order to escape the roles they usually play in organizations and access new sources of their fantasy, ideas and emotions stored in the body. Choreographic tools can provide frames and structures to guide the creative process and can increase awareness and knowledge about using body,

movement, space, time and composition in innovation processes. Whereas in organizations people are usually driven by external expectations, goals and performance indicators, dance methods can help shift the focus from the outside to the inside, and start from what the body tells people they really feel and need in the moment. Through creative movement, the knowledge that would not be reached linguistically or cognitively can be accessed because the body is intuitively able to communicate what cannot be expressed in words (Hujala, Laulainen and Kokkonen 2014, p. 44). It reveals things about behaviour that a person is not aware of, and it stimulates unconscious and unknown emotions that find means of expression through bodily movement (Hujala et al. 2014, p. 50).

But there are also various challenges to working with dance-based interventions. The action research study shows that engaging body and movement involves people on a very personal level, evoking a variety of emotions and questions. Although joy and passion often emerged in the process, some participants also experienced fear, anger and frustration. It is therefore important to learn how to provide a safe environment for employees not only to open up but also to deal with emotions and issues that emerge in the process.

Another challenge in the study was how to find the right balance between encouraging participants' innovative thinking and behaviour by using choreographic concepts and tools, and going beyond the threshold of what they experience as too unusual and uncomfortable. When this happens, participants cannot make sense of their experiences. However, if choreographic methods are used in too simplified a way, they may not have a profound impact. Additional questions about the limits of dance-based methods merit further exploration: Do they work for all individuals and organizations? Or are they only useful for specific people, types of organization, sectors and cultural environments?

Even though many open questions remain, I believe that methods from contemporary dance have the potential of engaging people from within, cognitively, emotionally and bodily. They can provide space for transformation on personal and organizational levels because, as Scharmer (2009) says, radical change and innovation can only happen if we shift the place from which we operate.

References

Adler, N.J. (2006) 'The arts and leadership: Now that we can do anything, what will we do?' *Academy of Management Learning and Education*, 5(4), pp. 486–499.

Badiou, A. (1993/2001) 'Ples kot metafora misli [Dance as a metaphor of thought]'. In Hrvatin, E. (ed.), *Teorije sodobnega plesa* [Theories of contemporary dance]. Ljubljana, Slovenia: Maska, pp. 25–37.

Banes, S. (1987/2012) 'Terpsicore in sneakers'. In Lepecki, A. (ed.), *Dance*. Cambridge, MA: MIT Press, pp. 43–47.

Barry, D. and Meisiek, S. (2010) 'Sensemaking, mindfulness and the workarts: Seeing more and seeing differently', *Organization Studies*, 31(11), pp. 1505–1530.

Berthoin Antal, A. and Strauß, A. (2013) *Artistic interventions in organisations: Finding evidence of values-added*. Creative Clash Report. Berlin: WZB. Retrieved from www.wzb.eu/sites/default/files/u30/effects_of_artistic_interventions_final_report.pdf (Accessed January 24, 2015).

Blom, L.A. and Chaplin, L.T. (1989) *The intimate act of choreography*. London: Cecil Court.

Bozic, N. and Köping Olsson, B. (2013) 'Culture for radical innovation: What can business learn from creative processes of contemporary dancers?' *Organizational Aesthetics*, 2(1), pp. 59–83.

Corpus (2013) *Theme: What is choreography?* Retrieved from http://www.corpusweb.net/thema-theme-7-was-ist-choreografie-what-is-choreography-2.html (Accessed January 30, 2014).

Cvejic, Bojana (2013) 'Proceduralism'. In Cvejic, B. and Pristas, G.S. (eds.), *Parallel slalom*. Belgrade, Serbia: Walking Theory, pp. 236–248.

Darsø, L. (2004) *Artful creation: Learning-tales of arts-in-business*. Frederiksberg, Denmark: Samfundslitteratur.

Friedman, K., Smith, O. and Sawchyn, L. (eds.) (2002) *The fluxus performance workbook*. Performance Research e-Publications. Retrieved from http://www.deluxxe.com/beat/fluxusworkbook.pdf/ (Accessed January 5, 2013).

Gormly, J. and Klien, M. (2005) *Choreography as an aesthetics of change*. Limerick, Ireland: Framemakers, Daghdha Dance Company.

Harrison, S.H. and Rouse, E.D. (2014) 'Let's dance! Elastic coordination in creative group work: A qualitative study of modern dancers', *Academy of Management Journal*, 57(5), pp. 1256–1283.

Herr, K. and Anderson, G.L. (2005) *The action research dissertation*. Thousand Oaks, CA: Sage.

Hrvatin, E. (2001) 'Introduction'. In Hrvatin, E. (ed.), *Teorije sodobnega plesa* [Theories of contemporary dance]. Ljubljana, Slovenia: Maska, pp. 7–12.

Hujala, A., Laulainen, S. and Kokkonen, K. (2014) 'Manager's dance: Reflecting management interaction through creative movement', *Work, Organisation and Emotion*, 6(1), pp. 40–57.

Kamnikar, G. (2012) *Zmes za ples* [Mix for dance]. Ljubljana: Javni Sklad Republike Slovenije.

Ladkin, D. and Taylor, S. S. (2010) 'Leadership as art: Variations on a theme', *Leadership*, 6(3), pp. 235–241.

Meisiek, S. and Barry, D. (2014) 'The science of making management an art', *Scandinavian Journal of Management*, 30, pp. 134–141.

Monnier, M. and Nancy, J. (2005/2012) 'Alliterations: Conversations on dance'. In Lepecki, A. (ed.), *Dance*. Cambridge, MA: MIT Press, pp. 68–70.

Schaeffer, J.A., Bozic, N. and Backström, T. (2012) 'The physical space as an artifact of innovative culture – Findings in art and manufacturing industry'. Paper presented at the *28th EGOS Colloquium*, Helsinki, July 2012.

Scharmer, C.O. (2009) *Theory U: Leading from the future as it emerges*. San Francisco, CA: Berrett-Koehler Publishers.

Schiuma G. (2011) *The value of arts for business*. Cambridge: Cambridge University Press.

Spångberg, M. (2013) *Dance and the museum: Mårten Spångberg responds*. Retrieved from www.movementresearch.org/criticalcorrespondence/blog/?p=8100 (Accessed July 21, 2014).

10 Playing the 'Magic If'

A theatre director's perspective on intervening

Victoria Brattström

Point of departure

Since 2007, I have applied my work as a professional actor and director in several assignments in organizational intervention projects. I have discovered that the interplay between working in traditional settings within my artistic field and venturing into organizational settings outside my field to be most rewarding. As the artist in the intervention I provide the organization with new perspectives and I receive new perspectives from the organization. The unfamiliar context of the organization encourages me to find alternative ways to combine perspectives and techniques used within my artistic practice. Also, the practical collaborative encounters, as part of the artistic intervention process, provide ways to confront ideas and preconceptions about what an artist is as well as what an artist does. I believe my experience with artistic interventions has played an important role in my attempts to more fully understand and articulate artistic knowledge and skills that are activated in my own profession.

Here I present an example of my work as the artist in an 18-month long artistic intervention project conducted in a mid-sized Swedish municipality during 2010–2011. The project was part of a European inter-regional project KIA, with TILLT (www.tillt.se) as the Swedish intermediary organization. The municipality wanted to find ways to support their service managers in their work with diversity in all its forms. I worked with a group of the municipality's service managers. We used methods and perspectives from the performing arts to investigate different ways of seeing and working with the municipality's ethics and values concerning issues on human diversity in the workplace (for example, non-discriminatory policies with concern to ethnic origin, gender, age, disability, sexual orientation or social economic circumstances).

From the outset the project's objectives were not defined as a specific task or as producing a certain product. The service managers and I started with a list of what the municipality's director and TILLT had agreed together to be primary needs. These included gaining a more thorough understanding of how a diverse work force can contribute to growth, job satisfaction, creativity, better communication and innovation; investigating how to expand the individual's comfort zone in order to be more tolerant within a multicultural society; and

examining power structures in relation to a multicultural society and the rights of the individual. Activities were mainly in the form of workshops, sometimes with invited guests with special competences. I also visited participants' places of work, where I conducted interviews, collected research material and organized discussions on selected topics.

In this chapter I focus on an episode about halfway through the intervention when participants lost confidence and started to question the project. In order to take an analytical stance, I fictionalize the critical moment in the intervention process, comparing it with a critical situation just before a significant turning point in a play or a film, as a turning point where decisions taken and subsequent actions will have a profound influence on the future direction of the story. The critical moment presented a situation where I, in my role as facilitator, had to improvise based on my professional experience.

The chapter is structured in three sections. First I introduce the theory and practice that I use in my theatrically based work and applied in this artistic intervention. In the second section I present my artistic inquiry into the critical moment in the intervention process, using an autobiographical narrative in the form of two scripted scenes and epilogue. The first scene, describing the situation of the participating managers questioning of the project is followed by a scene displaying stages of my cognitive process as actor and director attempting to comprehend the underlying reasons for the participants questioning. The two scripted scenes are interspersed with commentary in a voice-over that traces my reflections and intuitive actions during this process and compares them with work strategies used by actors and the director during a rehearsal at the theatre. The epilogue briefly describes subsequent actions based on insight, the steps taken in the project to re-define objectives and regain confidence in the project, followed by a short description of the remainder of the project. I then apply theatrical concepts to analyse and discuss the case and end with concluding reflections.

Theory and practice in a theatrical setting

In my work as an actor and director and in artistic intervention projects I rely on theoretical constructs and practical skills acquired in my artistic training. Here I introduce two central concepts, the 'Magic if' and the 'Given Circumstances', which are part of the system of acting techniques developed by Russian actor and theatre director Konstantin Stanislavski (1863–1938) (Stanislavski and Benedetti 2008, 2010). These two intertwining concepts function as practical tools in my profession as actor and director.

Stanislavski's concepts

Central to the Stanislavski system of acting techniques is the idea of 'acting as action', referred to as the Method of Physical Action. Stanislavski's work

primarily deals with actors' strategies when they collaborate with the director during the rehearsal to interpret the written play script through their actions. This process turns the text into the resulting performance and also keeps that performance alive and fresh when repeatedly performed in front of an audience.

> Everything that happens onstage must occur for some reason or other.... Acting is action. The basis of theatre is doing, ... So, drama is an action we can see being performed, and, when he comes on, the actor becomes an agent in that action.
> (Stanislavski and Benedetti 2008, pp. 39–40)

Stanislavski uses the example of an actor sitting motionless on stage to point out that the actors' actions can appear as both physical (outer) and mental (inner) actions. The actor is not necessarily being passive – he or she can "nonetheless be fully active, not outwardly, physically, but inwardly, mentally." (Stanislavski and Benedetti 2008, p. 40).

Magic If and Given Circumstances

The concept of the "Magic If" and the concept of the "Given Circumstances" (Stanislavski and Benedetti 2008 p. 53) could be described as two interdependent fields of energy in the rehearsal process. Analysing the Given Circumstances could be a starting-point to formulate the Magic If. By formulating the Magic If in a certain way the actor will be urged towards a specific action or actions. This, in its turn, launches a creative process that can help the actor and the director to further recognize, interpret and specify the Given Circumstances. By the use of these two concepts it is suggested that the actor builds her (or his) interpretation of the role by assuming she finds herself in the role's situation, asking herself, "If I am under the circumstances given in the play script, what would I do, and how would I do it?" The inherent power of the Magic If is that it is a hypothesis generating a question that is answered by the actor in the form of action onstage. For example, an actor is presented with the hypothesis that a 'mad man' is knocking at the door of her apartment. The actor could intuitively respond to the situation with a number of different actions, such as trying to jump out of the window, hiding behind the couch, freezing in the middle of the room, or just opening the door and saying, "Welcome!" The response she chooses depends on her interpretation of the Given Circumstances relevant to the character's situation in the scene.

The meaning of the concept of the Given Circumstances can be understood as:

> the plot, the facts, the incidents, the period, the time and place of the action, the way of life, how we as actors and directors understand the play, the contributions we our selves make, the mise-en–scène, the sets and costumes,

the props, the stage dressing, the sound effects etc., etc., everything which is a given for the actors as they rehearse.

(Stanislavski and Benedetti 2008, pp. 52–53)

During a rehearsal when the actors and the director interpret the dramatic text, actors, propelled by the Magic If, physically try out actions on stage with the director watching and interpreting, followed by sharing reflections on the experiment. In this way the actor comes to understand the objectives, thoughts and feelings of the character, and ultimately a thorough understanding and interpretation of the play script is created. Within the framework of their partnership, the actor and the director use different functions based on their specific expertise.

The Stanislavski Method of Physical Action suggests that it is through the actions executed that the situation is understood and the character created. Thereby the concepts of Magic If and Given Circumstances function as means for both analysing the dramatic situation and creating a character. In this way, my experience exploring and analysing dramatic situations as an actor and director is key to how I analysed the critical moment in the organizational intervention project. I was able to analyse the scene and understand what was actually happening in the intervention process through re-enacting the situation by rehearsing the participants' roles on the stage of my mind. I came to understand the critical situation by going back and forth between an actor's perspective and a director's perspective on the situation. Taking as a starting point my own acting and directing approaches, I describe this process below through an interplay of two phases that I call (1) Playing and game and (2) Negotiating the rules of the game.

Interpreting by playing: the actors and director's co-creative 'rehearsal game' of staging

The rehearsal process begins with pre-rehearsal preparations where the actors and the director separately read and familiarize themselves with the script. Then follows the staging process in the rehearsal room when the actors' and the director's prepared interpretations of the script merge into what will be the resulting performance experienced by the audience. The actors' movements, gestures and intonations are established for the performance in an intricate interplay between the actors and the director. They explore different perspectives on the text material through a series of practical try-outs, each followed by the actors and the director reflecting on the experiment, sharing and comparing their different experiences. Then they adjust the Given Circumstances or 'the rules of the game' based on their shared observations and experiences before trying out the same situation again with new or adjusted circumstances. Through this dialogue between experiments and reflections ideas and meanings interpreted in the text come to the surface and finally come to life through the physical actions of the actors.

This rehearsal-game of staging is characterized by interplay between two phases, here called "playing the game" and "negotiating the rules of the game". The phase of playing the game is initiated by the director's command "Action!" During this phase both the actors and the director make use of the Magic If as a condition for the play mode, so the "what if" is easily translated to "let's play that . . ." (Rynell 2003, p. 127). The actors play as if in the situation of the character, while the director plays the role of a future audience member. The director asks herself, what if, or more accurately, let's play that I sit here, in the auditorium as member of the audience and have no idea about what will happen next in the story of the play – How would I then perceive what I see in front of me on the stage?

It is also the director who decides when it is time to end the phase of playing the game and shift to negotiating the rules of the game. This is done by the director's words, "Thank you, and . . . cut!" During the phase of negotiating the rules of the game the actors and director discuss what they have noticed while playing the game. It is during this phase that the rules of the game, that is, the Given Circumstances relevant to the dramatic situation, are verbalized and reformulated. The actor and the director negotiate the rules of the game from the perspective of their professional roles. When a new or reformulated set of rules is agreed upon it is again time for the director to initiate a new round of playing the game.

Key competencies in my artistic practice

On the bases of the above discussion I have come to understand the Stanislavski Method of Physical Action and the concepts of Magic If and Given Circumstances as foundational building blocks to two central competences of my artistic practice as actor and director. I call these (Competency A) The ability to recognize Given Circumstances at play, and (Competency B) The art of modifying Given Circumstances at play.

Competency A: The ability to recognize Given Circumstances at play

The actor works with strategies and training to make her/himself physically and mentally receptive to Given Circumstances relevant to the dramatic situation. The director can also use this ability when working with the text during her/his pre-rehearsal preparation, and continue to use it in collaboration with the actors when deciding if the rehearsal process is moving towards the artistic vision of the desired performance.

Competency B: The art of modifying Given Circumstances at play

During the rehearsal the actors and director work together to recognize Given Circumstances relevant to the dramatic situation. These are then modified, adapted and reformulated in relation to what the actors and director understand

to be the various characters' objectives. During this process the characters' objectives are also often re-examined and adapted.

Thus the actors and director together explore, re-interpret and reformulate circumstances suggested in the dramatic situation. Their aim is to define a specific set of circumstances that enables the actor's body, as an instrument of communication, to create a performance that is coherent with what they envision should be expressed to the audience. The actor's proficiency in using her/his body facilitates a more precise communication with the director during this process. The director must also be skilled at recognizing and understanding relevant Given Circumstances so that s/he can work with the actors to interpret the Given Circumstances from different perspectives. Proficiency in Competency B thus builds on skilfulness in Competency A.

In the next section I undertake an artistic inquiry into the critical moment in the intervention. I do so by writing the story as if it were a film script. This approach allows me as the artist (and now you the reader) to observe the interaction in a fresh way and to gain insights that I needed in order to advance the process at the time. This format is unusual for organization studies and requires the reader to follow multiple kinds of writing and various voices. In my role as screenwriter I describe the setting at the outset and provide instructions on significant actions within the scene at various other points in the text. I refer to myself in the third person as the artist, and I give the participating managers fictitious names. The script includes my – the Artist's – comments and reflections on the scenes presented as a voice-over or off-camera commentary. It is presented in a modified version of a traditional film script.

MOMENTS OF CRISIS AND INSIGHT

Two scripted scenes with artist's voice-over

Scene 1: Interior of a seminar room - daytime

In the centre of the room 11 chairs are arranged in a circle. The Artist is alone in the room. She is hastily hanging up document boards with texts and photos so that they enclose the circle of chairs.

A big clock hanging over the doorway entrance ticks loudly towards 10:00 a.m. as the Group of Participating Managers enter the room: six women and four men, ages ranging from 35 to 60. They take off their jackets and move towards the circle of chairs. The camera pans over the document boards: a collage of photos and citations, arrows, crossing outs, underlines and sketches on the themes of diversity and equality.

The artist (commenting voiceover)	When I recollect this scene, aiming to trace elements of acting and directing, the first thing that catches my attention is the ring of chairs. During the rehearsal process at the theatre this is a formation I use as director as often as possible. I think it is a good way to sit during a creative process. The distance to the centre of the circle is the same for everyone; we all see each other's bodies and can best capture body language signals. I envision that it is my practical experience from the process of staging in the rehearsal room that has led me to choose this form when preparing the workspace for the intervention. And I assume that this experience of interpreting and evaluating physical information in a theatrical context also became a factor at play in the events that now followed.

The group sits down in the circle. The Artist goes through the plan for the day. She pauses and looks around in the circle.

The artist	Is there anything of relevance to the project that someone is thinking and wishes to share before we get going?

This question is answered by a sudden feeling of charged silence in the room before one of the participants Mr H, clears his throat.

MR H	I . . hrm . . I have been doing some thinking . . lately, and I just wonder, hrm, what all these . . these efforts will lead to in the end, more exactly?

MRS E *(cuts in)*	Yes precisely! And my question is: Is this an issue that is really important for the administration, anyway? I mean does the Municipality really want change, or are we just doing this more or less as a show-off, in order for the Top Management to be able to say 'They are addressing the issue'?
MRS B *(fills in)*	Exactly! How can we be expected to succeed with this project when we, this group, aren't even in any sense of the word diverse? I mean look at us . . . ethnically, when it comes to age, when it comes to education et cetera, et cetera?

Suddenly the atmosphere in the room is heated. It is clear that feelings that have been dammed up are now released. There is a flow in the room as the participants express frustration and continue to question the project in various ways. The Artist reaches for her pen and her notebook. Her posture is very alert, upright.

The artist (commenting voiceover)	*I remember thinking, 'Good! Here we are in the process, finally!' I compared this situation with what in the theatrical rehearsal context we may refer to as a creative artistic crisis: A critical situation that if not acknowledged risks ruining the whole project, but also holds the potential to move the process forward and take it to new levels by generating knowledge and insights.*
	Intuitively sensing that what was now about to take place in the workshop room could contain information of great importance for the project, I saw my task to be assuming a director's role of being a good listener and observer. With the same focus as during a rehearsal at the theatre, I therefore concentrated on trying

> *to capture the situation as accurately as possible. I turned on my internal camera, switched to a theatrical mode of observation and put myself into a state of heightened attentiveness towards the situation. Then information went through my body coming out as sketches, written phrases and comments in my notebook. I was now acting as a director in the rehearsal-room when focused on capturing impressions of the scene in my director's notes.*

The artist writes intensively in her notebook. Once or twice she askes a clarifying question, mirroring back certain statements from the participants, but otherwise does not interfere with the discussion.

Close up on the Artist's notebook. She writes, "a heavy pressure throughout the room". Quickly she draws a cloud with arrows pushing the group down. Her sketch indicates how the participating managers' statements seem to originate from this cloud.

In the notebook we also find statements and specific expressions used by the participants during the discussion, mixed with observations like: "Dropping their guard", "Saying things to each other that must have been impossible earlier" and "a degree of trust in the group gained through this process".

It is Mrs E who drives the scene now, as she has taken over from Mr H and the discussion has taken a turn toward questions on deployment of methods in the project. Close-up of Mrs E.

MRS E	And how do we actually use your artistic competence in this project, anyway?
MR A (cuts in)	Yes, since you are a director maybe we should instead work with theatrical scenes about diversity? For example, act out a scene for the Municipality Director's Top Management Team?

Carefully writing down Mr A's suggestion in her notes, the Artist answers him that it is, of course,

possible to change strategies concerning the use of artistic methods in the project, but that she is not sure, right now, if that would be the best way to tackle the situation. She suggests that they wait with making a decision, but keep the idea on the back burner. She assures Mr A that she has made a note of it and says that they will revisit it. Mr A seems to be content with this answer and the group continues to discuss the situation from different perspectives.

The artist (commenting voiceover)	During a rehearsal process at the theatre, as the director I am faced with a continuous flow of decisions to take. Each decision requires juggling of the actor's suggestions, i.e., what is seen in front of me on the stage during the present rehearsal, and an idea about how this specific suggestion would influence the final performance in the future.
	If it is not clear to me whether a proposal from the actors would lead towards or away from the desired vision of the future performance, from my experience it is best to postpone the decision, and put it on the back burner, so to say. Then the rehearsal can be continued. The scene can be further explored and I as the director can digest the specific proposal in perspective to a more thorough understanding of the dramatic situation rehearsed, relating this particular situation to the story as a whole.
	When the process is in a good flow, it may also be the case that I as director intuitively know that a certain decision will lead to progress forward; it just feels right, but the motivation for this decision cannot

yet be verbalized. The actors may then accept following my instructions before getting a verbal motivation for a certain action if the actors and I have created a sufficiently trustful and playful work environment. This saves time in the rehearsal process and may therefore have a direct effect on the final results. It may actually also be easier for the actor to comprehend a verbal motivation for a certain action after s/he has had the physical experience of performing it.

In the intervention process when I was faced with Mr A's suggestion of changing strategies and instead work with acting out theatrical scenes I remember my intuition telling me, 'No, solely changing the deployment of artistic methods would not be most efficient way to meet this crisis,' but I could not immediately verbalize why I felt that way. Therefore, I chose to postpone the decision so that the process of questioning could continue in a flow and instead I could concentrate on just trying to capture the content within the scene.

The discussion is still charged with energy as the big clock hanging over the doorway entrance ticks towards 11:00 a.m. The artist decides to put aside the planned workshop activities and instead use the time to continue the discussion as long as necessary.

Scene 2: Interior of train compartment – daytime. Two hours later

The artist is on the way home after the workshop. She enters the compartment, sits down on the seat and pulls out her notes from Scene 1. Concentrating, she

goes through the notes, reading them over and over again. Sometimes she takes a break and looks out the window. We see her lips moving. She is quietly talking to herself while lost in the passing landscape outside the train. Then she takes a deep breath and dives into the notes again.

The artist (commenting voiceover)	*I recall the event and go through it over and over again. I re-enact it on the scene of my mind, in order to be able to grasp what is implicitly at play in the situation. By trying the participating managers' words as I remember them and with support from my notes, I try to see the scene from different angles. In this manner, I explore the situation from the participating managers' perspectives and ask myself: How does it feel? What pictures, feelings and thoughts are emerging?*
	As when working on a manuscript, I also alternate between an actor's way of identifying with a certain character's perspective of the situation and a director's way of trying to grasp the content of the scene in relation to the whole story. Associations are emerging, as they do when working on a play script. Keywords and themes keep bubbling up to the surface and I add these into my director's notes – my script. What I keep coming back to is the cloud I drew in my notes with the arrows pointing down at the group: what does it represent?
	Then suddenly I am transferred back in time to a conversation that took place two weeks earlier. It was on the day we had presented our work-in-progress to the Municipality Director's top management team.

On my way home after the presentation I met Mr T, one of the team members, on the train. When this memory is replayed in my mind it takes the shape of a flashback scene in a movie.

Flashback

A medium shot of Mr T and the Artist standing in a crowded train carriage and talking intensely about the presentation and the workshop earlier that day. Mr T is genuinely interested in the project and asks questions about how things are going. The conversation seems to flow smoothly. Zoom in to a close up on Mr T's face as we hear him say:

MR T	Well, diversity is a large and complex issue to resolve, but if you succeed you have the opportunity to achieve a substantial change with this project.
The artist (commenting voice-over)	*In my resurrected memory I choose to freeze the frame right here, in the middle of Mr T's sentence. I realize that this is the key moment and what drew me to this memory. Therefore I now direct my attention towards my own physical experience of this moment. What was I feeling? How were his words affecting me?*
	On an intellectual level I knew that T's intention was to support and encourage me in my work with the intervention project, but on an emotional level what he said made me feel anxious. I felt an overwhelming pressure to succeed in the expectations of the project.
	This feeling of anxiety and pressure, resurrected in my memory, is what transports me back to the drawing in my director's notes. And makes

me recognize the same feeling of anxiety and pressure present in the room during the group's questioning of the project.

I realize this feeling of pressure coming from demanding but vague expectations about the project is represented in my drawing of the cloud. I interpret this feeling as the origin of the group's concerns and as a driving force behind their questioning of the project.

Back to Present

In the train compartment, we see the Artist still turned toward the window, lost in her thoughts. Suddenly she seems to wake up from her daydreaming. She looks drowsily around the compartment, puts aside her notes and picks up her computer. She opens the screen, turns it on and begins to eagerly write down her thoughts.

The artist (commenting voice-over)	*I now shift from the acting strategy of exploring the situation by enacting it and instead begin to use the director's perspective of trying to see the process as a whole. I make this shift in order to compare the feeling I recognized as pressure coming from perceived expectations of the project with what is actually known about factual expectations of the project.*
	This shift allows me to conclude that we, as a group, are hindered in our process by an idea of what we believe is expected of us – an idea that does not match actual expectations. If the objective of the intervention project had been to deliver a policy document with

> guidelines for how service managers should handle questions of equality and diversity, then the group's concerns would have been most warranted. We would have been a badly formed group who used our time inadequately. But this was not our task. On the contrary, the municipality decided to invest in this project in the hope that by using unconventional methods they would generate results that otherwise would not have been possible.
>
> I write down this interpretation of the situation and my conclusion in order to be able to share and discuss it with the group. If the group finds my interpretation relevant and in accordance with their own understanding of the situation, we could revisit, reformulate and specify our objectives, adjusting them to realistic expectations on the outcomes of the project, then make decisions about changing or keeping work strategies such as the deployment of artistic methods in the project.

The tiredness previously noted in the Artist's face is now gone. Zoom out as she types excitedly.

End of Scripted Scenes

Epilogue: action from insight

My intent was to initiate actions to re-define the projects' objectives, regain the whole group's energy and renew confidence in the project. During the pause in the workshops I worked closely with the process group, consisting of four of the participating managers and me, which met regularly as a steering committee throughout the intervention. This work resulted in a suggestion to restate and specify the project's outcome as, "Documentation of the group's experiences when exploring questions of equality and diversity in relation to

their everyday work-practice within the municipality, and ideas about the challenges and opportunities arising from this exploration". At the next scheduled workshop, after approval by the municipality director, the whole group of participating managers agreed to move forward with this plan. The group of participating managers regained its confidence and trust in the project, so this agreement marked the turning point of the critical situation. Now work could continue with renewed energy and we were able to decide what we would do to complete our task.

The participant group, under my guidance, created a public exhibition at the entrance of the town hall to present the results of the project. The exhibition included two documentary films showing workshop activities and interviews with the participants, and photographic artwork created in collaboration with a professional photographer where participants reinterpreted and re-staged photographs chosen from the local archives. It also included participants' images of their workplaces interwoven with documents concerning the municipality's diversity policies, and conclusions made by the group about obstacles and opportunities for the municipality's future work with these questions. After the exhibition the material was transferred to a digital platform as a resource for further work on diversity and equality in the municipality.

Analysis and discussion: application of theatrical concepts

During the organizational intervention project I used acting and directing competences to tackle the critical situation. I also used an interplay between the two phases of a rehearsal, playing the game and negotiating the rules of the game.

Playing the 'Magic If' in the organizational context

To exemplify how I used acting and directing competences during the critical moment in the organizational intervention, I describe the process as a four-step analysis and transformational model: (1) Framing reality as theatre, (2) Analysing by re-enacting, (3) Reformulating circumstances at play, and (4) Re-playing the game. Within the steps the actor/director uses a number of strategies and specific professional competencies.

Step 1: Framing reality as theatre

Step 1 is initiated in the scripted scenes of Moments of Crisis and Insight when participants question the project and the artist decides to switch to a theatrical mode of observation. From that moment the artist's focus is on trying to capture the situation in her notes as if it were a theatrical scene. Here she is assuming a role resembling that of a director taking notes during a rehearsal at the theatre during the phase of playing the game.

Acting and directing competences A and B (described above) are used when the artist makes what could be described as a 'halt before action' (strategy 1). The artist recognizes the critical situation as a potential key scene in relation to the project as a whole. By switching to a theatrical mode of observation and focusing on capturing the situation as accurately as possible in her director's notes she creates a pause as a space for a more thorough interpretation and analysis of the situation before action is taken.

To be able to sufficiently capture the situation in her director's notes the artist assumes 'a state of heightened attentiveness towards the situation' (strategy 2), allowing her to more easily recognize motives and intentions present in the room.

Step 2: Analysing by re-enacting

The framed situation is re-enacted with the aim of identifying Given Circumstances at play. This step could be performed either on an external stage, as in the case of the rehearsal or staging process at the theatre or, on an internal stage, the stage of the mind, as in the case of the scripted scenes Moments of Crisis and Insight.

Step 2 in the case is initiated in scene 2 when the artist sits in the train compartment and begins reviewing her notes. During this step she is switching between the actor's and the director's perspective on the framed situation as if in a rehearsal process, trying to re-enact the situation on the stage of her mind. Acting and directing competences A and B (described above) are used here when the artist "explores her understanding of the situation by performing it" (Sjöström 2007, p. 10, my translation). She uses her imagination as an actor, trying to embrace the participants' different perspectives on the critical situation by re-enacting the situation in her mind. In theatrical terms this could be described as using the Magic If to recognize and specify Given Circumstances at play. During this process a specific personal memory of the artist's is triggered. This resurrected memory helps the artist to recognize what may, implicitly and emotionally, be at stake within the critical situation.

The artist then switches from an actor's process of 'trying to identify with the character's situation in the scene' (strategy 3) to a director's process of 'trying to grasp the story as a whole' (strategy 4). This enables her to compare her "empathetic insight" (Lagerström 2008, p. 12) about possible implicit drivers within the critical situation, with what is known about overall expectations on the outcomes of the project. In theatrical terms this could be described as comparing ideas about Given Circumstances suggested within a particular scene with Given Circumstances interpreted from the point of view of the play (or the story) as a whole. Shifting between the actor's and director's perspectives helped the artist to a more thorough understanding of the situation and hence to interpret relevant circumstances at play. In the above case the artist concluded that the group was acting on incorrect assumptions about the expected outcomes of the project.

Step 3. Reformulating circumstances at play

The artist shares her interpretation of the situation with the group of participants. Here, acting and directing competency B (described above) is used when they discuss this and possible alternative interpretations and develop a revised conclusion of the identified circumstances at play. The artist here takes the role of 'facilitator in the process of comparing and integrating different perspectives' (strategy 5), saying, "If you feel like this, but you see it like that, and if we also take that other point into account, then if we formulate it like this, we could try to go in the following direction . . ." In the case it resulted in a reformulation of the group's objectives.

Step 4: Re-playing the game

During a theatrical rehearsal process step 4 would be equivalent to the director saying, "OK, everybody ready . . . and action!" Either this would mean shifting from the rehearsal phase of negotiating the rules of the game to a new round of playing the game, or it would mean that the rehearsal is over and it is time to open the curtain before the audience. In the case, step 4 was initiated during the meeting described in the Epilogue when the participating group made the agreement to act on reformulated objectives for the project. This agreement marked the turning point for the critical situation in the project.

Concluding reflections

My retrospective inquiry highlights the theatrical rehearsal process as a core collaborative interpretation process where, within the framework of their partnership, the actor and the director use different functions based on their specific expertise. Comparing my actions and thought processes during the critical moment in the intervention project with work strategies used by actors and the director during a rehearsal at the theatre highlights the director's role as a facilitator in the process of comparing and integrating different perspectives. It also makes visible how the acting process works as a means to analyse a given situation from various perspectives. This form of analysis allowed me to gain empathetic insights about the situation during the intervention process. These insights could then be discussed, explored and modified before being acted upon together with the group of participants.

The artistic inquiry approaches acting and directing processes from hermeneutical aspects by treating the theatrical rehearsal-process as a 'way to understand the world' (Rynell 2003, p. 130). In the case my acting and directing competences worked together as ways to gain a more thorough or nuanced understanding of the given situation. This leads to four implications:

- For researchers of artistic interventions in organizations I have revealed my artistic mind-set and mode of inquiry, also expressed as "artistic perception and reflective way of thinking" (Lehikoinen 2013, p. 54). My method

of interpretation and analysis suggests ways in which artistic inquiry may enhance social science research methods. At the same time, as Hempel and Rysgaard (2013, p. 39) note, more research from the artist's perspective is needed.

- For those within theatrical disciplines I have presented a model of the rehearsal process and suggested a description of the working relation between the actor and director as a partnership building on expertise. The model shows how the actor and director analyse and play with different alternative perspectives in order to understand the dramatic situation more deeply. It also underlines the collaborative approach in this kind of theatre work, which could challenge traditional and hierarchical structures within the field of the theatre. This model may be further developed and elaborated.
- For readers not familiar with theatrical processes this study may contribute to a more nuanced understanding of the actor's and director's work processes. During my work with artistic interventions I have encountered many preconceptions about artistic work, for example that the actor's task is to "fake" and that the director's role is to manipulate and "tell people what to do". These preconceptions do not coincide with my own experiences from within the practice.
- For me as an artist the process of participating in an artistic intervention and then analysing it has increased my understanding of my own professional competencies and how I apply them in theatrical and in other contexts. These insights add to my professional growth as well as to my future work in the field of artistic research.

References

Hempel, G. and Rysgaard, L. (2013) 'Competencies – in real life'. In Heinsius, J. and Lehikoinen, K. (eds.), *Training artists for innovation: Competencies for new contexts*. Helsinki, Finland: Kokos Publications Series 2, 2013 Theatre Academy of the University of the Arts Helsinki, pp. 28–47.

Lagerström, C. (2008) 'Artistic research in the performing arts – in search of a poetics', *Nordic Theatre Studies*, 20, pp. 9–15.

Lehikoinen, K. (2013) 'Qualification framework for artists in artistic interventions'. In Heinsius, J. and Lehikoinen, K. (eds.), *Training artists for innovation: Competencies for new contexts*. Helsinki: Kokos Publications Series 2, 2013, Theatre Academy of the University of the Arts Helsinki, pp. 48–63.

Rynell, E. (2003) 'Stanislavsky, Ricoeur and the hermeneutics of acting', *Nordic Theatre Studies*, 15, pp. 121–132.

Sjöström, K. (2007) *Skådespelaren i handling- strategier för tanke och kropp* [The actor in action – strategies for mind and body], Stockholm: Carlsson.

Stanislavski, K. and Benedetti, J. (2008) *An actor's work: A student's diary*. London: Routledge.

Stanislavski, K. and Benedetti, J. (2010) *An actor's work on a role*. London: Routledge

Part V
Responsibility for making it happen

11 Managers in artistic interventions and their leadership approach

Katarina Zambrell

Artistic interventions in organizations are a phenomenon of growing interest in Sweden and in other countries (Berthoin Antal 2013; Berthoin Antal and Strauß 2013; Schiuma 2011; Darsø 2004). It is not easy to find managers who are willing to take the risk of introducing an artistic intervention into their organization. According to Pia Areblad (director of the Swedish intermediary organization TILLT), she meets with approximately 40 managers to get one contract for an artistic intervention project: "The problem is to get hold of organizations that dare. Where can you find those bold managers?" (personal interview 2007, my translation). There is surprisingly little research about such managers that might help answering this practical question. I became curious: might a study focusing on managers who have undertaken artistic interventions also contribute to new insights for leadership theories?

Bringing arts into businesses and organizations can take different forms. This chapter focuses on Airis[1] projects produced by TILLT. In these projects a company employs an artist part time for 10–12 months to work with the manager in charge and the employees to specify the focus of the intervention, plan activities and then realize them. I soon learned that these 'bold' managers often face questions both from the employees and management colleagues when they introduce and implement such projects. For example, Mr PJ[2] described the kind of reactions a creative disturbance like Airis could cause:

> It [the Airis project] was very different and not everyone thought it was good. Maybe it was too different for some? . . . People from other departments were wondering what we were doing. They probably thought I was insane to be working with an artist in my department.
>
> (Mr PJ)

In this chapter I offer a closer look at these managers and their experiences with such controversial initiatives. The chapter is structured unconventionally in order to introduce the reader first to the managers rather than to the relevant management literature. After a brief description of the research method, I provide data about the sample: the managers' level of experience as leaders, position and their interest in the arts. Then I report on the objectives and motivations

of these managers for undertaking an Airis project. Drawing on the managers' stories, I propose an aesthetic-inspired leadership approach, which I then connect to the literature.

Method

This research is based on the empirical data from interviews with 33 Swedish managers (representing approximately 75 per cent of all the Airis projects that TILLT produced from 2006 to 2011). Access to these managers was possible thanks to TILLT, which introduced my research to each potential respondent. All the interviews were conducted by phone between January and April 2012 using a semi-structured interview guide with 13 open questions and follow-up questions. The managers received these questions in advance in order to have the time to reflect on them. The interviews usually lasted about 45 minutes and I recorded and transcribed every conversation. Each manager then had the opportunity to read the text and to confirm its content.

The analysis of the interviews and the interpretation were made in several steps, inspired by the principles of grounded theory (Strauss and Corbin 1998; Glaser and Strauss 1967). My understanding and learning increased during a constant interpretation process while analysing interviews, studying related research and discussing observations with others at seminars and conferences such as EGOS (Zambrell 2012, 2013, 2014). Accordingly, every transcribed interview has been read many times with various focuses. Secondary material was also important in increasing my understanding, for example, presentations and reports covering TILLT's projects (see www.tillt.se). The illustrative quotations from the interviews are my own direct translations from Swedish (with minor grammatical editing).

Airis managers' characteristics

Demographic composition of the sample

The opportunity to introduce an artistic intervention appears to appeal especially to experienced executives: the average time in a management position of the Airis managers is 17 years. Their typical age was around 50 and they were somewhat more often women (58 per cent) than men. Young, newly appointed managers were scarce in this sample. The majority of the managers (82 per cent) had a university education and 79 per cent held powerful positions like CEOs, department managers or headmasters, but the sample also included seven middle managers responsible for Airis projects. Just over half (55 per cent) of the organizations they represented were in the public sector and the sample covered a wide range of activities (for example, hotel, hospital, industrial company, primary school, retail business).

It is interesting to look at the managers' relationship to the arts and creativity. It is conceivable that they might have affinities that lead them to be particularly open to trying out an artistic intervention.

Affinities to the arts and creativity in the sample

The majority of the Airis managers declared a relatively high interest in the arts. For example, Ms YÅ said, "I think my private interest in arts was the reason for finding Airis interesting in the first place". Another manager even said he would have become an artist if he had had the chance. However, most common was having a general arts interest, like Ms CB who said, "All humans, no matter what we are doing, have some relationship to arts and culture. Culture is a part of us". Several also said how the artistic intervention raised their interests in different kinds of arts as well as in how the senses can be used in different ways.

Did these managers regard themselves as creative? The idea of what it means to be creative varies of course; however, almost all the Airis managers described themselves as curious and open-minded. Some managers associated the arts with coming up with useful ideas. For example, Mr KL remembered that: "We felt that we were open for new things. Which is our new exciting step? … There was a kind of driving force within our management-group". Others regarded themselves as having a somewhat deeper creative attitude to life. According to Ms YÅ: "It is my responsibility to take the opportunity when it comes to me. I felt like doing something new when Airis came my way.... I like to come up with ideas".

In summary, the majority of the bold managers who took the decision to introduce Airis projects into their organizations were over 50 years of age and held senior positions. They were somewhat more likely to be women than men and most started the project with some kind of an affinity for the arts. With this background in mind, it is now interesting to look at how they experience the situation of leading an Airis project.

The Airis managers' experiences, objectives and motivations

In the quote below the CEO of an industrial company illustrates how a manager may experience an artistic intervention. He is 48 years has and had held leading positions for over 20 years.

> The attraction for me at that time (I was chief executive at a plant then) was this. There are a lot of employees working with the packaging of our products for 35 years. It is not anyone's dream-job; at least it is very hard for me to believe it is. Many of our staff end up here, and perhaps they are satisfied with it after all. Hopefully they have a good life elsewhere, but it is not so damned funny to work in a factory for 30 years.
>
> Then [as a manager] one always can try to develop the business. To make people daring and wanting to act and thinking work is fun. I am driven very much by the idea of people working, not for the company, but for, and together with, other humans. When you find your work fun it is because you have nice colleagues and maybe a manager who cares about you.

The artistic intervention was supposed to bring in some new ideas and I also wanted to try to make people take a little more personal responsibility. There are a lot of fixed positions. I would not call it conflicts, but . . ., the employees have been there for a long time and everything has always been in a certain way. The idea was to stir the pot and make people start reflecting and get something different to talk about.

By chance I came in contact with these Airis people. They described a lot of different types of projects they were doing and . . . I do not know exactly why, but I felt, "Damn, that sounds fun". . . . I just had started a small group of representatives from the various departments of the factory . . . We had meetings once a month and talked about: How is it? How are the employees feeling? . . . After a private dinner one evening, when I was told about Airis, I felt,. . . "I like it". Then I talked about the Airis project with this group at the factory, "What do you think about this? It is crazy but should not we try to be a little crazy?" They bought it and so we did.

What about the expectations? Yes they were very emotional. I got the expected reaction. There were some who thought that I was completely stupid and some who thought the idea was great. Some of those who thought I was an idiot in the beginning thought it was great at the end, and some of those who thought it was great at first grew tired. But at least they all had a year when something different happened and I am sure there was at least someone who grew as a person and dared to take a more prominent position in the organization. I thought it was time well spent.

(Mr HD)

This narration contains several key aspects related to the decision to initiate an artistic intervention: the motivation for engaging in an Airis project, as well as underlying features characterizing these managers' approach to leadership. The next step is to explore each of these elements more closely.

The decision to initiate an artistic intervention

Mr HD's characterized his decision to accept an artistic intervention as grabbing an opportunity that sounded like fun. Several Airis managers spoke of deciding impulsively, appearing to act more from a gut feeling than calculated reasoning. Some talked about the importance of timing: to run into this offer when looking for ideas for interesting ventures for the employees. Three managers had researched the project before deciding, discussing its possibilities with former participating companies, with important references coming from respected organizations like Volvo or Astra Zeneca. In almost every project the representatives from the intermediary organization TILLT had a crucial role in explaining and arguing for an artistic intervention. In nine cases the decision to embark on an artistic intervention was made by a senior manager who then gave responsibility for the project to my interviewee and in the other 24 cases the interviewed managers decided themselves.

Respondents often mentioned the need for courage and the willingness to take risks when taking on such an unusual and potentially controversial project in an organization. For example:

> You have to be persistent when you initiate something you believe in. You also need the courage to do it and the ability to communicate this untraditional project and to generate an interest and an involvement for it ... To walk out on the thin ice and do something ... you have to be confident in yourself ... if it fails you stand all by yourself.
>
> (Mr LL)

The managers' motivations

The long quote above from Mr HD illustrates the combination of motives for undertaking the artistic intervention. However, eight Airis managers said that they had no explicit objective in the beginning except doing something different for the employees and hoping that something interesting would happen. In these cases the motives developed throughout the project and were then communicated to other participants and stakeholders. Ms CS, one of managers who was persuaded by her top-manager to take on an artistic intervention, illustrated this:

> The purpose was not clear in the beginning ... What important matters were we supposed to do? It felt a little bit shaky and strange not knowing in the beginning what we should accomplish. ... It felt like working with the big consultancies that have already decided what to do when they arrive. Here [in Airis] it is more about listening, a process with intensifying involvement within the project. The artist had many tools and approaches for reaching the goal we decided to accomplish: to strengthen the identity of the department, the individual identity for persons and most of all our internal identity within the big factory.
>
> (Ms CS)

Mr HD also talked about the expectations for such projects and the risk that art-projects tend to be analysed too conceptually: "These projects you have to do based on your own inner feelings".

Four main answers emerged to a direct question about the arguments for initiating an Airis project:

- To develop the creative potential within the organization (73 per cent)
- To improve collaboration and trust among the employees (58 per cent)
- Having activities together with colleagues for pleasure and fun (45 per cent)
- To introduce discussions about company values and culture (33 per cent)

A majority of the managers stated two of these aspects. Other less mentioned aspects were 'individual development' and 'problems/re-organizations'. Similar

arguments for artistic interventions are documented in other studies (for example, Berthoin Antal and Strauß 2013; Darsø 2004; Schiuma 2011; Styhre and Eriksson 2008).

The managers' leadership approach

Mr HD emphasized the value he places on employees enjoying their work together. Many Airis managers expressed similar wishes and concerns for their employees and their work conditions, often focusing on the human aspects. Mr JP explained, "You have to find it fun to work with humans, being interested in and having respect for other humans in order to be a good leader".

Other stories emphasized building relations, encouraging employees to take initiatives, be creative and suggest new ideas. Mr TL showed a caring and confirming approach towards the employees:

> People have so much to give, much to contribute with, to become happy... that is why I choose to work with people, to make people feel good because they then may perform.
>
> (Mr TL)

One of the most common comments in the interviews referred to enabling employees to grow as persons. This approach echoes the leader-as-gardener metaphor proposed by Huzzard and Spoelstra (2012), among others. Ms YÅ was an example of a manager who emphasized employee growth and also explained her own role in the process:

> The manager has a crucial role for the impression of work. The manager has to see the employee's competence ... Giving space for the employee's growth. Then the desire will emerge among them. It is a matter of being present, and being without prestige.
>
> (Ms YÅ)

It is significant that in Airis activities the manager was in a somewhat different position than in normal working situations. Rather than maintaining their hierarchical status, managers (in this sample 82 per cent) participated on an equal footing with the employees because they, too, were beginners in the art world. Mr TB explained:

> In traditional ventures, like conferences, then managers are managers ... There are expectations of the manager. When this [Airis] happens the manager becomes on the same footing as others. All get equal. In this dance-project – what was the expectation of me as manager? Am I supposed to do choreography? No, of course not. Here we were all equal in front of the challenge. This was the biggest advantage with the project.
>
> (Mr TB)

This situation, a manager acting together with the employees, may be a special feature of Swedish working relations. In other cultures the presence of a top manager might restrict the employees behaviour by his/her presence (Berthoin Antal and Strauß 2014, p. 10). Three managers in the sample decided not to participate in the project for that reason. In the Swedish context this cooperation with the employees is considered important and helpful for building relations and getting to know each other better. These values probably underpin the leadership approach of these managers who brought in Airis projects to their organizations.

An aesthetic-inspired leadership approach

A leadership approach with five aspects emerged from the interviews with the Airis managers. When they talked about the results of the artistic intervention managers mentioned how it caused people to cooperate in different ways, how different groups were put together and enabled the emergence of new relations, how doing silly activities opened up a creative climate, and how these activities strengthened trust-building. Based on my analysis of the interviews, I propose that five areas co-constitute these bold managers' aesthetic-inspired leadership, as illustrated in Figure 11.1:

- On the organizational level two areas emerge: Creating Context and Establishing Creative Climate.
- On the individual level two other areas emerge: Strengthening Relations and Liking Employees.
- The fifth area, Initiating Triggering Activities, supports the other four areas and their interrelations.

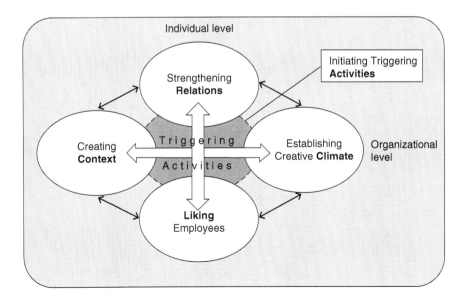

Figure 11.1 Five areas of managers' aesthetic-inspired leadership

Almost 50 per cent of the Airis managers focused on both organizational and individual areas and used artistic activities to enforce and trigger their co-constitution. They combined a high ambition for promoting context and climate with ambitions to build good relations and a personal and sincere interest in the employees. Most notable was the managers' concern for the employees as persons, for example, talking about really caring and 'liking' employees.

This liking area rarely appears in the leadership literature: "research and the media do not devote a great deal of attention to caring leaders" (Vie 2012, p. 160). A few authors such as Fineman (2002) discusses "emotionalization" at work; Iszatt-White (2012) looks at leadership as emotional labour; and Burchell and Robin (2011) introduce the role of the leader in creating great workplaces. However, they do not discuss emotional aspects or expressions for managers' feelings for the employees in terms of liking. By contrast, some scholars discuss how employees like the manager (for example, Alvesson and Tengblad 2013, p. 168; Barling Kelloway, Loughlin, and Turner 2012, p. 50; Vie 2012, p. 157). In one explicit example Sveningsson and Alvesson (2014, p. 135) quote a manager who said, ". . . to like humans . . ." and note (2014, p. 147) that many managers express interest in humans and their meaning making (like the Airis managers here). However, the authors' interpretation is that this is mainly a way for the managers to express a positive picture of themselves (and thus create their selves as emphatic leaders). Nevertheless Sveningsson and Alvesson also see more focus in current leadership research on the therapeutic side of leadership and the growing importance of relational and emotional aspects (2014, p. 156), which supports the findings in this study.

The contents in this aesthetic-inspired leadership approach have also similarities with the ideas in Alvesson and Sveningsson (2012, based on Alvesson and Ydén 2000) about how to understand leadership. They mention four parts (but not liking explicitly): "a) the leader's action, b) social relations between leader/employees, c) the organizational context that do the scene for the leadership-relation, and d) how the employees interpret and relate to the leader's actions" (Alvesson and Sveningsson 2012 p. 314, my translation). Other scholars discuss "organizing for innovative learning" (e.g., Bennis and Nanus 2003, p. 195), which resonates with the findings in this study regarding creating an inspiring context along with an aim to develop an open and creative climate. In a similar vein, Alvesson (2012 p. 227) points out that an important task for leaders is to create common orientations and identities in the organization culture.

Fleshing out the five areas of an aesthetic-inspired leadership approach

It is now possible to illustrate each of the five areas with material from the interviews, and to connect them to existing leadership theories.

Creating context

This area entails several kinds of leadership actions: consciously creating an organization-context through good and caring work-conditions, employee-

participation, meaningful tasks and rendering work more fun (for example by bringing arts into the organization). Empirical examples are:

> ... to work in a position where one is able to influence, better and develop the organization, the employees and the work-processes ... to make people grow and develop their ability and self-confidence.
>
> (Mr LL)

> ... stable and secure people influence the work-context.
>
> (Ms AK)

> In some organizations the "system" is more important than creative employees one knows by first name ... I believe in getting employees involved then the engagement will be far better. Spending such long time at work [as working people do] it has to be meaningful, giving something more than a salary.
>
> (Mr TL)

Establishing creative climate

This leadership-focus means consciously working for and establishing a climate within the organization that is dominated by encouragement, creativity and openness for new ideas. Experiences from ventures like Airis may establish a punishment-free zone where anyone may feel the permission to come up with creative ideas and suggestions. Empirical examples are:

> ... now there is a better sense for "us", a feeling that we are able [competent] ... there were a lot of hidden energy released.
>
> (Ms CB)

> ... after a couple of months [of Airis] there was a more positive atmosphere. The employees had something to talk about ... the artist/the project opened up the climate.
>
> (Ms PH)

> If one is seen, seen as a human, if you are involved in the work-activities – of course one dares more ... one goes outside the box if one knows one is allowed to.
>
> (Mr. TL)

Strengthening relations

The leadership behaviours relating to caring about strengthening relations include consciously focusing on seeing and reaching the employee as a person, not only confirming her/his formal position, but showing concern for internal relationships. Stimulating and exciting activities requiring cooperation (such as

developed in Airis) can enable trustful relations within an organization. Empirical examples are:

> ... to create participation and engagement ... seeing people and making them understand that they are needed and thereby creating a positive feeling for what they do and increasing their interest for work.
>
> (Mr LL)

> The things I wanted to accomplice – to increase the understanding for each other, getting to know each other in another way ... that succeeded ... I sensed that the employees thought it was quite nice to go to work.
>
> (Mr PJ)

> One has getting to know the colleagues in another way ... learning more dimensions about them ... being more humble about their different backgrounds.
>
> (Ms PH)

Liking employees

A leader who focuses on liking the employees does so by consciously working for the personal growth of employees, having a sincere concern, a personal interest and genuine care for them as persons. Activities with arts could thus be a different way to strengthen each person individually. This liking area may not always be expressed explicitly, but is shown by personal concern and engagement with the employees. Empirical examples are:

> To like and being interested in people ... that is what leadership is about... liking people and guiding, coaching, daring to let the ambitions of others come true.
>
> (Mr PB)

> ... telling your employees that they are good and actually saying it directly as soon as you have the opportunity ... in a true way. ... The employees are really important to me.
>
> (Ms ME)

> [Leadership] ... it is about being interested in the people you have around you and wanting to see them grow. ... Not for my own sake but for what I [as a leader] may do for someone else.
>
> (Mr LL)

Initiating triggering activities

Leaders who consciously initiate different activities for the employees (like Airis) find that such activities may boost energy and stimulate all kinds of

development. These leaders are aware that changing the overall organizational culture requires long-term ventures. In order to stimulate, enhance and enrich areas like "climate, context, relations and liking the employees", initiating activities may be catalysts for employee development and, accordingly, the overall organizational culture may develop. Empirical examples are:

> The Airis project is like starting a journey without knowing where you are going. It is the travel itself that gives the great benefit (not to reach the destination), along with how one develops during the road.
>
> (Mr LL)

> In a profession that is hard, both physically and mentally it is important to initiate "feel-good"-activities for the employees, to fill in with new energy.
>
> (Ms YÅ)

> To create an arena for testing new things/ideas . . . breaking the ordinary ways of doing things. . . In the management team we have different activities . . . almost once a month. We have raised so many thoughts that never had been said to each other without these happenings . . .
>
> (Ms UK)

Occurrence of the leadership areas among the Airis managers

A closer analysis of the interviews shows that each leadership area occurred differently among the managers. Table 11.1 presents the number of managers (and proportion of managers in total) who showed expressions for each of the five areas.

The most mentioned areas were Activities and Context. Significantly, 45 per cent of this group of aesthetic-inspired managers expressed the emotional area Liking employees, which has hardly been mentioned in previous studies. Some Airis managers talked about more of the five areas of the leadership approach than others. In total, 19 managers (58 per cent) showed expressions for three areas or more, suggesting that they exhibit an aesthetic-inspired leadership to a greater extent than the other managers in this study. Two of the 33 managers indicated all five features, 10 showed expressions for four areas, 7 showed three areas, 8 showed two areas, 5 showed one area, and 1 showed no area.

Table 11.1 Leadership areas expressed by Airis managers

$n=33$	Creating CONTEXT	Establishing Creative CLIMATE	Strengthening RELATIONS	LIKING Employees	Initiating Triggering ACTIVITIES
Number of managers	23 (70%)	15 (45%)	13 (39%)	15 (45%)	26 (79%)

(Note: some managers expressed all five areas)

Four of the Airis projects were conducted in the same municipality, where the head of the local government decided that they all had to participate. Two of these 4 managers belonged to the group of 19 with several leadership areas. The other two showed no or only one of the aesthetic-inspired areas. What is remarkable is that both these managers worked with art and culture professionally (one as head of a culture school, one as head of a library). The headmaster was critical of the instrumental view of how art is "supposed to" help in projects like Airis: "They look at art/culture as a product, not as a means for your own creation and your own free thinking" (Mr LG).

This instrumental aspect regarding arts was also mentioned by Ms ME: "There is a risk that one thinks it is possible to 'make packages' of arts and try to see them as a business advantage. The value lies in keeping art outside the business". Managers who did raise critical aspects regarding the artistic intervention and its outcome represented 25 per cent of the sample, although half of them seemed to be aesthetic-inspired in their leadership, which indicates that their leadership approach was independent of the Airis results.

Among the nine managers who did not decide about the Airis project themselves, seven showed low signs of aesthetic-inspired leadership. Maybe arts-projects like Airis do not fit with these managers' leadership approach. This probably causes problems for the need for sincere commitment and support for the intervention, an aspect that corresponds with the discussion in Berthoin Antal and Strauß (2014, p. 3) about how the absence of management support is evident in artistic interventions with disappointing outcomes.

In addition to the five leadership areas, 32 per cent of the stories contained references to the effects in terms of efficiency and profitability or similar factors (and these managers tended to focus on the context and climate areas, that is, the organizational level). Such comments, however, are found both among those with few areas of aesthetic-inspired leadership and those with three areas or more.

Discussion: connection to the literature

Leadership and artistic initiatives

Arts-Based Initiatives are considered valuable for leadership "for mindfulness and richer sense making in organizations" (Barry and Meisiek 2010, p. 1522), meaning that artistic initiatives ("workarts" in their terminology) may shift contexts and create new distinctions, that is, allowing participants "to see more and see differently" (Barry and Meisiek 2010 p. 1505). Such statements fit with many of the expressions found in the interviews characterizing the leadership approach among the managers, for example, those about undertaking different ventures and stepping outside the box.

Schein (2006, pp. 299–300) points out the need for managers "to trust their own artistic impulse in deciding what kind of intervention to make in a human system", which he also refers to as a manager with an "artistic license". My

interviews indicate the kinds of characteristics that enable a license to legitimate an Airis project, namely many years of managerial experience, curiosity and an interest in arts.

Leaders and/or managers

There is a longstanding, on-going discussion about differences between managers and leaders (see, for example, Alvesson and Willmott 2002; Kotter 1990; Tengblad and Alvesson 2013; Zaleznik 1977). In the long quotation above from the CEO it is evident that bureaucratic processes connected to both management and leader-related aspects are manifested in the same person/position. This reality supports the assertion that "it seldom makes sense to divide people up into leaders and managers" (Tengblad and Alvesson 2013, p. 172). In this study Mr HD 'the manager' probably calculates the possible outcomes, takes the decision, implements and organizes, while Mr HD 'the leader', carries out leader-typical activities like sense-making, engaging, inspiring and trying to affect feelings.

Several studies show that managers spend most of their time working with manager-issues such as administration, problem-solving and operative work, rather than activities for encouraging and inspiring (see for example, Tengblad 2012; Alvesson and Sveningsson 2003). Accordingly, one way to understand bringing arts into organizations is to regard the artistic venture as an approach focusing more on the encouraging and inspiring parts of managing. Alvesson and Willmott (2002, p. 620) believe that there is as a discursive change from the notion of 'managers and management' to a more positive meaning in the notion 'leader and leadership', thus descriptions that suggest leader "have replaced less 'attractive' titles such as … 'supervisor' or even 'manager'". A way to understand managers initiating an Airis project is thus to consider their action as an attempt to strengthen their leader-identity (Zambrell, under review). Indeed, several statements from the Airis managers suggest that an artistic intervention is a way for managers to do something fun, exciting and inspiring. Hence Airis could also be conceived as a contrast to what could be described as the grey, bureaucratic and ordinary activities that normally fill management.

Rather than continuing the discussion distinguishing between leaders or mangers per se, it is more interesting to try to understand the overall leadership approach exhibited by the bold managers who engaged in artistic interventions.

Areas that in particular indicate an aesthetic leadership approach

By initiating artistic interventions the Airis managers enabled new processes and interactions in their organizations, often from a wish to strengthen relations, increase cooperation, trigger creativity and develop cultures. Such activities endorse understanding leadership as relations, interactions and processes between leader and followers (Tengblad and Alvesson 2013, pp. 176–177). "To express liking", the more uncommon area of leadership identified in the

interviews, corresponds to "the power of feelings and emotions in leadership" discussed by Hansen, Ropo and Sauer (2007, p. 557), who advocate for aesthetic dimensions in leadership, related to meanings people construct based on feelings experienced through their senses. The authors propose that followers use their aesthetic senses in assessing leadership qualities, such as leaders being charismatic (with 'magnetic' personalities and abilities to enthuse) and authentic (being genuine and true to themselves) (Hansen et al. 2007, p. 544, building on earlier work by Aviolo and Gardner [2005]; Luthans and Aviolo [2003]; Bass [1985]; Burns [1978]). They continue, "The senses followers make, and feelings they have, about the contextualized experience of leadership phenomena produces aesthetic knowledge" (Hansen et al. 2007, p. 551). Other scholars also emphasize the relational dimensions and "aesthetic approaches to knowing in organizations", for example by "experimenting, exploring and learning with the arts" (Berthoin Antal and Strauß 2014, pp. 13–14).

Accordingly, the aesthetic dimension seems suitable in many ways for an increased understanding of Airis managers' leadership approach. Guillet De Monthoux, Gustafsson and Sjöstrand (2007, pp. 268–271) characterize aesthetic leadership as an ability to connect and master the fields of management, administration and aesthetics. In this study leadership is shown as a collection of different areas that stimulate feelings, emotions and senses with an ambition to empower sense-making, an open-minded climate and caring relations. An aesthetic-inspired leadership may also achieve a well functioning workplace (context) where people like each other, and where it is important that managers like their employees.

Tengblad and Alvesson (2013) find that leaders are involved in symbolic management and they argue (with reference to Bryman 1996; Ladkin 2010): "Leadership is a sense-making activity that entails symbolic actions and processes which generate meaning" (Tengblad and Alvesson 2013, p. 171). The symbolic aspect of leadership is obvious in artistic interventions, which is supported also by Salzer-Mörling: "From being characterized as an administrative activity, leadership is increasingly being described as a symbolic art: the art of creating meaning, values and context in a complex and fragmented world" (Salzer-Mörling 2009, p. 378, my translation). The manager-participation was discussed above and is a visual symbol of this leadership. Although the majority (82 per cent) of the managers were personally engaged in the Airis project there were six managers who did not join the activities. Nevertheless, five of these still showed several signs of the aesthetic-inspired leadership. It therefore seems that even if they do not participate personally in an artistic intervention, managers can symbolically represent this leadership approach.

To sum up, an aesthetic-inspired leadership approach can thus be described as influencing people's "heads, hearts and values" (Sveningsson, Alvesson and Kärreman 2009, p. 53, my translation). Haslam, Reicher and Platow (2011) hold a similar view:

> Good leadership is not determined by competent management, skilled decision-making, or accepted authority in and of themselves. The key

reason for this is that these things do not necessarily involve winning the hearts and minds of others or harnessing their energies and passions. Leadership always does.

(p. x)

Accordingly, this study indicates that several of the Airis managers exemplify and can be understood through the aesthetic-inspired leadership approach.

Critical aspects

Some Airis managers (25 per cent) expressed problems with the Airis project and showed less positive experiences than others. Examples include: their expectations were not met; they encountered a lot of resistance; only a few employees participated; or the artistic intervention did not lead to any significant change in the organization. Still, six of them (12.5 per cent) showed several signs for aesthetic-inspired leadership, which indicates that their approach is connected to aspects other than the results from the artistic intervention.

Some scholars have warned against taking an overly romantic view of artistic interventions, pointing out that "what unites these approaches ... is an assumption that by using aesthetic/artistic methods, employees' creativity and innate talents can be 'freed' for the good of the organization" (Gilmore and Warren 2007, p. 111). Of course ventures like Airis can appear overly positive when managers look back and try to legitimate the project. If a manager takes the initiative for a risky venture like Airis that has to be defended in front of employees, there is probably a strong desire for successful evaluations and positive feedback. However, the majority of the Airis managers were aware of and open about the problems, such as uninterested employees or a disappointing cooperation with the artist. A majority also seemed quite aware of the limited tangible results that could be expected when they decided to launch the Airis project in the first place. Their realistic expectations probably contributed to their subsequent positive assessment of the value of the Airis project.

Continuing with artistic interventions

Only 4 of the studied 33 Airis managers have conducted more than one Airis project. However, 30 per cent said they have continued with some kind of shorter activities, both with arts and other forms. Given the length and scope of Airis projects it is not surprising that most managers do not intend to embark on another in the immediate future. However, another 30 per cent of the managers explicitly declared ambitions to undertake further Airis projects. Three managers reported that even after a successful experience with Airis, they still had an uphill struggle persuading their top management to plan another project of this kind. Mr KL gave one example of the lack of understanding and interest he encounters, "When we got a new head of the local government the first

thing he said was, 'How can you put 50,000 euro on hocus-pocus?'" Mr PJ gave another example: "I have a manager now who solely thinks in terms of screws and nuts". More empirical studies will hopefully raise the consciousness for how aesthetic-inspired leadership may contribute in several ways for members' development in an organization.

Conclusion

My contribution in this chapter is to derive from interviews of 33 Swedish managers, who led artistic intervention projects in their organizations, the features that characterize them and their leadership. A key commonality of the managers is that they have many years of leadership experience and credibility. Other shared characteristics are that they have a general interest in arts, are open-minded and have the courage to initiate an Airis project.

Alvesson and Spicer (2011, p. 9) point out that a universal theory of leadership is not possible. Nor can a universal kind of leader be identified among these managers. However, five focused areas emerge from the study as co-constituting, what I call, an aesthetic-inspired leadership approach: Creating context, Establishing creative climate, Strengthening relations, Liking employees and Initiating triggering activities.

Liking the employees is the most striking aspect and is considered making a real difference for experiences at work, like relations, trust and engagement. This need for managers expressing liking has not received much attention in the management literature to date. One notable example is Mother Teresa, the nun who was awarded the Nobel peace prize in 1979. In a keynote speech about 'the core of leadership', addressed to Indian HR-Executives, she simply asked, "Do you know your employees? And do you love them?" Then she left the stage (Danielson 2011, p. 1). Such questions are not explicitly raised in this study, but the managers' personal and genuine interest for confirming and caring for the employees, as well as their wish for employees' growth and development, attest to a desire for such a leadership core. Hence, bringing arts into an organization could be seen as an aesthetic-inspired approach for managers to create a *context* in the organization, showing concern for *relations* as well as genuine *liking* of the employees and also appreciating a *climate* for creative ways of acting. Such a leadership approach creates added values in the organization: values that may be triggered by the arts.

Notes

1 Airis was originally an acronym for "Artist in Residence" until TILLT realized that this concept was confusing for managers, so they kept the name but dropped the words behind it.
2 I translated all empirical illustrations from Swedish and the Airis managers are named Mr or Ms (and unique initials) to indicate that they are different persons (without revealing their identity).

References

Alvesson, M. (2012) 'Företagskultur och organisationsidentitet – stödjande normsystem eller hjärntvätt?' [Corporate culture and organization identity – supporting norms or brainwash?]. In Alvesson, M. and Sveningsson, S. (eds.), *Organisationer, ledning och processer* [Organizations, management and processes]. Lund: Studentlitteratur, pp. 201–229.
Alvesson, M. and Spicer, A. (eds.) (2011) *Metaphors we lead by: Understanding leadership in the real world*. London: Routledge.
Alvesson, M. and Sveningsson, S. (2003) 'The great disappearing act: Difficulties in doing "leadership"', *Leadership Quarterly*, 14, pp. 359–381.
Alvesson, M. and Sveningsson, S. (2012) 'Ledarskap – hjältemyter och inflytandeprocesser' [Leadership – heromyths and processes for influence]. In Alvesson, M. and Sveningsson, S. (eds.) *Organisationer, ledning och processer* [Organizations, leading and processes]. Lund: Studentlitteratur, pp. 297–326.
Alvesson, M. and Willmott, H. (2002) 'Identity regulations as organizational control: Producing the appropriate individual', *Journal of Management Studies*, 39, pp. 619–644.
Alvesson, M. and Ydén, K. (2000) 'Ledarskap som verklighetsdefinition, relation och process' [Leadership as reality definition, relation and process]. In Ydén, K. (ed.), *IT, organiserande och ledarskap* [IT, organizing and leadership]. Göteborg, Sweden: BAS, pp. 47–78.
Avolio, B.J. and Gardner, W.L. (2005) 'Authentic leadership development: Getting to the root of positive forms of leadership', *Leadership Quarterly*, 16, pp. 315–338.
Barry, D. and Meisiek, S. (2010) 'Seeing more and seeing differently: Sensemaking, mindfulness, and the workarts', *Organization Studies*, 31, pp. 1505–1530.
Bass, B.M. (1985) *Leadership and performance beyond expectations*. New York, NY: Free Press.
Business, W. and Nanus, B. (2003) *Leaders: Strategies for taking charge*. New York, NY: Harper Busienss Essentials.
Berthoin Antal, A. (2013) 'Seeking values: Artistic interventions in organizations as potential cultural sources of values-added'. In Baecker, D.P. (ed.), *Öekonomie der Werte/Economics of values*. Marburg, Germany: Metropolis Verlag, pp. 97–128.
Berthoin Antal, A. and Strauß, A. (2013) Artistic interventions in organizations: Finding evidence of values-added. Retrieved from http://www.creativeclash.eu/category/reports/: Creative Clash (Accessed January 15, 2015).
Berthoin Antal, A. and Strauß, A. (2014) 'Leadership as the alpha and omega of artistic interventions in organizations?' *EGOS Colloquium 2014*. Rotterdam, The Netherlands.
Bryman, A. (1996) 'Leadership in organizations'. In Clegg, S., Hardy, C. and Nord, W. (eds.), *Handbook of organization studies*. London: Sage, pp. 276–292.
Burchell, M. and Robin, J. (2011) *The great workplace [electronic resource]: How to build it, how to keep it, and why it matters*. San Francisco, CA: Jossey-Bass.
Burns, J.M. (1978) *Leadership*. New York, NY: Harper & Row.
Danielson, C.C. (2011) 'Leading in uncertain times: Leadership characteristics of the self-transforming mind', *Integral Leadership Review* [Online]. Retrieved from http://integralleadershipreview.com/ (Accessed August 25, 2014).
Darsø, L. (2004) *Artful creation: Learning-tales of arts-in-business*. Copenhagen: Samfundsliteratur.
Fineman, S. (2002) 'Preface', *Advances in developing human resources*, 4, p. 3.
Gilmore, S. and Warren, S. (2007) 'Unleashing the power of the creative unconscious within organizations: A case of craft, graft and disputed premises', *Tamara Journal*, 6(1), pp. 106–122.

Glaser, B.G. and Strauss, A.L. (1967) *The discovery of grounded theory: Strategies for qualitative research*. New York, NY: Aldine de Gruyter.

Guillet De Monthoux, P., Gustafsson, C. and Sjöstrand, S.-E. (2007) *Aesthetic leadership: Managing fields of flow in art and business*. Basingstoke, UK: Palgrave Macmillan.

Hansen, H., Ropo, A. and Sauer, E. (2007) 'Aesthetic leadership', *Leadership Quarterly*, 18, pp. 544–560.

Haslam, S.A., Reicher, S.D. and Platow, M.J. (2011) *The new psychology of leadership: Identity, influence and power*. New York, NY: Psychology Press.

Huzzard, T. and Spoelstra, S. (2012) 'Ledaren som trädgårdsmästare – ledarskap genom att främja växande' [Leaders as gardeners: Leadership as facilitating growth]. In Alvesson M. and Spicer, A.R. (ed.), *Ledarskapsmetaforer Att förstå ledarskap i verkligheten* [Metaphors we lead by: Understanding leadership in the real world]. Lund, Sweden: Studentlitteratur, pp. 105–128.

Iszatt-White, M. (ed.) (2012) *Leadership as emotional labour [electronic resource]: Management and the "managed heart"*. Abingdon, Oxon, UK: Routledge.

Kelloway, E.K., Turner, N., Barling, J. and Loughlin, C. (2012) 'Transformational leadership and employee psychological well-being: The mediating role of employee trust in leadership', *Work & Stress*, 26, pp. 39–55.

Kotter, J.P. (1990) 'What leaders really do', *Harvard Business Review*, 68, pp. 103–111.

Ladkin, D. (2010) *Rethinking leadership: A new look at old leadership questions*. Cheltenham, UK: Edward Elgar.

Luthans, F. and Avolio, B.J. (2003) 'Authentic leadership: A positive development approach'. In Quinn, R.E., Dutton, J.E. & Cameron, K.S. (eds.), *Positive organizational scholarship: Foundations of a new discipline*. San Francisco, CA: Berrett-Koehler Publishers, pp. 241–261.

Salzer-Mörling, M. (2009) 'Symboliskt ledarskap: Om kultur och meningsskapande' [Symbolic leadership. Culture and meaningmaking]. In Jönsson, S. and Strannegård, L. (eds.) *Ledarskapsboken [The ledarshipbook]*. Malmö, Sweden: Liber, pp. 351–381.

Schein, E.H. (2006) 'From brainwashing to organizational therapy: A conceptual and empirical journey in search of "systemic" health and a general model of change dynamics. A drama in five acts', *Organization Studies*, 27, pp. 287–301.

Schiuma, G. (2011) *The value of arts for business*. Cambridge: Cambridge University Press.

Strauss, A.L. and Corbin, J.M. (1998) *Basics of qualitative research: Techniques and procedures for developing grounded theory*. Thousand Oaks, CA: SAGE.

Styhre, A. and Eriksson, M. (2008) 'Bring in the arts and get the creativity for free: A study of the Artists in residence project', *Creativity and Innovation Management*, 17, pp. 47–58.

Sveningsson, S. and Alvesson, M. (2014) *Chefsliv [Managers' life]*. Lund, Sweden: Studentlitteratur.

Sveningsson, S., Alvesson, M. and Kärreman, D. (2009) 'Ledarskap i kunskapsintensiva verksamheter: Hjälteideal och vardagsmagi' [Leadership in knowledge intensive businesses]. In Jönsson, S. and Strannegård, L. (eds.), *Ledarskapsboken [The leadershipbook]*. Malmö, Sweden: Liber, pp. 30–57.

Tengblad, S. (ed.) (2012) *The work of managers*. Oxford: Oxford University Press.

Tengblad, S. and Alvesson, M. (2013) 'Leadership'. In Strannegård, L. and Styhre, A. (eds.), *Management: An advanced introduction*. Lund, Sweden: Studentlitteratur, pp. 157–180.

Vie, O.E. (2012) 'R&D managers leading knowlege workers with care'. In Tengblad, S. (ed.), *The work of managers*. Oxford: Oxford University Press, pp. 146–164.

Zaleznik, A. (1977) 'Managers and leaders: Are they different?', *Harvard Business Review*, 55, pp. 67–78.

Zambrell, K. (2012) 'Artistic organizational interventions through "*culturalistic*" leadership', *EGOS Colloquium*, Helsinki, Finland.

Zambrell, K. (2013) 'Arts in Business: A management venture for organizational development and identity work', *EGOS Colloquium*, Montreal, Canada.

Zambrell, K. (2014) 'Leadership and artistic interventions: Manager characteristics and leadership expressions', *EGOS Colloquium*, Rotterdam: The Netherlands.

Zambrell, K. (under review) 'Artistic interventions in organizations: A challenge for managers' work-related identities'.

12 Mind the gap!

Bridging strategies for artistic interventions in organizations

Ulla Johansson Sköldberg and Jill Woodilla

Artistic interventions in organizations aim to disrupt the dominant economic logic that permeates most organizations with an artistic logic that is supposed to nurture creativity and innovation – two buzzwords of our age. The ironic problem with the economic logic is that it has been so successful in slimming activities that the process has resulted in "the anorexic organization" (Radnor and Boaden 2004). Such an organization does not have the capacity to innovate or develop, since there are no resources left. The artistic logic, on the other hand, is marked by the desire to produce art for art's sake or to contribute to the greater good (Bourdieu 1990; Eikhof and Haunschild 2007). This logic creates the disruption of an intervention by bringing an artist's open process to idea generation and concept development, which can support organizational and individual development, particularly in work relating to the fuzzy front end of the innovation process.

Previous research, as well as our own, has shown the presence of an additional actor, namely intermediaries. Their purpose is to bridge between the world of the arts and the world of organizations and to facilitate the melding of the two logics so that the disruption becomes a fruitful experience. Studies have shown that intermediaries can play a wide variety of roles in the bridging process (Berthoin Antal 2012; Grzelec 2013). Given that the number and variety of intermediaries is growing (Grzelec and Prata 2013), we wonder: How do differences in the intermediary process affect the outcome of the intervention?

In order to address this question, we compare three intermediary organizations in Sweden, a country in which many artistic interventions have been conducted over the past decade. We present findings from interviews with employees from these intermediary organizations, complemented with previous knowledge from in-depth research by one of the authors (Johansson Sköldberg forthcoming).

The chapter proceeds in five sections. After placing the study within previously published research, we describe our methodology and introduce the cases. The findings section comes alive with quotations from the interviews, illustrating the different purposes, structures and experiences of each intermediary throughout the process of bridging between artists and organizations. In the subsequent discussion section we examine the strengths and weaknesses of each

model. Finally we reflect on links between the logics of individuals guiding the intervention and its desired outcomes.

Literature about intermediary organizations

The task of arranging and supporting an artistic intervention is frequently carried out by an intermediary organization. A growing number of organizations, mainly in Europe but also in the United States and Australia, have a general role described as "actors who bridge between the worlds [of the arts and organizations] . . . intermediaries who understand the values, codes and practices of both worlds and are equipped to find and bring together artists and people from organization" (Berthoin Antal 2012, p. 46). They may be referred to by various names, including consultancies (Darsø 2004), matchmakers (Barry and Meisiek 2004), catalysts (Barthelme 2005), producers (Grzelec 2013), intermediary organizations (Berthoin Antal 2009, 2012), intermediaries (Berthoin Antal 2012), mediators, process supporters, creative brokers or agents (Grzelec 2013). Demographic statistics from Grzelec and Prata's (2013) study on eight dimensions of the work of an artistic intervention, elaborated through Berthoin Antal's (2012) interviews with members of seven European organizations, provide a general description of the intermediary's role. The intermediaries may be structured or organized differently, but almost all have multiple sources of funds, with various levels of contribution from the organization holding the intervention (see Vondracek 2013 for a discussion of support schemes in Europe). All share objectives of innovation, organizational change, social interests, creation/art work and advancing artists' interests, weighted differently for different intermediaries and using different methods to achieved desired outcomes (Berthoin Antal, A. [in collaboration with Gómez de la Iglesia and Vives Almandoz] 2011). All assume 'added values' as outcomes of the intervention, noting that such outcomes do not arise spontaneously.

Grzelec (2013) details the steps in the process of 'producing' an artistic intervention. These are: recruit organization, find suitable artist, create a safe environment for social interaction during the project and help participants translate their concepts between worlds of arts and organizations. To this list Barry and Meisiek (2004) add the critical stage of formulating the challenge for the intervention, as the statement or goal guiding the process. Grzelec notes that the full value of an artistic intervention is reaped when the needs and potentials of all partners involved are respected and integrated.

Intermediary organizations assign one or more people to actively support the artist, manager and employees in intervention process (Berthoin Antal 2012). This person, sometimes referred to as the process manager, has multiple tasks: matching the artist with the organization, making a contractual agreement, initiating the project in the organization in a way that all stakeholders understand the way forward, having mechanisms in place that allow them to detect the need to address problems, helping create a platform for communication and sharing the experience, and possibly documenting the 'values added',

although few projects have a formal evaluation process. She concludes that intermediaries help build trust between artists and members of the host organizations while maintaining the boundaries between them. This trust is not automatic, and working across the different cultures of business and the arts entails communicating with different codes. Maintaining difference is important, but so is developing a common language so that the artist and business employees can work together. An important aspect of the role is to support and nourish the interaction and relationship between the artists and organizations "making it possible for other spheres to learn and develop through learning with and from the arts" (Grzelec 2013, p. 98).

The individuals who work directly with the unfolding process of an artistic intervention come from a variety of backgrounds. Many have had some form of prior training or experience in the arts, as was the case with the individuals we interviewed for this chapter. Among various arrangements for connecting artists with public, private or non-profit organizations Berthoin Antal (2012) mentions a professional curator who manages the process on a regional basis for the New Patrons (France) program, project managers from arts-based institutions appointed as the intermediary role on a project-by-project basis at Interact (UK), and a situation (Eurogroup Consulting, France) in which there was no intermediary organization, but an 'intermediary tandem' composed of a consultant in the company who had the initial idea and an art critic, "thereby establishing a bridge with one member standing in the world of the arts and one in the world of the organization" (Berthoin Antal 2012, p. 50).

Our aim and methods chosen

We are interested in how individuals in the intermediary role describe their process for bridging the gap between artists and the work organizations in which they make interventions. In order to gain this understanding, we contacted three quite different Swedish intermediary organizations with experience in this field (TILLT, SVID, SKISS). This choice enabled us to keep the socio-economic context stable while studying various organizational approaches. In December 2013 we conducted in-depth interviews with a process or project leader in each of these intermediary organizations (Roger Sarjanen from TILLT, Marie Loft from SVID and Eva Mansson from SKISS) and with artist (Malin Lobell). The interviews, which lasted from two to three hours, were in English (because one of the authors does not speak Swedish but all the respondents were comfortable in English). Apart from a few questions prepared in advance we followed Hopf's (2004) recommendations for focused interviews. In addition to these individual interviews, we later invited two of the respondents (Roger Sarjanen from TILLT and Marie Loft from SVID) to meet for two hours to discuss and discover differences and similarities in their ways of handling the process. We recorded all the conversations and had them professionally transcribed, then we indexed the transcripts for themes to structure our storyline and generate

quotes. For brevity we edited the transcripts to remove hesitations while the non-native English speaker searched for the appropriate English phrase or used a Swedish word that was then translated and checked by others present.

Three ways of handling the intermediary process

As we suspected, both the intermediary organizations themselves and their facilitation processes differed from each other.

Thumbnail sketches of three intermediaries

TILLT: an experienced intermediary organization

TILLT (www.tillt.se/in-english/) is an independent non-profit organization based in Gothenburg, partly subsidised by Västra Götaland, the regional county council (www.vgregion.se/en/Vastra-Gotalandsregionen/Home/). TILLT's roots connect to Skådebanan, a cultural organization founded in the late nineteenth century with the aim to make culture accessible to as many people as possible, and is dedicated to producing artistic interventions with the dual aims of organizational development and increasing opportunities for artists.

According to the website:

> TILLT is a producer of artistic interventions in organizations. An artistic intervention is established when an organization enters into a collaboration with an artist, such as an actor / director / playwright, visual artist / painter / photographer, dancer / choreographer, writer / poet, composer / musician or a conceptual artist. The aim of such collaboration is to cross-fertilize the competences of the two worlds: the world of the arts and the world of the organization. The work of TILLT is focused in two directions; on the one side TILLT focuses on processes of human growth and organizational development – artistic competence as a tool to stimulate creativity, innovation, human development, and more. On the other side, TILLT works for increasing the field of work for artists where new art can be born and new artistic methods can be developed.
> (www.tillt.se/in-english/) accessed March 21, 2014

The organization, developed under the entrepreneurship of Pia Areblad, has become the world's largest producer of artistic interventions, completing hundreds of different interventions with more than 80 projects lasting a year or more. In 2013 TILLT had an average of 11 employees. There were two business support positions (business manager and accountant), a person responsible for *Kreative Support* (a special service provided by TILLT), six people responsible for finding projects and acting as process leaders and a CEO and a strategist (the former CEO Pia Areblad). There was also a one-year part-time project leader for European projects. Roger Sarjanen,

our interviewee, has been active for more than 10 years and responsible for much of the development of TILLT's process. He frequently worked with between four and eight projects simultaneously. Almost 70 artists from different disciplines have completed the formal application process and are available for freelance part-time work on artistic interventions with TILLT.

In contrast to TILLT, whose focus is on artistic interventions, when Swedish Industrial Design Foundation (SVID) participated in a research project its representative acted as an intermediary when designers worked with members of organizations to introduce innovation processes.

SVID: an organization that promotes design and research

Since 1989 SVID has been disseminating knowledge about design as a force for development and a competitive device. As presented on the website:

> We work to ensure that design is used in all work on innovation and change. Putting the user at the centre of development means that what is offered is fantastic and attractive. It benefits companies, public services, society and Sweden. But above all it benefits the user.
>
> (www.SVID.se/en/About-SVID)

SVID's portfolio of services promotes good design through maintaining a roster of designers available to work as consultants, sponsoring broad research projects and publishing a peer-reviewed journal. SVID works with designers who have foundational training in artistic methods; therefore, we consider them to be similar to artists from different disciplines that participate in an artistic intervention, and SVID's role in matching a designer with a company for specific projects to be that of an intermediary. We interviewed Marie Loft, one of SVID's regional project managers and an independent design consultant, on her facilitation work with a doctoral research project concerning the role of designers in early stages of the innovation process in organizations that had not previously worked with a designer (Jahnke, 2013).

Whereas TILLT and SVID are well-established and on-going organizations, our third example of an intermediary organization, SKISS, existed for only five years.

SKISS: a temporary intermediary organization

SKISS was a project initiated by Konstfrämjandet (http://konstframjandet.se/om-oss/english/), a Swedish organization founded in 1947 for the advancement of art through various projects.

> Our mission is to bring art to the people in their everyday lives, based on a belief in the liberating role of art and education, and that everyone should

have access to it in an equal society. Konstfrämjandet produces and provides art throughout Sweden, e.g., through traveling exhibitions, the production of new works of art, the sale of graphic art and courses as well as other in-depth projects.

(http://konstframjandet.se/om-oss/english/
Accessed November 15, 2014)

SKISS (www.cinergy.info/index.php?option=com_content&view=article&id=21&Itemid=14) was involved in a project lasting from 2005 to 2010, followed by a summarizing year ending with a conference in 2011 and the publication of the research report (Widoff, 2011). We interviewed the project leader for SKISS, Eva Månsson, and one of the artists, Malin Lobell, who was also employed as assistant project leader.

SKISS was the brainchild of a politician active in the arts and culture and the chair of Konstfrämjandet.

> Unhealthiness at working places was rising and that was a big problem. They [politicians] didn't know what to do. And then she [one politician] had this vision that artists can make a big difference. So she wanted to start a big project and to hire artists, not just making them work for free but to hire them.
>
> (Månsson)

The project was financed mainly from the European Social Fund (ESF) together with a number of Swedish governmental funding agencies to cover the salaries of the project leader and artists. The full-time project leader, Eva Månsson, was responsible for conceptual development of the project, budget and obtaining funds from public funding (finance), hiring, training and managing the artists (personnel), communication within the public sphere (public relations), and the development of new projects. She worked alone, with some administrative help from Konstfrämjandet and Malin Lobell, an artist (who also had experience working with TILLT). Each project had a contact person who also became part of the SKISS steering committee, together with a staff member from Konstfrämjandet and a member of a research group from Umeå University that was following the project.

These different arrangements of the three intermediary organizations definitely affected how they initiated an artistic intervention project, as described in the following section.

Establishing and funding an intervention project

Each intermediary organization had a detailed process for establishing the connection between an organization desiring an intervention, which could be private, public, governmental or non-profit, and the artist involved.

At TILLT, marketing the artistic intervention came first

The strategist, marketer or another staff member recruited organizations that would like an artistic intervention and negotiated funding. The company normally paid for the artist and the process leader and in a few cases also for the administrative costs. The company portion varied between €3,000 (early projects were heavily subsidized) and €45,000. Subsidies from a regional government covered administration and marketing, and EU funding normally covered part of the company portion.

Then a process leader was assigned who subsequently selected an artist from TILLT's database:

> The process leader goes out to the company and has a deep talk about what's going on and listens between the lines and tries to check out what challenges they have and what problems there are and why they want to order this kind of project. And so on. And the same with the artists, you have to get a good feeling of what type of person [is needed]. We use only one artist. It's not important if they are a dancer, choreographer, or painter or writer, it's more like the competence artists have so they can rest in the process. They are not afraid if they don't see what's around the corner. . . . After recruiting the artists they have to go through a kind of preparation, I made a folder with all the things the artist needs to know, such as group dynamics.
>
> (Sarjanen)

For SVID, the specific circumstances determined funding and selection criteria

The project was a collaboration between SVID and the Business & Design Lab at the University of Gothenburg (www.bdl.gu.se/About+us). The aim of the research project was to find out how designers influenced the innovation process, specifically in the early stages in companies that had not previously worked closely with designers. The project was funded by VINNOVA, The Swedish Governmental Agency for Innovation (www.vinnova.se/en/), and covered the researcher full-time for four years and the salary and expenses of the project leader from SVID for half time during a year and a half, although she worked much longer for the same pay. The companies received some money from the grant to cover part of the designers' initial work; afterwards they had to make their own contract and pay all costs for the designers. The project leader frequently worked with projects that required additional funding and on-going facilitation. In this situation the introduction of a designer into a company without previous experience of working with design created concerns similar to when artists were introduced through TILLT's process.

Marie Loft, the project leader, recruited six manufacturing companies that were geographically spread out and with different situations and various sizes

(however, one of the companies dropped out and one was sold). Between them, the remaining four companies made showers, work-wear, flooring, and centrifugal milk and cream separators. Loft drew on her network as SVID Regional Coordinator or through referrals from colleagues to select the designers with the researcher. For example:

> The workwear company wanted a little bit of academic connection, so I called someone at Borås College of Textiles and asked. It's a little bit of doing research about who can be good as a designer, so I wanted a person who had practical skills, of course, but also connection with the academic field. So then we had the matching situation with the company and the designers. And [Researcher] and I had done the brief or the questions from the companies. What did they want to do? . . . And that changed over the time of course, because as always they got into the situation with one question and they came out with a lot of other results. They changed the brief with time too.
>
> (Loft)

After a daylong start-up conference with all companies and designers, the company CEOs took turns to host three similar conferences. In addition, there were meetings of just designers, or just companies. One of the authors (UJS) attended about half of these meetings because she was responsible for the research project and doctoral supervisor of the researcher.

At SKISS the artists came before the host organizations

The project leader, Eva Månsson, was appointed in January 2005, and she hired the first group of 20 artists in April after reviewing applications and interviewing interested artists.

> We wanted to get a picture of what the artist wanted because it was an investigation for the artist. Do I like to work like this and in that case how can I work? And it was a little bit the same for the working places. This was something new for them and they didn't want to say, oh what is an artist? He's going to hang a picture on the wall or something? Well, we don't know. So it took very many different discussions in this first part. It was also some kind of investigation program [for SKISS]. How can we work with an artist and what difference does it make to the working place?
>
> (Månsson)

As a result:

> We were very different kind of artists with different kinds of media, expressions and experience from the field. Some were used to work more with

relational aesthetics, others were painters and video artists and sculptures. The oldest one was over 60 years old, the youngest [had just completed] their art education.

(Lobell)

Before entering the companies the artists completed a two-month training period held at Konstfack, University College of Arts, Crafts and Design, to prepare them "to discuss what is workplace health and why and what we should do" (Månsson). They had courses in organization theory, visited workplaces, and read and discussed health issues. It was the artists' responsibility to find an organization that suited them and to convince the management that their time there would be beneficial. This was almost the opposite of TILLT's way of handling the situation, and also quite different from SVID's way of organizing.

In total SKISS realized 56 artistic projects in different organizations: 30 in Stockholm (twenty in first round, ten in second) and 26 in various regions of the country. They included organizations in the public sector, such as schools, utility companies, eldercare facilities and public housing management. The size of the organizations varied from 4 or 5 to 2,000 people. In most projects the artists were employed half-time for a year and paid for their time, not for the artistic end result. According to the artist we interviewed:

> You got paid for your work, not the object you're producing. That was important. I think a very important political statement . . . that we should be paid for our work and the competence. . . . and it doesn't matter if it's an object or a sculpture or a painting in the end. . . . In a way we were working with processes that change minds – changed ways of thinking and reflecting on experience in the world. And that's something that you can have in the working places. I mean the artist can come in to that kind of process.
>
> (Lobell)

The SKISS organization differed both from TILLT and SVID. Whereas at TILLT 8-10 employees provided different forms of project support, SVID's regional office had only one person, who was supposed to work half time as a recruiter administrator in addition to being project leader for the six projects, SKISS had only one full time employee for 20 projects a year which made it impossible to act as a process leader. Instead artists performed many of the intermediary tasks, at times aided by members of the Umeå University research team.

The intervention began

Once the host organization and artist were named, the process or project leader worked to establish a good beginning to the intervention itself.

TILLT called the first few months "anchoring the project"

At the start there are the all-important steps of anchoring the project and building trust (in this volume see also Darsø):

> It's so important with trust building. So after the matchmaking this anchor work has been going on at the company to inform the board, inform different groups, the unions. And to present the artist and to have the first meeting with this project group at the workplace.
>
> (Sarjanen)

Then the artist works in the company one day a week:

> A phase of two months with the researching, building this project group strong, and getting to know people and the working place for the artist and vice versa. And build trust and starting to do some small workshops and so on.
>
> At the end of these two months they have to make a plan for the rest of the project. What are we going to do? How are we going to do it? When are we going to do it? Everyone's voice is important. . . . Every idea is good at first. Then you have to sort it out and see what is not subject for this project, and if you have to address these questions to the right persons in the company to take care of.
>
> (Sarjanen)

In contrast to TILLT's established process for the early stage of the intervention, SVID discovered that its previously used processes did not work, as the project leader explains below.

At SVID, both the project leader and the designers needed to approach their work differently from their usual approaches

Once the project leader had established initial contact with the companies and assigned an appropriate designer, the designers started holding workshops.

> That was the most intensive period when they were doing the real designer work. . . . It was a shock for the designers. . . . They had read the brief, this is what they want to explore from the company's side. And then the designers came out and started to work with the question. We want to change this and that. And how are we going to do that? They had no response because it was a totally empty vacuum in all the companies. They didn't have any processes at all. It was more like they were answering the market.
>
> We were totally unprepared for that situation because we thought that designers could do this. Or we think of them as very creative persons.

And they are, in a given situation together with others [designers]. But not creative in confrontation with people and not good at working with organizational change or organizational processes. So it was a long way to build up confidence between us and between the designer and the company. [Researcher] and I had met the companies three or four times. And then the designer came in and it was a new situation. The goal was to come closer to each other so that the company and the employees were feeling good about the situation and they could do something and be a part. And they could push their company and themselves forward to bring more meaning into the situation. So we did a lot of workshops around that.

Except for [Shower Manufacturer]. And they were bringing in a lot of examples of how they used to work in the innovation process . . . a lot of sketches and schemes and Power Points and everything about their innovation processes. They were just jumping on different kinds of models and trying to grasp what we had in our brief. So it was a totally different situation. It took a long time [with three different designers]. But in the end [it became] very good.

(Loft)

At SKISS the intermediary kept the artist's interest foremost

The project leader's role:

> . . . was to safeguard the project's budget and funding, to get a good, safe program for the artists. And then try to make good conditions for the artists in the project at the working place – to let the artist choose their own way of working. And try to make it open. I needed clearly to inform the contact persons at the workplace that this was an investigation and the artist had no expectations in the beginning. The artist needed to have a free process to see what will be happening. And then the working place could feel that they had this open process to work in a new way with the artist.
>
> (Månsson)

The artists had to anchor the idea for the project with both management and employees, work out the aim, and complete the intervention. During the initial training period the artists worked in pairs or small groups and they continued this structure to give each other support during the workplace period.

The intermediary's role for the remainder of the intervention

Once employees and the artist had established their joint working relationship, interventions proceeded. There were always some incidents that the intermediary needed to solve.

For TILLT, each intervention was different within an established overall process

The project work began in earnest:

> After these first two months you have six months, and you never know what's going to happen. And that is the challenge of the whole concept, not coming in with a fixed box about what we will do. It's a challenge to make people understand and feel the good things about, oh I am going to do something! I can give voice to what I think is interesting, and so on. It takes time. I worked with a project for 18 months and after about 12 months they said, "Oh, now we understand, we are in a process."
>
> <div align="right">(Sarjanen)</div>

The process leader kept an eye on the project through monthly coaching meetings with the artist and more frequent communication when necessary. He stepped in when he sensed there may be a conflict: often to meet with "the bosses" (Sarjanen's term for decision-making managers and supervisors of project members' on-going work) to make sure they understood the working conditions necessary for the project's success, or to reiterate the need for an open process in which everyone participates and all ideas are considered.

TILLT organized seminars at intervals during the projects so all the participants could learn from each other:

> We had three seminars over the project year with the kick off seminar when they had been working for maybe a month. When we had all eight projects starting on the same date and following each other the seminars were really supporting the process. Later we had rolling starts, so it could be one project starting in January, another in May, and so on. So we had two smaller seminars then.
>
> <div align="right">(Sarjanen)</div>

Ending the project:

> At the end of the project they have to make a plan for the future. . . . It's kind of an evaluation of the project. It can be coffee and cakes, or a big show, but it's very important to make clear that this phase of this project is over. And now you have to carry it forward by yourself. There is no artist coming next week.
>
> <div align="right">(Sarjanen)</div>

At TILLT, the process leader we interviewed had many years of experience and he kept the company's interests foremost in his mind while he dealt with the unique circumstances of each intervention. The company was paying for the intervention and the CEO would be speaking about the experience with

other CEOs as potential buyers of TILLT's services. SVID also had an established process for facilitating designers working in host organizations; here the project leader made sure that the designer worked with members of the organization in a productive way for both.

For SVID the project demonstrated the intermediary's facilitation skills

The intermediary supported the designer:

> I had to support the designer to come into the situation about working very consciously with the people in the workshop group.... Sometimes it went well and sometimes we lost each other and I had to step in. So I did a lot of symbolically running between the company and the designers to support the designers, to learn something about how they can work with their tools while thinking about how you reach the person here. Because that person doesn't understand when you say, "What is the feeling when you come into a shower like that?" So you have to think about talking about that in another way.
>
> (Loft)

According to the process leader the projects had mixed results at enabling innovation. Of the six original companies, three completed all the intended process in the intervention. Two were successful; for example, the project at the work-wear manufacturer influenced their products and created new product segments; the company also created a new showroom and meeting room with whole collections displayed on the wall. One was partially successful, where some of the employees were doing good things, and others could not grasp the difference between short-term thinking and long-term thinking. They thought only of what they must do immediately, and not about building for the future, and once the formal project was over they did not continue. Two had insurmountable problems, like the one where the project leader and researcher were never able to build up confidence in working with the designer rather than the designer just telling them what to do, so they withdrew from the project, and the second where the company was sold soon after a few project meetings. The sixth never finalized the initial contract.

The project leader reflected after the end of the projects:

> I have been thinking about something called pre-design that is part of my work before the project starts. If I had done that in this project, I could have prepared the company for innovation and organizational change better than I did because the pre-design process is like preparing the customer for what they are going to do and to understand what they are doing.... It is like being a good design buyer. Because if you're not prepared for the situation you waste the time learning, you don't have the right competence,

you don't put the right questions and you don't have the head and the heart in place.

The designers have learned a lot. I think they didn't think it was easy. They were proud of some things that were really good and where the company has had good results. You can count it as a good investment for the company they helped.

(Loft)

In the SKISS interventions the intermediary process was handled in a different way from that at either TILLT or SVID.

For SKISS the artists handled the on-going intervention

SKISS did not have a process leader like TILLT and SVID because the project leader did not have time to work individually with each project. She had no fewer than 20 parallel projects, while TILLT had 7 or 8 and SVID had 6 on a half-time basis. Instead, the artists at SKISS worked in groups where they supported each other and discussed problems as they occurred and how to solve them. Also, when new projects began artists from earlier ones were mentors or process developers. Sometimes a researcher from Umeå University was included in the discussions and reflections. This structure seemed to function well. It is noteworthy that the artists here worked halftime on the project instead of 20 per cent (one day a week) at TILLT.

The artist we interviewed reflected on her general way of working:

The way of thinking or solving problems is my way of looking at the world or the society and I want to be a part of the society. And I think a problem in the art world is that we're almost separate.... In contemporary art you're working with issues that are everyday things. Yeah, and then you should be out in everyday things.

(Lobell)

According to Månsson, the SKISS interventions were on the whole received very positively. The artists left the project at the end of their contract and returned to their own practice. However, once the initial funding ended there were no further interventions since there had been no time for the project leader to gauge interest or obtain other funding. She took another position where she could use some of her insights from SKISS.

Discussion: points of similarity and difference

As our conversations showed, the intermediary organizations had different roots, purposes and structures, and although the overall processes were similar individual approaches varied. We present these points of similarity and difference in Table 12.1 and Table 12.2.

Table 12.1 Intermediary organization differences

	TILLT	SVID	SKISS
Purpose of intermediary organization	Non-profit with government support, single purpose.	Foundation with many activities.	One-time project.
Overall purpose of project	Cultural, partly commercial project.	Research project.	Fulfil Konstfrämjandet's mission of 'Art for all' and provide opportunities for artists.
Structure of project(s)	4–8 parallel projects, each about a year, one day per week for this project leader.	6 parallel companies, running for 3.5/4.5 years, with varying intensity.	20 different organizations, each for half year.
Artist involvement	Salary and time equivalent of one day a week for one year.	Initially about 250 hours for artist in total. Most companies funded additional time.	Half-time salary provided for at least half a year.
Intermediary involvement	4–8 parallel projects, 4 parallel projects ideal. Others from TILLT's administrative structure were selling the projects (which sometimes took more time than facilitation).	Original agreement was for one and a half years, half time. In fact worked much longer. Took care of all the administration, including selling, external contacts, etc.	Administered projects. Not involved in selling or specific activities of projects, instead supported the artists who acted as own intermediary with organization.
Payment/ financing of artist/designer	Company paid artist's fee plus an amount to TILLT to cover process leader and overhead, i.e., administration and selling.	Research funding and company each paid 50% of initially agreed cost for designer. Most companies funded additional designer time.	European Social Fund and smaller amounts from Swedish governmental funds covered artist and project administration. (Organizations did not pay anything.)

The varied experiences of the intermediary organizations in developing and running artistic interventions indicated that different structures are possible and that projects can run for different lengths of time. TILLT, as the most experienced intermediary organization, needed considerable administrative resources to maintain its viability. SVID, in contrast to TILLT's single purpose, engaged in many activities that promote design, and was accustomed to finding external funding when needed. In the projects described here, an externally funded doctoral research project provided the project leader with on-site support. The experience of SKISS, on the other hand, as a temporary

Table 12.2 Intermediary process differences

	TILLT	SVID	SKISS
Recruitment of companies	Special "seller" (recruiter/marketer) approached company and developed relationship and contract, then assumed role of process leader.	Project leader recruited company after discussion with researcher. Recruiting seen as offering to company since they received a subsidy towards the designers.	Project leader recruited artists. Artists recruited the organizations themselves. Organizations did not pay anything except for their own time.
Recruitment of artists	Selected from database of interested artists. Formal recruitment process for inclusion in database.	Project leader recruited designers in discussion with researchers.	Formal recruitment process from list of unemployed artists.
Process support	Process leader dealt with problems as they arose.	Project leader and researcher worked together.	Artists worked in pairs and supported each other.
Dealing with problems ('people problems')	Process leader talked with management as needed to make sure project was understood within company.	Project leader dealt directly with problems and discussed them with researchers. Assigned a new designer when necessary.	Artists mentored each other and dealt directly with problems as they arose.
How projects ended	Employees and artists wrote report guided by process leader.	Researcher decided. Project leader and researcher wrote a "popular" report covering all projects for the funding organization.	Artist left company at end of employment period. No written report of each project.
Intermediary's view of outcomes for company	Better communication, better understanding for each other's different roles at the working place. Project works at individual, group, and organisation levels.	Met the goal set by the project group. Gained tools for future work.	Respite from daily work during project workshops.
Intermediary's view of outcomes for artist	Benefitted in ways related to why they were motivated to become involved in the first place.	Opportunity to reflect on own competencies.	Interaction with members of society. Networking with other artists. Steady salary.
Intermediary's view of outcomes for self	Satisfaction of seeing people become engaged and contributing ideas and opinions.	Impetus to develop new "pre-design" stage. Seeing how creative methods can be as strong as technical methods.	Leader too busy for self-development.

organization with only one full-time employee, suggests that artistic interventions can occur with far less administrative support than the other two organizations used.

The process differences were related to the amount of support provided by the project structure and also to the individual's past experiences. With the exception of SKISS, where the project leader could not point to a personal outcome, all our respondents reported that there were positive outcomes for all the involved parties. They all noted that goals for providing developmental opportunities for the artists were met in addition to company benefits.

Positive outcomes included:

- TILLT has completed 80 projects lasting 12 to 18 months, in addition to other kinds of art-based activities in host organizations (see in this volume Brattström, Styhre and Fröberg, Zambrell). The intermediary is set up to create opportunities for artistic interventions and then support the artists and participants during the process. Projects had strong endings that included an event, a report and company commitment to continue using "tools gained". They also stimulated learning between host organizations.
- For SVID the projects lasted between a year and a year and a half, with 10 to 15 full-day workshops for each company. Clear co-financing arrangements existed between the company and other funds, and although the amount given to each company was relatively small, it ensured commitment to the project from top management. SVID's project leader had specific criteria in mind when finding appropriate companies for the intervention. She also gained insights in what she called "pre-design" as a concept she was interested in developing.
- In SKISS the artists formed peer support groups and therefore became their own intermediaries. The contract provided them with half-time work, which allowed sufficient time for peer group meetings and the artists' own development.

The fragility of these structures is also evident:

- In TILLT the administrative overhead has become too large to be financially viable.
- For SVID this was a particular research project within a portfolio of development projects.
- For SKISS there was insufficient personal interest or administrative and financial support to continue.

Overall evaluation

Organizations and artists need disruptions to enable innovation. By bringing artists into organizations to share their competencies within an open process

and introduce working methods involving the senses and emotions, both organizational and individual development can occur (Berthoin Antal and Strauß, Schiuma and Carlucci, this volume). However, as other studies show (in this volume see Raviola and Schnugg, Styhre and Fröberg), this desired outcome is not always achieved. The different logics easily lead to conflicts and misunderstandings, as for example when artists are comfortable with ambiguity in the process, while members of the target organization demand goals and signs of progress. Roger Sarjanen, who has been a process leader for over 70 projects in TILLT, says that he does not remember a single one being totally without any problems: this does not mean that there will be no success, provided the differences are acknowledged and resolved, as others have also noted (see Berthoin Antal 2012; Eriksson 2009).

Gaps emerge in the meeting of artistic logic with the technical logic of the workplace, suggesting that some sort of mediation or intermediary process could help to bridge these gaps before they become overwhelming chasms. Here the unobtrusive skills of an experienced person guiding the process seems important, as someone who understands both the artist's perspective (both Loft and Sarjanen had backgrounds with artistic training), and the managerial view, including access to senior management (SKISS artists participated in university courses covering organization theory and workplace health, in addition to visiting various workplaces). However, given TILLT's process of selling artistic interventions and Sarjanen's concern with understanding management's goals for the intervention before engaging an artist, we see a risk that with TILLT the artistic logic could easily be dominated by the economic logic. This is likely the case due to the high co-funding from the company hosting the artist. According to Areblad, the aim in the TILLT-processes has been to start with a 'blank page' to be able to explore the artistic inquiry into challenges in the organizations (private communication, March 2015). However, making the organization invest in such an open process is very challenging. The more TILLT raised the price of the interventions, the less interested the organization's decision-makers became from an artistic point of view, leaving Areblad questioning at what cost the artistic quality can be kept sufficiently high for an appropriate investigation. A different financial model might have given the artistic questioning more space. SVID's commitment to design suggests that designers entered the target organization with some understanding of how the economic logic and artistic logic might interact. These expectations were overturned when the designers discovered that members of the project group did not have pre-set goals and new practices were needed. For SKISS the artistic logic came first, tempered by aspects of the economic logic as understood by the artists from the university courses. With this background the artists were able to select a compatible organization and navigate its economic logic while performing the intervention.

A major similarity between all three organizations and their intermediary processes was their acceptance that an artistic intervention takes time and much confusion and many misunderstandings are likely to occur. TILLT's process leader and SVID's project leader had similar time available for each project.

However, whereas TILLT's administrative structure handled finding the company and signing contracts, leaving the process leader able to devote all his time to working with the intervention, SVID's project leader needed to find the company and sign the contract herself. In SKISS the artists were paid for sufficient time to find and negotiate their own conditions.

Summary reflections

From our experience, some form of intermediary work between organizations and artistic interventions seems to be recommended, if not essential. However, this role in between the organization and artist is a difficult one to perform. We do not think that it is possible to be neutral or objective when trying to fill the gap between the artist and the organization: the situation most likely is one where the intermediary organization's values permeate the project. Thus, as an outcome of our research, we provide the following suggestions for others wishing to implement artistic interventions in organizations.

First consider the extent of the artistic perspective desired. If the intervention focuses on the artistic perspective introduced into the company (as in the case of SKISS), the outcomes may be more diffuse and take longer to be integrated into company processes, but eventually be extremely beneficial. On the other hand, if management has a definite outcome in mind before the intervention, then a facilitation process similar to that at TILLT would be more beneficial, since there the organization's interest can take precedence over the artistic process.

Second, when selecting an intermediary organization to provide the artist (or designer) to work with employees, consider whose values will be foregrounded in the process. TILLT first assigns the process leader who starts with the organization's objectives and engages the artist who takes some time to research the organization. The artist then works with a group of employees from different parts of the organization to re-clarify the objective of the project and their interest in it. The brief can change, but remains focused on the organization's needs, a practical necessity when the organization is paying high fees for the intervention. Alternatively, as in SKISS, if the artist decides that the organization's environment would be interesting from an artistic perspective, then artistic values may permeate the project. As a third possibility, participating in a university research project, as in the SVID example, brings additional benefits of a theoretically informed holistic approach in which the framing research question determines the value of the outcome.

We suggest that a fourth possibility exists, that of modelling the intermediary role on that of a curator who acts as an intermediary between the art world and the public when presenting artwork in museums or exhibitions (Berthoin Antal 2016; Johansson Sköldberg and Woodilla 2014). Each curator brings his or her own perspective, background and experience to the work, but contemporary curating involves letting the art itself be the centre of attention with the curator remaining in the background. Graham and Cook (2010) redefine

curating any art that may be "process oriented, time-based or live, networked or connected, conceptual or participative" (p. 284) as a set of behaviours, and conclude that "the only way to best know how to curate – to produce, present, disseminate, distribute, know, explain, or historicize – a work of art is to know its characteristics and its behaviours, rather than imposing a theory on the art" (p. 303). Thus curating is always unique to the artistic process or product at hand, rather than assuming a ubiquitous open process as with TILLT.

Contemporary curators appear to be in agreement that strong bonds develop between curator and artist (Genre Creates Ghetto 2014). From the artists' perspective, the curator is in service to the artist, but from the curator's perspective, the relationship with the artist is key: while the artist achieves the vision, the curator deals with underlying conditions and protects the artist from executive decisions/questions from the institution. The soul of the creative idea comes from the artist and the curator must ensure that the idea can last as long as it needs to. Involving a curator in the intermediary role would resemble the situation with SKISS, but relieve the artist of administrative tasks and allow her or him to concentrate on the specific artistic process of the intervention.

Taking the curator role as a model for the intermediary process suggests that the process or project leader would need a background in contemporary art practice or art history. The artist's work would be considered more seriously, resulting in this, rather than artistic methods in general, being the primary focus for the selection of an artist. However, the curator would also need an extensive corporate network in order to have credibility with company decision-makers, a key factor in establishing an open process for the intervention. Then, if the decision-makers and employees accept that the artwork itself can create a social environment in which people come together to participate in a shared activity (a relational perspective as described by Bourriaud 2002), both parties in the communication processes of the artistic intervention would have equal importance, and artistic development would be as important as organizational development. As a result the artist would have a strong position and before would (see notes) would be chosen based on criteria and a process different from those currently used.

References

Barry, D., and Meisiek, S. (2004) *NyX Innovation Alliances Evaluation Report*. Retrieved from www.dpb.dpu.dk/dokumentarkiv/Publications/20051215151928/CurrentVersion/rapport.pdf (Accessed July 15, 2010).

Barthelme, L. (2005) 'The view from the trenches: An interview with Harvey Seiffert and Tim Stockil', *Journal of Business Strategy*, 26(5), pp. 7–13.

Berthoin Antal, A. (2009) Research framework for evaluating the effects of artistic interventions in organizations. Gothenburg, Sweden: TILLT Europe. Retrieved from www.wzb.eu/sites/default/files/u30/researchreport.pdf (Accessed December 20, 2014).

Berthoin Antal, A. (in collaboration with Gómez de la Iglesia, R and Vives Almandoz, M) (2011) Managing artistic interventions in organisations. A comparative study of Programmes

in Europe, 2nd ed. Gothenburg: TILLT Europe. Retrieved from http://www.wzb.eu/sites/default/files/u30/report_managing_artistic_interventions_2011.pdf (Accessed January 26, 2015).

Berthoin-Antal, A. (2012) 'Artistic intervention residencies and their intermediaries', *Organizational Aesthetics*, 1(1), pp. 44–67.

Berthoin Antal, A. (2016.) 'The studio in the firm: A study of four artistic intervention residencies'. In Farías, I. and Wilkie, A. (eds.), *Studio studies: Operations, sites, displacements*. Abingdon, UK: Routledge pp.171–186.

Bourdieu, P. (1990) *The logic of practice*. Redwood City, CA: Stanford University Press.

Bourriaud, N. (2002) *Relational aesthetics*. Dijon: Les presses du réel.

Darsø, L. (2004) *Artful creation: Learning tales of arts in business*. Frederiksberg, Germany: Samfundslitteratur.

Eikhof, A. and Haunschild, A. (2007) 'For art's sake! Artistic and economic logics in creative play', *Journal of Organizational Behavior*, 18(5), pp. 523–538.

Eriksson, M. (2009) *Expanding your comfort zone – The effects of artistic and cultural intervention on the workplace. A study of AIRIS 2005–2008*. Gothenburg, Sweden: Institute for Management of Innovation and Technology.

Genre Creates Ghetto: Curating in a Post-Genre World. (2014) Symposium held at the John and Mable Ringling Museum of Art, Sarasota, Florida. March 22–23, 2014. Transcript.

Graham, B. and Cook, S. (2010) *Rethinking curating: Art after new media*. Cambridge, MA: MIT Press (Leonardo Books).

Grzelec, A. (2013) 'Exploring competencies in practice: Collaboration between artists and producers in artistic interventions'. In Heinsius, J. and Lehikoinen, K. (eds.), *Training artists of innovation, competencies in practice*. Helsinki, Finland: Helsinki Theatre of the Arts, pp. 85–99.

Grzelec, A. and Prata, T. (2013) *Artists in organizations – Mapping of European producers of artistic interventions in organisations*. Retrieved from www.creativeclash.eu/wp-content/uploads/2013/03/Creative_Clash_Mapping_2013_GrzelecPrata4.pdf (Accessed January 25, 2015).

Hopf, C. (2004) 'Qualitative interviews'. In Flick, U., von Kardoff, E. and Steinke, I. (eds.), *A companion to qualitative research*. London: Sage, pp.203–208.

Jahnke, M. (2013) *Meaning in the making*. Gothenburg, Sweden: ArtMonitor.

Johansson Sköldberg, U. (Forthcoming) *Konstnärliga interventioner i organisationer. Boken om TILLT, en föregångare i branschen. Artistic interventions in organisations* [A book about TILLT – a forerunner in the field]. Gothenburg, Sweden: Art Monitor and BAS.

Johansson Sköldberg, U., and Woodilla, J. (2014) 'Curatorial practice in artistic interventions in organizations: Insights from Swedish practitioners'. In *Proceedings of the Seventh Annual Art of Management and Organization Conference*. Copenhagen, Denmark.

Radnor, Z., and Boaden, R. (2004) 'Developing an understanding of corporate anorexia', *International Journal of Operations & Production Management*, 24(4), pp. 424–440.

Vondracek, A. (2013) *Support-schemes for artistic interventions in Europe*. Retrieved from www.creativeclash.eu/wp-content/uploads/2013/03/Creative_Clash_Support_Schemes_Vondracek_2013.pdf (Accessed December 20, 2014).

Widoff, A. ed. (2011) *SKISS. Konst. Arbetsliv. Forskning. Nio rapporter* [SKISS. Art. Working life. Research – nine reports]. Stockholm: Konstfrämjandet.

13 Organizational studios
Enabling innovation

Stefan Meisiek and Daved Barry

In artistic interventions elements from the art-world – people, practices or products – inspire organizational members to think and work in more creative ways. Their purpose is usually to help organizational members to see their daily routines, work patterns, client relationships and organizational processes in a new light (Barry and Meisiek 2010). Purported benefits for employees and their organizations range from entertainment and catharsis to identity work and organizational change (Berthoin Antal and Strauß 2014).

In a typical engagement the commissioned artist studies the organizational culture, processes and concerns of employees before developing and making an intervention. The intervention, for example a performance in the premises or production of artefacts, might happen with or without the direct participation of organizational members. For the duration of the intervention the artist legitimizes the presence of artistic work processes and artefacts in the organization. Practices that under ordinary circumstances would be considered strange are temporarily accepted and tried out. What organizational members look at, feel or understand during the artistic intervention enlivens the sense-making in the organization, potentially leading to changes in perception and action. The artistic intervention offers them the opportunity to see and experience the daily work environment and problems through the mirror of artistic practice and perspective (Meisiek and Barry 2014).

Artistic interventions are in this sense carnivalesque: the order of things is questioned for a limited time. When the intervention finishes and the artist leaves, matters return to a (new) normal. Yet, the growing need for innovativeness and difference under simultaneous pressures for cost-effectiveness has been pushing organizations to look for new ways of engagement. This raises the question whether artistic processes of inquiry could have a more permanent presence in organizations, becoming a part of the organizational repertoire. Relative to this, some managers are asking, "Can we do this ourselves?" How might an organization generate a process of artistic inquiry, experimentation and production in a designated studio space without an artist?

Can an organizational studio enable artistic processes? In research and development (R&D) facilities and innovation centres there exists a tradition of establishing special, dedicated places for creating difference in organizations.

Most R&D facilities are science-driven, and most innovation centres seem to be design-driven. We can place the organizational studio as a hypothetical entity next to these and investigate what it would have to be like to enable artistic inquiry, experimentation and production.

To shed light on how a studio might work in an organization and what its benefits might be, we present a case study of an organization that created and used such a space. The challenges that the project team encountered along the way and the results highlight how different organizational and artistic work are, and what perspectives and actions could help bridge the world of the arts and the world of organizations. The case reveals that art-making as research, that is, a materially-enhanced inquiry process, is a fruitful point of contact between the worlds of art and organizations.

We first describe some aspects of the studio as a place for artistic research and work. Then we provide a detailed account of the case organization and its journey towards establishing an organizational studio. In the concluding section, we formulate some recommendations on studios without artists as artistic interventions.

Studios: a place for artistic inquiry

The popular notion of the studio evokes images of a dedicated, secluded space, where an experimental, investigative and materially rich inquiry can take place. Participants pass through the space, working, making and thinking, and then consider how the results might lead to practical application.

Since the term was coined, a studio has meant a place for study, for discovery, for finding new, untried ways forward (Barry and Meisiek 2015). People use studios to conduct a material-intellectual inquiry into some interest at hand. The topic of inquiry might be how to improve on the practical items of everyday use, how to express the felt truth of being in the world, or to further knowledge and insight into complex matters. The framing and scope of the problem are subject to the inquiry process as well (Hetland, Winner, Veenema and Shreidan 2007).

Studios of one sort or another have been around for a long time. Yet, exactly what a studio contains and means has changed over time. The practices of making, problem solving and knowledge creation have shifted from the craft workshops of ancient Greece, to the kitchens of medieval alchemists and the studios of the enlightenment. The current romantic notion of the studio harkens back to prominent artist-inventors like DaVinci and the Italian enlightenment, where studios became known as places for intellectual thought, scientific curiosity and practical endeavour.

With the Industrial Revolution, the roles of craftsmen and artists changed, and engineers standardized processes for the factory that were previously done in the studio. Organizations grew around factory floors, and with this came a need for scientific management. The studio was left to the artists, whose role changed from expressing the glory of the Church to providing an independent,

critical voice in society. To do this, artists nurtured and developed their material studio practices, turning studios into places of apprenticeship, constant experimentation, inquiry, and expression of an alternative view to the sciences, politics or religion (Austin and Devin 2003).

During the twentieth century many artists abandoned the studio, wanting to carry their art-making out into the world and into the moment. The emergence of artistic interventions in organizations can be understood as a part of the out-of-studio movement. By leaving the studio and entering into organizations, artists offer their practices to a wider community. In some sense, the organization has become the studio, and with it a space for artistic inquiry.

It is this process of inquiry, "art practice as research" (Sullivan 2005), that makes studios valuable to organizations. The idea is that artists engage in iterative, insightful, robust and disciplined research practices that are distinct from scientific or humanistic research, and which generate knowledge. The material aspects of this research practice happens mostly in studios, and it is the reflexive conversation between material and ideas about a subject matter that generates insights and is finally expressed in the artwork. Theories created in this way are distinct from scientific theories in that they do not exclude alternative interpretations, but rather use these to further the process of inquiry.

The case: addressing inter-departmental problems in a Danish government organization

Our case is a Danish government organization with about 7,000 employees. A pernicious problem was the lack of collaboration and knowledge sharing between its two largest departments: law making and citizen services. A silo mentality, internal rivalries and a lack of knowledge sharing were roadblocks to a more effective and cost-efficient organization. To address these problems, an Innovation and Knowledge Sharing department (hereafter IKS) was established in 2009 with the aim of fostering organizational change, knowledge sharing, a holistic mind-set and an innovation culture. The manager of IKS knew artistic interventions from previous work assignments, and some of the early IKS projects involved artists as well as artistic materials to enable conversations about the problems of the organization. The results of these interventions were deemed positive, yet the effects seemed to be short-lived.

Seeking to generate more profound effects, an IKS project team established an organizational studio in 2010, drawing on ideas from the first author. The team consisted of two project managers representing the law and service departments, two junior project members and two internal consultants. Apart from one project manager and one internal consultant, all team members were women. After a year of preparing the associated process and space, IKS ran a pilot workshop with employees from law and services. The results were strikingly good, and IKS members thought they had found a generative way of working across internal organizational boundaries with pernicious problems.

In the following case description we follow the IKS project members from creating the studio and its process, via the pilot project, to the perceived outcomes. We pay special attention to the artistic inquiry process and artistic materials that were interwoven throughout.

To study the IKS studio initiative, two research assistants[1] conducted five semi-structured interviews with IKS members, two interviews with the internal consultants, and one interview with the first author of this chapter, who had introduced the IKS manager and project members to the studio idea. All the interviews were audio recorded. To preserve a certain level of anonymity, the interviewees are referred to as Interviewee 1 through 8 (abbreviated to I.1 to I.8), and their role is added where appropriate. The research assistants and the second author provided a more distanced and analytical view on the case to balance the direct involvement of the first author.

Introducing the idea of "an organizational studio"

When the first author introduced the studio idea to IKS, the project members framed it in terms of the artistic interventions they had already tried. "I didn't know whether [the Studio] worked, but I knew that art is working in some cases and prototyping almost always works. So combining these two, I thought that we could achieve something" (I.7, IKS department manager). Another IKS member recalled:

> [The IKS manager] is very open to [experimenting] so it was sort of her idea that it came up: "Hmmm I know this associate professor ... at CBS, it would be fun to do something with him, he has this thing called the Studio. We don't really know what it is actually but it has something to do with solving wicked problems and creative methods for doing it ... not reducing complexity but actually taking in complexity." And that's sort of what we knew when we started out.
>
> (I.1, project manager law)

After a short introductory meeting, the project team concluded that a studio could be implemented fairly easily and lead to significant outcomes for the organization. However, they soon encountered challenges that made them wonder whether the studio really was what they initially perceived it to be. It seemed somehow foreign to their organizational world. The project team associated the word "studio" with a tool or technique that could easily be implemented and transferred to others. The advising co-author explained to them that he conceives of the studio as a mind-set:

> It's not like something that is sitting on the shelf and you are like "oh, let's apply that".... we are using a different understanding of the word "method".... So there was actually quite an amount of negotiation forth and back to let them know that this is a method, but it is not a tool.
>
> (I.8, advisor)

In previous artistic interventions, IKS had hired an artist to introduce artistic practices and materials. Now the project team had to develop and introduce an artistic feature, the studio, themselves. The task challenged their sense-making and the way they saw their organization, causing frustrations in the team. They were also irritated by the first author: a junior project member recalled that the advisor

> was able to pose the questions in a totally different way. He could flip it upside down and then "oh yes, of course that's the right way". We were still in the old paradise of thinking linearly, even trying to position ourselves elsewhere.
>
> (I.3)

The frustrations arose because they wanted to have a method that would produce foreseeable, repeatable outcomes, while the studio method stresses unforeseeable, original outcomes.

Anxious to reach a conclusion, the project manager ended the discussions.

> I took my agenda [makes a motion of taking the paper in his hand and crushing it into a paper ball] ... "okay, we are going to my place ... but it is all up to you. What do we need now as a group to get further?" It was actually [the sceptical group member] who said "I need to put my word on this as well. We have to come up with our name for it." And that is brilliant.
>
> (I.1, project manager law)

This moment turned out to be a breakthrough for the team. The internal consultant for the project facilitated a creative session at the project manager's apartment, where they worked on a name for the studio that would make sense to them and the rest of the organization.

> We realized we can't call it the Studio because ... if you give things an English name in this organization, it is dead from the beginning. So, we came up with the New Room [in Danish "Det Nye Rum"] ... because we kept on discussing what was new about the Studio and how did it differ from what we usually do. "Well, in the New Room we do this, and in the old room we do that." ... Also we liked that it had this physical connotation.
>
> (I.2, project manager service)

They found a name they could all relate to, fit the organizational context, and own.

The advisor, who at this point was no longer needed, turned into a reminder for the need for abstract, non-linear thinking.

> We are very much inspired by him ... it's more his way of thinking when we ask ourselves "hmm, are we getting too much into dududu [indicating very rigid processes with his voice and hands] boxes, or are

we actually twisting this around?"... because for him it's always about twisting it just a little bit more and just a little bit more.

(I.1, project manager law)

The organizational studio space: close, yet different

The IKS project team planned a studio that would maximize the feel of "otherness" and temporally disconnect participants from their usual work context. To this end the project team chose a room in a structure connecting the service and the law department wings of the office building. The structure also housed the reception, a café lounge and a library. It was a suitable place because participants had to leave their usual wing where they worked, but were still in the same building.

The IKS project team wanted to create a visual contrast to the normal meeting rooms. To them, "the old room" represented the setup of a usual meeting room, the working style of fast problem and solution definition, and a conservative mentality, which they perceived as too linear and restricting. In contrast the "New Room" studio had a movable wall, allowing for an easy change of arrangements. This was in line with their idea of being able to change the setting of the room between sessions, keeping it dynamic and different. They traded typical office furniture for more flexible pieces such as cushions, and painted the walls with whiteboard paint, making it possible to write on them. Colour, shape and flexibility, employed to create an atmosphere that suggested something new and different, was about to happen each time the participants entered the room.

Furthermore, they decided to serve the participants high-quality food and coffee:

> When you as a participant can see that there has been put a lot of effort into it, resources, money, the food, and little things like the food is good, then the scenography has been changed ... the way the facilitators put in effort also signals the participants' "hmm, it may be weird and I may not understand, but they probably know what they are doing and it is pretty serious. This is not just ... another one of those team-building events where we do something fun for two hours and then we go back to whatever we did before". I think it is very important to send the signal that this is different and it is serious.
>
> (I.1, project manager law)

The project team attempted to create an atmosphere that would stop the participants from placing the workshop within their habitual expectations. Instead they received cues that did not fit with their established sense-making patterns and working with physical artefacts helped initiate a mind-set of inquiry and reflectiveness. The environment signalled and invited artistic inquiry.

The pilot project: knowledge sharing between departments

The IKS project team wanted to address one of the core problems of the organization in the studio pilot project, namely the lack of knowledge sharing and collaboration between the law and service departments. They organized a pilot project lasting five days, which 18 participants, 2 internal consultants and 4 project team members attended. The first author was not part of the project at this point. The project team leaders selected a mix of participants from service and law with the goal of minimizing social boundaries within the group and to generate an open and honest dialogue. The chosen participants had different backgrounds within the organization, both professionally and geographically.

Moreover, the team leaders consciously sought out participants with different personalities.

> We were very keen to not just get the happy-go-lucky people who love this sort of stuff and leave out the people that we know traditionally are personally more negative towards change and doing something like this. We wanted all kinds of people.
>
> (I.1, project manager law)

To create the trust necessary for participants to open up, the goal was to create a bubble, a universe separate from the rest of the organization. Participants could not leave the room throughout the day; even lunch was served within the room. Hierarchy was to be suspended, and participants' minds freed from mundane tasks and departmental worries. In the pilot everyone was supposed to be as equal as possible.

The whole first day went into team building. "People have to sort of ease into the room and feel comfortable there" (I.2, project manager service). As a result, they now felt ready to listen and open up to the others' perspectives. The importance of trust, safety and team building was crystallized in the words of one of the two internal consultants in the pilot:

> They were very different people ... some of the people were the quiet types, and we also had these people with big arms and everything is possible, and then other people that were "this is not going to be possible, we have tried that, no just forget about it already" but when they finished after those 5 days they were one group and they had the same mind-set.
>
> (I.5, internal consultant)

The internal consultants set two strict rules that the participants had to follow. First, they forbade people from saying "we can't do this" or "we have to do that" and secondly, they told people not to talk until it was their turn. These

rules allowed the participants to talk and listen to each other without interfering or projecting a restrictive message.

> And all of a sudden, they heard each other. "So that was what you said. Well, then I agree with you!" and we didn't have problems there. It wasn't that we forced the conflicts to disappear from the room, but all of a sudden, by setting up these rules, everyone actually listened to each other.
> (I.2, project manager service)

This approach successfully signalled that the "Old Room norms" could be not only challenged, but also changed.

The facilitation process

Not allowing the participants to interact with the outside was intended to prevent participants from arriving at conclusions prematurely. They perceived this effect to be a major strength of the studio. It avoided the risk that dialogues with non-participants could start justification processes before the workshop was over. Further, by not allowing interference or restrictive generalizing, the organizers wanted to encourage the participants to venture further than usual in their reflective search for the kind of deep understanding that artistic inquiry can achieve.

The internal consultants' role was to encourage discussions and inquiry in order to reveal underlying issues within the organization and challenge habitual ways of thinking. The participants had to undergo a similar experience of disturbance as the project team had when challenging their own mind-set in order to develop the studio idea. The workshop was intended to bring people beyond their usual horizon, and the participants sometimes needed a push in order to get there. "We forced them to go way out there instead of discussing what little, small changes they had to do" (I.2, project manager service).

The internal consultants actively challenged the participants' cognitive models:

> Oh, they're just coming up with the old ideas. They just wanted a new IT system. But then suddenly, at 2 o'clock on the second day there was this kind of funny tension in the room where one of the central employees had ... an argument with one of the local employees from Jutland, and they were arguing in this really interesting way and suddenly the local one said "Don't you understand that I'm afraid of you! If I have a problem, I'm afraid of calling you." So suddenly we just had it all out that the human factor was not about IT systems or reward systems. It was about knowing and becoming comfortable with one another to be able to get to "oh it works! We just have to be patient. With time it will come to us if we bring people into the room and use this method". It will lead people to say things that they would not have said

in the traditional way of facilitating a workshop and we were just like "oh, yes we did it!"

(I.3, junior project member)

Artistic practices and materials

The internal consultants asked participants to express their ideas in artefacts in order to trigger conversations and bring to light some unspoken and hidden aspects of organizational reality. Using low-cost materials like Styrofoam, buttons, ribbons and paper, the participants created models of the law principles and service ecologies. The materialization of their perceptions served as a point of departure for discussing what is and what is not, and how to reach from here to what might be. They made physical, colourful models of an integrated organization of the future, looking for scenarios towards which the organization might move from its present form. They turned the whole studio into a "museum of services to the citizen", and then acted as visitors to their museum to imagine how the citizens would make sense of it as if they were seeing it for the first time. This was their idea and practice of artistic inquiry.

All the creative exercises took place collectively. Right from the start, the finish-it-fast mentality of the organization became apparent. As soon as a task had been assigned to the participants, they asked for a time frame. When the answer was, "however long you need", they tried finishing the task as quickly as possible. "They just completed the task without any reflections of 'this might be my chance to get to know the other people'. At least these three guys stood there saying 'Done!'" (I.3, junior project member). Ironically, the goal was not to 'solve' the tasks or to be quick and effective because this approach can lead people to overlook key points based on organizational assumptions and prevent them from reflecting on how things could be done differently. It took time for the participants to realize this, but by the end of the workshop they felt increasingly comfortable with the creative methods and material.

The silo mentality also became visible through the artefacts. For example, in one exercise the facilitator asked the participants to draw the process of the services as a flowchart and then to place themselves in it. Almost all the participants put themselves into the process, except for two employees from the law department who placed themselves outside it. This positioning revealed a problem that had not been clear to the participants until then, namely that the members of the law department did not consider themselves part of the process. It illustrated how the employees of the law department looked at problems in a detached manner rather than placing themselves within it.

The internal consultants tried to move the participants away from their everyday context when they discussed their organizational view, in order to open up perspectives. "You got to sort of think out all sorts of the crazy ideas. You got to ask all the 'what if' questions. You got to make assumptions: 'well, what if there was no society and all ... how would we do this?' That triggered

them" (I.2, project manager service). These discussions were then taken further into the creation of artefacts that were supposed to reflect how participants saw specific features of the organization: "People said that 'it's interesting how we got to talk about some very interesting things while making the collage'. So the collages are kind of secondary to the talk going on while making them" (I.3, junior project member).

Artefacts triggered reflection and sense-making processes that led to the possibility of seeing different aspects of the organization. It is the reflective conversation between materials and ideas that marks artistic inquiry in studios. The process shed new light on things that people previously thought were clear. It enhanced their understanding of the organization and its binding mechanisms. It revealed some underlying problems that had not yet been detected, allowed people to see more and see differently, and to understand how law and service were interlinked.

The project group considered the intentional process of keeping the participants from reaching a conclusion to be one of the most important aspects of the studio. A member of the group used a metaphor to explain the learning impact: "What is so different from the usual way of being part of a workshop is that it needs to go from the heads down to the stomachs. And that was the new part for most of us" (I.3, junior project member). However, the organizers underestimated the need for concreteness at the end of the process: "We probably missed out on helping [the participants] back to their heads again. And I think that is also why, whenever you come out of the New Room into ... your normal daily tasks, the clash becomes even bigger" (I.1, project manager law). Preventing the participants from reaching an immediate conclusion was difficult (I.3, ll. 233): "They wanted more concreteness in the end of the workshop and so after the day was done, Day 4, we changed the program in Day 5 and said 'okay, they need it to be more concrete'; We want to be able to say when they go out of the door tomorrow 'they've had 5 great days and they took something with them out of the room'. So we changed the program in order for them to become more concrete" (I.5, internal consultant). It was important not only to increase the participants' ability to see and work with equivocality, but to help them connect their insights to their specific organizational realities.

Outcomes: a promising proposal for a new law

The seed that the pilot project planted took on a life of its own. The participants from the pilot joined a new project group. This group followed up on their earlier discussions and used their newfound understanding of the organization to develop a new approach to the pernicious problems of the tax collection system. They repeatedly asked IKS if they could return to the New Room and IKS facilitated new sessions to help them maintain creativity and abstract thinking. The group worked well together: "Being in the room 5 days made them really strong as a group. So the glue that we built up was so strong that they have worked really well afterwards as a group" (I.5, internal consultant).

Approximately a year after the group was established it delivered a promising proposal for a new law. This was considered a great accomplishment. Two IKS project team members praised it as follows:

> The board of directors . . . approved of it, saying that it's one of the best they've seen in many years. The way they're going to do it, the process behind, everything is just really something that's setting the goals for years to come on how we really want to work. Yeah, it's probably THE main area of the whole business where we collect over 5 billion DKK. It's a very, very big thing.
>
> (I.1, project manager law)

Although the new law proposal had not yet gone before the parliament, people in the organization were already giving credit to the studio process for it. The project manager who had advocated entering into the pilot, noted:

> We tried this so many times before; we worked with this for ten years. Now we have the law. Before that we had the New Room. For me it is not difficult. That is the connection. Simple. . . . That is the one thing we haven't done before.
>
> (I.1, project manager law)

The success story: demand for the New Room

The success story of the pilot started to circulate within the organization. The participants in the pilot workshop as well as managers who had witnessed the results became advocates for the New Room:

> The whole idea about implementing change of laws incrementally, where you sort of innovate the tax system incrementally, but with sort of a radical vision—that is new. And the directors have discussed that . . . So the different levels of management have started talking about how it makes sense.
>
> (I.2, project manager service)

This positive word of mouth resulted in an increased demand for taking problems into the New Room.

For the IKS department the goal with the New Room became inquiring deeply in ways usually associated with art or design processes: using analogous artefacts, reflecting and then continuing the process in order to reach a better understanding of organizational complexities. They learned not to define the studio as a clear means to an end, because they came to believe that it is the studio process that brings forth new understandings of internal issues, which then informs the traditional problem solving processes that follow.

Despite this apparent success, the IKS department was disbanded when the government organization was merged into a larger entity two years after the

pilot project. With the reorganization and move of the departments the studio was discontinued.

Conclusion

The case study points to a number of issues and opportunities around establishing and running a studio in an organization. The artistic inquiry that takes place in a studio can help people in organizations to address the pernicious problems that arise from organizational structures. While organizational structures are created to solve problems, the inquiry process in our case revealed the problems that the organizational structure creates, and how difficult it is for organizational members to get a handle on them.

The case demonstrated that it is indeed possible for organizations to benefit from artistic practices in studio spaces without professional artists. The studio was successfully (albeit temporarily) established within the organization, the processes embodied a number of artistic characteristics, and the outcomes surprised the members of the organization. All interviewees said it would have been impossible to achieve what they had done without working together in the studio.

We can draw a few speculative recommendations from this experience:

1. Artistic studios are foreign places to most organizations, and they need to be legitimated in language, appearance and process to become acceptable. The IKS project team showed great creativity in reinterpreting the existing structures in the light of the studio process they were aiming at. It began with the name. While the word "studio" was unacceptable, the "New Room" made sense to organizational members.
2. The location of the studio between the two wings of law and service proved crucial. A studio should be near, yet separate from the main work places of the organization. The flexible and colourful furnishings and decorations suggested that things are done differently in the organizational studio.
3. The participants were separated from their usual work places for the duration of the studio session. This was an important practice because separation keeps attention in the room, fosters team building, and it enables collaboration between people who have either zero or antagonistic contact in their everyday work routines.
4. The studio requires facilitators to guide participants through a pre-defined process replete with rules for behaviour. Since artistic inquiry is foreign to most participants, it is unlikely to happen by itself in a studio space. Facilitators need to establish rules that replace the usual workplace rules for the duration of the workshop. Based on the rules, facilitators should encourage, enable and challenge participants to draw benefit from the inquiry process and the studio materials.
5. Participants in an organizational studio work in collaboration with one another, bringing the organization into the room in this way.

6 The artistic process – in terms of skill and mastery – remained at a beginner's level. Skill in drawing, modelling, curating and performing were not aims in themselves, but rather means to find out more about the people in the room and the organization they were all part of. It enabled conversations and debates. It was the knowledge that was gained from the drawings, models, exhibitions and performances that were important.
7 The artistic inquiry process involved a reflective conversation between materials, concepts, ideas and suggestions. We believe that this relationship between the material and the cognitive is at the core of what makes an organizational studio tick. We would need to conduct more research to understand how this reflective inquiry process works in detail in order to draw broader conclusions. Our case study is still too coarse. We see this as a wide field for future scientific investigation.

Unfortunately, many artistic interventions are not followed up with long-term measures, and while company members might leave the workshop or performance energized and inspired, the possibilities of translating it into actionable improvements and changes are slim. Organizational members might see more or see differently following an arts-based intervention, but the real work of developing an answer to the organizational, cultural and managerial structures has just begun. And this work will naturally need to deviate and make compromises from the impressions and expressions of the artistic intervention. The organizational studio, as in our case, might well be the bridge between the two worlds, and the place where the next steps will be taken.

Note

1 Special thanks to research assistants Ragnhildur Ágústsdóttir and Michaela Bublitz, who helped in the data collection and analysis process.

References

Austin, R., and Devin, L. (2003) *Artful making*. Upper Saddle River, NJ: FT Prentice Hall.

Barry, D. and Meisiek, S. (2010) 'Seeing more and seeing differently: Sensemaking, mindfulness and the workarts', *Organization Studies*, 31, pp. 1505–1530.

Barry, D. and Meisiek, S. (2015) 'Discovering the business studio', *Journal of Management Education*, 39(1), pp. 153–175.

Berthoin Antal, A., and Strauß, A. (2014) 'Not only art's task – Narrating bridges between unusual experiences with art and organizational identity', *Scandinavian Journal of Management*, 30, pp. 114–123.

Hetland, L., Winner, E., Veenema, S. and Sheridan, K.M. (2007) *Studio thinking: The real benefits of visual arts education*. New York, NY: Teachers College Press.

Meisiek, S. and Barry, D. (2014) 'The science of making management an art', *Scandinavian Journal of Management*, 30, pp. 134–141.

Sullivan, G. (2005) *Art practice as research: Inquiry in the visual arts*. Thousand Oaks, CA: Sage Publications.

Part VI
Reflections

14 From revolution to evolution ... and back again?

Ariane Berthoin Antal, Jill Woodilla and Ulla Johansson Sköldberg

Editing a volume is as much of a learning adventure as it is to read it, although the process is different. We had the pleasure of inviting younger and senior colleagues to contribute to our book project by addressing a certain aspect of the field that we believed merited attention, then meeting with them in person and online many times during the preparation of this volume. Over the months, we learned from and with these authors while reading their drafts and helping them clarify their ideas.

You, the reader, have in your hands a completed book that offers a journey across the territory of new research on artistic interventions in organizations. At the outset we introduced you to the contours of the field, its development and its dominant discourses. Now we would like to share with you our thoughts about what we learned from our colleagues about the evolution of the field. We also want to express our concerns about the absence of some critical discourses and outline some challenges that we encourage bold academics, artists, managers, intermediaries and policymakers to take up to reignite a revolutionary spirit in the development of research, theory and practice of artistic interventions in organizations.

Learning with and from our colleagues

The contributions from our colleagues in this volume have helped us discover a greater quantity and quality of research than expected at the outset of this book journey. We see various kinds of growth documented in the chapters, and our sense is that on the whole they have protected the field from a typical problem when ideas become popular in organizations, namely becoming a superficial management fad (Abrahamson 1991; Kieser 1997).

Quantitative expansion

Evidence for the quantitative growth is especially visible in the chapter by Lotte Darsø, who presents a map of the development of artistic interventions an a framework for practice. It is also evident in the chapter by Ariane Berthoin Antal and Anke Strauß, whose extensive review of empirical studies documents the great number and variety of artistic interventions in organizations

in Europe, and provides a realistic assessment of the different kinds of value such initiatives have generated. The subsequent chapters serve to illustrate the continuing expansion of artistic interventions into all kinds of organizations, including a municipal authority, a newspaper and a publishing house, as well as an automotive company. We are struck by the fact that several examples come from experiments in various educational settings, underscoring our introductory thoughts about artistic interventions in universities and business schools as multipliers and Lotte Darsø's reflection on the importance of drawing on the arts for the renewal of education.

Qualitative extension

The qualitative evolution of research is evident in many chapters and takes several forms. The volume supports the observation in the literature review by Ariane Berthoin Antal and Anke Strauß that there is a shift from publications with claims based mostly on anecdotal evidence to careful empirical research, often drawing on multiple perspectives. The value of having doctoral students contributing to the development of the field by engaging in case studies over an extended period of time, combining several methods of data collection and drawing on different bodies of theory for their analysis emerges clearly in the chapters by Marcus Jahnke, who relates to hermeneutics, and Victoria Brattström, who draws on theatre studies for her inquiry in combination with bodily ways of knowing. Another qualitative development in research is the collaborative approach that combines the theoretical perspective of a senior academic (Alexander Styhre) with the practical experience of an artist (Jonas Fröberg).

Several authors in this volume contribute to expanding the reach of the field by bringing cases about art forms or agents that have not yet received much attention in the literature. For example, we learned a great deal from the chapter by Nina Bozic Yams presenting the first detailed analysis of an intervention with contemporary dance, and from Katarina Zambrell's first empirical study of managers responsible for hosting an artistic intervention in an organization. Stefan Meisiek and Daved Barry also break new ground by addressing a different type of 'agent' that has received little attention in the literature so far, namely, space.

A particularly significant way to enrich the quality of the field that our authors illustrate is the value of looking at artistic interventions with a critical eye, such as the two cases that Elena Raviola and Claudia Schnugg deconstruct to reveal the problematic nature of attempting to commodify creativity. The critical comparative study of intermediaries by Ulla Johansson Sköldberg and Jill Woodilla highlights the drawbacks of different models and illustrates the fragility of these actors, and thereby of the field itself, because they are so central to its development.

The chapters show that it is both possible and generative to expand the range of research methods with experiments initiated by the authors. Linda

M. Ippolito and Nancy J. Adler may well be the first to document a carefully designed multiple-experiment approach to assessing the effects of an artistic intervention with music. Nina Bozic Yams, too, co-designed a series of exercises then participated in some, thereby generating data from her personal experience along with the reports on experience from other participants, a combination that allowed her to achieve a deeper understanding of the situation than a purely cognitive research approach would permit. Another experimental approach is illustrated in the chapters by Giovanni Schiuma and Daniela Carlucci, and by Stefan Meisiek and Daved Barry: in both cases managers in an organization felt inspired to try out an idea proposed by an academic, and allowed the academics then to study the implementation process.

Fad-free expansion

What strikes us as a healthy sign in the evolution of the field is that none of the authors attempt to develop a comprehensive theory of artistic interventions in organizations. They ground their work in carefully collected data from different sources, seeking to achieve an understanding of the quite complex dynamics at play when people from the world of organizations engage with people, practices or products from the world of the arts. This choice appears to be saving the field from the trap of feeding yet another management fad, which would lead artistic interventions along the typical curve from a rapid growth in popularity for a while to a steep decline in interest and attention, leaving little trace (Berthoin Antal forthcoming). Instead of aiming at grand theory or simple prescriptions, most authors draw on concepts from their own discipline; these in turn indicate the many ways of interpreting the process and outcomes of an artistic intervention.

The field has benefitted from the fact that artistic interventions have been tried in diverse contexts and the researchers, too, are based in different countries. One of the items to put on the research agenda for the future is an examination of the cultural embeddedness of artistic interventions. Although researchers, artists and intermediaries have explored *how* culturally shaped understandings of what is appropriate, unacceptable, or necessary are suspended in the interspace of an artistic intervention in an organization, little attention has been paid to *which* norms are suspended and which norms are being maintained in order to suspend others. In order to understand the phenomenon better, we need to know how the national, regional, professional and organizational cultures affect the process. Comparative studies are therefore needed both to contribute to theory building and in order to help the actors clarify how to learn from experiences in different settings.

From evolution back to revolution?

Although we observe that research on artistic interventions has advanced and has documented many valuable outcomes, we are not satisfied with the current state of the art. The field started with great enthusiasm, as Lotte Darsø pointed

out in Chapter 2. There were high expectations of the revolutionary potential inherent in bringing together the world of the arts and the world of organizations. But the actual development has been evolutionary. The reality-check of many experiments has undoubtedly had a healthy sobering effect. We nevertheless feel that a return to revolutionary expectations is warranted and promising, on the condition that future studies are grounded in more critical perspectives than have been taken by most publications to date, thereby creating a discontinuous change in the research agenda.

Introducing more critical perspectives

Currently researchers focus on how differences and difficulties between the world of the arts and the world of organizations are overcome in order to improve the existing order of things. They have provided evidence from many engagements that artists, employees and managers have experienced as valuable, but it is dangerous to take it for granted that artists and members of organizations outside the art-world can always truly meet. There is also a need to dwell on the nature and value of the underlying differences in order to specify, for example, the conditions under which artists should not take the risk of leaving their world to enter the world of organizations. It is equally problematic to assume that the sole purpose of artistic interventions is to improve the existing order of things. We sense that artistic interventions in organizations and research about them are stunted by being caught in the paradoxical situation that Luc Boltanski and Eve Chiapello have characterized as "the new spirit of capitalism" (2005). Management (and management scholars) have become so enamoured of notions from the art-world, like beauty, authenticity and passion, and have absorbed them in their language in such a way as to mask the fundamental differences between the worlds. By assuming a high correspondence between 'new' management and the arts, they have blunted the critical voice inherent in the arts that society needs to hear in order to challenge comfortable assumptions and deeply engrained power structures.

When we outlined the dominant discourses in our introductory chapter, we were already aware of important discourses not present in our book. For example, we found no potential contributors who could examine the field from feminist perspectives, and researchers steeped in critical management theory or actor-network theory have not yet participated in the conversation. Such colleagues would certainly challenge many of the current assumptions about the dynamics of artistic interventions, leading to new questions and different interpretations about what is happening when people, practices and products from the world of the arts enter the world of organizations.

Taking bolder steps

In this volume, Katarina Zambrell characterized the managers in her sample as "bold". At the outset it was indeed revolutionary for managers and artists to try

meeting in artistic interventions, and it was daring of researchers to study the new phenomenon with eyes wide open rather than playing a safe publication game by imposing existing theoretical lenses on the field. Now the field has matured enough with many examples from the pioneers to reassure managers that the risk is worth taking, and with sufficient rich description that researchers can advance theoretically. The time has therefore come to take bolder steps again. We outline what we mean by this for academics, managers, intermediaries and policymakers. Artists are not included in this list for two reasons. There is no need to challenge artists to become bolder: first because those who are making the choice to step out into the world of organizations are bold in each new endeavour they undertake; second because the artists whose projects we have studied have told us from experience that not all artists are suited for artistic interventions, so those who are not interested deserve respect rather than pressure.

Bold academics and academic institutions

First and foremost we call on members of our academic community to become bolder in the questions they ask, the conversations in which they engage, and the methods they use in research and teaching.

- For research this challenge implies seeking deep understanding of the dynamics of artistic interventions in organizations from multiple critical perspectives. It requires courage to undertake such research today under the institutional career pressures in academia to publish in mainstream journals that favour established formats (Funken, Rogge and Hörlin 2015; Nedeva and Boden 2006; Simon and Knie 2013). Understanding dynamics involving power and different cultural norms in organizations requires longer-term studies in the field, rather than brief snapshots. The quality of understanding also benefits from using mixed methods that reveal mysteries in realities and breakdowns between data and theory (Alvesson and Kärreman 2011). In addition, we strongly encourage scholars to draw on different theoretical frames rather than relying on a single approach to data collection and analysis. For example, if researchers were to explore artistic interventions from multiple feminist perspectives (Tong 2013) and draw on arts-based methods such as Hélène Cisoux' *écriture féminine [feminine writing]*, they could "challenge and oppose the masculine discourse of academic writing" that dominates management and organization studies (Biehl-Missal 2015, p. 179). Such a counter-cultural recommendation for research implies not fearing to use emotions in the whole research process – from observations, to interpretation and documentation (Alvesson and Sköldberg 2009). We therefore recommend that researchers use not only their heads but also their hearts, and bring a critical sense of humour to their work, as Barbara Czarniawska does in her Postlude to this volume.

We have pointed out how valuable the contributions of doctoral students are because they have dedicated several years to their fieldwork and have drawn on different bodies of theory to make sense of their data. We should expect scholars at all levels in academia to exercise the boldness and perseverance we demand of doctoral students in their research projects, despite pressures to publish rapidly. Just as artistic interventions require managers and artists to move out of their comfort zones (Eriksson 2009), researchers, too, should do so by working not only with scholars who use different methods and theoretical approaches, but also with artists, in order to learn from diverse forms of inquiry, reflection and writing (see for example Brellochs and Schrat 2005; McNiff 1998). The value of drawing on art-forms in the research process is already starting to be documented by some scholars, such as Barbara Czarniawska's (2004) use of narrative methods, Louise Grisoni's (2012) creation of poem houses, Steve Taylor's (2002) experiments with theatre and storytelling, and Samantha Warren's (2012) work with photography in ethnographic research.

- The need to make changes in teaching in universities and business schools, in terms of both content and format, has been underscored in many reports (recent ones include Holtom and Dierdorff 2013; Statler and Guillet de Monthoux 2015). Fortunately, as we pointed out in the introduction, some colleagues have been bold in experimenting with integrating arts-based experiences into their courses, enabling students at various levels, including executive education, to work with different ways of knowing. Such courses have already shown the value of working with the arts to stimulate students to have the courage to tap into their emotions and aesthetic sensibilities (for example, Darsø in this volume; Taylor 2014). As the contribution by Ippolito and Adler in this volume illustrates, well-designed experiments with arts-based methods in business schools can contribute both to the development of students and to theory-building, thereby building bridges between research, education and practice in organizations. Our research leads us to add two countercultural lessons we believe future and current managers need to learn from the arts in order to innovate: (1) appreciating 'not-knowing' as a generative state, a resource rather than a problem to be avoided or masked (Berthoin Antal 2013); (2) developing several possible ideas, then dedicating care and energy to perfecting one of them, rather than being satisfied with the first thing that comes to mind, a problematic tendency we encounter all-too-often in business school classrooms.

Bold managers

Research has documented how the first generation of bold managers has pioneered the practice of artistic interventions in organizations. The second generation of bold managers needs to be significantly larger: they already have evidence of the multiple forms of values-added that such adventures can

generate. In addition to the quantitative growth, we envisage boldness to entail a greater commitment by managers to position themselves as learners in the process, rather than limiting their commitment to creating learning opportunities for others in their organization. Equally importantly, we challenge bold managers to tap into their experience and participate actively in enriching the language of evaluation beyond the narrow technical indicators of performance taught in business schools. Their insight and authority is urgently needed for evaluating innovative approaches in organizations in order to resolve the dilemma that 'not everything that can be counted counts, and not everything that counts can be counted'.

Bold intermediaries

The field of artistic interventions needs intermediaries who can bridge between the world of the arts and the world of organizations, and indeed they are growing in number, often benefitting from published research reports about the different formats and services developed by pioneers like TILLT in Sweden and Conexiones improbables in Spain. As Ulla Johansson Sköldberg and Jill Woodilla illustrate in this volume, some are temporary organizations so the future might hold pop-up intermediaries as well as longer-term actors. What do the bold intermediaries of the future need to do? First and foremost, have the courage to resist the temptation of treating artists and artistic interventions like a commodity and promising to satisfy managerial expectations (in this volume see Raviola and Schnugg; Berthoin Antal and Strauß). Second, they should dare to stimulate their own learning and challenge their own assumptions by engaging in artistic interventions, rather than just selling them to other organizations. Third, they should keep forging their own professional identity. Rather than orienting themselves towards consulting, which is rooted in the norms and language of management, bold intermediaries should pursue a strategy of learning from the art world that is currently reinventing curating (Berthoin Antal 2016; Johansson Sköldberg and Woodilla in this volume; Smith 2012).

Bold policymakers

The European experience with artistic interventions in organizations has shown that the curiosity of policymakers willing to invest in experiments and concomitant research projects has had a significant impact on the development of the field. The bold policymakers of the future need to be in many other countries and regions, including the United States and the People's Republic of China, where the dominant economic models would benefit from learning how to value multistakeholder perspectives. Furthermore, bold policymakers at all levels and in all regions should take the plunge and experience artistic interventions in their own organizations, rather than limiting their commitment to funding experiments elsewhere. Participating in artistic interventions would deepen their understanding of programmes they are supporting, and

even more importantly, develop their capacity for policymaking under conditions of not-knowing.

Looking back from the future

At the end of this journey together, you, the readers of our volume, may ask what we expect for the field five to ten years from now. As 'bold editors' we are comfortable in 'not-knowing' but we can express hopes! The return from evolution to revolution that we hope for should hold a vibrant, expanding practice of artistic interventions in organizations, accompanied by bold researchers who dare to tread softly. While respecting that such adventures are not for every organization, manager or artist, we envisage many more organizations around the world experimenting with artistic interventions in ways that will benefit not only the participants, but also the larger community in which they are embedded. Unrestricted by a detailed template, every intervention is a unique way to open a space of possibility in which people and organizations can discover and try out generative responses to Charles Handy's (2015) provocative call to get onto the "second curve" in the quest to reinvent society. We hope to see bold scholars engaging in collaborative co-learning processes with artists and members of organizations, using multiple ways of knowing, applying mixed methods and contributing to diverse discourses, rather than building towards a single model or theory.

References

Abrahamson, E. (1991) 'Managerial fads and fashions: The diffusion and rejection of innovations', *Academy of Management Review*, 16(3), pp. 586–612.
Alvesson, M. and Kärreman, D. (2011) *Qualitative research and theory development: Mystery as method*. Thousand Oaks, CA: Sage.
Alvesson, M. and Sköldberg, K. (2009) *Reflexive methodology: New vistas for qualitative research*. London, UK: Sage.
Berthoin Antal, A. (2013) 'Art-based research for engaging not-knowing in organizations', *Journal of Applied Arts and Health*, 4(1), pp. 67–76.
Berthoin Antal, A. (2016) 'The studio in the firm: A study of four artistic intervention residencies'. In Farías, I. and Wilkie, A. (eds.) *Studio studies: Operations, sites, displacements*. Abbingdon, UK: Routledge, pp. 171–186.
Berthoin Antal, A. (forthcoming) Artistic interventions in organizations: Beyond the fad. In Anders R. Örtenblad (ed.), *Handbook of research on management ideas and panaceas: Adaptation and context*. Cheltenham, UK and Northampton, MA, US: Edward Elgar.
Biehl-Missal, B. (2015) '"I write like a painter": Feminine creation with arts-based methods in organizational research', *Gender, Work & Organization*, 22(2), pp. 179–196.
Brellochs, M. and Schrat, H. (eds.) (2005) *Raffinierter Überleben: Strategien in Kunst und Wirtschaft* [Sophisticated survival techniques: Strategies in art and economy]. Berlin, Germany: Kadmos.
Boltanski, L. and Chiapello, E. (2005) 'The new spirit of capitalism', *International Journal of Politics, Culture, and Society*, 18(3), pp. 161–188.
Czarniawska, B. (2004) *Narratives in social science research*. London, UK: Sage.

Eriksson, M. (2009) Expanding your comfort zone: The effects of artistic and cultural intervention on the workplace. Institute for Management of Innovation and Technology, Gothenburg, Sweden. Retrieved from http://issuu.com/tillt/docs/expanding_your_comfort_zone/1 (Accessed January 15, 2013).

Funken, C., Rogge, J-C and Hörlin, S. (2015) *Vertrackte Karrieren* [Problematic careers]. Frankfurt, Germany and New York, USA: Campus Verlag.

Grisoni, L. (2012) 'Poem houses: An arts based inquiry into making a transitional artefact to explore shifting understandings and new insights in presentational knowing', *Organizational Aesthetics*, 1(1), pp. 11–25.

Handy, C. (2015) *The second curve: Thoughts on reinventing society*. London, UK: Random House.

Holtom, B. and Dierdorff, E. (eds.) (2013) *Disrupt or be disrupted: A blueprint for change in management education*. San Francisco, CA: Jossey Bass.

Kieser, A. (1997) 'Rhetoric and myth in management fashion', *Organization* 4(1), pp. 49–74.

McNiff, S. (1998) *Art-based research*. London, UK: Jessica Kingsley.

Nedeva M. and Boden, R. (2006) 'Changing science: The advent of neo-liberalism', *Prometheus*, 24(3), pp. 269–81.

Simon, D. and Knie, A. (2013) 'Can evaluation contribute to the organizational development of academic institutions? An international comparison', *Evaluation*, 19(4), pp. 408–418.

Smith, T. (2012) *Thinking contemporary curating*. New York, NY: Independent Curators International.

Statler, M. and Guillet de Monthoux, P. (2015) 'Humanities and arts in management education: The emerging Carnegie paradigm', *Journal of Management Education*, 39(1), pp. 3–15.

Taylor S.S. (2002) 'Overcoming aesthetic muteness: Researching organizational members' aesthetic experience', *Human Relations*, 55(7), pp. 821–840.

Taylor, S.S. (2014) 'Open your heart'. In Ladkin, D. and Taylor, S.S. (eds.), *The physicality of leadership: Gesture, entanglement, taboo, possibilities*. Bingley, UK: Emerald, pp. 237–250.

Tong, R. (2013) *Feminist thought: A comprehensive introduction* (4th ed.). Abbingdon, UK: Routledge.

Warren, S. (2012) 'Having an eye for it: Aesthetics, ethnography and the senses', *Journal of Organizational Ethnography*, 1(1), pp. 107–118.

15 Postlude

Barbara Czarniawska

Business and art have a long shared history, extending far beyond the history of rich business people acquiring works of art and funding art galleries. At the beginning of the twentieth century, artists designed marketing posters (Alphonse Mucha being one famous example) and everyday objects (Fortunato Depero and Lyobov Popova, for example). Designers were also invited into formal organizations, to draw organizational charts and to shape office furniture. Traditionally, the flows of influence were well defined: ideas and images from art to business, and money from business to art. Only recently has the flow of ideas become reciprocal, as both sides increased their interest in the processes – not merely in the products. Thus artists believe that they can learn something about business, and business scholars and practitioners believe that they can learn something from the process of creation. Researchers and teachers specializing in management and organization give courses on the details of business making, and the artists reciprocate, intervening in the very process of organizing.

Connections between the arts and management are many and varied. The early symbolist scholars of management and organization studies, the founders of the Studies of Cultures, Organizations and Societies (SCOS) network, launched the motto "research is fun" – a slogan that could be extended to other types of work. Here, I would like to mention yet another form of artistic intervention in organizations, perhaps the least common form: poking fun at it.

In 1997, the vice chairman of Logitech invited Scott Adams to come into the firm under the guise of a management consultant called Mebert.[1] Mebert cited a fictional study on the value of mission statements, and then proceeded to draw three interlocking circles. After apologizing for his poor artwork, he explained that the figures were his "cognitive framework" – a "mission triad" of "Authority", "Linguistics" and "Message". Where the circles meet is the "Buy-In Zone" – the area in which employees will accept the mission statement, Mebert told the executives, some of whom were dutifully taking notes. It was only when Mebert compared mission statements to broccoli soup that some managers began to suspect that they were being had (or so they said afterwards). In their defence, it must be said that an appeal to produce "real-life Dilbert quotes" demonstrated that actual corporate life is similar to Dilbert's descriptions.[2]

The intensely debated question is whether or not Dilbert-like spoofs help to counter the corporate culture, or merely render it more palatable (Czarniawska 2014). Journalist Norman Solomon (1997) has claimed that although Adams seems to caricature the aims of top corporate management, his satire ultimately supports them.

> Xerox management had recognized what more gullible Dilbert readers did not: Dilbert is an offbeat sugary substance that helps the corporate medicine go down. The Dilbert phenomenon accepts – and perversely eggs on – many negative aspects of corporate existence as unchangeable facets of human nature... As Xerox managers grasped, Dilbert speaks to some very real work experiences while simultaneously eroding inclinations to fight for better working conditions.
> (Solomon 1997, p. 35)

Adams responded in a comic strip from February 2, 1998, simply by restating Solomon's argument, suggesting that it was absurd. His book, *The Joy of Work* (1998, pp. 256–258), includes a fictive interview that Dilbert's anthropomorphic pet dog, Dogbert, is conducting with Solomon.

Opinions differ. Filipczak (1994, p. 29) has suggested, for instance, that "Adams exposes many 'cutting edge' workplace issues to the severe light of day, inviting us to laugh at re-engineering, cross-functional teams, business meetings, corporate buzzwords, management fads". This assessment of Adams' comic strips seems to be a common perception, but there are others.

One suggestion is that the popularity of Dilbert is a sign of growing cynicism and increasing disengagement of workers from their employers, particularly in response to the on-going downsizing of corporations that began in the 1990s (Van Biema 1996, p. 82). Another stance criticizes Adams' vision as defeatist and in opposition to the possibility of moral progress in organizations (Borowski 1998). Adams came to be regarded by some commentators as an anti-management guru, "whereas most business writers write for the one in ten people who are interested in management theory, he writes for the nine who hate it" ("The anti-management guru" 1997, 64). Yet, as Adams said in an interview with Filipczak (1994, p. 33), "all I really do is take what the employees are already thinking and just express it". Later he added:

> For example, it seems to me that the ultimate victory in life is to mock large corporations and have them pay me to do it while everyone watches. To me, that's funny. Maybe even ironic. To the media, that is blatant hypocrisy.
> (1998, p. 255)

The double edge of irony, particularly in the context of work and organizations, has been discussed elsewhere (Johansson and Woodilla 2005). Here, I would like to suggest another possibility: that Adams' intervention caused

participants in the meeting to distance themselves from their work and their organization, and, as is well known, distancing opens the opportunity for reflection.

Will such distancing and the consequent reflection improve employees' productivity and intensify their well-being, or will it set them on a path of war with the management? Who knows? I am not going to join either the eulogists or the critics of Dilbert and Adams. In my opinion, the power of art, and of art interventions, lies exactly in the fact that their consequences are unpredictable. An artistic intervention disrupts and enriches the everyday routine of organizing. Consequences may be of the sort that will help to construct a business case – or an anti-business case. The important thing is a touch of the different.

Or, as Michel Serres (1982/2007) could have put it, art is a parasite on the corporate body, causing interference or interruption, and by doing so becomes a catalyst for complexity. The host either incorporates the parasite, innovating its own ways of being, or it attempts to expel the parasite, which also results in the transformation of everyday practices. In both cases, an (unplanned) innovation occurs. In both cases, it's worth it.

Notes

1 http://web.archive.org/web/20000914093255/http://www.mit.edu/~jcb/humor/scott-adams-mgmt-consultant (Accessed February 17, 2015).
2 http://blogs.msdn.com/b/architectsrule/archive/2008/07/01/real-life-dilbert-manager-quotes.aspx (Accessed January 11, 2013).

References

Adams, S. (1998) *The joy of work*. New York, NY: Harper Business.
'The anti-management guru. Scott Adams has made a business out of bashing business. Why does the hand he bites love to feed him?' (1997) *Economist*, April 3, p. 64. Retrieved from http://www.economist.com/node/146641 (Accessed February 19, 2015).
Borowski, P.J. (1998) 'Manager–employee relationships: Guided by Kant's categorical imperative or by Dilbert's business principle', *Journal of Business Ethics*, 17, pp. 1623–1632.
Czarniawska, B. (2014) 'Hard is soft, precise is fuzzy, concrete is abstract, or, where does the economic information belong?' In Bourmistrov, A. and Olson, O. (eds.), *Accounting, management control and institutional development*. Oslo, Norway: Cappelen Damm, pp. 219–231.
Filipczak, B. (1994) 'An interview with Scott Adams', *Training* 31(7), pp. 29–33.
Johansson, U. and Woodilla, J. (2005) (eds.) *Irony and organizations: Epistemological claims and supporting field stories*. Malmö/Copenhagen: Liber/CBS Press.
Serres, M. (1982/2007) *The parasite*. Baltimore, MD: Johns Hopkins.
Solomon, N. (1997) *The trouble with Dilbert: How corporate culture gets the last laugh*. Monroe, ME: Common Courage Press.
Van Biema, D. (1996) 'Layoffs for laughs', *Time*, 147(12), pp. 82–83.

Index

AACORN (Arts, Aesthetics, Creativity and Organization) 20
ABIs *see* Arts-Based Initiatives
Abreu, Jose Antonio 125
acting 165, 166, 167, 179, 180
action research 12, 153–60, 162
Adler, Nancy J. 32
aesthetic-inspired leadership 186, 191–6
aesthetics 5, 8–9
AIRIS 108, 111–15, 117, 185–90, 191, 193–200; managers 186–92, 195, 197, 199
Amabile, Teresa 22
Analytic Hierarchy Process 11, 61, 67–71
ARCOM 6
art 123, 124, 126, 132
artful: *Artful Creation: Learning-Tales of Arts-in-Business* 18, 40; creation 22; ways, of working 41, 48, 50
Artful Creation: Learning-Tales of Arts-in-Business (Darsø) 18, 40
artistic approach 19, 30–1; creativity 21; field of 116, 164; initiatives 11, 60, 66–7, 72, 131, 196; inquiry 12, 165, 169, 182, 221, 225–7, 230, 232–4, 236; materials 24, 31, 227–8; methods 24, 173–4, 178, 208, 223; practices 13, 86, 164, 168, 225, 229, 236; processes 8, 30, 88, 96, 99–100, 123, 222–3, 225, 237; projects 97, 116, 212; research 182, 226; work process and 81, 99, 102, 182, 225–6
artistic competence 172
artistic inquiry 165, 169, 181
artistic interventions 37–55, 77–88, 107–118, 164–5, 169, 181, 185–200, 204–23; bridging strategies for 13, 204; development of 6, 241; effects of 37, 52, 54; managers in 13, 185, 187, 189, 191, 193, 195, 197, 199; in organizations 3–5, 7, 9–11, 13, 19, 21–3, 25, 37–41, 47, 49–50, 53–4, 204, 241, 243–4, 246–8; outcome of 11, 99; producing 37, 207; programs 115–16; projects 6, 24–5, 43, 45, 49, 51, 85, 111, 113–16, 165, 185, 200, 209
artistic logic 204, 221
artistic research 182
Artists in Labs 6
artists-in-residence 5, 21, 29, 91, 107, 110, 115
Art of Management and Organization Conferences 19–20
arts: business managers 8, 207; business organizations 91, 101; business processes 62–3, 66; management 107, 112, 117; performing 9, 164
Arts & Business 6, 8, 18–21, 24, 31
Arts-Based Initiatives (ABIs) 3, 8, 10–11, 60–72, 196; business impact of 10, 60–1, 63, 65, 67, 69, 71; impact of 60–1, 63, 66–7, 72
arts-based methods 13, 55, 245–6
arts-in-business 7, 18–19, 21, 23, 24, 25, 27, 29, 31, 40
arts management 107, 112, 117
Arts Value Map 8, 11, 61, 65–9, 71–2; designing 68
artworks 62–3, 98–102, 107, 115, 222–3, 227, 250
Ashridge Management College 7
assessment 10, 60–3, 65, 67, 69, 71–2, 101, 242, 251; of ABIs 60, 62, 63, 71–2; AIRIS project value 199; of element weight 69; in organizations 63; tool, maps 65
Austria 5, 91, 98

Banff Centre 7, 29
Bi-Communal Choir for Peace 129
big meets small 91–6
bodhran, 130
bridging 204–23

254 Index

Carnegie Hall-Weill Institute's Musical Connections Program 125
case studies 101
Cecilia String Quartet 135, 139
change 225–7, 230
choreography 12–13, 149–62, 190, 207, 210
cognitive processes 149, 165
collaborative work 107–8
commodification 92, 102
communication 66, 101, 102, 127, 128, 130; media 98; nonverbal 64; quantity and quality of 45; skills 69–71
competences 4, 12, 23, 62, 63, 69, 107, 112; directing 179–81; innovation 31–2
Conexiones improbables 6, 40, 247
conflict 123, 124, 128–33
constructed situations 11, 107–18
constructive disturbance 22–5, 31
contemporary dance and choreography 12, 149–50, 161
context 3, 4, 6, 8, 10, 12, 22, 23, 24, 25, 31, 42, 47, 51, 52, 54, 64, 67, 85, 101, 109, 150, 151, 153; creating context 191–3
Copenhagen Business School 7
Creactivity 93–6, 103
creating context 191–3
Creative Clash 6, 40
creativity 19–20, 60, 62–3, 87–8, 90–3, 95, 99, 101–3, 139, 141, 149, 157, 160–1, 186–7, 197; creative abrasion 115; creative climate 191–3; practice 92–101; processes 12, 53, 65–6, 88, 99–100, 102–3, 149–62, 166, 170; work 80, 91, 99, 102, 150
creativity theory 90–104
critical perspective 244
curating process 223, 237
curator 206, 222

dance, contemporary 12, 142, 149–50, 160–2, 242
Darsø, Lotte 18, 40
Debord, Guy 109
decision support methods 66–7, 72
Delval, Anne-Valérie 6
Denmark 5, 6, 20, 26, 29, 40, 49, 52, 78, 112
design 7, 11, 25, 29, 53, 62, 63, 67, 80, 84, 111, 116, 133, 150; design process 68–71, 235
détournement 107–11, 114–16; and constructed situations 11, 107–9, 111, 113, 115, 117
development of artistic interventions 6, 10
Different Drums of Ireland 129–30

Dilbert 250–2
directing 167, 170, 179, 180, 181
discourses, 4, 7–14; managerial discourse 9; metaphors 9, 10; multistakeholder 9, 11, 13
dispute resolution processes 136, 138
disruption 204, 220
diversity 138, 164, 169, 172, 176, 178–9

economic logic 204, 221
economics 6, 107, 124
education 25–6, 31–2, 64, 171, 208, 246
El Sistema 125
emotions 24, 27, 39, 51, 60, 62, 97, 124, 134, 136–9, 149, 155, 161–2, 198, 221
employees 4–5, 38–52, 54–5, 69–72, 91, 94–100, 102–3, 160–2, 185, 187–95, 198–200, 214, 222–3, 232–3, 250–2; relationships among 69–71
enabling agents 5–7
energy 19, 21–3, 39, 50–1, 62, 84, 159–60, 166, 174, 194, 199, 246
environment: innovative working 154, 157; work environment 4, 42, 155, 157, 159, 174
European Commission 8, 40, 112
evaluation 9, 11, 38, 39, 43, 46, 49, 52, 53, 54, 63, 65, 72, 99, 100, 102, 139, 140, 157, 158, 199, 206, 115, 220–2
everyday work life 44, 111, 113
evidence 37–55
evolution 10, 31, 32, 241–8
exploration 134, 150, 152, 154, 156, 157, 159–60, 162, 179

fostering creativity 11, 90–1, 93, 95, 97, 99, 101, 103
France 6, 40, 206

Gadamer, Hans Georg 87
Gergen, Ken 123
Germany 6, 40, 47
Given Circumstances 165–9
global leadership 123–43
Gothenburg Research Institute 7
Guillet de Monthoux, Pierre 7, 8, 24, 107, 198, 246

Hall, Alexander 157
HEC Paris 6
hermeneutics 78, 86–7

identity 77–88
IEDC Bled School of Management 7

IKS (Innovation and Knowledge Sharing Department) 227–9, 234; project team 227, 230–1, 236
impact evaluation 60–72
innovation 78; centres 225–6; competencies 31–2; culture and space for 154, 159; management processes 66; organizational 149; processes 4, 31, 90, 154, 156, 162, 204, 208, 210, 214; tools 149-62
inquiry process 226, 236; artistic 228, 237
intelligence, social 133–4, 143
intermediaries 3–7, 13, 32, 37, 54–5, 91–2, 96–8, 100–3, 204–5, 207–8, 214, 216–23, 241–3, 245, 247; bold 247; organizations 5, 91, 188, 204–9, 217–18, 222; process differences 219; role 206, 222–3; Swedish intermediary organizations 13, 108, 164, 206
intermediary process 207–17
interpersonal levels 38, 44–6, 48
interpretation 87, 88
interspaces 11, 25, 31, 38–40, 51–2, 54, 116–17; artistic 52; temporary 39
interventions 8–9, 11–13, 38, 41, 51, 53–4, 164–5, 169–70, 196, 204–7, 209, 212–17, 220–3, 225–9, 237; artistic 77–8, 164; arts-based 126, 131, 237; dance-based 161–2; music-based 131, 135, 143; process 78–9, 165, 167, 174, 181, 205; project 78, 176–7, 181, 209
interviews 13, 18, 23, 41, 42, 46, 49, 68, 78, 82, 83, 85, 91, 92, 150; interactive interviews 68
irony 233, 251
Iziamo, Gustaf 157

KIA (*Kreativa Innovationer i Arbetslivet/* Creative Innovation in Working Life) 78
knowledge 226, 227, 231–4; assets 65–6, 69–72; management 71; organizational 66–7, 69, 72

lambeg 130
law 127, 132
leadership 4, 6, 8–9, 12, 13, 26, 29–30, 32, 43, 46–7, 123–43, 185, 190–2, 194–200; aesthetic-inspired 21, 186, 191–2, 195–6, 198–200; areas 195–6; and artistic initiatives 196; artistry 123, 126, 128, 131, 139; development 18, 25, 32, 43
Learning Lab 6
learning processes 7, 9, 21, 25–9, 54, 62, 155; affective learning 136; behavioural learning 136; cognitive learning 136; co-learning 248; cross-cultural 4; initiating cross-border 6; music-based 136; learning transfer 136
Lefebvre, Henri 108
legal practice 134, 139, 141
level-spanning effects 48
liking employees 191–2, 194–5
liminal space 108, 117
logics, artistic 21, 204, 221; economic logic 204, 221
London Business School 7

making space, concept of 39, 52–4
Mälardalen University 153
management 3–5, 7–9, 19–20, 48, 50, 53–4, 61, 63–4, 67–9, 71–2, 78, 149, 197–8, 244–5, 250; development 12; fads 241, 243, 251; ideas 101; literature 115, 185, 200; scholars 9, 37, 244; support 48, 196; team 49, 71, 78, 195
management theory, critical 10, 244
managers 3–5, 7–9, 13, 21–2, 38–9, 43–6, 50–2, 60, 64–5, 67–72, 91–2, 185–92, 195–200, 241–8; in artistic interventions 13, 185, 187, 189, 191, 193, 195, 197, 199; bold 185, 187, 191, 197, 246–7; service managers 164, 178; top managers 21, 68, 154, 191
mapping process 64
maps, causal 64–5
material-making 84
meaning-making 86–8
meta-analysis 38, 40, 42, 44, 47–8, 50, 54
metaphors 9, 11, 13, 29, 30, 43, 82, 83; discourse 9, 10; musical 135–6
motivations 21–2, 173, 185, 187–9; manager's 189–91
multistakeholder 37–55
music 123–43; classical 159; ensemble 124, 132, 134; sacred 130
musical interventions 123–4, 128, 134, 140, 143
musicians 124–5, 127–8, 133, 207

negotiation process 138, 139, 142
newspaper 77–80, 82–8, 242
Nova School of Business and Economics in Lisbon 6
Nussbaum, Martha 32

organizational change 10, 24, 62, 205, 214, 216, 225, 227
organizational development 123–43

organizations: aesthetics 5, 19; artistic interventions in 13, 204; behaviours 61–3; capabilities 66, 69; context of 6, 23–4, 47, 51, 150, 153, 156, 179, 192, 229; creativity and 90–3, 95–7, 99, 101–3; culture 19, 47, 195, 225, 243; development 9, 20–1, 41, 46–7, 62–3, 67, 207, 223; host 206, 211–12, 216, 220; intervention projects 164, 167, 179; interventions 9, 179; leadership in 10; learning 44, 51, 53–4; level effects 38, 46–7; level of 9, 11, 38–9, 41, 46, 53, 162, 191, 196; members 9, 42, 49, 52, 95, 117, 225, 236–7; practice of artistic interventions in 241, 246; processes 63, 214, 225; public 21, 61; studies 107, 169, 245, 250; studio 13, 225–7, 236–7; studios 13, 25, 225, 227, 229, 231, 233, 235, 237; theory 9, 11, 212, 221; value drivers 65, 72

parasite 252
pilot project 228, 231, 234, 236
pioneers 5, 6–7
playlists 134, 138–9
poetic activism 123–4, 128, 131
policymaker 241, 245, 247–8
Pontanima Choir 130–1
process leader 79, 85–6, 207, 210, 212, 215–19, 221–2
process performance objectives 68
professional development 126, 133, 136–7
project leader 86, 206, 209–13, 216–20, 223
project managers 79, 91, 93–4, 103, 206, 227, 229, 235; project management 93, 101
project team 79–80, 226, 228–30, 232
public sector 5, 40, 107, 112, 116–17, 149

reality 64, 99, 123–4, 143, 197, 245; organizational 233–4
reflection 42, 52, 135, 139, 152; stories 154–5, 160
rehearsal process 166–8, 170, 173–4, 180, 182
Reklam 91, 96–103
relations 190–2
relationships 9, 19, 23, 31, 41, 44–5, 64–5, 67, 69–70, 123, 136–7, 186–7, 206, 219, 223; internal 44–5, 193
research project 86, 208, 210–11, 218, 220, 246
research team 68–9, 71
revolution 10, 127, 241–8

Sarajevo 130–1
scenography 26, 153, 230
scepticism 3, 23, 25, 48, 50, 80
Schaeffer, Jennie Andersson 153
scholar 244–6, 248
Schutz, Alfred 114
sensuous learning 28–9
Serres, Michel 252
services 61, 63, 67, 90, 159, 164, 178, 208, 216, 227
Sisters Academy 26–9
Situationist International 107–11, 114, 116–17
SKISS 20, 206, 208–9, 211–12, 214, 217–23
South Africa 124, 127–8
South Korea 6
space: organizational 13, 40; working 93
Spain 6, 40, 43, 47, 51, 52, 112, 247
Srhoj, Dejan 156
Stanislavski, Konstantin 165–8
String Quartet 135, 139, 141
structures, organizational 53, 236
studio 13, 225–37
SVID (Stiftelsen Svensk Industridesig/ Swedish Industrial Design Foundation) 206, 208, 210, 212–13, 216–22
Sweden 6, 12, 20, 29, 40, 42, 45–6, 49, 51, 82, 91, 112, 153, 204, 208–9
Switzerland 6

Taylor, Steven 7
TILLT 6, 40, 45–6, 51, 77–81, 84–6, 91, 112, 164, 185–6, 206–10, 212–13, 215, 217–23, 247
transformation 252
triggering activities 191, 194–5, 200
"Troubles, The" 130
tuning-in 150, 151

Ugli Orange 135, 140
UK 6, 19, 20, 42, 43, 53, 206
University of Gothenburg Business and Design Lab 7, 210
University of the Arts Innovation Insights Hub 7
Unternehmen! KulturWirtschaft 6

values 3, 9, 11, 13, 38, 40–52: creation 3, 66–7; of leadership 10; values-added 37–55

Washington, David 129
West–Eastern Divan Orchestra 128–9

workarts 196
work environment 4, 42, 155, 157, 159, 174
work life 22, 113; experiences 116
workplace 5, 7, 12, 45, 51, 54, 60, 63, 107, 116, 164, 198, 213–14, 221
workshops 18–19, 44, 47, 68, 81–4, 95, 154–8, 160–1, 174, 176, 178, 213–14, 230, 232–4, 236–7; first 81, 84
workspaces 117, 170

work strategies 165, 178, 181
World Economic Forum 18
world of organizations 4, 37, 77, 112, 204, 226, 243–5, 247
world of the arts 3, 4, 6, 37, 77, 112, 204, 206, 207, 226, 243, 244, 247
writing 7, 12–13, 29, 113–14, 116–17, 169, 245–6
WZB Berlin Social Science Center 7